GRAND OPERA

ERIC A. PLAUT

Grand Opera

MIRROR OF THE WESTERN MIND

Ivan R. Dee

CHICAGO

Photographs of performances are used by permission of the Lyric Opera of Chicago. Photographs from *Lucia di Lammermoor, The Ring, The Tales of Hoffmann, Otello, Tosca,* and *Madame Butterfly* by Tony Romano. Photographs from *The Barber of Seville, Die Fledermaus, Carmen,* and *Samson and Delilah* by Dan Rest.

Library of Congress Cataloging-in-Publication Data:
Plaut, Eric A.
 Grand opera : mirror of the western mind / Eric A. Plaut.
 p. cm.
 Includes index.
 ISBN 1-56663-034-7
 1. Opera. I. Title.
ML1700.P58 1993
782.1'09—dc20 93-8351

In memory of

Dr. Lowell P. Beveridge

who taught me the meaning of being a musician

and

Dr. Saxton T. Pope

who taught me the meaning of being a psychiatrist

Acknowledgments

THIS BOOK took root almost twenty years ago when Indianapolis Public Radio invited me to do a series of programs on the psychological aspects of opera. This confidence in me provided the original stimulus to my pursuit of the subject. I thank Hanley and Belfus, Inc., for permission to use material previously published in their journal *Medical Problems of Performing Artists*. Earl McDonald, through a combination of extensive knowledge of opera and superb clerical skills, offered much help. Ivan R. Dee provided expert editorial assistance.

My wife Eloine spent a good deal of time compensating for my lack of skill with word processors and printers. She and my son Ethan have tolerated the many evenings and weekends I spent sequestered in my study. My lifelong friend, Dr. Donald McIntosh, reviewed and criticized numerous earlier drafts of the book. His wise advice has been invaluable.

E. P.

Evanston, Illinois
April 1993

Contents

Preface

THIS IS A book about grand opera from the time of the French
Revolution to World War I, from when the steam engine was
invented to the time of the airplane. It is the era of the critique of
reason, starting with Kant and culminating in Freud. It begins
with the still orderly world of Mozart's *Marriage of Figaro* and ends
with the chaotic world of Strauss's *Salome*. I could have called it a
book about nineteenth-century opera, but the period extends
beyond that at both ends. I could have called it a book about
romantic opera, but that term has meant too many different things
to different people. I chose to call it a book about grand opera
because, though that term has sometimes been used to refer to a
specific period of Parisian opera, it is during this time that opera
was at its grandest. No longer just an interest of the aristocracy, it
became a passion of the rising middle class. Freed from the
rigidities of the baroque style, it became the dramatic art form best
expressing the individualism that characterized the era.

Grand opera has been called the medium par excellence for
expressing human willfulness. It is a good description. Grand
opera's characters are driven by emotions of passionate intensity,
their actions are governed by feelings more than by rationality.

The vagaries of human motivation are the subject of grand opera. The study of human motivation (notwithstanding the claims of economic theorists) is best approached from a psychological perspective, and that is my primary focus. But human motivations never exist in a vacuum. They exist in social, political, religious, artistic, and philosophical contexts. Although my chief viewpoint is psychological, I have included these other perspectives when they seemed important to a deeper understanding of an opera.

Great opera, like all great art, is both a study of its time and a study of life at any time. No matter how original, how avant-garde an artist may be, he remains, like all of us, a product of his era. Not only the underlying assumptions about life that form his view of the world, his myths, but also the tools available to him are time-bound. But if his work is only time-bound it will not long endure. Great art addresses the timeless in the context of its own time. Grand opera from the 1780s to the 1920s continues to have such great appeal to us because it was an artistic medium that lent itself so successfully to the expression of timeless issues as seen through the eyes of its era.

Art does not build on the work of its predecessors cumulatively as science does. Shakespeare's plays are not an improvement over those of Sophocles. But certain art forms achieve high development in certain eras. The novel and symphonic music achieved such development in the nineteenth century. They remain artworks of continuing vitality for us while most nineteenth-century plays now seem time-bound and dated. The novel and symphonic music became the artistic media for expressing the era's focus on passionate human relationships, subjectively experienced, over a long, continuing time span. Grand opera incorporated the novel's sweep, the richness and power of symphonic music, and added that most expressive of instruments, the human voice. To many, like myself, grand opera is the era's most monumental artistic achievement.

And the houses that were built for opera performances became the era's great civic monuments, in some ways the era's temples. In the words of the anthropologist Claude Levi-Strauss, "The

music that took over the traditional function of mythology reached its full development with Mozart, Beethoven, and Wagner." As befits ceremonial occasions, opera performances came to involve many rituals, with prescribed behavior for both those on stage and those in the audience.

Myths are about heroes. In grand opera everything is writ large, in heroic dimensions; human emotions are expressed in extremes. The subtleties lie in the music, not in the plots and only rarely in the words of the libretti. It is the composers, not the librettists, who are the dominant figures in grand opera. It was also the era in which, for the first time, composers came to be seen as heroic figures. Before the nineteenth century composers were paid artisans, beholden to their employers. The artists of the romantic era glorified the emotional, the subjective, rather than the rational, the objective. As the expression of emotions became the ideal, the artists who gave them expression became idealized figures. Not only did the public view them as heroes, they often viewed themselves that way. The heroes, both on and off the operatic stage, thus became fascinating subjects for psychological study.

The underlying themes in grand opera are the timeless ones of love and hate, forgiveness and vengeance, loyalty and betrayal, family bonds and family feuds. These themes are played out in dramas pervaded by the important, time-bound characteristics of the culture—Western European, Christian, class-conscious, nationalistic, and patriarchal. It was also the era of the development of the nuclear family as the primary social unit. Father, mother, son, and daughter are reflected in the four voice ranges—bass, contralto, tenor, and soprano. With almost ritual regularity the authoritarian older generation is assigned to the deeper voices, bass and contralto, while the rebellious younger generation are tenors and sopranos. Also, with few exceptions, it is the younger generation's insistence that heterosexual love relations take precedence over everything else that creates the dramatic conflict.

Although basic cultural assumptions remained unvaried in these 140 years, it was also a time of great change. I have arranged the chapters of the book chronologically in order to capture the

changes sequentially. This arrangement has certain disadvantages; for example, I could not in one section discuss the unique nationalistic characteristics of operas, as would have been possible had I organized the book primarily around German, Italian, and French operas. It also results in some anomalies, such as the wide separation between the two chapters on Verdi. The chronological arrangement seemed best for my purpose of interweaving discussion of the timeless and the time-bound. It also enables a reader interested in only a specific composer or country to selectively read those chapters.

As indicated by the chapter subtitles, the chapters vary in what is addressed. In some the primary focus is on timeless issues, in others on the time-bound. In some the focus is on the composer, in others it is on the drama. In some it is on the artistic dimensions, in others on the social. Four composers have two chapters devoted to their work—Verdi, Wagner, Puccini, and Richard Strauss. In each case one of the chapters focuses on the composer while the other chapter focuses on different perspectives.

Four operas are discussed both because of their intrinsic value and because they are examples of important dimensions of grand opera. In these chapters I have included discussions of some issues important not just to the understanding of the specific opera but to grand opera in general. *Lucia di Lammermoor* is the only *bel canto* opera in the book. Nowhere is the primacy of the singer greater than in *bel canto* opera. Accordingly, I have considered singers and their relationship with audiences in that chapter. *Die Fledermaus* is the most purely comic opera in the book, so in that chapter I have examined the nature of comedy in general and its limitations in grand opera. *Carmen*, which so uniquely combines greatness and popularity, becomes the occasion for an investigation of artistic creativity. And *Otello*, based on one of the world's greatest plays, presents the opportunity for exploring the relationship between words and music in opera.

Throughout, the psychological discussion is primarily a modified

Freudian psychoanalytic approach. I know of no better assessment
of Freud than W. H. Auden's 1939 eulogy:

> If often he was wrong and at times absurd,
> To us he is no more a person now
> But a whole climate of opinion
> Under whom we conduct our differing lives.

Psychologies are products of their eras as much as anything else.
Freud, born in 1856, was very much a nineteenth-century man.
His psychology both sprang from and was a critique of the culture
in which he lived. No other psychology is as well suited for a
discussion of nineteenth-century issues. Although he was the
greatest psychologist of the Western world, and although all
psychology since has built upon his work, he was, as Auden said,
often wrong and at times absurd. In many places my approach will
be seen to be a modification of his views. Should some twenty-
first-century writer undertake a study of twentieth-century opera,
he would very likely use a somewhat different psychological
approach, one more focused on twentieth-century issues such as
self psychology.

My hope is that this book will be read as an overall discussion of
grand opera, and that it will then be put on the shelf, to be taken
down for rereading of a chapter before one goes to hear a given
opera again. I know that writing this book has greatly increased
my appreciation of grand opera. If reading it does the same for its
readers, my efforts will have been amply rewarded.

GRAND OPERA

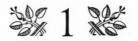

Mozart's Operas

MASTERY AND MISOGYNY

ALTHOUGH Mozart wrote music for twenty-five stage works, his status as an operatic composer rests principally on only four of them. Eighteen of these compositions are never or only rarely produced. Two—*Idomeneo* and *La Clemenza de Tito*—are in traditional Italian *opera seria* style, a stiff format with which Mozart was never really comfortable. Both operas contain beautiful music and are occasionally produced. *The Abduction from the Seraglio*, though in German, is in traditional *opera buffa* style, a form of comic opera which Mozart liked and used twice more after *Abduction*, his first opera of lasting popularity. Had he written only these twenty-one operas, Mozart would not be included among the great operatic composers. Of course he would still rank as one of the greatest composers of all time for, unlike the other operatic geniuses (such as Rossini, Verdi, Wagner, and Puccini), Mozart was a master of almost all musical forms while the others are ranked as truly great almost exclusively because of their operas.

Four operas account for Mozart's achievement: one dramatic opera, *Don Giovanni*; two comic operas, *The Marriage of Figaro* and *Cosi fan tutte*; and one musical theatre piece, *The Magic Flute*. After more that two hundred years they remain among the most

popular of operas. The operas of Mozart's great predecessors—
Handel, Gluck, and others—may be of great interest, but they
strike us as period pieces. Mozart was very much a man of his
time, yet his operas remain contemporary. In many ways he was
the founder of grand opera as we know it today.

Although each of these operas is unique, an underlying theme
runs throughout all four—the unresolved and unresolvable tension
between, on the one hand, what is traditional, established,
authoritative, and well ordered, and, on the other, what is
innovative, changing, rebellious, and impulsive. This theme re-
flects Mozart the man, Mozart the composer, and the times in
which he lived. Although powerful, conflicting forces are the stuff
of which all grand opera is made, there is a balance, a sense of
ultimate unity that is unique in Mozart's works.

Mozart well understood that he wrote about the coexistence of
irreconcilable opposites. He identified his *Don Giovanni* as a *drama
giocosa*, a comic drama. But *Don Giovanni* is far more tragedy than
it is comedy. It is Mozart's only great operatic tragedy. And
though tragic grand opera has dominated the operatic stage since
Don Giovanni, it remains, in the opinion of many, the greatest of
that genre.

The Don Juan tale probably had its origins when the Christians
first invaded Spain in the twelfth century. Originally it was two
separate stories, one of a compulsive womanizer, the other of a
man who offends the dead. The two stories were first merged in
1613 in Tirso de Molina's play *The Seducer of Seville*. Since then
the story has been remarkably popular—at last count there were
some three thousand versions. It has attracted such writers as
Molière, Dumas, Byron, Hoffmann, Balzac, and Shaw as well as
such composers as Gluck, Purcell, and Strauss. The version
crafted by Mozart and his librettist, Lorenzo Da Ponte, drew
heavily on a libretto that Bertatti had written for an opera by
Gazzaniga, first produced in the same year, 1787, as Mozart's
version. There had been numerous earlier operatic versions, for
example by Melani (1669), Le Tellier (1713), Caldara (1730),
and Righini (1776).

The character of Don Giovanni, the compulsive seducer, is the focus of the opera. But the frame of the opera, in its opening and closing scenes, is about Don Giovanni the murderous blasphemer. In the opening scene Don Giovanni, having raped (or seduced and abandoned) Donna Anna, is the agent of death of her father, the Commendatore. In the closing scene the Commendatore's statue is the agent of the Don's death. Although the theme of the relationship between men and women, between love and sex, runs through all of Mozart's operas, the particular version of that theme in *Don Giovanni* was no doubt heavily influenced by the librettist, Da Ponte, and his friend Casanova.

Da Ponte, who also wrote the libretti for *The Marriage of Figaro* and *Cosi fan tutte*, as well as libretti for many other composers, was himself an extraordinary character. Born Emanuele Corigliano, a Venetian Jew, he converted to Catholicism, took the name of the local bishop, and, after study at the seminary, declared himself an abbé. From an early age he lived by his wits. He became a notorious womanizer and was eventually expelled from Venice for adultery. Finding his way to Vienna, he became court poet there in 1782. He was forced to leave Vienna in the 1790s and ended up in New York, via London. After numerous unsuccessful business ventures, his last years were spent as the first professor of Italian at Columbia College. Casanova, who became our society's prototype womanizer, contributed to the libretto as well as attending the opening performance.

Psychological interpretations of Don Giovanni's character have often described him as having an unresolved Oedipus complex. Freud chose the tale of the man who slept with his mother and murdered his father as his central metaphor when he realized that the "memories" of childhood incest that he heard from his patients were often memories of fantasies, not actual events. Understanding the importance of childhood sexual fantasies was one of Freud's great contributions. He was so impressed with the significance of these fantasies in personality formation that he failed to recognize that the fantasies sometimes coincided with reality, that sometimes parents had sexual and murderous impulses

toward children and that when this occurred it could be exceed-
ingly damaging to the child's development.

Had Freud paid more attention to the beginning of the Greek
tale, he might not have come to his mistaken assumption that real
child abuse was a rare occurrence. For the tale starts out with the
story of how Laius, Oedipus's father, fearing that his infant son
would one day supplant him, attempted to murder the child by
leaving the baby in the wilderness. The *Don Giovanni* story is a
Laius tale far more that an Oedipus tale, particularly since it is as
much a tale about intergenerational power struggles as about
sexuality. In fact the Don does all he can to avoid dueling with
the Commendatore. It is only when forced to defend himself that
he slays the old man.

The Don's thousands of sexual conquests are far more important
to him as conquests than they are as sexual experiences. That is
why, once he has conquered a woman, he is forced to move on to
another. Sexuality without conquest has no meaning for him. His
sword is not a penis symbol; his penis is a sword symbol. His
incessant womanizing is not, as he would like to think, evidence
of his secure masculinity. It is evidence of exactly the opposite—
the terrible insecurity of his sense of being masculine. He is
compelled to prove his sexual prowess to himself, over and over
again, because it is the only way he can reassure himself that he is
safe from the murderous father. When Leporello tells us that the
Don has had relationships with 1,003 women in Spain alone, it is
comic. But it is also tragic, and because it is both, Don Giovanni
is a human figure with whom we can identify. That the tale of the
father who has murderous thoughts toward his son had special
meaning for Mozart is evident from his having chosen the same
theme for his first successful opera, *Idomeneo.*

We are never totally out of sympathy with the Don because he
is amoral rather than immoral. He does not consciously intend to
hurt the women he seduces. Not being aware of any wish to harm
them, he is constantly surprised and a bit irritated that they do
not view what has happened with his bland equanimity. Rather,
they pursue him seeking either marriage (Donna Elvira) or venge-

ance (Donna Anna), both of which for him are equally distasteful prospects. But being amoral, without a conscience, he feels no remorse over what he has done to the women or the Commendatore. Being without a conscience is not just one aspect of the Don's character, it is a central aspect, one of the ways by which he defines himself. Were he to allow himself to feel guilt or remorse, he would no longer know who he was. In the final confrontation with the statue, the statue demands that the Don repent. Adamantly, repeatedly, he refuses. It is something he cannot do, and it is for that refusal that he is dispatched to hell.

Originally the voice of conscience was the voice of our parents. As we mature it gradually becomes our own voice, but some of the original, often very frightening, parental quality always persists. A wish to be free of it, like the Don, always remains with us. Although the original voice will contain elements from both mother and father, in most societies, and certainly in eighteenth-century Europe, the father is the primary source. Far more than for most people, this was the case for young Wolfgang, for his father dominated his childhood to an unusual degree. Clues to Mozart's profound understanding of the Don can be found in that relationship.

Mozart's father was a well-known musician; he wrote the standard textbook of that era on violin playing. Mozart was exposed to music from infancy on and took to it immediately—he was scribbling notes on paper before he scribbled words. His father recognized his unusual gifts very quickly. From then on Leopold essentially subordinated his own career to his son's. Although there were elements of exploitation in this, there was clearly also much love and appreciation of Wolfgang's genius. The potential for problems in the relationship was noted by a friend of the family who wrote, "He adores his little son a little overmuch, and does all he can to spoil him; but I have so good an opinion of the innate goodness of the young man that I hope that, despite the adulation of his father, he will not allow himself to be spoilt but will turn out an honorable man."

* * *

Emotional disturbance in geniuses has long been recognized. Plato was explicit: he considered it integral to creativity. Biological, psychological, and social factors are undoubtedly involved in the origin of these disturbances. Among the social factors of importance are sibling position and family environment. A first-born male, like Mozart, has long enjoyed a favored position. Historically, in order not to break up family estates, the first-born male became the inheritor of family assets and title. Any sense of specialness he may have had about himself found considerable support in reality. Freud felt that, moreover, mothers held a special affection for first-born sons. It may have no statistical significance, but eight of the fourteen composers discussed in this book were first-born sons. Yet this sense of specialness, so essential to artistic creativity, can also be fertile ground for the development of isolation, loneliness, and depression.

The role of family environment is, at least for this group of composers, clearly of great significance. Nine of the fourteen composers had fathers who were professional musicians. Not all the fathers were as explicit as Mozart's that they expected the boy to become a musician. But fulfilling a father's expectations can be a powerful incentive, both as motivation to attain his love and as permission to exceed him. It can also serve as motivation *not* to, in order to establish an independent identity and obviate rivalry. Ambivalence toward his father was a lifelong problem for Mozart. The self-defeating life-style of so many composers suggests that they too struggled with this issue.

Bernard Shaw once said, "The reasonable man adapts himself to the world; the unreasonable one persists in trying to adapt the world to himself. Therefore all progress depends on the unreasonable man." The creative artist is likely not only to be "unreasonable," he is also likely to care deeply about the world, perhaps at the expense of his relationships with individual people. Such a "love affair with the world" may have its origins in earliest infancy. The artist may have an unusual sensitivity to outside stimuli, a heightened perceptual reactivity. The stimuli and perceptions may assume a relatively greater importance; other people, as individu-

als, a relatively lesser one. This may lead to difficulties in the usual sequences of development and later difficulties in interpersonal relationships. This is likely to be a factor particularly in musicians, whose talent is often manifest very early in life, as was the case with Mozart.

Although feelings of depression are ubiquitous in mankind, they may be more intense among the artistically gifted. The list of composers known to have had depressive symptoms includes Lassus, Handel, Schubert, Schumann, Berlioz, Mahler, Wolf, Rossini, Bruckner, Tchaikovsky, Scriabin, Elgar, and Rachmaninoff.

Understanding the meaning and significance of their depressive symptoms is, however, a difficult task. Symptoms have different significance in different eras and social settings. Other issues complicate the picture. Schumann and Wolf had cerebral syphilis. Schubert and Tchaikovsky were homosexuals. Berlioz, Mahler, and Scriabin were highly unusual, flamboyant personalities. Convincing evidence of an important genetic factor exists only for manic-depressive psychosis. In my judgment, of the composers discussed in this book only Rossini clearly had a psychotic illness. In all the others, while they certainly suffered significant psychological difficulties, the evidence for psychosis remains equivocal.

Similarly, the high incidence of emotional instability among geniuses is variously attributed to a genetic connection between genius and emotional difficulties, or to the developmental hurdles facing geniuses and their parents. A combination of the two is probably often involved. Raising an ordinary, normal child poses enough difficulties for most parents. Raising a genius well is too difficult a task for all but the most unusual parents. How does one deal with a five-year-old who is smarter that oneself? There is something uncanny, perhaps even frightening, in confronting the reality of genius. Mozart's unusual upbringing had a profound impact on his character structure, but he never became seriously disturbed. In many ways Mozart simply never quite grew up. In his sister's view, "Outside of music he was, and remained, nearly always, a child. This was the chief trait of his character on its shady side; he always needed a father, mother, or other guardian."

This is scarcely surprising: for the first twenty-two years of his life he was without direct parental supervision for only one week! Most of the time it was his father who hovered over him. Leopold Mozart taught his son, supervised his practice, regulated every aspect of his existence, and accompanied him everywhere. Between ages seven and fourteen Wolfgang spent five of the seven years traveling with his father.

Such intensive contact between young boys and their fathers has been rare since the Industrial Revolution. Before that time little boys began participating in their fathers' work lives at early ages—on farms, in small businesses, in craft shops. With the separation of the workplace from the home that accompanied industrialization, this was no longer possible. The impact on a boy's development of this exclusion from most of his father's working-hour activities is not yet understood. It seems likely that it makes a secure, comfortable identification with the father and his masculinity more difficult. For the most part, at least until very recently, little girls had far more opportunity for participation in their mothers' working-hour activities.

Mozart's intense childhood attachment to his father continued into adulthood. At age twenty-two he wrote to his father, "Your accuracy extends to all things. 'Papa comes directly after God' was my maxim as a child and I shall stick to it." With regard to music, however, Wolfgang knew he was Leopold's superior. Wolfgang retained a supreme self-confidence in his musical judgment throughout his life. But Leopold never lost his conviction that he knew better than Wolfgang how his son should manage all other aspects of his life. To his dying day Leopold continued to send Wolfgang long, detailed, often angry letters spelling out in great detail how Wolfgang should conduct his professional, personal, sexual, and financial affairs.

By simultaneously dominating his son and subordinating himself to him, Leopold created a profound psychological dilemma for Wolfgang: how does one rebel against a father who has subordinated himself to the son in a crucial way and yet continues to try to dominate that son for the rest of their lives? It was a dilemma

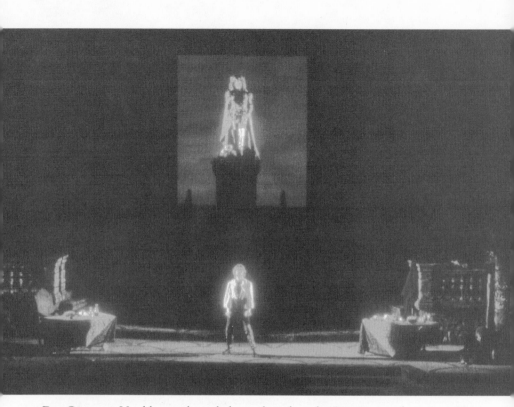

Don Giovanni: Unable to acknowledge guilt or fear, the Don invites the statue of the Commendatore to dinner, thereby sealing his doom.

Mozart never resolved. He did, however, achieve a balance between his love and his hate for his father. That sense of reliable structure, of balance, and of underlying conflict and tension pervades Mozart's music. It is his musical signature. We need hear only a few bars of a piece to recognize it instantly as Mozart.

The Don is the central figure of Mozart's opera, but it is the story of eight people, each of whom is very much a real person, someone with whom we can recognize and empathize. Each of the eight also represents a special aspect of human nature. Each character is thus both a personality and a vehicle for commenting

on the nature of life. The eight characters are paired: Donna
Anna and the Commendatore are the voices of conventional
morality; Donna Elvira and Don Ottavio are the voices of roman-
tic idealism; Zerlina and Masetto are the voices of simple inno-
cence; and the Don and Leporello are the voices of the unfettered
pursuit of pleasure. While the Don represents love without con-
science—lust—Leporello represents work without conscience,
namely greed. And since the target of Leporello's greed is the
Don, himself without scruples, Leporello's lack of conscience
produces comedy while the Don's produces tragedy.

In act 1 of *Don Giovanni* the real action is over by the end of
scene 1; the Don has slain the Commendatore. There is much
activity but no real plot development again until scene 5, act 2,
when the statue sends the Don to hell. The rest of the opera is
almost entirely devoted to developing the personalities of the
characters—particularly through the device of the characters learn-
ing about themselves and each other. For this purpose Mozart uses
both the ensembles and the arias.

This process of learning takes place on three levels. The first
level is the overtly factual. It is not until scene 3 of act 1 that
Donna Anna realizes that the Don is her father's murderer.
Similarly, in scene 2, act 1 the Don does not immediately
recognize Donna Elvira, just as in scene 4 of act 2 he does not at
first recognize that the statue is the Commendatore.

On the second level are the numerous disguise-unmask se-
quences. In scene 4, act 1 Donna Elvira, Donna Anna, and Don
Ottavio appear masked at the party; in scenes 1 and 2 of act 2 the
Don and Leporello exchange outfits and masquerade as each
other.

The third and most important level on which the characters
come to know each other is in their understanding of each other's
personalities and motivations. Of the eight characters, two are
capable of only limited learning—the two romantic idealists,
Donna Elvira and Don Ottavio. To the end of the opera Donna
Elvira cannot give up her illusions about Don Giovanni. Despite
Leporello's description to her of the Don's incessant womanizing,

despite his repeated lying to her, despite the admonitions of Donna Anna, Donna Elvira persists in her self-deception, continuing to hope that some day Don Giovanni will change. At the end, when the Don is gone, she withdraws to a monastery. He will remain the only man in her life.

The other romantic idealist, Don Ottavio, is similarly incapable of realizing that Donna Anna is unlikely ever to be his. The horrors of the opening scene lead her to faint. As she awakens she repels Don Ottavio with "Away, unkind man." This might have occasioned a less naive man to pause for a moment's thought, but not Don Ottavio. He blandly pursues his suit. Donna Anna does not help him at all. She leads him on, needing him to avenge herself on Don Giovanni. In scene 3, act 1, when she asks of Don Ottavio only that he avenge her father's death, he responds with a romantic love song, quite missing the point of her passionate statement. In scene 4, act 2 he again presses her to consummate their love, promising that her father's death will soon be avenged. Again she puts him off, saying that her sorrow is too great. Finally, in the closing chorus, she tells him he must wait a year before her grief has spent itself. Her grief is not just for her father. Underneath her hatred for Don Giovanni, she too has felt the pull of his appeal, and so she grieves for him as well. Although she has not yet acknowledged it to herself, she really doubts that she can ever marry Don Ottavio.

Masetto and Zerlina, the voices of simple innocence, have learned a great deal, not only about each other but also about the world of nobility. Mozart was fully aware that his two peasants are the most appealing people in the opera. He emphasizes the point by making them the most capable of personal growth. They stand in sharp contrast to the two members of the nobility, Donna Anna and her father, who have learned only that their status as nobles does not give them unlimited power. The relationship between ordinary people and the nobility was an issue of great importance to Mozart. It is only a subsidiary theme in Don Giovanni but a central one in The Marriage of Figaro.

And what of the two remaining characters, Don Giovanni and

Leporello? What do they learn? In truth they learn nothing at all. Nor do they wish anyone else to learn anything about them. The importance Mozart gives this issue is highlighted by the Don's very first words in the opera. He says to Donna Anna, "Foolish woman, you scold in vain. Who I am you shall not know."

People need to be able to care about other human beings in order to know them and to let themselves be known. Without this capacity, another person's knowledge about oneself is seen only as giving that other person greater power. For both the Don and Leporello, other people do not exist as individuals in their own right. They exist only insofar as they can gratify the needs of these pleasure seekers. Deep feelings about other people are not part of their world.

To illustrate this point Mozart uses a musical device: Don Giovanni has no great arias, just a little serenade and a patter song, even though he is on stage throughout much of the opera. Leporello has just one big aria, and it too is a patter song. Mozart uses the great arias as opportunities for people to pour out their deepest feelings. Since the Don and Leporello are unable to care deeply about other people, they would have nothing to say in a great aria. Leporello and Don Giovanni can concern themselves with someone else only if that person is present. Out of sight is truly out of mind for them. Indeed, they are both part of many duos, trios, and quartets. Don Giovanni's inability to love, and therefore to learn, dooms him to hell. Leporello's inability leads him to a milder but not unrelated fate: he is doomed to be the perpetual fool.

Two hundred years after it was written, *Don Giovanni* continues to be a moving, dramatic piece. For in each of us there is a little bit of the Don and of Leporello; to be free of the burden of conscience, to pursue pleasure without responsibility—even the most saintly among us knows these wishes. And every man has a bit of the righteous, unforgiving Commendatore, a bit of the idealistic, boyish Don Ottavio and of the decent, simple Masetto in him. Just as each woman has in herself a bit of the powerful, vengeful Donna Anna, of the romantic unrealistic Donna Elvira,

and of the gentle, flirtatious, loving Zerlina. In Mozart's *Don Giovanni* we all find aspects of ourselves. Insofar as the opera has touched us, it is because through it we have learned something about ourselves. For as the characters get to know each other better, we come to understand the interrelations of various aspects of ourselves.

Although called a tragicomedy, *Don Giovanni* is dramatically and musically predominantly a tragedy. The overture opens with the theme of the Don's doom, and while the action ends with that event, there is a closing ensemble, a paean to conformity and virtue. Such endings were standard for *opera seria*. Many great opera conductors (Mahler, for example) have felt that the opera should end with the Don's death. But since there is no clear cadence at that point, and because Mozart would never have ended an opera without a clear cadence, he certainly wanted the ensemble included. Still, there is so much hatred in the opera that Mozart may unconsciously have needed to alloy it through the pietistic final ensemble. Mozart wrote the opera during his father's terminal illness. Its first performance was just five months after Leopold's death. The world owes Leopold much for his recognition and cultivation of his son's musical genius. But for Wolfgang his father's unremitting attempts to dominate and control were a tragedy. Unconsciously, Mozart knew that his wishes to rebel were doomed to fail. His attachment to his father was too strong. His father's death would not free him; the Don's fate was also his.

Mozart's three other great operas are comedies. At the same time, with Mozart's characteristic sense of balance, they all deal with serious issues of importance to the composer. Whereas the comedy in *Don Giovanni* is often sardonic, the comedy in the other three is ironic, wry, gentle, sometimes whimsical. The issues addressed are serious, but they do not carry the profound significance for Mozart of his relationship with his father. Potentially serious dramatic situations arise, but tragic consequences are always averted. Man remains a mixture of good and evil, life a mixture of the comic and the tragic. But in the comedies it is the good and the comic which finally prevail.

Beaumarchais said of his play *The Marriage of Figaro*, "I make people laugh and then change the world." Napoleon called it "revolution in full swing." Emperor Joseph had banned its performance in Austria. For both these rulers, having a barber who was wiser, kinder, and more honest than a nobleman had revolutionary implications. But Da Ponte, that master persuader, convinced the emperor that Mozart's version of *Figaro* would omit its politically sensitive material. And it was omitted, overtly. But covertly the opera remained a powerful critique of royalty. Enchanted by the opera, Joseph nonetheless allowed its performance.

Whereas in *Don Giovanni* Mozart explored his conflict with authority on a deep, highly individual level, in *The Marriage of Figaro* he explores that conflict on a social level. That level also had great personal significance for Mozart. His ambivalence about royalty plagued his life. As a child he was often a pampered favorite of crowned rulers. As a young man he came into open conflict with the Prince Archbishop of Salzburg. Then, for a while, he was in considerable favor with Emperor Joseph. At the end he was again, to a large extent, alienated and out of favor. After his death his widow received better treatment than he had enjoyed.

Mozart was never able to accept the fact that his genius, which had brought him such adulation as a child, would not automatically bring him similar rewards as an adult. He refused to adapt himself to the realities of life in late-eighteenth-century Austria. At a time when a commoner was flogged into unconsciousness for striking a nobleman, Mozart, when told by the emperor that there were far too many notes in *The Abduction from the Seraglio*, replied, "There are no less and no more notes in it, Your Majesty, than are required." Coming from anyone but Mozart, such a remark would have been considered *lèse-majesté*. Joseph did not retaliate. Nor did he reward Mozart with a court position. Mozart's failure to acquire an adequately salaried position at the court meant that he never achieved a dependable source of income.

In retrospect it is difficult to assess how much of Mozart's failure to secure a court position was due to his irreverent behavior and

how much was due to his refusal to participate in the court intrigue that was required if one was to remain in the monarch's favor. In addition, Mozart was financially irresponsible. At times he earned a great deal of money through concerts, opera performances, and the sale of his compositions. Yet he was constantly broke. He gave money away, spent lavishly on clothes, gambled away large sums at billiards, and refused to take on pupils. He begged money from his father, his sister, and his friends. During his last few years he was increasingly in debt, often hounded by creditors and threatened with lawsuits. But he tended to blame royalty for his disastrous financial situation. Mozart knew that his feelings about royalty touched a highly vulnerable side of his character. As he once said, "I hate the archbishop to the verge of madness."

Still, there was another dimension to Mozart's relationship with royalty. He was the first great composer to remain independent of patronage, the first musician not to be at the beck and call of a master and to have his work constantly under the constraints imposed by his status as a servant. He was the transition from Haydn, who remained an Esterhazy employee, to Beethoven, who considered himself the equal of royalty, subordinate to no one.

Figaro was the perfect figure for Mozart to use in expressing his feelings about royalty. Employed by the Count Almaviva, Figaro considers himself in every way the count's superior. Since the count has all the power, outwitting him becomes Figaro's way of life. The count has been womanizing. His current target is Susanna, Figaro's fiancée. The count plans to exercise his *droit de seigneur*, the lord of the manor's claim to bed the bride before her wedding night. The countess, much distressed by her husband's philandering, joins the lovers in a conspiracy to thwart the count's plans and to humiliate him. The many convolutions of this plot, including mistaken identities, disguises, and forged letters, provide the opportunity for comedy. Yet the comic situations are frequently almost out of hand and near tragedy. For example, in act 2, when the count opens the door and discovers Susanna rather than Cherubino, whom he suspects is having an affair with his

wife, everyone is momentarily filled with dread, suspicion, and doubt. All are suddenly aware that their playful masquerade could have serious consequences. Similarly, in act 3, when Susanna pretends to respond to the count's advances, she becomes caught up in the ardor of his approach and almost forgets that she is only pretending to respond.

Many times the comic disappears entirely. This is most dramatically the case in the countess's two great arias in acts 2 and 3, as profound statements about unrequited love as can be found in any operatic tragedy. In this *opera buffa*, as in all comic opera, there is an element of caricature in most of the players. It is strikingly absent from the countess. She also stands apart from the conflict between the ordinary people and nobility. She participates in the plot against the count only in the interests of saving her marriage. What's more, her relationship with Susanna is much more one of friendship than it is a master-servant relationship (the very depiction of a friendship between a commoner and royalty was in itself revolutionary). Susanna also participates only to save her marriage to Figaro. For Mozart, the conflict with authority is primarily an issue between men. Women are not much involved. Their main concern is their relationship with men.

Positioned halfway between the men and women is the figure of Cherubino. He is halfway in that he is only an adolescent, just barely grown out of the bisexuality of latency, not yet fully a man. The point is doubly emphasized not only by it being a trouser role (sung by a woman dressed as a man), but also by having him then dress up as a woman. The folly of the count's jealousy of his wife (he is the unfaithful one, not she) is heightened by his picturing as unlikely a figure as Cherubino as a rival. Nowhere in opera, except possibly in *Der Rosenkavalier*, is there such an affectionate portrait of the exultant joys and despondent sorrows of adolescence. Mozart poured into Cherubino all his wishes for the adolescence that was denied him and that, not having struggled with the issues at the appropriate time, he spent the rest of his life in trying unsuccessfully to master. His lifelong love of the scatological and of wordplay, his irresponsibility in regard to money, and

his troubles with women all reflected the perpetual adolescent side of his personality. As his sister said, he never established for himself an identity fully independent of his parents.

As a theme, the relationship between women and men (with a special focus on sexual fidelity) runs throughout both *Don Giovanni* and *The Marriage of Figaro*, but always in the context of a conflict with authority. In *Cosi fan tutte* it becomes the sole subject for discussion. While the subject greatly occupied—and preoccupied—Mozart consciously, it did not have the same power as his largely unconscious conflict with his father. Thus where the humor in *Don Giovanni* is sardonic and that in *The Marriage of Figaro* poignant, in *Cosi fan tutte* it is wry and ironic. There, even in the big "serious" soprano arias, the dramatic element is so exaggerated that they become self-mocking. *Cosi* is Mozart's most purely comic opera. Yet it is not farce. One is always aware that the issue of sexual fidelity is important to Mozart and that his purpose is not just to entertain us but also to tell us what he really thinks about the relationships between men and women.

The structure of the opera is designed with Mozart's typical balance. The six characters come in pairs: Guglielmo, an officer, and Fiordigili, his wealthy fiancée; her sister Dorabella and her officer-fiancé Ferrando; Despina, the sisters' maid, and Don Alfonso, a man about town. The plot is furthered with typical eighteenth-century disguises: the officers disguise themselves as Albanians in order to test the sisters' fidelity; Despina disguises herself first as a doctor and then as a notary to help Don Alfonso win his wager that the sisters will prove unfaithful. And once their frailty has been proven, the opera ends with a typical Mozartean ensemble of reconciliation. Although the opera is all about sexual fidelity, Mozart could not resist slipping in one touch of antiauthoritarianism, in Despina's aria about her exploited status as servant to the sisters.

Unfaithful sisters was a topic close to Mozart's heart. At age twenty-two he had fallen madly in love with the young singer

Aloysia Weber. His plan to propose to her brought forth a storm of protest from his father—she was too young, too poor, a seductress; she would ruin his career, he would soon have a house filled with squalling brats he could not support, her mother was an evil woman, and so on. This barrage did not alter Mozart's passion, but it may have delayed his action. At his father's insistence he went off to Paris with his mother (he had wanted to go to Italy with Aloysia), and by the time he returned to Aloysia she had abandoned him for another man. All evidence is that his passion had throughout been unrequited.

Five years later Mozart was rooming with the Weber family in Vienna, having moved there after his break with the Archbishop of Salzburg. He began seeing a lot of Aloysia's younger sister Constanze. At first she too rejected his proposals. But this time he persisted and, despite his father's objections and her mother's machinations, they married. The course of the marriage was not smooth. The couple had many difficult realities to deal with— chronic indebtedness, frequent moves, the deaths of four of their six children. They also had to deal with each other's infidelities. But somehow, as in the opera, they always reconciled and forgave each other.

Mozart's attitude toward women was complex. It is said that he loved his mother dearly but had absolutely no respect for her. His sister, whom he always loved very much, had also been a musical child prodigy. But Leopold had put all his efforts into promoting his son's talent. Most likely these early relationships shaped the women Mozart limned in his operas. For the most part he treats them with great affection but not much respect. The only two he clearly respects are Donna Anna and the countess. They are totally different from the noble, long-suffering heroines who inevitably die for their men and who pervade nineteenth-century opera. But even these two are not totally reliable sexually. Donna Anna's commitment to Don Ottavio is always shaky, and although the count's accusations of infidelity by the countess are projections of his own faithlessness, she does enjoy Cherubino's flirting with her.

As he made clear through both Count Almaviva and Don

Giovanni, Mozart had no more confidence in male than in female fidelity. He had been raised as a devout Catholic and felt obligated to remain a virgin until marriage. He was explicit about his need to marry because he felt he could no longer contain himself sexually. There must have been a premonition of his later marital infidelities when, under pressure from Frau Weber to marry Constanze, he wrote to his father, "If I had to marry all those with whom I have jested, I should have two hundred wives at least."

But when Frau Weber initiated legal action against Mozart (accusing him of having seduced Constanze), he and Constanze married without his father's knowledge or consent. The marriage was not off to a good start. As their indebtedness increased, their relationship grew worse over the years. By 1791 Constanze was spending most of her time at health resorts, often in the company of Mozart's student Sussmayer, after whom she named her last child.

As the marriage deteriorated, so did Mozart's attitude toward women. In The Marriage of Figaro (1786) the contessa is loving and faithful but not subservient; she can be both serious and playful; she is altogether a complete and wonderful person. In Don Giovanni (1787) Donna Anna is strong and passionate, but there is a hard edge to her, while Donna Elvira is warm and loving but foolish and unrealistic. In Cosi fan tutte (1790) the two sisters are faithless and flighty. By the time of The Magic Flute (1791), misogyny is rampant. Mozart has the "divinely wise" Sarastro tell Pamina, "A man must guide your heart, for without that every woman tends to overstep her natural sphere."

Mozart's ambivalence about women is also reflected in both the major female characters of The Magic Flute, the Queen of the Night and Pamina. In act 1 the Queen of the Night is the good witch; in act 2 she is the evil witch. Her desire is for revenge; she destroys others. Pamina is our heroine, yet her major aria is about suicide. She is self-destructive. They are mother and daughter, opposite sides of the same coin. Mozart further emphasizes the connection between the two by writing identically constructed second-act arias for them. Each one is in sonata form; it starts in a

minor key, modulates to a second key followed by a long coloratura passage, and then returns to the tonic.

Sarastro's misogynistic words reflect a second source of Mozart's changed attitude toward women. In 1784 he had joined the Masons, a totally male-oriented society. It became the focus of his social life; fellow Masons loaned him the money he desperately needed for survival; his last completed composition was written for his lodge. The Masonic influence pervades *The Magic Flute*; most of the second act is set against the background of a Masonic temple, and Masonic symbols are present throughout the opera. Mozart expresses the Masonic attitude toward women by having a chorus of priests state, "Guard yourself from women's wiles, this is the first duty of our order." Calling it the "first duty of the order" is hardly descriptive of the Masonic movement as a whole. Rather, 'it probably describes how important this aspect was for Mozart.

But the order also had other significant meanings for Mozart. Eighteenth-century Masonry reflected eighteenth-century Enlightenment thinking: the conviction that a philosophical education would lead to a noncoercive world order; the belief in the perfectibility of man; the faith in an abstract deity. Although Mozart had been raised as a strict Catholic (and had at age twenty-two rejoiced at Voltaire's death), the ten years in Vienna (1781 to 1791) had profoundly changed his thinking. During almost all of that time Vienna was the home of Emperor Joseph, probably the most enlightened ruler of the time. He abolished serfdom, instituted equal taxation, encouraged religious and press freedom, and saw the function of the state as achieving the greatest good for the greatest number. In spite of the Catholic church's opposition to Masonry (which, although originally a Catholic order, had abandoned all connection with organized Christianity when it began admitting Jews in 1723), Joseph supported the order. Even though Joseph never gave Mozart a court position, Mozart was very attached to his monarch. In 1789, despite being disastrously in debt, Mozart turned down an offer of three thousand thalers per year from the court of the King of Prussia, asking "Shall I leave my good emperor?" Three thousand

thalers were, at the time, the equivalent of $60,000 in 1990 dollars. And at that time Mozart owed the equivalent of $30,000 to just one of his Masonic friends.

The structure of *The Magic Flute* is, as in all of Mozart's operas, built around balanced pairs: Tamino and Pamina, Papageno and Papagena, Sarastro and the Queen of the Night, the three girls and the three boys. Perhaps to mitigate some of the opera's misogyny, Mozart tossed in Monostatos, a dastardly villain, albeit a comic one, who gets his comeuppance but is not destroyed. The plot of the opera is the tale of Tamino's path from being a lost adolescent to becoming a happily married man, reconciled with his "father." Through this tale, at a time when he knew he was increasingly seriously ill, Mozart was resolving the two problems he had struggled with all his life—moving from adolescence to adulthood, and reconciling himself with his father. At the end of the opera Tamino and Pamina are united with Sarastro's blessing. The similarity of the names emphasizes that the couple were meant for each other, as does the union of Papageno and Papagena. Sarastro, the father with whom the son must reconcile, is pure morality. Although the opera is about Masonry, in some ways Sarastro is a very Catholic figure. He is the celibate priest who cannot be tempted; he sends the Queen of the Night to hell. Mozart illustrates the unbreachable gulf between Sarastro and the Queen of the Night by having him sing in the lowest possible range of the bass voice and her in the highest possible of the soprano. He also underscores the gulf by giving Sarastro flowing sonorities and the Queen jagged, staccato melodic lines.

Tamino's path is strewn with obstacles. At the opening he is a Japanese prince, wandering, lost in a strange land. First he must escape from the clutches of the lying Queen of the Night, then he must survive the trials devised for him by Sarastro. At the beginning he is surrounded by the darkness of the Queen of the Night; at the end he stands in the blazing sunlight of Sarastro's temple. That temple has three doors. The one on the right is named "reason," the one on the left "nature." Tamino is not to enter either. He is to enter the center door, "wisdom." Mozart uses

the scenery, as well as the music and plot, to find a way to reconcile polarities.

Tamino's triumph in a blaze of light reflected late (1790s) Enlightenment optimism about the perfectibility of mankind. If he tried hard enough, man would achieve liberty, equality, and fraternity. Mozart himself had achieved a measure of liberty when he freed himself from dependence on a royal patron in 1781. Fraternity and equality he had never known. His unusual childhood and adolescence had foreclosed his experience of membership in a group of peers. For most boys such experiences are essential to mastering the developmental tasks of adolescence. Mozart makes clear in *The Magic Flute* that this issue remained very alive for him. There are essentially two groups of characters in the opera: the adolescents (Tamino and Pamina, Papageno and Papagena) and the adults (Sarastro and the Queen of the Night, and the priests). The split between the adolescents and the adults is further emphasized by the operatic styles assigned. The adolescents' sections are in *opera buffa* style, the adults' are in *opera seria* style.

Such a pastiche was quite appropriate in *The Magic Flute*, which was written not for the opera house and its upper-class patrons but for the musical theatre and its middle-class audience. For the same reason, much of the comedy verges on the slapstick, and there are many silly gimmicks like the sprouting of flowers and the appearance of strange beasts. In contrast to his other great operas, Mozart almost completely omits the use of ensembles to present the complexities of human behavior. The great music in *The Magic Flute* is almost all in arias. The messages in the opera are not subtle. Papageno's antics are blatant slapstick while Sarastro's speeches are sermons. And yet for two hundred years audiences have continued to be moved by the opera. Mozart's joy in the slapstick is so infectious, his belief in the Masonic messages so sincere, and his music so marvelous that despite the opera's lack of coherence we never lose interest.

The lack of coherence may also have reflected what was going on in Mozart's world in 1790. It was rapidly falling apart. His

marriage was strained, his finances a shambles, his health deterio-
rating. Emperor Joseph had died, his reforms a failure. The Age of
Enlightenment was coming to an end, as was Mozart's life. But
Mozart was not just a child of his time. Like all true geniuses he
was also ahead of it. The highly structured, formal design of his
music reflected the Enlightenment's faith in rationalism. Mozart
took this format and built into it an intense emotionality, antici-
pating romanticism. In his harmonies, his modulations, his instru-
mentation, he was as innovative as he was traditional in the
formal structure of his work.

The formal structure of Mozart's music is most clearly evident in
his many concertos. The first movement of almost all of them
follows an identical pattern of orchestra and soloist passages,
sequences of modulation, the use of repeats and recapitulations,
and so forth. Mozart also locates us musically by using specific
keys for specific moods: C minor is sad, F minor is seriocomic, G
minor is tragic, A major is seductive. Within these rigid parame-
ters Mozart was a remarkable innovator. One publisher returned to
him a completely accurate manuscript, convinced it was filled
with errors. Prince Grassalkovitch, finally realizing that his musi-
cians were playing some Mozart quartets correctly, tore up the
scores. Mozart's quartet K574, which uses eleven of the twelve
tones of the scale in its first two bars, anticipates the twelve-tone
music of two centuries later. The innovations in Mozart's operas
anticipate the romantic era that was to follow. The operas can be
viewed as either the final expression of classic opera or the first
expression of the romantic.

But the tension between unreconciled opposites in Mozart
continued until the very end. His last two compositions were both
religious works, the first a cantata for the Freemasons, the second
his Requiem for a Catholic Mass, which he did not live to finish.
Both pieces were written in 1791. The preceding year had been a
terrible one for Mozart. He was in serious financial trouble and
during the entire year wrote nothing except two quartets, one
quintet, and one piece for musical clock. By comparison, 1791
started out favorably. Two lucrative opera commissions greatly

improved his finances, and he soon began pouring out a series of magnificent compositions. It was to be one of his most prolific years, despite the fact that by spring his health had begun to decline. By fall he had developed badly swollen ankles and had frequent fainting spells. His condition deteriorated rapidly, and he died on December 5, 1791, at age thirty-five. In contrast to 1790, Mozart's last year was so productive that one can only wonder if perhaps the perpetual adolescent had at last begun to grow up. We shall never know what incomparable music we might now have, had he only lived to full maturity.

2

Beethoven's Fidelio

THE EXTRAORDINARY COMPOSER
AND HIS ORDINARY OPERA

BEETHOVEN was an extraordinary man and an extraordinary musi-
cian. His dedication to his art was intense. He was a perfectionist
who worked and reworked his compositions until he was fully
satisfied. He often rejected offers to compose music to suit some-
one else's wishes. He was right to do so. Whenever he broke this
rule, as in the "Wellington's Victory" Symphony and the "Conse-
cration of the House" Overture, the results were unsatisfactory.
His symphonies, concertos, and chamber music are some of the
most powerful, moving, sublime music ever written.

Fidelio, his only opera, is by comparison ordinary. It contains
some magnificent music, but it lacks the coherence, the dramatic
logic, the sense of inevitability of progression that characterize
Beethoven's greatest works. He left us a great deal of firsthand,
written information about his thoughts and compositional process
in some seventeen hundred pages of conversation books (from the
last decade of his life, 1818–1827, when he was deaf, forcing his
friends to write out what they wanted to say to him), letters, and
diaries. And in his composition books (some eight thousand
pages) are his working notes as he developed his pieces. A study of

why Beethoven's only opera, beautiful as it is, is not up to the standard of his greatest works is thus possible without having to depend solely on often unreliable secondary sources.

Fidelio was first performed in Vienna on November 20, 1805. The libretto was by Sonnleithner, based on a French libretto "Leonore, or Conjugal Love," which had already been set four times. Beethoven had wanted to use this title for his opera, but because of possible confusion with a version by Paer, produced just the year before in Dresden, he reluctantly accepted the title Fidelio. The production was delayed by the censor who was understandably nervous about the revolutionary implications of the story and insisted that the setting be changed from a contemporaneous one to the sixteenth century. When it finally took place, the first performance was a fiasco. Napoleon's troops had entered Vienna a few days before, and all the nobility, the usual opera audience, had fled town. Some French officers came, and so did a few of Beethoven's friends. But the opera lasted only three performances.

Beethoven's friends knew that Fidelio's problems went far beyond politics. They tried to persuade the composer to make changes: the opera was too long; there were too many set-piece arias and long orchestral passages; there was no reason for it to be in three acts; there were problems with the libretto, and so forth. At first Beethoven rejected these criticisms, but after the elderly Princess Cristiane, whom Beethoven held in high esteem, pleaded with him, he agreed to modify the work. The shortened two-act version was produced the next year. Claiming there was a cabal conspiring against him, Beethoven withdrew the score after three performances. It is unclear if the opera would have been a failure or if Beethoven felt he was being cheated of his share of the revenues.

Eight years later, in 1814, with the help of the librettist Treitschke, he produced a third version of Fidelio, the one heard today. In the chaos that characterized his lodgings (and perhaps because of his ambivalence about the opera), he could not find a copy of the score and had to borrow a copy he had given a friend. Treitschke proved to be the perfect collaborator. The opera was a

great success and was chosen to open the festivities accompanying the Congress of Vienna. That gathering, which attracted some ten thousand visitors to the city, not only reestablished the old conservative monarchies of Europe after Napoleon's defeat but also bankrupted the city and initiated a long period of financial and artistic decline in the Austrian capital, leading to a diminished interest in serious music like Beethoven's.

More than anything he ever wrote, *Fidelio* remained of continuing concern to Beethoven. In 1814 he noted, "My *Fidelio* has not been understood by the public. But I do know that, someday, it will be valued.... Furthermore, this whole business with the opera is the most troublesome in the world, for I am dissatisfied with most of it and there is scarcely a number which I have not been compelled, here and there, to patch up my present dissatisfaction with some satisfaction. There is, however, a great difference between the situation of being able to give oneself over to free consideration or to enthusiasm." That same year he lamented, "The opera is gaining for me a martyr's crown." On his deathbed he gave the manuscript to a friend, confessing, "Of all my children, this is the one that has caused me the worst birth-pangs, the one that brought me the most sorrow; and for that reason, it is the one most dear to me."

Even though the 1814 version was a success and has remained so, Beethoven had reasons for his continuing concern. In the decade between the original version and the final one, Beethoven's style had changed. The 1805 version is traditional rescue opera, as is the much improved 1806 version. The 1814 version has many elements of romantic opera. The opera's multiple musical traditions make it not far amiss to say that it starts out as German singspiel, develops into Italian melodrama, and ends as English oratorio.

Most musicologists divide Beethoven's work into four periods: the first, up to 1799, a classical period in which he had not yet fully established his personal style; a revolutionary period from 1800 to 1812 (some have described all his music as revolutionary—always striving to break free of structure); the fallow

period from 1812 to 1819 when little new was written; and the final years when he was able fully to express himself musically. *Fidelio*, like the Eroica Symphony, is an explicit statement about Beethoven's revolutionary convictions during his middle years.

The revolutionary spirit was very much in the air throughout Europe in the first decades of the nineteenth century. Napoleon was a hero in the view of the best German minds of the time: Kant, Hegel, Goethe, Schiller, and others. Beethoven too was caught up in what he later called his "revolutionary fever." Not being one to conceal his feelings, he railed against the Austrian authorities, often in public. The police listed him as possibly dangerous, though he was never politically active. In 1802 Cherubini's revolutionary operas came to Vienna. Beethoven greatly admired Cherubini as a composer, and the operas made a deep impression on him. In Italy opera was no longer just the province of the nobility, it had become the popular mass entertainment and thus a vehicle for the expression of revolutionary sentiment. In Belgium the revolution of 1830 actually began when the audience left a performance of Auber's *La Muette de Portici* and became the nucleus of a popular uprising that toppled the government.

Before the nineteenth century the romantic concept of the artist as the outsider, the bohemian, the revolutionary, did not exist. Bach, Handel, Haydn, and Mozart all considered themselves very much in tune with the established order. Beethoven was the first loner artist, and he has remained the prototype for artists since. The two greatest operatic composers of the century, Verdi and Wagner, were both committed revolutionaries at some time in their lives. In many ways *Fidelio* is the transitional opera between its classical predecessors and the romantic and revolutionary operas that dominated the rest of the nineteenth century.

Despite all his problems with *Fidelio*, Beethoven never gave up the idea of further operas. He considered more than twenty subjects, and in 1807 he unsuccessfully petitioned the directors of the Royal Theatre for an annual stipend in exchange for which he

would, among other things, write for them "every year at least one grand opera." When a friend suggested Macbeth as a possibility, Beethoven replied, "I have already occupied myself with it: The witches, the murder scene, the ghost banquet, the cauldron spirit-seance, the sleep-walking scene, Macbeth's death. . . ." A few sketches exist in Beethoven's 1808 composition books; but the librettist with whom he had planned to work died. Even before *Fidelio* Beethoven had written a number of sketches for an opera called *Vestas Feuer* but decided it was not a good subject. In 1816 he negotiated with theatre directors for a proposed *Romulus*, but they could not agree on terms. That same year he recorded in his diary, "Leave aside operas and everything else; write only in your manner. And then a cowl to end this unhappy life." The number of different excuses Beethoven found for not writing another opera—not enough money, no good librettist, no proper subject— suggest there may have been deeper reasons. Yet just months before his death he was still thinking about an opera to Goethe's *Faust*, a project he had been contemplating for decades.

The overture to *Fidelio* used today is the last version of four. Beethoven wrote it for the 1814 revival, though it was not ready for opening night. The other three are known as the Leonore overtures no. 1 (1807), no. 2 (1805), and no. 3 (1806). No. 1 is rarely heard; no. 2 is occasionally played as a free-standing orchestral work; no. 3 is a masterpiece. Besides being frequently played as a free-standing orchestral work, it is usually inserted into the opera between scenes 1 and 2 of act 2. This practice, begun by Mahler, recognizes that the music is simply too powerful to serve as an overture. Even though it makes no dramatic sense to place it in the middle of act 2, it does not interrupt the action since the drama has effectively already ended. And the opera simply seems incomplete without it. Wagner saw Beethoven as so exclusively an orchestral composer that he wrote, "Is not the dramatic action of *Fidelio* an almost repulsive dilution of the drama presented in the overture?" Another example of Beethoven's essentially orchestral thinking was in the original 1805 version of *Fidelio*, in which, after the curtain had fallen on act 1, Beethoven continued

his musical argument with a sixty-measure orchestral passage. Beethoven was fully aware of this conflict between opera and the symphony. While working on the 1814 revision he wrote, "Although I know well the worth of my *Fidelio*, I know equally clearly that the symphony is my true element. When there are sounds in my head, I always hear the full orchestra. I can rely on instrumentalists for everything; when writing for the voice I always have to ask myself: is it singable?" And in another letter about the opera: "In my instrumental music I always have the whole in mind; here, however, that whole is to a certain extent divided, and I have afresh to think myself into my music!"

Beethoven once confided to a friend: "I carry my thoughts about with me for a long time before I write them down. Meanwhile my memory is so tenacious that I am sure never to forget, not even in years, a theme that has once occurred to me. I change things, discard, and try again until I am satisfied. Then, however, there begins in my head the development in every direction and, since I know exactly what I want, the fundamental idea never deserts me—it arises before me, it grows—I see and hear the picture in all its extent and dimensions before my mind like a cast, and there remains for me nothing but the task of writing it down, which is quickly accomplished when I have the time, for I sometimes take up other work, but never to the confusion of one with the other."

Wagner, writing about the Ninth Symphony, had a similar view of Beethoven's compositional process. He saw Beethoven as having the melody of the "Ode to Joy" in mind from the beginning, of breaking it into component parts in the first three movements, and finally setting "his full melody before us as a finished whole."

The composition books confirm Beethoven's way of working. He would first decide whether the next work was to be a symphony, concerto, or sonata, a decision often determined by what was marketable at the time. Next would come a decision regarding key and overall character and often some indication of rhythm. Many of these ideas were put into words rather than notes, clearly indicating that motifs and melodies had not yet

taken shape. When the first themes do appear they are not infrequently completely undistinguished. The composition books are filled with reworking after reworking of phrases, sections, movements, and sometimes entire pieces.

Starting from the whole and working down to the details was by no means Beethoven's only approach. Particularly on smaller pieces, he often began with thematic material—not surprisingly, since Beethoven's first notoriety came through his gifts at improvisation. Not only did he have great compositional ease, but in the words of Czerny (a great musician himself) it was "astounding how quickly he could read and play compositions at sight, even in manuscript and from full scores." Beethoven clearly had great musical facility. But converting his ideas into final products that expressed exactly what he wanted to say involved a laborious process. His musical thinking was among the most complex and profound ever known. Undoubtedly perfectionism also played a role in his completion of a serious work. At certain periods in his life he suffered from writer's block. "For some time back I have found it hard to bring myself to write," he noted. "I sit and think and think: I have it, yet, I can't get it down on paper. I am afraid of beginning these great works. Once started all goes well."

Always a hard worker, Beethoven's work habits varied greatly. Sometimes he would regularly arise quite early and work steadily until afternoon. At other times he would work highly irregular hours, sometimes through the night. Although most of his composing was done at home at the keyboard, he loved to roam the streets of Vienna and into the countryside, jotting down ideas. If the thoughts were complex he would rush home to work on them. Asked about these habits Beethoven replied that since childhood he had had to write down his inspirations immediately so that he did not forget them. This seems to contradict his statement about an infallible musical memory, but he probably mistrusted himself and lived in constant fear of forgetting something.

Although Beethoven's repeated reworking of his material occurs with all kinds of music, it is particularly striking with vocal music. One passage of a song (op. 112) has thirty-seven versions. The

opening bars seemed to pose special problems for him. There are, for example, eighteen different beginnings for Florestan's big act 2 aria. Although he composed some eighty songs, Beethoven was aware that he found the writing of songs not very gratifying and the most difficult of his endeavors. For one thing, he had strong feelings about the emotional tone of not only the standard twenty-four major and minor keys but others as well—thus D sharp was a different key from E flat. The words had to be fit to the right key, and every word had to have precisely the rhythmic emphasis he wanted, with the high point of the melodic line occurring on the most suitable word and the movement of the melody reflecting the content of the words.

Music had so much more meaning for Beethoven than words. He was one of those rare people who, when not specifically addressing another person, thought musically rather than verbally. He once wrote, "If I could give as definite expression to my thoughts about my illness as to my thoughts in music, I would soon help myself." He greatly enjoyed conversations with friends, but he was apparently strange and challenging to talk with because of the unusual sequences in which his thoughts would pour out. He was often naive; his sense of humor inclined to punning and practical jokes, which often put people off.

There were great gaps in his education. He could not multiply. At his death he had a library of only three hundred or so books, including both classical and contemporary authors. What litera-ture meant to him is hard to say. He had a special fondness for pseudoprofound religious and philosophical aphorisms, copying favorites out in bold writing and keeping them under the glass on his writing desk where they were always visible. For example: "HE IS ONLY AND SOLELY OF HIMSELF; AND TO THIS ONLY ONE ALL THINGS OWE THEIR EXISTENCE." Clearly, what mattered to him lay beyond the realm of words.

Beethoven was not alone in having trouble writing operas. Although composers had important social and financial reasons for trying, after Mozart not one of the great German composers of symphonies, chamber music, or lieder had succeeded. Schubert

wrote a number that have disappeared from the repertory. Schumann wrote only one; it is rarely performed. Brahms never tried. Neither did Mahler, though he was the most renowned opera conductor of his time. By contrast, Italy, which had dominated orchestral music in the eighteenth century, produced no significant orchestral music in the nineteenth but a stream of great opera composers.

The opening scene of act 1 of *Fidelio* is devoted to Rocco, the chief jailer in Pizarro's castle, his daughter Marcellina, and his assistant Jacquino. These three are the "little" people, the working-class figures, of the opera. Beethoven's music for them is rather simple, the characterizations are superficial and stereotyped. The contrast to Mozart's treatment of his working-class figures, Figaro and Susanna, is striking. Marcellina is given a few touches of real humanity, but the men, Rocco and Jacquino, are cliché characters, and the interaction is farce. Marcellina is rejecting Jacquino's advances, fancying herself in love with Fidelio who is really Leonora disguised as a man. Rocco thinks Fidelio would be a fine catch for his daughter.

When Leonora arrives on the scene in *Fidelio*, she has apprenticed herself to Rocco, hoping his secret prisoner is her husband Florestan. She, Rocco, Marcellina, and Jacquino sing a quartet, each expressing his or her view of the situation. Mozart, Rossini, and Donizetti all used ensembles for similar situations. Beethoven chose an unusual musical form, the canon, for this ensemble. It is a magnificent piece of music; the part writing is superb, the orchestral accompaniment exquisite. But because the melodic line for each voice in a canon is required to be as similar as possible to that of the others, it is also one of the most rigid of musical forms. As such it is peculiarly unsuited for the scene in which four people are supposed to be expressing very different points of view. Perhaps Beethoven chose the canon form precisely to express his feelings that these four very different people were at heart all the same, all very human. This idea, the essential brotherhood of humanity, so

alien to his actual relationships, was nonetheless central to his idealistic philosophy. It ennobles his music. But love of mankind is very different from love among individual human beings, which is the stuff of opera. And the canon does nothing to further the dramatic action of the opera.

The next piece, Rocco's paean to the importance of money, was an indictment of money in the more revolutionary 1806 version. Beethoven considered removing it completely, but the bass engaged for the 1814 premiere refused to sing unless he had one big aria.

Following Rocco's Gold aria is a trio in which Rocco, Marcellina, and Leonora speak of their concerns for the future, and then Pizarro, governor of the prison, enters. Having learned that a prison inspection is forthcoming, Pizarro orders Rocco to kill and bury Florestan immediately, and then departs to make preparations. After Pizarro leaves, Leonora sings her great aria "Abscheuchlicher" (vile monster). As becomes clear when Florestan first appears in act 2, he is a Christ-like figure. The opening phrase of Leonora's aria is a musical allusion to this. The notes (two E-flats dropping down to two F-sharps) and the rhythm (the opening note is followed by a dotted eighth, a sixteenth, and then a quarter) are identical to the opening of the "Ah, Golgotha" aria in Bach's St. Matthew Passion. Leonora is an equally idealized figure. The refrain that closes the opera (repeated over a dozen times) is, "Every man will join us proudly who has won a noble wife. Ne'er can praises ring too loudly: Hail to her who saved his life."

Leonora's great aria is followed by the prisoners' chorus. Starting softly, as the prisoners emerge from their dark dungeon into the light, it gradually builds to a crescendo, then falls back to a double piano. After a thematically different middle section, the first section is repeated, ending in pianissimo, as it began. As a choral depiction of hope amid the desperation of a people oppressed by tyranny, it has no equal in all of opera. Once again the blending of orchestra and voices is superb. The theme is about men standing together. Beethoven inserted it into the opera all on his own; there is nothing similar in Bouilly's original French libretto,

Fidelio: Straining to see the light as a deaf man strains to hear sounds, the prisoners emerge from their dark dungeon.

on which the opera was based. Just as Beethoven wrote into his opera the ideal relationship with a woman that was so unattainable to him in real life, so he added the sense of togetherness among men that he could never attain, especially with his own brothers. As with many other sections of the opera, it also became a model for future composers, for example, for Verdi's choruses depicting similar situations in *I Lombardi, Nabucco,* and *Macbeth.*

Evidence suggests that Beethoven's contempt for working-class people, such as Rocco and Jacquino, had some of its origins in his relationship with his two younger brothers whom he considered his inferiors. His efforts to establish hegemony over them pervaded his personal life. As he once wrote to Johann, the youngest, "I hover over you unseen and influence you through others." Beethoven's mother, Maria Magdalena, had seven pregnancies from which only three boys survived infancy: Ludwig born 1770, Karl born 1774, and Johann born 1776. His mother's death in 1787, at age forty, required Beethoven to return to Bonn from Vienna where only months before he had been sent to study. Shortly thereafter a sister, aged eighteen months, also died. At the same time his father, a court singer, lost his voice and was pensioned off. Less than two years after his mother's death, his father's alcoholism accelerated. Over his father's objections, Beethoven petitioned the authorities for half his father's pension to assume responsibility for his two younger brothers. The petition was granted and so, at the age of nineteen, he became his brothers' guardian. In 1792 he returned to Vienna. His father soon died suddenly, but his brothers remained in Bonn until 1795 when he brought them to Vienna.

Beethoven's relationship with his brothers was never smooth. After Johann became wealthy through profiteering in wartime, he signed his letters "Johann Beethoven, Property Owner." Ludwig's reply was sarcastically signed "Ludwig Beethoven, Brain Owner." The two brothers had quarrels about Johann's wife, of whom

Ludwig disapproved, and they argued over Ludwig's refusal to repay money he owed Johann.

The relationship with Karl, who for a period helped Ludwig manage his affairs, was constantly stormy. They sometimes came to blows. Ludwig sought to control Karl's life totally, objecting to his marriage and later suspecting that Karl's sudden death was a result of his wife's poisoning.

Karl's will made his wife and Ludwig coguardians of his son, but Ludwig embarked on a campaign to become the sole guardian of his nephew. For the next three years Beethoven was consumed with this legal battle and composed scarcely anything. When he won, his relationship with the boy turned out to be the same as it had been with Karl—effusively affectionate and unbearably controlling. In his mind the child was no longer his nephew, he was his son. Besides the tyrannical-father dimension to his relationship with the boy, there was also an overwhelming, hovering, mother dimension. The relationship was undoubtedly the most intense one of Beethoven's adult life.

Beethoven's stormy relations extended beyond his family and included contempt for anyone he considered inferior. Among his servants there was constant turnover. In 1814 he said, "Never show to men the contempt they deserve; one never knows to what use one may want to put them." He clearly had a high opinion of himself at an early age. As a relatively unknown young pianist he remarked, "With men who will not believe and trust in me because I am as yet unknown to universal fame, I cannot hold intercourse." As a child he was often unkempt and preferred to be by himself, disinterested in the usual children's games. When elders reproved, "How dirty you are looking again—you ought to keep yourself clean," he replied, "When I become a lord no one will take notice of that." Music probably occupied his thoughts from a very early age. At age ten he was described by a friend as knowing nothing pertaining to social life outside of music. One suspects that intimately connected with his musical thoughts were fantasies about being a special child, not the child of his father.

A fantasy about secretly having royal blood is common in many

children. Psychiatrists call it a "family romance." Besides his sense
of superiority there is specific evidence that such a fantasy played a
powerful role in Beethoven's psychological makeup. Into his diary
he copied Telemachus's words to Athene: "My mother saith that
he is my father; for myself I know it not. For no man knoweth
who hath begotten him." The idea that he was of noble lineage
achieved sufficient acceptance that a contemporary German ency-
clopedia stated he might be an illegitimate son of King Friedrich
Wilhelm II. Ambiguity about Beethoven's birth date reinforced
these ideas. It started when his father, hoping to exploit his young
prodigy as had happened with Mozart, passed him off as younger
than he actually was. The ambiguity was furthered by the fact that
an earlier stillborn child of his mother's had also been named
Ludwig. Beethoven refused to accept his birth certificate as valid.

A peculiarity of local usage also helped Beethoven perpetuate
his fantasy. The *van* in his name, stemming from his family's
Dutch origin, simply meant "from." In Vienna that usage was not
common; but *von* meant "of (the house of)." Beethoven was so
successful in his pretense to royal blood that when he sued
Johanna for custody of his nephew, he was able to get the case
heard in a court reserved for nobility. Here he easily won against
Johanna, a commoner. She exposed the deception and had the
ruling set aside, and when the case was reheard in ordinary court,
she won. But Beethoven would not give up, and using all his
connections he succeeded in winning a third trial. Neither did he
give up his fantasy of nobility.

Beethoven's operatic heroine is high-minded, determined, cou-
rageous, noble, and asexual. She is his ideal of womanhood, the
woman he yearned for all his life, the idealized mother of the
family romance. He continuously searched for her. Numerous
women became the object of his fantasies. They were always
unavailable, usually already committed to other men. Beethoven
would be briefly, madly in love with them, despondent when it
didn't work out, and then, before long the cycle would repeat

itself. There may have been one particularly important woman—perhaps the one for whom he wrote his song cycle, "An Die Ferne Geliebte" ("To the Distant Beloved"), perhaps the one to whom he wrote (but never mailed) a long, passionate letter about hopeless love. The mystery of these relationships, after almost two hundred years of historical research, testifies to how little they were based in reality.

Beethoven's search for the ideal woman continued until late in his life. At age forty-eight he wrote, "Love alone, yes, only love can possibly give you a happier life. Oh God, let me, let me finally find one who will strengthen me in virtue, who will lawfully be mine." The "lawfully" was important. His ideal woman would certainly never have relations with anyone but her husband. There is no evidence that any of his romantic attachments included a sexual relationship. A conscious sexual puritanism allowed Beethoven to hide from himself how desexualized his image of the ideal woman was. He wrote, "Sexual indulgence without a communion of minds is bestial." Not surprisingly, he found his own sexual outlets with prostitutes. The gun-toting Leonora, dressed in man's clothing, is a sexually neutral figure. She offers no danger of temptation.

He once wrote, "Blessed is he who has suppressed all passions." But that was not possible, for Beethoven was a highly passionate man. And although his music is rarely sensual, it is intensely passionate, as it is in Leonora's aria. For although his ideal woman in real life is asexual, in his inner musical life she (and he) are indeed passionate. Somehow he knew it. He wrote, "Melody! I pursue her, I clasp her with new fire, she slips from me, is lost in the midst of vague impressions. Soon, driven by surging passions, I seize her again. I cannot loose myself from her, I must perpetuate her in a spasm of ecstasy with every urge of soul and body. And then, at the last, I triumph over her, I possess her whom I have pursued, for whom I have longed. And behold—a symphony."

We know practically nothing about Beethoven's relationship with his mother. Consciously he loved her and felt much bereaved by her early death. But we do know that a "family romance"

inevitably creates ambivalence about one's mother. If mother is unfaithful to father, how can she be trusted? That Beethoven ended up with great ambivalence about women, and that he dealt with it by picturing women as either ideal or evil, is clear. His worst fights with his brothers were over their romances. He sought to prevent both their marriages. To his brother Johann, then twenty, he wrote, "Only beware of the whole tribe of bad women." In his suit for guardianship of his nephew he accused his sister-in-law (whom he called "bestial") not only of trying to poison her husband but also of prostitution, an equally unfounded accusation. For Beethoven there were only two kinds of women, angels and devils. Marriage was never in the cards for him, nor was the ability to depict real women in opera.

Marriage was ruled out for another reason—his erratic finances. Beethoven complained constantly of money problems, but a clear picture of his financial situation is hard to come by. At times he earned a great deal of money. A single gentleman could live comfortably on twelve hundred florins a year in Vienna in 1803, a year in which Beethoven netted that amount from just one concert. In 1809 a group of nobles, in order to assure that Beethoven would not leave Vienna, guaranteed him a substantial lifetime stipend. One of them died suddenly, one went broke, and so the composer never received the full amount regularly. Inflation reduced the value of the stipend. Still, Beethoven received a substantial payment for much of his life.

Underlying his financial problems was his attitude toward money. He could not avoid dealing with it, yet he considered it a fit subject only for the world of ordinary people, not for his noble world of music. "The creative spirit," he wrote, "ought not to be fettered by wretched wants." On the one hand he was quite right. When he wrote music purely to make money, it was largely a waste of time, time that could have been devoted to serious composition. On the other hand his arrogant, abrasive attitude greatly complicated his financial situation. Rossini, when he visited Beethoven in 1822, found his situation so appalling that he tried to convince Vienna's cultural elite to raise funds for him.

He soon abandoned the effort, finding that Beethoven had so alienated almost all of them that there was no hope of getting their help.

Beethoven undermined himself in other ways. Potential commissions evaporated because he made excessive demands. He was dishonest often enough so that people distrusted him. He would promise a piece to one publisher and then, if he received a better offer, give it to someone else. Instead of three new pieces that he had contracted to send to England, he sent very mediocre old works. No further good offers came from England. His difficulty with mathematics made it very hard for him to manage his own affairs, but he was too suspicious to entrust them to anyone else. He constantly changed his living arrangements (seventy-one times in thirty years), which must have been expensive. He had a habit of refreshing himself while working by pouring a full pitcher of water over his head. When this leaked through the floor onto the neighbors below, the landlord would give notice. He was also foolishly generous to friends in need and particularly to his nephew. At the root of his money problems was his profound psychological need to keep his inner world of music (and fantasied nobility) totally separate from his real relationships (and the mundane business of making a living). As Freud once remarked, neurosis is expensive.

While Fidelio contains only the loving side of Beethoven's ambivalence toward women, both sides of his feelings about men are dramatically presented. That his villain, Pizarro, appears in both acts while his hero, Florestan, must wait until act 2 may indicate that his feelings about men were preponderantly hostile. Opera requires exaggeration of characteristics, but with the exception of Puccini's Scarpia, Pizarro is possibly the most purely evil villain in opera.

Yet Pizarro is not a figure without some depth. His murderous intentions toward Florestan cannot be explained only by their political differences. Florestan threatens him on a very personal

level by exposing his corruption. He stirs in Pizarro both fear and (insofar as he is capable of experiencing it) guilt, the two greatest sources of mankind's destructiveness. This picture of Pizarro, a man of unpardonable villainy, was not Beethoven's original intent. He wanted Pizarro pardoned at the end, on the basis that Pizarro did not have the moral strength to withstand the kind of punishment that Florestan had received. The idea was dropped. In a rescue opera, good must triumph and evil be punished.

While the picture of Pizarro contains elements of Beethoven's view of his father, it also contains elements of Beethoven's self-image. He once said, "Power is the moral principle of those who excel all others, and it is also mine." For, like Pizarro, he could be violent, treacherous, unscrupulous, and tyrannical. Generally these were impulsive acts, directed at almost everyone he loved, and they were soon followed by profuse apologies and self-recriminations.

Many people who are pervaded with ambivalence, as Beethoven was, are filled with contradictions. The other side of his impulsiveness was a terrible indecisiveness. His endless procrastination about matters like where to live or where to vacation drove his friends to distraction. He was terribly untidy but fastidious about cleanliness. He was committed to high moral principles but often dishonest. Sex without marital communion was bestial, but he visited prostitutes. Only in his inner world of music was he able to reconcile these contradictions. The very intensity of those contradictions, combined with his ability to reconcile them in his compositions, make his music the most powerful ever written. Actual relationships with people interfered with his composing. For instance, relatively fallow periods followed his mother's death and the struggles with his nephew. He worked haltingly when human relationships were built into the music. It is no wonder *Fidelio* gave him so much trouble.

Beethoven was under almost constant medical care for the last thirty years of his life. Starting in 1799 he suffered from stomach trouble, colic, and diarrhea, all of which, with occasional periods of remission, continued for the rest of his life. Early nineteenth-

century physicians could do little to treat most illnesses. Beetho-
ven was also a difficult patient. He would discharge his physician
and, when the next one did no better, rehire him. In 1821 he had
his first attack of jaundice, which lasted several months. His
physicians wisely recommended restricting his wine consumption,
but their advice probably had little effect.

Beethoven loved his wine—not to the point of drunkenness,
but daily consumption of a good deal of wine was an important
part of his life. He drank when alone at home, or in cafes with
friends. His attacks of jaundice became more frequent in 1825,
including nosebleeds and the spitting of blood. Clearly he was
headed for chronic liver failure due to cirrhosis. His terminal
illness began in November 1826 when he began accumulating
fluid in his abdomen and legs. He died March 26, 1827. His last
words, "Pity, too late," referred to a gift of his favorite wine that
had just arrived. Autopsy confirmed the diagnosis of chronic
disease of the liver and pancreas from alcohol consumption—
despite rumors, there was no evidence of syphilis.

Beethoven's psychiatric illness was by no means as clear-cut as
his physical problems. His diaries and letters are filled with
passages about his misery, his suffering, his hopelessness, his
thoughts of suicide and of death. But there are many arguments
against calling this a serious depression. We live now in a society
where the open expression of suffering is considered gauche. In
Beethoven's time the opposite was true. Goethe's *The Sorrows of
Young Werther*, when published in 1774, provoked an epidemic of
suicides across Europe. To give voice to one's suffering was to
reveal oneself as a man of feeling, of a noble soul. In this context
Beethoven's expressions of suffering have a very different import
than they would have today.

Depressed people tend to be immobilized, their condition inter-
fering with productivity. Granted, some people can alternate
between depression and elation and can be highly productive
while elated; but there is no evidence this was the case with
Beethoven. A last will and testament, written in 1802, is his most
extensive discussion of depression, suicide, and death. Yet 1802

was a year of great productivity for him: five piano sonatas, three violin-piano sonatas, a symphony, and many minor pieces. The same is true of numerous other years when he was feeling unusually depressed. Nor did the content of his music change during these periods; it changed as his musical thinking developed, unrelated to depressions.

The best data for an understanding of Beethoven's psychology can be found in his behavior. His ambivalence, his great difficulty in sustaining close personal relationships, his emotional turbulence, his sense of specialness, his feelings of persecution, his litigiousness, his disregard for social amenities—all these suggest that he suffered from a personality disorder. Did he ever have psychotic episodes? Many of his contemporaries thought so. Such episodes are not uncommon among people with serious personality disorders. Given his rages, his impulsiveness, his eccentric behavior, and his propensity for saying anything that came to his mind, regardless of how illogical it might be, it is not hard to understand why some people thought him "crazy," though there is no solid evidence for it.

Beethoven had one other illness of critical importance, his deafness. Most likely it was due to a gradual loss of function of the small bones that transmit the sound vibrations from the eardrum to the nerve cells of the inner ear. The technical term is otosclerosis. It may have been triggered by childhood ear infections. He first noticed symptoms in 1796, at the age of twenty-six. Two years later the symptoms had become sufficiently troublesome for him to consult several doctors. Over the next twenty years his deafness became progressively more severe. By 1812 he was having great difficulty hearing music, though he did not abandon public performance until 1815. By 1818 he was almost totally deaf.

The despairing Heiligenstadt Testament of 1802 was precipitated by his recognition that his deafness was progressive and incurable. From then on he wrote repeatedly of his rage at the loss of what was, to him, his most important sense, of his despair about it, about how it excluded him from human relationships, and how there was nothing to do but accept his fate and devote

himself exclusively to his music. "So be it then: for you poor B," he wrote, "there is no happiness in the outer world, you must create it in yourself. Only in the ideal world can you find friends."

Beethoven's deafness created a truly ironic paradox. On the one hand it caused him untold misery, terrible isolation and loneliness, and destroyed his career as a performer and conductor. On the other hand it protected him from involvement with people, which he had never been able to handle well. It forced him into his "ideal world" of music where his genius could express itself. His acceptance of that fact came only gradually. Between 1812, when his hearing began deteriorating rapidly, and 1818, when he became almost totally deaf, he composed almost nothing of importance. Between 1819 and his death he wrote some of the greatest music known.

By then he had somehow not only adjusted to his situation but also had found new emotional depths in himself that he was able to pour into his compositions. His ability to do this is a good example of the difficulty in understanding the extremely gifted. The very existence of his separate, inner musical world was an important part of his psychopathology as well as his strength and the integrity of his personality. Wagner saw Beethoven's deafness as contributing to his creativity. Referring to the Oedipus drama, he said, "We recognize the blind seer Tiresias to whom the world of appearance was closed, [but] who became aware, in return, of the ground of all appearances with his inner eye. He has his counterpart in the deaf musician who, undisturbed by the world's clamor, listened henceforth to his inner harmonies alone. To that world, which has nothing more to say to him, he still speaks—but only from the depths."

Additional evidence of Beethoven's newfound emotional strength was his ability in these last years to give up his two most bizarre ideas: he reconciled with his sister-in-law and acknowledged that he was not of noble birth. He no longer needed the family romance. Freed of the neurotic component of his sense of specialness, he was more able to fully exercise the real specialness of his musical genius.

* * *

In *Fidelio* Beethoven anticipates his suffering and his triumph. When the curtain rises for act 2, the scene is a dank and gloomy dungeon where Florestan has been chained for two years. The first words of his great aria are "Gott, welch Dunkel hier! O grauen-volle Stille!" ("O God, such darkness! O silence full of terror!"). The silence full of terror is the most clearly autobiographical moment in all of opera. While Pizarro depicts a disguised version of the darker side of Beethoven, Florestan is the expression of his conscious self-image: the noble, long-suffering hero who, though he anticipates death, still awaits rescue by a virtuous wife and remains committed to his cause of freedom. Florestan falls asleep after his exhausting aria. Rocco and Leonora enter to dig a grave for Florestan. In their half-spoken, half-sung duet, Rocco is trying to dig the grave while she is trying to find out if the prisoner is her husband. Just as she discovers that it really is Florestan, Pizarro arrives. As he prepares to stab Florestan, Leonora steps between them, crying, "First kill his wife." Only moments later she draws a pistol, so the scene makes no dramatic sense. But it does offer Beethoven the opportunity to leave no doubt about Leonora's nobility in being willing to sacrifice herself for her husband. A trumpet sounds announcing the approach of the king's minister. Pizarro rushes off, and the scene ends with a long duet of joyful reunion between husband and wife.

In this scene Florestan speaks of Leonora as "mein Weib," my wife. In the final scene she becomes "ein holdes Weib," a noble wife, or "ein solches Weib," such a wife. The personal has been abandoned for the abstract, the individual for the general. It was the abstractions that really concerned Beethoven. He was inter-ested in good and evil, not in a specific conflict between a good man and a bad man. Musically he is thus at home in this final scene, a celebration of nobility, love, and fraternity. All are together here. The chorus now contains men and women. The chorus and the soloists sing together; little people are no longer isolated: Marcellina sings the same lines as Leonora.

What is it that makes Beethoven at his best such a supreme genius? Certainly he was innovative and employed an unusually large musical vocabulary. He conceived a piece as a totality, yet used very short phrases; there are sudden crescendi and decrescendi along with exceptionally long passages of uniform dynamics. The simplest of figures not only coexist with, but often develop into, the most highly complex and ornamented passages. The chromaticism of the late quartets prefigures music of half a century later. His music remained within the classical format, but he greatly expanded the envelope. When someone had the temerity to point out that he was using parallel fifths and that this was not permitted, he replied, "Then I permit it."

But while a large vocabulary may extend a poet's possibilities, by itself it has nothing to do with greatness. Nothing illustrates the problem better than the question of repetitions. They exist in all music, but Beethoven pushed their use to unusual extremes. A high A in op. 110 is repeated twenty-seven times; the use of trills in the Hammerklavier Sonata seems almost endless. Best known is the opening four-note theme of the Fifth Symphony, with its many repetitions—each time one has the sense that one less repetition would have diminished the dramatic effect, one more would have been too much. Counting them tells us nothing. It was Beethoven's genius that told him when to stop, and we have no way of defining that. Some point to Beethoven's high moral purpose, to his commitment to his art as the expression of man's nobility, and to his relationship to God. But none of these attributes really helps us either, for there is much music clearly devoted to noble ideas and religious themes that is pretty terrible music. The nature of genius like Beethoven's remains an enigma.

Central to the difficulty in understanding Beethoven's complexity is the extent to which he lived separate inner and outer lives. *Fidelio* was his attempt to combine the two. His difficulty with that attempt in life is reflected in the shortcomings of the opera. His friend, the writer Grillparzer, who composed his eulogy, once said of him, "Beethoven was so accustomed to unfettered flights of fantasy that no libretto in the world could be adequate to contain

his outpourings within its preordained limits." With all its limitations, *Fidelio* remains a beautiful opera. It was Mahler's favorite. It is our good fortune that Beethoven suffered all his birth pangs to produce his favorite child.

🌿 3 🌿

Rossini's The Barber of Seville

THE COMIC OPERA AND
THE TRAGIC LIFE

Rossini's *Barber of Seville* was first performed in Rome on February 20, 1816, just a few days before the composer's twenty-fourth birthday. Rossini worked closely with the poet Sterbini on the libretto. It was drawn from a play by the French horologist-politician-playwright Beaumarchais, who had been instrumental in gaining French support for the American Revolution. Beaumarchais' sequel, *The Marriage of Figaro*, which had provided the plot for Mozart's opera, contained far more antimonarchist sentiments than did the *Barber*, so Rossini did not have Mozart's problems with the censors. Nevertheless, all involved were fully aware of what Beaumarchais represented, and this undoubtedly reflected Rossini's early political views.

Rossini's contract to write the opera was typical for the time. He had to accept the libretto chosen by the impresario; he had to agree to modifications requested by the singers; he had to lodge with the baritone where the impresario could keep an eye on him; he had to be present for rehearsals and for the first three performances. Dates were specified for the completion of the first act and for opening night. Compensation was set at the equivalent of $200 plus a coat with gold buttons.

Rossini completed the six-hundred page score in three weeks, a pace facilitated by considerable borrowing, from himself and from others, which was customary in those days. He had already used the overture twice previously; and many aspects of the opera followed predetermined, standard formats. Yet there is much in the opera that is highly original. The relation of music to words is ingeniously constructed; the dramatic flow never falters (perhaps a bit in the last scene); and although the characters are stock *opera buffa*, they all have individual touches that bring them alive. Altogether the creation of the *Barber* in twenty-one days is difficult to comprehend. Verdi considered it the most beautiful *opera buffa* ever written.

When such a phenomenon occurs there must be a close match between composer and libretto. What is needed must come naturally, almost intuitively from the composer's pen. So it is with this opera, a hilarious comedy pervaded by cynicism. Deception, concupiscence, and greed motivate all the characters. Although it is now an acknowledged masterpiece, it was a failure on its opening night. Rossini so feared the audience reaction that, his contract notwithstanding, he feigned illness on the second night and did not attend. After the performance, hearing a crowd approaching, he barricaded himself in his quarters. Only when he realized they had come to cheer him did he show himself to acknowledge the accolades. It was a harbinger of the retreat into illness that was to dominate much of his later life. Omitted from Rossini's version is a line from Beaumarchais's play: "I forced myself to laugh at everything, for fear of having to weep." In Francis Toyes's words, "Decidedly God must have relished from the outset the tragicomedy He intended to make of the life of Gioacchino Rossini."

The opera opens with a street scene. Almaviva has hired some itinerant street musicians to serenade Rosina as dawn breaks. When they finish he pays them off handsomely and is rewarded for his generosity by such uninterrupted, effusive thanks that the whole neighborhood is awakened. That Almaviva's good deed does not go unpunished sets the cynical tone for the opera.

The rowdy musicians call to mind Rossini's father, an itinerant trumpet and horn player. His rambunctious, irrepressible style brought him the nickname of "Vivazza." It also led him to constant money troubles, much traveling, and repeated trips to jail. His difficulties with the authorities stemmed partly from his personal style, partly from his revolutionary political activities (he was an ardent Francophile). At age thirty-two he married nine-teen-year-old Anna Guidarini, a seamstress. Five months later, on February 29, 1792, their only child, Gioacchino, was born. The little boy was sometimes taken along by his itinerant parents, sometimes left with aunt and grandmother, who apparently provided little supervision. Although unable to read music, Anna was pretty, a good actress, and had a fine voice. After her husband's first imprisonment in 1796 she became an increasingly important source of family income through her roles on operatic stages.

Rossini was thus exposed to opera from a very early age. He learned to play wind and percussion instruments. He was also a wild, undisciplined child. Attempts to structure his life, such as apprenticing him to a blacksmith, always failed. Not until he was ten years old did the family settle down long enough for him to receive regular musical instruction. He was clearly gifted, and by age twelve his first compositions were being performed and he was earning money both as an instrumentalist and as a singer. The family had moved to Bologna where Rossini was exposed to excellent musicians. As his mother's voice gave out, from age fourteen on he became an increasingly important provider for the family. His career was not hampered by his good looks, his charm, and his skill with the ladies.

A man of many talents, charming, skillful with the ladies—this is exactly how Figaro describes himself in his entrance aria "Largo el factotum." He also makes it quite clear that he is arrogant, self-willed, mischievous, and a little unscrupulous. Figaro has facets of both Vivazza and Gioacchino. When he wrote the Barber Rossini was already the most famous opera composer in Italy. His first great success, Tancredi, completed before his twenty-first birthday, was performed that year fifty-three times in Milan, then

a city of 200,000. By the time he was thirty his operas were being staged all over the world, from Russia to South America. In one season at La Scala · in Milan, of 129 performances, 125 were Rossini's operas. His contemporary and biographer Stendhal wrote, "Napoleon is dead, but a new conqueror has already shown himself to the world." In the *Barber* Figaro's self-assessment is that he is "a genius," one who "rises right to the top." He boasts, "Nature has given me higher ability by far, fortune assigned me its favorite star." Figaro's braggadocio is so exaggerated that it has a self-mocking quality. Although it was not characteristic of Rossini at age twenty-three, by the end of his life self-mockery had become his pervasive style.

Figaro loves his work. But "best of all, it is a gold mine." When Almaviva enlists his help, Figaro extorts a hefty fee. By the time the opera ends Almaviva has had to pay off almost everyone—all are greedy and for sale. Rossini's own childhood featured erratic sources of money. He began to earn his living at a very young age, and by the time he was thirty he had married a wealthy woman and was earning large sums of money. On a visit to England he charged exorbitant fees for every appearance he made, including attendance at dinner parties. The best London music teachers received one guinea per hour; Rossini asked a hundred guineas. But as with so many people who are poor in childhood, the fear of poverty persisted all his life, regardless of how much money he had. He fought a six-year legal battle with the French government over his pension rights (which he eventually won) and was often less than upright in his financial dealings. During his severest depressions he had delusions of poverty.

After the opening serenade in the *Barber*, Rosina at last appears on her balcony. Within minutes she and her guardian, Dr. Bartolo, have revealed themselves to be scheming and duplicitous. Among such a cast of characters Dr. Bartolo might be forgiven for being a lecherous old tyrant who lusts after his ward. What he cannot be forgiven is that he hates opera, and in keeping with the tone of self-mockery the opera he hates is *The Useless Precaution*, the original title of *The Barber of Seville*. At the end of the scene

all rush off to pursue their plots: Rosina to escape from the house, Dr. Bartolo to force Rosina to marry him, and Figaro to smuggle Almaviva, disguised as a drunken soldier, into Rosina's house.

Scene 2, act 1 opens with Rosina's self-revelatory "Una voce poco fa." As she says, "I am so well behaved, so easygoing, so obedient....But if you cross my will, a thousand tricks I play, until I have my way." The aria parallels Figaro's opening aria in the first scene, and Rosina is, in her own way, a similarly appealing character—vivacious, pretty, and romantic, but also a self-willed, determined little vixen. Hers is the only significant female role in the opera. Rosina's contradictory nature, both charmingly loving and dangerously treacherous, must have struck a responsive chord in Rossini. Consciously he idealized his mother. But intense as that feeling was, it could not hide his underlying ambivalence which colored his relationships with all the other women in his life.

Anna Rossini was the oldest of four children of a baker. Her next younger sister, Annunziata, became a prostitute. Anna was a pretty young woman. Rossini described her as "tall and well proportioned, with a fresh, rather pale complexion, perfect teeth, and magnificent black, curly hair. She was always cheerful and good-tempered, a constant smile on her lips, and on her face an expression of truly angelic sweetness." To him she was the definition of beauty: "If the Virgin Mary in heaven turns out to be more beautiful than mother, I shall cry for the rest of my life." The relationship was eroticized. When an uncle suggested that the boy singer become a *castrato*, according to Rossini it was not his father but his "brave mother" who preserved his masculinity and "would not consent at any price." Yet his relationship with both parents was in many ways unsatisfactory for him. "The feeling which moved me most in my life," he wrote, "was the love I had for my mother and my father, and they repaid it at a usurer's rate of interest...." That there was a guilt-laden connection between writing operas and his feelings toward his mother was evident early

on in his career. He always wrote her about his failures, rarely about his successes. The intense attachment between mother and son was mutual. Once, when Rossini came to visit her, she was so overwrought with emotion at seeing him that she became ill. After she died at age fifty-five of a ruptured aortic aneurysm (most likely syphilitic in origin), Rossini was unable to join in celebrating the success of one of his operas. Instead he sat sighing, "Ah, but she is dead."

Later events in his life revealed far more serious problems in his early relationship with his mother, which the oedipal "successes" obscured during his young adult years. Both of Rossini's most intimate loves "belonged" to other men. The first was Isabella Colbran. Seven years his senior, she was an established star, the "favorite singer" of the King of Naples and the mistress of the impresario Barbaia, for whom Rossini worked when he moved to Naples shortly before writing the *Barber*. After Isabella shifted her favors from Barbaia to Rossini, the three continued to collaborate on operatic projects for many years. Rossini married Isabella in 1822, two years after she became an heiress. Years later Rossini claimed it was at his mother's insistence. The marriage turned out not to be a great success, and as Isabella's voice deteriorated she became increasingly difficult. When they moved to Paris in 1832 she began gambling compulsively and was sent back to Bologna, to be watched over by Rossini's father.

That same year Rossini met Olympe Pelissier, a well-known Parisian *demi-mondaine*. Her unmarried mother had sold her, when still very young, to a French duke. She then passed successively to a rich American, the painter Vernet, and a stockbroker who soon died, leaving her a considerable fortune. She saw Rossini whenever possible. The composer and Isabella separated in 1837, and when she died, Rossini and Olympe were married in 1846.

The next character to enter the stage of scene 2, act 1 (after slapstick involving the servants) is Don Basilio. Figaro has already described him to Almaviva in scene 1: "A meddlesome rogue, a

shady subject, an eternal beggar. A man without a conscience, as corrupt as can be and a professor of music." Rossini never thought much of his music teachers. He used to claim that he had learned more from reading Mozart and Haydn scores than he had from his teachers, and he may have been right. On the other hand he had been such an undisciplined, rebellious youngster that teaching him may have been an impossible assignment. The elderly Don Basilio is the only character in the opera with no redeeming features.

In order to attract competent singers for a production, every role in nineteenth-century Italian opera had to have at least one major aria. Don Basilio's is "La Calumnia" ("The Slander"). Some critics dubbed Rossini "Mr. Crescendo" because of his penchant for long, sustained crescendos. "La Calumnia" is the prototype. Don Basilio describes how a rumor starts quietly, "first a murmur, slowly seeping," and gradually grows "louder, bolder, brazen sounding," ending as "a tremendous tempest raking, a tornado shaking, like the day of judgment breaking." The words of the aria and its music are perfectly attuned. At the end "the victim, poor accused one, wretched slandered and abused one, has to slink away in shame and wish he had never been born."

Rossini was always a fearful man, hypersensitive to criticism. While an opera composer was vulnerable to mob disapproval (sometimes organized, sometimes spontaneous) if his work did not please, Rossini's reactions were often extreme. After a bad experience in Pesaro at age twenty-seven, he refused to set foot in the town again for the remaining fifty years of his life, despite entreaties by the town fathers. No matter how many good reviews one of his operas might receive, one bad review could send him into a funk. His fearfulness was widespread. After a friend died in a fire, he became phobic about fires. Badly frightened on his first train ride, he would never ride one again no matter how great the inconvenience. Malicious rumors made him indignant, and given his fame, these appeared not infrequently in newspapers. With his characteristic humor he observed that the two things he feared most were colds and journalists; the one caused "humeurs mau-

vaises" (distempers) in his body, the other "mauvaise humeur" (bad temper) in his mind.

After Basilio's aria there are exchanges first between Figaro and Rosina and then between Bartolo and Rosina. Dr. Bartolo gets his required big aria. When Almaviva enters disguised as a drunken soldier, things grow increasingly chaotic. The cast becomes so noisy that the police are brought in and the act ends in a great ensemble, all singing at the top of their lungs. Such ensembles typically end acts in *opera buffa*, in contrast to *opera seria*, in which acts typically end with a great solo aria, an "exit aria." It was also *opera buffa* which, more than *opera seria*, formed the basis for what became grand dramatic opera. Next to Mozart, Rossini was probably the most pivotal figure in initiating that transition. His first opera was an *opera seria*, and he continued to write tragic operas for the rest of his career. In them he gradually moved from the traditional *seria* style to one that incorporated many techniques from *buffa*. His final opera, *William Tell*, was a full-blown romantic grand opera.

Successful as he was at tragic opera, his real genius lay in comic opera. Beethoven, who was familiar with Rossini's operas (and somewhat piqued by their tremendous success), said to him, on the occasion of their sole meeting, "Never try to do anything but *opera buffa*; wanting to succeed in another genre would be trying to force your destiny." Beethoven felt this way not only about Rossini but about all Italian composers. Prejudiced as that was, it also contained an element of great wisdom, for it was the combination of the Italian *buffa* tradition with the German orchestral tradition that produced nineteenth-century grand opera. If not at the time, certainly later, Rossini understood what Beethoven was saying. Not only was he criticized in Italy for his Germanic orchestration, but many years later, in a conversation with Wagner, he confessed, "To tell you the truth, I really felt more aptitude for *opera buffa*. I preferred to treat comic rather than serious subjects."

Act 2 of the *Barber* begins with Almaviva entering disguised as a sanctimonious music teacher, replacing the purportedly ill Don

The Barber of Seville: When neighbors call in the police because of the noise, things only get noisier.

Basilio. When Basilio appears, Figaro, Almaviva, and Rosina convince him that he has scarlet fever and must go straight to bed. When he made the music teacher, Don Basilio, a hypochondriac, Rossini may have had a premonition of what would happen to him in later years. From age forty until his death at seventy-five, Rossini's life was dominated by illness, partly physical, mostly psychological. After age thirty-seven he never wrote another opera. From age forty to fifty he wrote no music at all. After that he wrote only religious music and small pieces, mostly songs. Such abandonment of one's primary creative medium is unique among composers. Rossini's psychiatric illness cost the world untold operatic riches.

Rossini is the only composer discussed in this book who clearly had a major psychiatric illness. At times, when his illness was at its worst, Rossini was almost immobilized, unable to dress himself, totally dependent on Olympe to care for him. He suffered from severe insomnia, alternated between refusing food and overeating, was preoccupied with his physical ailments and with money, and was overwhelmingly depressed in outlook and sometimes suicidal. His illness fluctuated widely in the twenty-five years between ages thirty-seven and sixty-three. Periods of relative well-being alternated with periods of total incapacitation.

As with all psychiatric illness, Rossini's had biological, psychological, and social causes. There may well have been an inherited predisposition to manic-depressive disturbances. His father's life story as well as his nickname "Vivazza" suggest that he may have had manic propensities. His mother's family was somewhat chaotic, though there seems to be no record of any overt manic-depressive illness. The extent to which hereditary factors play a role in manic-depressive illness remains unclear. It is probably a necessary but not a sufficient cause. Part of the problem is the difficulty in separating hereditary factors from the behavioral influences of growing up with disturbed parents.

Rossini's upbringing was certainly erratic. When his parents were on the opera circuit together, Rossini was often left with his grandmother and his prostitute aunt. It seems likely that he carried intense insecurities with him from his earliest childhood. Ambivalence toward his mother was hidden beneath his idealization of her. Activity became his defense against an inner self-image of inadequacy. Sexual activity became his defense against an inner self-image of defective masculinity. He may have begun having sexual relations as early as thirteen. By age fifteen he had acquired the gonorrhea that was to plague him the rest of his life. His good looks, his charm and wit, together with his precocious success, brought him many willing partners. Exceptional fame at an early age did not alleviate his hypersensitivity to criticism; he

dealt with any setback or threat by withdrawal. His marriage to Isabella Colbran, a beautiful, successful singer who was seven years his senior and the king's favorite, undoubtedly reflected a union with an idealized version of his mother.

None of this behavior indicates serious psychiatric problems. It does offer clues to Rossini's fantasy life, his underlying self-image, and his defensive style—but not to his capacity for adapting to life's vicissitudes. The first real indication of serious difficulties came with his trip to England in 1824, at age thirty-two. Channel crossings were known for being unpleasant experiences. Rossini, however, was immobilized for more that a week afterward. Such trips later in his life frequently precipitated collapse. His first railroad trip was also his last, it threw him into such a panic. Given his itinerant childhood, traveling may have tapped into traumatic early childhood memories.

The London trip was also the first indication of a special connection between Rossini's psychological vulnerabilities and the writing of operas. While his stay in England was highly successful— he staged operas, sang, played the piano, gave lessons, and hob-nobbed with royalty, all visible indications that he had fully recovered from the trauma of his trip—the one thing he did not do was to complete the opera he had contracted to write. It was the first time he failed to complete a commissioned opera. He wrote only some sketches. These were deposited in a vault in London, together with the four hundred pounds bond he forfeited for noncompletion. When he left England Rossini settled in Paris, and there began his conflicts with the French government over his contract, conflicts which were to last ten years. Regardless of the merits of the arguments on Rossini's side, the fact remains that after 1824 he wrote only three new operas, Il Viaggio a Reims (1825), Le Comte Ory (1828), and William Tell (1829).

The onset of Rossini's psychotic depression was gradual. The ongoing conflict over his contract was undoubtedly a factor. (At the same time his depression probably exacerbated the conflict.) His beloved mother died in 1827. His gonorrhea began causing painful symptoms in 1832, the year he turned forty. He no longer

dominated the world of opera: Meyerbeer, Bellini, and Donizetti were being acclaimed as the new operatic masters.

All these were stressful events with specific, personal meanings for Rossini.

—Although he was already a rich man, his contract with the French government meant an assurance of lifelong support. When it was threatened, his omnipresent fears of destitution were stirred.

—He idealized his mother, and his inability to mourn her adequately (a problem with any idealized figure) may have been the single most important factor in his developing depression.

—His painful gonorrheal symptoms threatened his sexual identity. According to a report from one of his physicians, he abandoned his active sexual life after 1836. It had always been a necessary prop for his shaky masculine identity. At one particularly hypochondriacal time he declared, "I have all of woman's ills, all I lack is a uterus." His guilt about having contracted the gonorrhea from a prostitute was intense.

—Turning forty is a depressing event for many people. No longer being the dominant figure in the world of opera must have been painful to one so dependent on adulation as Rossini. Whatever his genetic predisposition to depression, at age forty he slipped into twenty-five years of incapacitating depression alternating with periods of moderate remission.

The final scene of the Barber opens with a new conspiracy of deception. Bartolo convinces Rosina that Figaro and Almaviva are about to betray her. Rosina then reveals a plan for her to escape at midnight via a ladder. Bartolo arranges to foil Figaro and also sends Basilio off to get a lawyer, so he can marry Rosina. An orchestral "storm" interlude, a Rossini signature, provides a bridge to the conclusion in which Figaro finds a lawyer to marry Rosina and Almaviva. Basilio, threatened with a gun and bribed with a diamond, participates. Bartolo, outmaneuvered, renounces concupiscence in favor of greed when Almaviva lets him keep Rosina's dowry, as the opera ends with all happy.

The last decade of Rossini's life was not exactly happy, but after his stormy depression it was relatively peaceful. Having restlessly traveled around Europe in search of relief for a quarter-century, he settled in Paris in 1855. A summer of treatment in 1856 at various spas brought him great improvement. Although he remained very fearful (for example, gas lighting was not allowed in his house for fear of fire), his agitated depression and mood swings abated. But he did become extremely compulsive. Everything had to be exactly in its allotted place; daily routines were followed precisely. When asked about his extreme orderliness by the painter De Sanctis, Rossini replied, "Order is wealth." Olympe supervised everything, assuring that all his wishes were met, that no visitor overstayed his limit. She devoted herself totally to the care of this man whom she considered to be godlike. Their relationship likely became asexual fairly early. He gained the ever-available mother he had never had. In turn the former courtesan became the wife of the world-famous composer and hostess of the most sought-after parties in Paris.

Musical soirees at the Rossinis began precisely at 8:30 P.M.; Rossini retired at 10:30. The elite of the city attended, including the operatic composers Auber, Boito, Gounod, Meyerbeer, Saint-Saens, Thomas, and Verdi. No comparable gathering place of operatic genius has ever existed. Rossini also received selected visitors on an individual basis. Wagner, Donizetti, and Bellini came to see him. He very generously helped younger composers like Auber, Carafa, Bellini, Sullivan, and Bizet. He arranged for Donizetti to conduct the Italian premiere of his *Stabat Mater*. As Paris became the center of grand opera, Rossini became its *éminence grise*.

In addition to resuming social activity, Rossini resumed composing. Collectively he called his final 186 works the "sins of my old age." Most he would not allow to be published. Many had facetious, satirical, or grotesque titles: "A Complaint for Two Voices," "A Tortured Waltz," "A Miscarriage of a Mazurka." The "March and Reminiscences of My Last Voyage" contains snippets from many of his operas and then ends with the word "requiem."

One group he describes as "a collection of 56 piano pieces...
dedicated to pianists of the fourth class to which I have the honor
of belonging." The only major work of this period is his "Petite
Messe Solenelle," a final orchestration of which was completed
just months before his death.

The notes which Rossini attached to the score of this Mass
convey his mood at this time:

> Petite Messe Solenelle in four parts, with accompaniment for two
> pianos and a harmonium, composed for my summer stay in Passy.
> Twelve singers of three sexes, men, women and *castrati*, will suffice
> for its performance, that is to say, eight for the chorus and four for
> the solos; twelve Cherubim in all. May God forgive me the
> following comparison. Twelve in number are also the Apostles in
> the celebrated fresco by Leonardo called Last Supper. Who would
> believe it? Among the disciples are some capable of singing wrong
> notes! Lord be reassured, I guarantee there will be no Judas at my
> luncheon, and that all mine will sing accurately and Con Amore
> thy praises, as well as this little composition, which is, alas, the
> last mortal sin of my old age....
>
> Dear God, here it is finished, this poor little Mass. Is this sacred
> music which I have written or music of the devil? I was born for
> Opera Buffa, as you well know. A little science, a little heart,
> that's all. Be Blessed then, and admit me to Paradise. G. Rossini,
> Passy 1863.

Rossini was not overtly psychotic at this time. But beneath the
surface of these passages is evidence of disturbed thought pro-
cesses—sexual preoccupations, grandiosity alternating with self-
abasement. The disturbed thinking is held in check by the
pervasive tone of mocking humor. This tone characterized all of
Rossini's interactions in his later years. One visitor wrote, "Alto-
gether it is not possible to talk seriously with the famous Maestro.
He is comfortable only with easy humor and genteel raillery." A
famous example is his comment about Wagner: "Mr. Wagner has
beautiful moments, but terrible quarter-hours."

In the opinion of world audiences, of Beethoven, and of Rossini

himself, opera buffa was his true metier. It is a format in which caustic humor is directed at the world. Characteristic of Rossini's buffa operas is a quality of manic energy and playful, vigorous, albeit never tender, sexuality. As long as his defenses were functioning adequately, the requirements of opera buffa and Rossini's personal style and needs were most compatible. During his depression he was unable to write music. Although this was partly the result of immobilization, it was also due to a specific phobia of music. For a long time, whenever he heard a note, he heard the third above it simultaneously. This was so distressing that a servant was stationed at the door to assure that no passing street musician accidentally played anything Rossini might hear.

The third is the most stable of musical intervals. I suspect that this curious symptom reflected a fantasied, unbreakable bond with his mother, that his operas were, unconsciously, love songs to her, and that with her death the fantasy could no longer be sustained and he could no longer write operas. The unremitting mocking humor of his later years represented a fragile compromise between the outwardly directed hostility of his youth and the inwardly directed hostility of his guilt-laden depression. It worked well enough to allow him to write "The Sins of My Old Age" and the "Petite Messe Solenelle," but not well enough for him to return to opera.

The terrible consequences of his inability to mourn his mother's death took some time to become evident. Between her passing and the onset of his depression, he wrote two more operas. Le Comte Ory is a light opera buffa; some consider it the first operetta. William Tell, his last opera, is a full-scale French grand opera. It contains great operatic writing and is highly valued by musicologists, but it is a huge, sprawling work which lacks dramatic consistency and, like his other serious operas, is only rarely performed. Rossini was a musical genius (the British composer Sir William Walton considered him the greatest musical talent in history), but his personality contained such profound internal contradictions that he could achieve full expression in only the somewhat limited medium of comic opera. His influence on

opera—on other composers and on musical innovation—was far greater than could be inferred from his present-day status as a composer. Before Rossini, Italian opera had always been provincial; he made it national and international. He made innovative use of bass suspensions, crescendos, and orchestral modulations. He greatly expanded the use of woodwinds, particularly the clarinet and the oboe. He used multiple horn voices and was the first to use the cornet. Orchestral accompaniment to recitatives was his invention, as were operatic prayers backed by a full chorus. His setting of Scott's *Lady of the Lake* was the first use of a romantic-era libretto. His grafting onto *opera seria* many aspects of *opera buffa*, for example the use of bass soloists, laid the groundwork for all future operas, as did the populist element in *Tancredi* and the exciting, dramatic finales and choruses of *The Siege of Corinth*. Nineteenth-century grand opera had Mozart for a mother and Rossini for a father.

Richard Wagner, not known for his generosity to any of his operatic contemporaries, wrote in his epitaph for Rossini: "Rossini will never be judged aright until someone attempts an intelligent history of the culture of our century....Were this character of our age correctly drawn, it would then be possible to allot to Rossini also his true and fitting station in it. And the station would be no lowly one, for, with the same title as Palestrina, Bach and Mozart belonged to their age, Rossini belongs to his....Then, and not till then, will it be possible to estimate Rossini at his true and quite peculiar worth." One can only wish this wonderful, sad man what he wished for himself: *Requiescat in Pacem.*

🌿 4 🌿

Donizetti's Lucia di Lammermoor

ON SINGING AND SINGERS

FROM THE MOMENT of the ominous opening drum roll it is clear that *Lucia di Lammermoor* will be not an *opera seria*, with a happy ending, but an unalloyed tragedy, the kind that would dominate grand opera for the next seventy-five years after its first performance in 1835. Some of Donizetti's contemporary writers of *bel canto* operas occasionally tacked happy endings onto their operas, but classical acceptance of life's ambiguities, as in Mozart's mixture of tragic and comic, was not for a romantic like Donizetti. He was of an era that railed against life, as in the tragedies, or mocked it, as in the comedies. (Donizetti did write some opera *semiseria*, but in them comedy and tragedy alternate rather that being an integral part of human existence.) Although he produced many other works after *Lucia*, it is his greatest operatic tragedy.

Salvatore Cammarano's libretto for *Lucia* was based on Sir Walter Scott's *The Bride of Lammermoor* and on plays and libretti of numerous earlier versions of the immensely popular novel. Scott's book was itself based on an actual event. In August 1688 Janet Dalrymple, the daughter of a prominent Scot father and a shrewish mother, had been forced to marry against her will. On the wedding night there was bloodshed. Exactly who stabbed

whom is unclear, but Scott chose the version in which Lucia stabbed her bridegroom and then went insane. In the opera Arturo (the groom) dies; in the novel he survives. Inevitably the opera is a highly condensed version of the novel and focuses on the love story. The novel contains a great deal of detail about the turbulent times. The Whigs were fighting the Jacobites; the Protestants opposed the Catholics; and the rising middle class challenged the impoverished aristocracy.

Scene 1 of act 1 describes this social context for the opera and sets the stage for the action to come. Enrico Ashton, Lucia's brother, having backed the wrong side, is fearful for his life and his estate, Ravenswood Castle, which his father had stolen from Edgardo Ravenswood's father. His only hope is for Lucia to marry the wealthy and powerful Arturo Bucklaw. When Enrico learns that Lucia's refusal to follow his wishes is not because she is still in mourning for their mother but because she is in love with his archenemy Edgardo, he is panicked and enraged. Given the violence of the times, his fear is realistic, as is the total support for him throughout the opera of the people of his estate, the chorus. If he falls, they fall with him. Enrico is no simple villain. As lord of the manor he feels responsible for all the people of his estate, and so his concern is not just for himself but also for them.

Scene 2 of act 1 takes place in the castle gardens near a fountain. Lucia and her maid, Alisa, are awaiting Edgardo. Lucia sings about her recent experience with the ghost of the fountain. Although irrelevant to the plot, the aria reflects the many super-natural gothic elements in Scott's novel. It also establishes Lucia's character as it is in the novel. Scott described her as prone to daydreams "of strange adventures and supernatural horrors," as having a penchant for "weaving her enchanted web of fairy tissue, as beautiful and transient as the film of gossamer, when it is pearled with the morning dew." The fountain aria is also the first of the magnificent *bel canto* arias that make this scene perhaps the greatest example of that genre. Edgardo enters. An oath impels him to avenge the death of his father at the hands of Lucia's father, but he is deterred by his love for her. He must now leave

for France. But first the couple vow their love and seal the vow with an exchange of rings. Donizetti knew a great melody when he had written one, and he was not inclined to waste it. First Lucia sings it as her love song to him, then he sings it to her, and finally they sing it together. No one ever objects to the repetition; indeed, the applause often demands an encore, so splendid is the melodic line.

Such melodies were Donizetti's forte. Not that his orchestral writing was lacking. He was always competent, often original, sometimes inspired. But he used the orchestra principally to set the mood and to accompany the singers and only secondarily to communicate subtleties. His biographer Stendhal's view was that "melody can do nothing with emotional half-tones and suggestions; these qualities are found only in the undercurrents of orchestral harmony." In the writing of beautiful melodies for the voice, however, Donizetti had no peer, and because of this, despite their lack of musical nuance and their simplistic plots, his operas continue to be great favorites. For beautiful singing remains, for most audiences, the core of opera's appeal. It has been so from the beginning. When the Florentine Camerata, that group of learned Italian theorists, gathered in the 1590s to recreate Greek musical theatre and created opera instead, they believed that accompanied solo singing could arouse the emotions whereas the complex polyphony of the time could not. Although the orchestra, or theatrical effects, or ballet, or staging have been prominent at times, for the past four hundred years audiences have consistently returned to opera for the great melodic lines.

Bel canto melodies are the most flowing in all of opera. Their lines are smooth and long; they soar, often ending on a high note. The analogy with flight was explicit in the poets of Donizetti's time. Shelley spoke of the nightingale as pouring out its full heart "in profuse strains of unpremeditated art," and that its "singing still dost soar, and soaring ever singest." It was this freedom of flight that appealed to the romantic imagination—committed to freeing itself from the rigidities of classicism and the restrictions of society. The constraints of objective reality were not to impede

subjective emotionality. As Shelley noted, their art was to be unpremeditated. But art without meditation is also likely to be art without subtlety. And so the greatest strengths of bel canto opera are also its greatest weaknesses.

That Scott's novels were highly suitable for adaptation to opera was recognized by many composers besides Donizetti (who also set Kenilworth). Among the better-known composers to do so were Rossini, Bellini, Auber, Boieldieu, Carafa, Nicolai, Flotow, Adam, Sullivan and Bizet. Only Bizet's The Fair Maid of Perth, Bellini's I Puritani, and Lucia are likely to be seen often today. Donizetti may have had a personal affinity for these Scotch tales: some believe his paternal grandfather was a Scotsman, Donald Izett, whose name was Italianized to Donizetti when he moved to Italy.

No one understood better than Scott himself why his novels were so well suited for the opera. About Jane Austen (his contemporary, whose great novels have never been set to opera) he wrote: "That young lady had a talent for describing the involvements and feelings and characters of ordinary life which is to me the most wonderful I ever met with. The big bow-wow strain I can do myself like any now going; but the exquisite touch which renders ordinary commonplace things and characteristics interesting from the truth of the descriptions and sentiments, is denied to me."

The big bow-wow strain, the lack of subtleties, was ideal for Donizetti's style. He composed rapidly and once said of himself, "You know what my motto is? Quickly! It may be reprehensible, but the good things I've written were always written too quickly; and often the accusation of carelessness is made against the music that cost me the most time." Lucia, including the libretto, was written in less than six weeks. L'Elisir d'Amore, his comic masterpiece, took just eight days. Upon hearing that Rossini had taken twenty-one days to write The Barber of Seville, Donizetti joked, "I always knew Rossini was a lazy man." The joke had a sardonic side: by then it had been fifteen years since Rossini had written his last opera. Donizetti, only five years his junior, was still churning out operas at a mad pace.

In his short lifetime (he died at fifty) Donizetti turned out seventy operas. The productivity was only partly of his choosing. The concept of repertory did not exist in those days, and audiences constantly demanded new operas. At the same time the operas were not to be too novel; they were to adhere to fairly rigid, conventional formulas, allowing Donizetti to grind out operas at the rate he did. Some of these conventions were dictated by local practice. In 1839 Donizetti wrote to his teacher Mayr:

I will give my *Poliuto*, forbidden in Naples because it was too holy, at the Opera [Paris], enlarged into four acts instead of the original three, and translated and adjusted to the French stage by Scribe. Because of this I have had to rewrite all the recitatives, make a new finale to Act 1, add arias, trios, dances related to the action, as is the custom here, all so the public won't complain that the texture is Italian, and about that they won't be wrong. French music and librettos have a cachet all their own, to which every composer must conform, both in the recitative and in the sung pieces. For example, banished are the crescendi, etc. etc. Banished are the usual cadences, felicito, felicita, felicita; then between one verse of the cabaletta and the other you should always have lines that heighten the emotion, without the usual repetition of lines which our poets customarily use.

Donizetti's early works were much influenced by Rossini, who was then immensely popular. Not until his mid-thirties did Donizetti develop his own unique style. Only then did he become sufficiently well known to secure a salaried position and to receive regular income from the performance of his works. The time between his arrival at professional maturity and the onset of his terminal illness was a mere decade. His fecundity is all the more remarkable considering that he was constantly traveling throughout Europe, mostly by stagecoach, to oversee the production of his operas. Fortunately he was able to compose regardless of the distractions around him. He could shut them out—all, that is, except the playing of music. For him that made composing impossible.

Bringing Donizetti's floating, lyrical melodies to life required magnificent coloratura voices. The women who had such voices became the great singers of the first half of the nineteenth century. Throughout the Middle Ages art music, like most art forms, was primarily supported by the church. Because women were forbidden to sing in church, and because boy sopranos could not handle the increasingly demanding high-voiced parts, the church turned to the *castrati* for soprano and contralto parts. The practice of using castrated males as singers was introduced into the Western world in the first half of the ninth century when the great Moslem musician Ziryab came to Cordoba, Spain. By the end of the sixteenth century castrated males appeared in church choirs in great numbers. During the first half-century of opera, until about 1650, interest in opera was confined to the nobility, who used the *castrati* extensively for both male and female parts. Many of the baroque opera roles now sung by altos and sopranos were originally written for *castrati*. Starting in the middle of the seventeenth century opera became increasingly popular, and women singers began competing with the *castrati* for the role of superstar.

Toward the end of the eighteenth century the *castrati* began to fall out of favor. Enlightenment thinking had turned against the practice of castration while the church remained ambivalent about it. Napoleon banned the practice, and the last great part for a *castrato*, Armando, in Meyerbeer's *Il Crociato in Egitto*, was written in 1824. After that *castrati* continued to play a role only in Italy. There the final chapter to the story was not written until 1903, when Pope Leo VIII explicitly forbade the recruitment of new *castrati* for the choir of the Sistine Chapel. In addition to the moral repugnance that led to their disappearance, the *castrati* also did not fit in with nineteenth-century opera's intense focus on romantic, heterosexual love. Nevertheless, the appeal of the sexually neutral or bisexual figure remains. Two prominent examples from the twentieth century are Marlene Dietrich and Michael Jackson.

The *bel canto* era ushered in the reign of the soprano superstar, the prima donna, which, except for the occasional appearance of superstar tenors, has continued to the present. Great sopranos like Catalani, Colbran, Pasta, Negri, Malibran, Viardot, and Grisi became more than just superstars, they became divas, goddesses. Not only did they attain great renown, riches, and adulation, they also won immense control over the world of opera. Composers, conductors, producers, and impresarios had to defer to their every whim, as had been true of the superstar *castrati*. Catalani's 1826 contract read: "Madame Catalani shall choose and direct the operas in which she is to sing; she shall likewise have the choice of the performers in them; she will have no orders to receive from anyone; she will find all her own dresses."

One of the ways these ladies exercised their whims was by singing what they wished rather than what the composer had written. It was a trick they learned from the great *castrati* of the previous century. That baroque era had favored ornamentation in all the arts. In opera the ornamentation came to overwhelm the score. Gluck, in the middle of the eighteenth century, made a valiant effort to stop the practice. He succeeded only partially.

The *bel canto* divas' demands for autonomy were exceeded only by their demands for money. They were unique and knew it, and charged not just what the traffic could bear but not infrequently more than that. Impresarios were often faced with a Hobson's choice of paying the fee and going broke or refusing, watching their competitor hire the diva, and losing their audience and going broke that way. It was the diva and the diva alone whom people came to hear.

In the 1820s a good meal could be had for ten cents, a ticket to the opera for fifty cents; a house servant received $30 a year plus room and board, an orchestra player $200 a year. At the same time a Catalani, a Pasta, or a Malibran could command fees of more than $500 a performance. The great *castrati* of the previous century had commanded similar fees, but what was remarkable about the *bel canto* divas was that nowhere else in their nineteenth-century world could women earn anything except very menial

salaries. Divas were treated like goddesses and, as such, were exempt from many of the constraints that other women faced. And, like the Greek gods, their behavior was often highly unconstrained. Lavish life-styles and promiscuity were not uncommon. Adulation has, throughout history, gone to the heads of superstars. Few have been able to resist the siren call of being free of ordinary social constraints. The social constraints on nineteenth-century women were extraordinary; it was a rare woman who did not indulge herself when freed from them.

A part like Donizetti wrote for Lucia was ideally suited for a "white" voice, that is, a voice with little vibrato or sliding into notes. But *bel canto* opera also brought the first parts—for example, Norma—better suited for the heavier voices that later composers like Verdi, Wagner, Puccini, and Strauss required in their operas. These two types of voices also reflected the two stereotyped images of women so prevalent in the nineteenth century— the fragile, passive, vulnerable, chaste (or at least faithful) woman, and the strong, aggressive, forceful, promiscuous (or at least unfaithful) woman. Operatic examples of the first group are Lucia, Marguerite, Desdemona, and Butterfly; examples of the second group are Carmen, Delilah, Brunhilde, and Tosca. Man's fear of woman's sexuality has often led him either to deny it or to demonize it. Nineteenth-century opera memorializes both images. Lest we condescend toward nineteenth-century man, we do well to acknowledge how much appeal both kinds of women continue to have for us.

The action of scene 1, act 2 of *Lucia* centers on Enrico's convincing Lucia to marry Bucklaw. He does so by deception, abetted by the Protestant minister Raimondo. (That the Catholics are favorably viewed while the Protestants are not must have pleased the Italian censors who otherwise were such a thorn in Donizetti's side that they eventually drove him to move from Italy to France.) Beleaguered by her brother's threats and his appeals to her loyalty and to her dead mother's memory; confused by a forged

Lucia di Lammermoor:
Having lost her mind
and all self-control,
Lucia is free to sing with
total abandon.

letter "proving" that Edgardo has been unfaithful to her; and told by Raimondo that her vow to marry Edgardo was not binding since it was made in the absence of a churchman, Lucia agrees to wed Bucklaw. Her words, "My mind is convinced and surrenders, but my heart, deaf to reason, resists," prefigure the split that will later drive her to insanity. She also foresees her ultimate fate and tells her tormentors they are sentencing her to death. Raimondo responds by telling her she will have her reward in heaven.

Raimondo's statement that her vow was not binding does not reassure Lucia. And well it might not have. In seventeenth-century Scotland people experienced their God as omnipresent; a vow made in the presence of God was not to be broken. The concept has continued to have force. In giving testimony in court,

in taking office, we utter a vow to God. Other verbal contracts can also be binding, including a promise of marriage. What was held binding by religious conviction in seventeenth-century Scotland has now, in the absence of similar religious conviction, been made binding by being incorporated in the law. That basic clash between loyalty to one's heritage and loyalty to one's lover, which seems to have obsessed nineteenth-century operatic composers, is here accentuated by having the lovers take oaths, thereby adding a religious dimension to their internal conflict.

Scene 2, act 2 involves the signing of the marriage contract. Immediately after the deed is done, Edgardo rushes in to denounce Lucia for having betrayed him; she is in despair. Amid general consternation, all the participants express their feelings in a sextet, considered by many to be the finest in all of opera. Of course it has a beautiful primary melodic line, but it also demonstrates Donizetti's great skill at ensemble writing. Although we know only his melodious operas, in his time he was esteemed for his many nonoperatic compositions, including sixteen symphonies, nineteen quartets, and twenty-eight cantatas. Donizetti is not the only operatic composer whose nonoperatic works have failed to stand the test of time. With the exception of the Wesendonck Lieder, how often does one hear anything by Wagner except his operas? Yet their operas would not be great had the composers been lacking in a wide variety of compositional skills.

The sextet is marked *larghetto* (broad and fairly slow). Donizetti wanted the tempo to fit the contemplative words of the sextet, to contrast it to the fast tempi of the action-oriented passages that precede and follow it. Edgardo and Enrico both speak about how their love for Lucia leads them to restrain themselves. Alisa, Raimondo, and Arturo are terrified by what is happening to Lucia; she wishes for death but finds she cannot even weep. The choral voices sing of their compassion for Lucia. Donizetti blends all this together into a rich sound that allows each voice to be heard and yet combines them into a totally coherent whole. Not since Mozart had anyone made such fine use of the operatic ensemble simultaneously to present the introspective thoughts of several

characters. Act 2 ends with another ensemble in which everyone suggests what should happen next to Edgardo. He pleads for them to kill him, Lucia for them to spare him, while Arturo, Enrico, and the chorus advise him to flee.

While an unspecified number of months have passed between acts 1 and 2, the rest of the opera takes place on the same day. By act 3 it is early evening. Scene 1 is another "oath" scene: Enrico and Edgardo swear vengeance against each other and set a duel for later that night. Scene 2 opens with a short chorus of rejoicing which soon turns to horror as a blood-splattered Lucia emerges from the bridal chamber, having slain Arturo. Lucia is never explicit about why she murdered him. When Raimondo finds her with the knife still in her hand, with a smile on her face she says to him, "My husband, where is he?" On one level in her mind, he was not her husband, so she was defending herself against being violated. On another level, plunging the dagger into him was turning the tables.

By going mad (and then dying), Lucia illustrates the only solutions to conflict available to the fragile, vulnerable, asexual version of the nineteenth century's dual images of women. Inevitably this dual image had a counterpart dual image of men. In Lucia's demented mind, poor Arturo had become the rapacious, unloving, satyr version. Enrico, whose voice she is hallucinating, had always been the noble, loving, asexual version. Their first meeting occurred when he saved her from that perennial symbol of the unfettered male, a raging bull. A consciously masochistic self-image, such as Lucia's, inevitably contains its unconscious opposite, a sadistic one. In her psychotic state that unconscious image surfaced and Lucia became the raging bull.

Nineteenth-century composers of opera were fond of mad scenes. Among the better-known operas in which they occur are Beethoven's *Fidelio*, Bellini's *Il Pirata*, Donizetti's *Il Furioso*, Verdi's *Nabucco* and *Macbeth*, Gounod's *Faust*, Wagner's *Tristan and Isolde*, Thomas's *Hamlet*, Moussorgsky's *Boris Godunov*, and Tchaikovsky's *Pique Dame*. Donizetti set his *I Pazzi per Progretto* in an insane asylum. Gilbert and Sullivan even included a mad scene in

Ruddigore, their parody of grand opera. Although some of these scenes were designed for men, most were for women.

The view that women lack men's strength of character, and thus are particularly vulnerable to insanity, is deeply embedded in the Judaeo-Christian tradition, beginning with Eve. When Constantine established Christianity as the state religion in 313, he also forbade the study of the classics. For a millennium religious views eclipsed scientific views, including the view of insanity. The consequences for the mentally ill were disastrous. Their illness became the work of the devil; ordinary people had to be protected from them, and so they were excluded from society—locked up in towers and cellars or exiled in ships of fools. When the scourge of leprosy began to recede toward the end of the Middle Ages, the old leprosaria (there had been as many as twenty thousand in Europe) became available for sequestering the mentally ill.

But sequestering them did not allay the fear of the insane. The devil had entered them. He might invade through any orifice, but being male his favored form of entry was through the woman's vagina. In 1484 two German Dominican monks published a book, *Malleus Maleficarum (The Witches' Hammer)*, which became the official guide for witch-hunting. Endorsed by Pope Innocent VIII, over the next two centuries it went through thirty editions at a time when few could read. Before the horror had ended, 150,000 had been executed, 98 percent of them women. The last witch was executed in Switzerland in 1782, only a few years before the sequestered mentally ill were released from their chains.

Lucia's insanity embodies elements of the more humanistic view of the early nineteenth century as well as leftovers from the past. She is now a victim of circumstances rather than a victim of the devil, someone to be pitied rather than to be feared and condemned. But she remains the frail woman who, lacking the strength to face reality, turns insane. And, though now absolved of guilt because of her insanity, she is still dangerous. Her story—unrequited love followed by insanity followed by death—appealed to the romantic imagination. As a dramatic device it was not new; the greatest writers of the Western world used it. In 1600

Shakespeare had written the identical scenario for Ophelia, as had Goethe for Marguerite in 1808.

It was a marvelous scenario for nineteenth-century opera. Because insanity was viewed as a loss of control, a mad scene offered an opportunity for depicting unfettered emotionality, freed even from the constraints of reason. The composer could loose the coloratura voice in whatever fashion he or the soprano fancied. In Lucia's aria Donizetti availed himself of a number of dramatic devices which exploit the possibilities of a mad scene. The mood shifts abruptly from pathos to joy to despair. Over the course of the scene Lucia becomes increasingly demented; at first she moves in and out of awareness of her surroundings, but by the end she has lost all contact with reality. Musical devices parallel the dramatic ones—wide, unusual intervals which must be negotiated very rapidly; long trills and fast chromatic runs; unexpected accents and syncopations.

For long stretches an accompanying solo flute obligato represents the disembodied voice of Edgardo that Lucia is hallucinating. How much of the flute obligato originated with Donizetti is not certain. As was the custom, he indicated only very generally the outlines of the long cadenza now sung with the flute obligato. The diva had great freedom with the cadenza. Whoever wrote it put great demands on the coloratura. Not only is it technically difficult, but the accompanying flute has unvarying pitch, so the singer's slightest inaccuracy becomes glaringly evident. Any coloratura who sings Lucia risks her reputation. Like a high-wire circus act, for an operatic career it is a death-defying undertaking. Its demands only intensify the anxiety experienced by a performing artist.

In all humans there is, behind every conscious motivation, an unconscious one. Because the performer is on stage, with all eyes and ears riveted on him, the danger that the unconscious wish will be perceived is great. Sometimes the unconscious motivation is the opposite of the conscious one—for example, the conscious

one is to be totally in control, the unconscious one not to have to control oneself at all. Sometimes the unconscious wish is closely related to the conscious one but has a specific meaning unacceptable to the conscious self-image. For example, the wish for intense interaction with the audience may have the meaning of fusion with the mother; the wish to be the star may have the meaning of being preferred by the parents over other siblings. Underneath the wish to be considered beautiful may lie a wish to exhibit oneself. The wish to be the perfect "good child" may conceal a wish to be a bad, rebellious boy or girl. Pablo Casals experienced intense anxiety with every performance until his death at age ninety-seven. Vladimir Horowitz had to abandon concertizing for many years but was able to return to it. Once he stopped, Glenn Gould never again performed in public.

For most performers, their anxiety is simply a part of their work rather than an impediment to it. The impresario David Belasco once said, "I wouldn't give a nickel for an actor who isn't nervous." Anxiety is actually a key element of the "electric" quality of a live performance. A great performance is always a "high-wire" act. We identify with the performer and share in his triumph over the anxiety when he succeeds. Modern video technology can give us a better view of the operatic stage on our TV at home than in the opera house. Modern audio technology can give us sound at home better than in all but the most expensive seats. But only at the live performance can we share the artist's experience of the moment.

Lucia's mad scene makes extreme demands on the singer. Throughout it we are on tenterhooks with her, and when she has mastered its technical and artistic hurdles we are delighted and relieved with her. The great demands that such parts made on *bel canto* divas became part of their justification for the great demands they in turn made on those around them. One of those demands was that they have the last great aria in the opera. The audience must leave thinking only of them. When Persiani, the first Lucia, realized that she did not have the last aria, she almost refused to perform. But Donizetti stood his ground, and the last scene of the

opera is devoted entirely to Edgardo who, after being told of Lucia's death, takes his own life. Still, Donizetti could not forgo a rousing finale. Although Edgardo's exit aria is about his suicide, it is in the vibrant key of D major. The affront to her status notwithstanding, the opera was such a success that Persiani happily continued in her role.

In contrast to many great composers, and despite a reputation for disobedience, prankishness, and indiscretion in his younger years, Donizetti appears to have been a quiet, outwardly easygoing person. He married at age thirty and was extremely devoted to his wife. In the nine years of their marriage, none of three children survived infancy. His wife's death in 1837 may have been due to postpartum fever, to the cholera then prevalent, or to syphilis, which led to Donizetti's own untimely death and which he may well have passed on to his wife. His comfortable manner may also have reflected a withdrawal from emotional involvement. After his wife's death he refused to return to the apartment they had shared and never mentioned her name again. Although he did not die until age fifty, he developed increasingly severe symptoms of syphilis over the last five years of his life. Rossini had written his last opera in 1829, Bellini his in 1835. With Donizetti's death in 1848, the era of *bel canto* opera came to an end.

𝖆 5 𝖆

Gounod's Faust

GIVING THE DEVIL HIS DUE

CHARLES FRANÇOIS GOUNOD was one of the nineteenth century's most influential French composers. Bizet, Fauré, Massenet, Thomas, and Tchaikovsky all acknowledged their debt to him. He was the major force in ending the domination of French opera by huge, overblown spectacles, such as those of Meyerbeer. He became rich and famous. Yet today he is rarely performed. Asked to identify any of his many choral, orchestral, or vocal works, the average music lover draws a blank. Only his opera *Faust* remains in the standard repertory, and it continues to be one of the world's most popular operas, simultaneously a deeply moving and frequently banal work. Of all the operas discussed in this book none has been more consistently applauded by audiences and more consistently deplored by critics than *Faust*. That it is one of the most singable of all operas is undoubtedly a reason for its popularity. Rossini and Gounod were the only composers covered here who had experience as professional singers. In his *Faust* Gounod combined a great legend, his superb compositional gifts, and a dramatization of the personal issues that dominated his life. The result was a masterpiece, Gounod's only one.

The opera is based on Goethe's version of the Faust legend.

82

Written at the turn of the century, it is considered by many to be the single greatest piece of German literature. In it Faust struggles to move from selfishness to altruism, to reconcile the shame of passivity with the guilt of action, to integrate the chaos of life with the harmony of nature. Goethe's position is pantheistic and classical. The opera encompasses only part one of Goethe's version, and it shortens and modifies that considerably. The libretto, by Barbiere and Carre, had been offered to Meyerbeer, but he turned it down. Originally German himself, he could not tolerate such truncation and alteration of a German icon.

In the opera's opening scene Faust, the aged philosopher, is in despair. His first word is "Rien" ("Nothing"). Goethe's words were, "Alas, I have studied philosophy, medicine, law, and, unfortunately, also theology, thoroughly and with great pains. And here I stand, poor fool, and am no wiser than before." In Gounod's hand, Faust's recognition that the power of knowledge is illusory became a statement that faith, not knowledge, is the answer.

Widely different interpretations of the Faust story have characterized this particular legend, which is based on the life of a real man, Georg Faust. Born in Germany in 1480, he became an itinerant palmist, astrologer, doctor, alchemist, and magician. Apparently he was both rather learned for his time and a somewhat seedy character who was frequently kicked out of town. He quickly became a legendary figure and has remained so for five hundred years. Each era has focused on those aspects of the tale suitable to its time.

Shortly after Faust's death these tales emphasized his punishment for hedonistic godlessness. By the end of the sixteenth century the focus had shifted to punishment for his intellectual curiosity. The most famous of these versions is Christopher Marlowe's 1592 drama. In the first half of the seventeenth century the focus became the magical elements, while in the second half of that century it was on the struggle between good and evil. By the end of the eighteenth century Faust has become a subjective figure, struggling with internal conflict, often one who challenges

the prevailing optimism of that century. The most significant modern version of the legend is Thomas Mann's. His Faust is a composer who can convert his dry, serene, intellectual musical genius into great compositions only by a bargain with the devil, who gives him passion and intensity.

Goethe's version of the legend is the most complex. He paraphrased the biblical "In the beginning was the word" into his "In the beginning was the deed." For Goethe the Faustian conflict between thinking and acting was unresolvable. For Gounod action came from the devil; its antithesis was not thought but faith. (On the opposite side of the issue was Adolf Hitler, for whom "In the beginning was the deed" was Goethe's only worthwhile concept.)

Since Gounod's *Faust* is a thoroughly Victorian Christian morality tale, it is not surprising that the devil, representing sexuality and aggression, is feared. But the energy of the id is not to be denied, and the devil becomes the agent of action in Gounod's version. Saint Augustine saw the devil's assertion of sexuality as an attempt to usurp the throne of the Almighty. In this view the devil exemplifies oedipal triumph. Hence his attractiveness. In Gounod, as well as in Goethe and Marlowe, the devil is the most interesting character.

In mankind's history the devil is a fairly recent concept, Goethe's description of him—"the Devil, he is old"—notwithstanding. In most early religions the godhead was the source of both good and evil. Not until the religion of Yahweh came under the influence of Zoroastrian dualism, about 500 B.C.E., did the Old Testament God have a demonic counterpart separate from himself. Throughout the pre-Christian era, however, the devil, though powerful, remained ultimately under God's control, as in the Book of Job. With the advent of Christianity the devil became increasingly more autonomous, more omnipresent, and more powerful. By the end of the fifteenth century the pope was describing a worldwide conspiracy of witches.

That the forces for good and evil were perceived by pre-

Enlightenment man as existing outside himself needs to be under-
stood as both defense via projection and as good reality testing.
For in those eras the Four Horsemen of the Apocalypse were
indeed likely to visit one at any time. Only with the development
of Western science and industrialized society was man able to gain
a measure of control over the ravages of natural disaster, disease,
and starvation. With the onset of the Enlightenment the devil's
power gradually abated, though to this day we retain some customs
from his heyday. For example, today's "Bless you" (when someone
sneezes) was once required, because at the moment of the sneeze
the person was out of control and thus demons might enter.

The Enlightenment brought a sense that man had power over
the forces of nature and over his own destiny. From the seven-
teenth to the twentieth centuries not only the devil but also God
came to have less power over man's daily life. Beginning with the
twentieth century, however, confidence in man's rationality began
to fade as forces beyond his conscious control reemerged, this time
in the unconscious. And the reemergence was in the pre-Zoroas-
trian combined form of Eros and Thanatos, both components of
the id. But no sooner had Freud thus internalized the devil (as
well as the deity) than reality changed. The devil has now been
reexternalized. The forces of destruction—the Holocaust, the
atomic bomb, and pollution—are man-made, but they are also
external reality. This ambiguity in the locus of the devil is
reflected in modern psychiatry—is the origin of neurotic conflict
to be found in internal conflict, á la Freud, or in conflict with the
environment, á la Kohut?

Gounod's *Faust*, though derived from Goethe's masterpiece and
though similar to seventeenth-century morality-tale versions, is
uniquely Gounod. The sinfulness of sexuality is apparent from the
moment of Mephistopheles' appearance. He has been summoned
when the despairing Faust, about to commit suicide by drinking
poison, invokes his name. Mephistopheles offers Faust first gold,
then glory, then power. Faust is not tempted. But when Mephi-

stopheles conjures up the vision of Marguerite and promises her to him, Faust succumbs. In exchange for his soul, Mephistopheles makes Faust young again. He will be given a second chance at love, something he failed at the first time. But, as the story shows, since his unconscious has not changed, he is no more able to love the second time than he was the first. The devil may be able to alter conscious time, but he cannot touch the timeless unconscious.

Faust and Mephistopheles are introduced in act 1 while the heroine, Marguerite, does not appear until act 2. Her first word in the opera is "No," paralleling Faust's opening word in act 1, "Nothing." By contrast, Mephistopheles' first words in act 1 were "Here I am." The Prince of Death is clearly the most life-loving of the three.

Marguerite's appearance does not take place until the end of act 2. Its setting is the town square of sixteenth-century Leipzig. Soldiers, students, and villagers are drinking in celebration of Easter. Valentin is concerned about who will care for his sister Marguerite while he is in the army. Mephistopheles magically produces some excellent wine, but when he proposes a toast to Marguerite, Valentin takes umbrage and the two fight. When Valentin's sword breaks in two in mid-air, the villagers recognize who Mephistopheles is. Making crosses of their swords, they negate his power and then leave. Faust and several dancing couples arrive, followed by Marguerite. She refuses to take his arm, and the act ends with Mephistopheles promising to aid Faust in pursuing her.

Act 2 does not especially further the dramatic action; rather, it is a set of musical tableaux. And here Gounod excels; he is one of the world's great painters of musical pictures. This talent underlies both his greatest artistic achievements and his artistic downfall. The "squareness" of Valentin's second-act aria precisely describes his bourgeois personality. Mephistopheles' jagged Golden Calf aria limns his cynical character. In the third act the solid, folk-ballad quality of Marguerite's King of Thule aria contrasts with the tinkling superficiality of the Jewel Song. Gounod hereby musically depicts the comparison Goethe made between the king's goblet (as a symbol of hospitality and friendship, to be proudly displayed

Faust: Overwhelmed by her sense of sinfulness, Marguerite cannot escape the voice of Mephistopheles, even in church.

as a lover's present) and Mephistopheles' jewels (as symbols of show, to be enjoyed only furtively, a devil's snare). Such musical pictures occur throughout the opera. They constitute almost all of the Walpurgis Night scene in act 5.

The painting of such musical pictures has a long and honorable history in music. It is "program music" in distinction to "absolute music," which has no visual or living sound referents, for example a Bach fugue. At the same time program music can degenerate into banality just as absolute music can sink into sterile intellectuality. Gounod's *Faust* constantly skirts the edge of banality, but it is saved both by Gounod's lyrical gifts and his great technical compositional skills, such as the use of seven choruses simultaneously at the start of act 2. And one always realizes that, whatever the sentiments expressed may be, they have great meaning for Gounod. Even when they are banal, one knows that Gounod is being sincere.

Acts 1 and 2 having set the stage, acts 3 and 4 contain the dramatic action and act 5 the resolution. The central action begins in the intermission between acts 3 and 4, for in good Victorian fashion, though sexuality is the driving force throughout the opera, it is never openly depicted. Act 3 ends with Faust rushing into Marguerite's house, and act 4 begins with her as a pregnant, fallen woman; the actual sexual relationship is only hinted at. Contrast this taboo on openness about sexuality to the opera's attitude toward violence: Faust's murder of Valentin occurs on stage. We have retained these attitudes to the present day. We allow virtually unrestricted depiction of violence on television but sharply restrict the depiction of sexuality in that public medium.

Act 3 finds Siebel, a young man in love with Marguerite, gathering flowers for her in the garden by her house. He had been warned in act 2 by Mephistopheles that any flowers he gathered would instantly wilt. This happens until Siebel dips them in holy water. Mephistopheles arrives, together with Faust, who sings of his chaste love for Marguerite while Mephistopheles produces a casket of jewels. Marguerite appears and sings two songs, the first a romantic ditty, the second about the jewels she has discovered in the casket. A neighbor, Marthe, enters and, upon learning that her husband has been mortally wounded, promptly begins wooing Mephistopheles. Faust and Marguerite have a conversation culminating in a love duet, but she will not let him into her house.

Mephistopheles has Faust linger long enough to hear Marguerite sing passionately about him out her window. He rushes to her and they fall rapturously into each other's arms as Mephistopheles gloats.

The first scene of act 4 takes place months after act 3. It involves Marguerite and Siebel and is usually omitted. (It is redundant, and the opera is very long as it is.) We now find Marguerite in a church, praying for forgiveness. Her prayers are interrupted by the voice of Mephistopheles, telling her she is doomed to eternal perdition. A chorus of priests sings the Dies Irae in the background. Overwhelmed, Marguerite faints. The last scene of the act takes place in a square near Marguerite's house. Soldiers are returning from battle, Valentin among them. Despite Siebel's warning, Valentin enters Marguerite's house. Faust appears with Mephistopheles, who sings a sardonic serenade at Marguerite's window. But it is Valentin who emerges and then is killed in a duel with Faust. Dying, he curses Marguerite.

Acts 3 and 4 are studies of the battle of the sexes. For Gounod, relations between men and women are not only conflict-ridden but always end badly. There are three kinds of male-female relationships in act 3: Mephistopheles' relationship with Marthe is purely manipulative—she wants to trick him into marriage, he wants to keep her from coming between Faust and Marguerite; Faust's relationship with Marguerite is one of passionate, sexual involvement; Siebel's with Marguerite is one of hopeless, idealized, romantic love. Equally doomed are the relationships in act 4. Valentin's idealization of his sister as virginal leads to his death, while Mephistopheles' unremitting sadism toward Marguerite leads to her insanity.

The cause of all these disasters is the illicit sexual relationship between Faust and Marguerite. Just in case the audience failed to get this message, Gounod added two set pieces on the subject: Marguerite's act 3 King of Thule aria extolling marital fidelity and Mephistopheles' act 4 aria warning young women not to give in without a wedding ring. This "overkill" suggests that Gounod was preoccupied with the issue. In the final scene Marguerite suffers

the ultimate punishment for her illicit sexuality—insanity (she has murdered her child) and death.

Opening act 5 is the Walpurgis Night scene. Mephistopheles has brought Faust to this satanic bacchanalia to distract him from his thoughts about Marguerite, by tempting him with all kinds of harlots and beauties from the past. In the midst of the wild celebration Faust sees a vision of Marguerite and, stricken with remorse, insists that Mephistopheles take him to her. Opera companies without an adequate *corps de ballet* often omit this scene as well.

The final scene takes place in a prison cell where Marguerite is awaiting hanging for having killed her child. When Faust awakens her from sleep she greets him as though they were still lovers, and Faust realizes she has lost her mind. Despite the urgings of Faust and Mephistopheles, Marguerite makes no effort to escape. Now frightened of Faust, she simply repeats her prayer, each time in a higher key, and is rewarded by a chorus of angels who carry her off to heaven. Increasing the intensity of music by raising a melody repeatedly to a higher key is a device common in popular music but rare in classical music. Here Gounod uses it to great effect, once again successfully skirting the edges of banality.

Marguerite's fate reflects the other side of the nineteenth-century view of woman as noble and self-sacrificing. Woman is also lacking in moral strength and unable to control her impulses. Faust actively chose to sell his soul; Marguerite simply lacked the strength to resist temptation. But this same "weakness" also leads to her insanity whereby she is absolved of her guilt. Gounod knew well whereof he wrote, for this was an absolution he seems to have intensely yearned for himself, and the music he wrote for this scene is indeed sublime. But this absolution is not available to men. A man can only suppress his guilt by satiating his appetites, as in the Walpurgis Night scene in act 5, where Mephistopheles offers Faust "a place at a feast of queens and courtesans to stifle the remorse in his enchanted heart."

Gounod's *Faust* is unique in his oeuvre. He wrote of it, "None of my works written before *Faust* gave any reason to expect a score

of this kind; nothing had prepared the public for it." *Faust* stands in contrast to Gounod's eleven other operas, mostly failures already in their own time. Only his *Romeo and Juliet* is still occasionally produced—a weaker opera on a theme for which Gounod had little feeling. He wrote much other music: symphonies, choral works, religious works, songs, but with the exception of his *Ave Maria* practically none of it is ever performed. The uniqueness of his *Faust* thus suggests that it had special meaning to Gounod. It was the high-water mark in his creative life.

Gounod came by his talents from his parents. His father was a gifted but not very successful painter, his mother an accomplished musician. In his autobiography Gounod describes his father as painting fine portraits but leaving the background unfinished so that, in order for them to be salable, Gounod's mother had to do the tedious work of completing them. In contrast is Gounod's idealization of his mother, to whom he dedicates his autobiography:

> This account of my life is a testimony of veneration and affection for the being who has given me the greatest love in the world— mother love. The mother is, here below, the most perfect image, the purest and warmest ray of providence; her never-failing care and watchfulness are the direct emanation of the eternal care and watchfulness of God.

Chapter 1 of Gounod's autobiography begins with the words "My mother," and his idealization of her continues throughout. By contrast, only a few sentences concern his wife. The passages about his father are revealing, albeit brief, since he was but five when his father died. That this loss left him incompletely identified with his father and overinvolved with his mother is clear from this passage:

> While my father was thus absorbed in reading, I used to lie flat on my stomach on the floor in the middle of the room drawing with a

white crayon on a varnished blackboard, eyes, noses and mouths, for which he had already traced the copy on the aforesaid board. I see this now as if I were still there, and I was then but four or four and a half years old at the most. This occupation had for me, I remember, so great a charm that I have no doubt if my father had lived I should have been a painter instead of a musician, but my mother's profession and the education received from her during the years of childhood determined the balance in favor of music.

Describing the origins of his interest in music, Gounod writes, "My mother, in nursing me, had certainly made me imbibe as much music as milk. She never performed that function without singing, and I can say that I took my first lessons without knowing it and without having to give them the attention so painful to tender years."

Despite his father's death, Gounod's interest in painting remained strong, and he was talented. While he was studying in Rome, having won the Grand Prix de Rome in music, it was suggested to him by the painter Ingres that if he dropped music for painting he could win a second Grand Prix in painting. Gounod decided against that course, but the continuing importance for him of visual thinking is evident in his music.

During the composer's years in Rome, Ingres became a father figure for Gounod. As Gounod recognized, few young men would have chosen Ingres for this role:

It has been said, and often mechanically repeated, that Mr. Ingres was despotic, intolerant, exclusive; but he was nothing of all that. If he asserted himself strongly, it was because he had strong belief, and nothing in the world gives more authority than that. I have never seen anyone admire more things than he, simply because he could discern better than anyone else in what respect and why a thing was admirable. But he was prudent; he knew to what extent the impulses of the young lead them, without discernment and without method, to be enamored of, and infatuated with, certain personal traits of such or such a master.

For Gounod, Ingres was a perfect choice. Ingres was not only a painter, like the composer's father, but also one who felt his talent was unappreciated. Furthermore, Ingres was a prototypical Victorian. Publicly his fame rested on his idealized studies of female nudes, and he adamantly denied anything prurient in these pictures; they represented the ultimate in beauty, and it was the role of art to depict beauty. But privately Ingres drew pornographic sketches. Publicly Ingres denounced the "ugliness" of Delacroix's paintings; privately he hated him as a competitor and was paranoid about the art world in general, long after it showered him with honors. This outwardly prudish, inwardly prurient man struck a responsive chord in Gounod.

As with many other creative geniuses, Gounod was clearly his mother's favorite. With the death of his father, Gounod's attachment to his mother became intense and remained so throughout his life. He idolized her as noble, self-sacrificing, and long-suffering. Such a view of women was a common cultural stereotype in the nineteenth century and appeared frequently in opera. This *mater dolorosa* image serves to desexualize the mother figure and protect against incestuous impulses. For someone like Gounod who, with father dead and brother away, had his mother all to himself, it probably played a powerful role. He was, furthermore, a devout Catholic, and the dominant role of the Virgin Mary in nineteenth-century Catholicism could only reinforce this image.

Gounod's only brother was ten years older and was away at school during much of Gounod's childhood. That Gounod had ambivalent feelings about him and that these influenced his artistic work is evident from this passage about the time immediately after his brother's death:

Strange fact! It seems as if sad and pathetic accents should have been the first to thrill the fibers of my being, so recently shaken by the most painful emotions! But it was to the contrary; the brighter scenes were those that first seized and took possession of me, as if my nature, bent under the weight of sorrow and mourning, felt the

need of reaction and of free respiration after those hours of agony and days of tears and sighs.

But such intense feelings of specialness—being mother's favorite, having father die, brother being away (thereby becoming the only male in the house)—are not retained without guilt. When Ingres told Gounod he could win a second Grand Prix in painting, he provided the support of a father figure for Gounod's sense of omnipotence, now in the form of a Faustian omnimath. But then the oedipal triumph became too much to tolerate. Gounod sought to allay his guilt by studying for the priesthood. This attempt to deny his grandiosity, however, meant abandoning both his artistic creativity and his sexuality. It lasted less than two years (1846–1848), but he continued to wear clerical garb. In 1851 he was described as a "philandering monk."

Four years later Gounod married. His autobiography says little about his wife, but he comments about his father-in-law (a music teacher) and the connections to the world of art and music that his in-laws provided. That the marriage was likely to fail was indicated from the one passage in his autobiography where Gounod discusses his wife:

> It was during the time of one of the grand annual meetings of the *Orpheon*, June 8, 1856, that my wife presented me with a son. (Three years before, on the same month, we had the sorrow of losing at birth our firstborn, a girl.) On the morning of the day when my son was born, my brave wife, although feeling the first pains of motherhood just as I was starting out for the meeting of the *Orpheon*, had the force to conceal from me her sufferings, and when in the afternoon I returned to the house my son was already in the world.

The *mater dolorosa* image was too powerful. It became his view of his wife as well as of his mother.

Gounod began working on *Faust* in 1856, and the opera's first production took place in 1859. After a slow start it soon became a great success. And here Gounod's autobiography ends. He contin-

ued to keep the private diary on which his autobiography is based, but he destroyed everything after 1859. Although his public life became increasingly successful after Faust and he continued to write a great deal of music, commanded large fees, and received much recognition, his artistic creativity and his personal life began a downhill course.

As he ground out one religious piece after another, his work grew more and more banal. He was only forty when he wrote Faust and lived to be seventy-five, yet nothing approaching the quality of Faust ever again flowed from his pen. Meanwhile his personal life deteriorated. With the success of Faust, Gounod's childhood sense of specialness was again reinforced. Only this time he dealt with it in a different way. It no longer appeared to trouble him, and the former novice priest became the profligate. During his stay in England (1870–1875) he not only took a series of mistresses but appeared with them publicly. The most notorious of them was a flamboyant patroness of the arts who eventually landed in jail, the only person ever known to have attempted to blackmail Queen Victoria—an ironic twist since Faust was Victoria's favorite opera.

Gounod could never reconcile his impulses with his conscience. He went from monasticism to promiscuity. In the latter half of his adult life both his mistresses and his compositions became interchangeable. He abandoned the creative struggle and became merely a producer of technically competent but aesthetically mediocre pieces. He suffered a number of "nervous breakdowns" during the course of his life. There was a flamboyant side to the man, evident in the highly decorated religious costumes he wore in his monastic phase, and in the public flaunting of mistresses in his promiscuous phase.

The banal quality of Gounod's later works is already evident in Faust. The danger of banality is almost built into romantic opera. The limitation on the number of words that can be sung (and understood) leads to inevitable oversimplification; the passionate intensity that opera is uniquely able to convey leads to overly dramatic plots. Gounod's character structure made him vulnerable to the appeal of banality, and indeed Faust is probably the most

banal of the great operas in the standard repertory. But Gounod's musical genius found its greatest expression in *Faust*. And to most, if not all, operagoers, the greatness vastly outweighs the banality.

A quote from Gounod suggests that his relationship with his mother, his many personal problems, his love of opera, and his special feeling for this narrow version of the Faust story were all connected and had early origins in his life. As a young child he was taken to a performance of Mozart's *Don Giovanni*. That opera has a subtitle, "Il Dissoluto Punito" ("The Libertine Punished"). Gounod wrote of it:

> The first notes of the overture, with the solemn majestic chords out of the Commendatore's final scene, seemed to lift me into a new world. I was chilled by a sensation of actual terror; but when I heard that terrible, thundering roll of ascending and descending scales, stern and implacable as a death warrant, I was seized with such shuddering fear that my head fell on my mother's shoulder and, trembling in the dual embrace of beauty and of horror, I could only murmur, "Oh, mother, what music! This is real music indeed."

Gounod wrote nothing comparable to *Faust*. Despite all its flaws it remains one of the world's operatic masterpieces. It is as though, understanding his subject matter so well and feeling it so deeply, Gounod was able to give it such exquisite expression that despite its sentimentality and narrowness of scope it touches us profoundly. Although he was a composer with considerable limitations, Gounod poured all of himself into *Faust*. Sometimes it is not an artist's scope that matters as much as his ability to allow us to see deeply into himself.

6

Wagner's Tristan and Isolde

ROMANTIC EROS AND THE ROMANTIC ERA

"SINCE I never had the unique luck of love in real life, so I wish to create a memorial to this loveliest of dreams in which, from beginning to end, such a love can at least once satiate itself." Thus wrote Wagner in a letter to Liszt in 1854, the year he first became acquainted with the Tristan legend. Two years earlier he had fallen in love with Mathilde Wesendonk. She was unwilling to abandon her husband, but the relationship had a profound impact on Wagner. He wrote (again to Liszt) that she "dared to throw herself into a sea of suffering that she should be able to say to me, 'I love you!' No one who does not know all her tenderness can judge how much she has had to suffer. We were spared nothing —but as a consequence I am redeemed and she is blessedly happy because she is aware of it." Although there is no evidence their relationship made Mathilde "blessedly happy," and although within five years Wagner had fallen equally intensely in love with the wife of another of his friends, there is no question that his feelings for Mathilde led him to drop his work on the *Ring* and devote the years 1857 to 1859 to writing *Tristan*.

The opera opens literally and figuratively on a sea of suffering. Tristan is carrying the Irish Princess Isolde on a boat back to

Cornwall to marry King Marke. Isolde is enraged and despondent because Tristan has betrayed her. She had saved his life and then fell in love with him despite his having slain her betrothed. Tristan is torn between his love for Isolde and his duty to his revered king. In this conflict between love and honor—the dramatic core of so many nineteenth-century operas—honor is generally valued more highly, as in Verdi's works. In *Tristan*, the most romantic of all operas, love, and only love, ultimately matters. But in act I both Tristan and Isolde are determined to preserve honor, so Tristan agrees to drink Isolde's poison potion with her. His words are, "To Tristan's honor highest troth." Hers are less noble: "Traitor, I drink to you."

But Brangene, Isolde's maid, has switched the poison for a love potion. That such partaking of a love/poison potion leads to sexuality is part of the Old Testament myth of Adam, Eve, and the apple. In *Tristan*, as in Genesis, the woman is the initiator; she brings about the transforming moment. And in *Tristan*, as in Genesis, the whole world changes. Nothing is as it was before. What had been the real world has now become only a dream. Says Tristan, "What did I dream of Tristan's honor?" Says Isolde, "What did I dream of Isolde's shame?" In *Tristan* the world after the event is the true world of freedom and love. The New Testament version of the transforming moment is Saul's conversion on the road to Damascus. His new world was, "His love is perfect freedom." But Paul, and later Augustine, retained the Old Testament connection between sex and knowledge (as in "having knowledge of a woman") and of the sinful nature of both. This view of knowledge played a not insignificant role in the relative stagnation of erudition and science in the European world during the thousand years of the dark ages, at a time when these pursuits were flourishing in the Arab world.

Wagner, that romantic revolutionary, was determined to overthrow the traditional view of the ancient myth. For his paean to romantic love he drew upon the medieval tale of Tristan and Isolde. It was an appropriate choice, for although romantic love existed in classical literature (Ovid, for example), the Western

concept of romantic love had its origins in tales of chivalry. The age of chivalry lasted about four hundred years, from 1100 to 1500, from the first Crusades to the triumph of artillery. Heroic military deeds and devotion to a ladylove were its hallmarks from the beginning. Indeed, the devotion to an idealized woman was thought to spur a man on to greater heroism in order to impress her. In its earliest versions the woman was worshiped, but only from afar. Love was pure and chaste. The woman was married, usually the spouse of the knight's lord. One author of the time regarded three deeds as high treason: to slay one's lord, to lie with his wife, or to surrender his castle.

By the time of the first recording of the Tristan story, around 1200, the hero was regularly lying with his lord's wife, as in the Arthurian legend. In most other ways he remained a man of honor, valor, and charity. Thus sexual love had become the most powerful force, outweighing the other values. The Tristan tale was thus an ideal vehicle to express Wagner's view that "all other love is merely a result, a derivative or an imitation of sexual love." In act 1, as soon as they have drunk the potion, Tristan and Isolde become oblivious to all other concerns except their love for each other. Here, in the first of their great duets, they are as one. They do not even have a conversation; they speak identical words. As they say, "I am aware of you alone," however, the practical world descends upon them as the ship arrives at Cornwall. Realizing what has happened, Isolde falls unconscious as the act ends.

The chivalric concept of romantic love has shown remarkable longevity. The prototypical American myth remains the Western movie with its gun-toting hero who saves the town. He is romantically but not sexually involved with an idealized woman. At the end of the tale he rides off into the sunset to embark on another noble crusade for justice. To achieve such staying power a myth must address profound psychological themes which, if not universal, are at least widespread in the culture. Wagner's version

of the myth contains such pervasive themes as well as those specific to his era and to his own character structure.

The power of romantic love lies in its potential for meeting a wide variety of profound human needs, from the most primitive (for example, the wish for fusion with the mother) to the most mature (for example, the wish to give freely to another person). The power of *Tristan and Isolde* lies in its depiction of so many ways in which romantic love meets these needs. The wish for fusion pervades the opera. It is most explicit when Wagner has Tristan and Isolde say, in unison, "one forever." They idealize each other and then raise their sense of self-worth by merging with the other and by basking in the esteem of the idealized other person.

The infant has no world beyond himself; he and his mother are one. Tristan and Isolde say, again in unison, "I am the world." In their relationship they seem to lack any sense of a world beyond themselves. They describe their own feelings but have no real interaction, no real conversation—though they did in act 1, before they took the potion.

The young child is unable to conceive of death, as in *Tristan:* "So, if his love could never die, how could Tristan die in his love?" The young child also struggles with issues surrounding activity and passivity. Tristan and Isolde, in their potion-induced self-absorption, change from very active figures at the beginning of act 1 to very passive figures, until the very end. Tristan, for example, is totally passive in his relation to both Marke and Melot. In act 2 he accepts both Marke's verbal denunciation and Melot's physical assault on him without any attempt to defend himself.

Wagner was explicit about his conception of romantic love as being primarily passive. He described Lohengrin as yearning for "the one thing which could release him from his loneliness and satisfy his longing: love, to be loved, to be understood by means of love." Along with issues of activity and passivity are issues of ambivalence. Wagner resolves the conflict by totally separating love from hate. At the beginning of act 1 Isolde feels nothing but hatred for Tristan; after the potion she feels nothing but love for

him. There is only one fleeting moment of ambivalence, during the transition from hate to love, before the potion has fully taken hold. Isolde says, "Faithless dear one." From then on it is all love.

As children move beyond early issues of separation and ambivalence, they begin to struggle with oedipal issues. Once Tristan and Isolde have drunk the potion, not a hint of oedipal concerns escapes their lips. Yet the plot is built around two oedipal conflicts: Tristan had slain Isolde's intended, Morold, and then taken her away from Marke. By placing the oedipal issues only in the dramatic action, not in the music or words, Wagner gives them lesser importance.

He was explicit about his intent that the music have the greatest importance, the words less, and the dramatic action least of all:

Here I sank myself with complete confidence into the depths of the soul's inner workings, and then built outwards from this, the world's most intimate and central point, towards external forms. This explains the brevity of the text, which you can see at a glance. For whereas a writer whose subject matter is historical has to use so much circumstantial detail to keep the continuity of his action clear on the surface that it impedes his exposition of more inward themes, I trusted myself to deal solely with these latter. Here life and death and the very existence and significance of the external world appear only as manifestations of the inner workings of the soul. The dramatic action itself is nothing but a response to that inmost soul's requirements, and it reaches the surface only insofar as it is pushed outwards from the inside.

Neither do such latency-age issues as acquiring the capacity for industry concern Tristan and Isolde. Before the potion Tristan was a warrior renowned for his skill. Afterward he will not even raise his sword against Melot. The idea that they might be expected to earn a living never crosses the lovers' minds. (Nor did Wagner feel he should be bothered with such mundane details.) Idealization and yearning, two dominant themes throughout the opera, are also hallmarks of adolescence. From this perspective the opera can be

seen as a huge, adolescent fantasy. But the search for an ideal lover is doomed to failure, as Tristan and Isolde are doomed. And endless yearning leads only to a growing abandonment of efforts toward mature gratifications and a self-destructive search for infantile ones. The danger of the regressive pull of infantile wishes is greater when the personality is on shaky ground to begin with. Tristan had never gotten over having been an orphan: "He begot me and died; she, dying, gave me birth." The regressive pull is more dangerous for him than it would have been in a better-integrated individual. He speaks of "this terrible yearning that sears me, this ravaging fire that consumes me."

The opera's many dimensions of both normal and pathological romantic love reflect Wagner's unique genius, his thinking, and his personality. They also reflect the era in which he lived. Born in 1813, he grew up in the midst of what is generally called the romantic era, from 1790 to 1850. Its explosion of creativity continues to be at the core of our artistic heritage: the writings of Austen, the Brontes, Burns, Byron, Shelley, Blake, Keats, Scott, Wordsworth, Coleridge, Dickens, Thackeray, Gogol, Dostoevsky, Turgenev, Pushkin, Balzac, Dumas, Hugo, Stendhal, Irving, Poe, Goethe, Schiller, Schopenhauer, and Hegel; the paintings of Goya, Delacroix, Gericault, Constable, and Turner; the music of Beethoven, Chopin, Liszt, Mendelssohn, Schubert, Schumann, Weber, Rossini, Bellini, Donizetti, Berlioz, Meyerbeer, and Glinka.

It was a revolutionary age: the industrial revolution (just getting under way), the political revolutions (starting with the French Revolution in 1789 and ending with the revolutions of 1848), and the artistic revolution against the verities of reason, ethics, religion, and civic virtue. The romantics replaced the Enlightenment emphasis on man's rationality with an emphasis on his emotions, dreams, and fantasies; the emphasis on abstract principles and fixed forms with an emphasis on specific examples and flexible forms. They replaced the emphasis on mankind with an emphasis on the individual man, with all his vagaries and potentialities; the

emphasis on man's productions and material reality with an emphasis on nature and the supernatural. They expanded the exclusive interest in Greco-Roman and urban culture with an interest in other societies and in the life of the ordinary man. Above all, the romantics made individual man's subjective experience the primary focus of artistic exploration. Although the romantic era ended more than a century ago, its focus on the subjective has remained a central theme in artistic endeavor.

The focus on the individual that resulted from the rejection of the classical verities received additional impetus from the unanticipated consequences of the industrial and political revolutions. Workers who moved from the countryside to seek their fortune in urban factories often found worse poverty. Almost all the political revolutions of the era eventuated in regimes as autocratic as those that had preceded them. Disappointment in the world of commerce and politics turned the artist inward. It was also the beginning of artistic elitism.

Wagner, exiled after his participation in the failed revolution of 1848, decided that the world could be changed only through art. He also decided that he was the only man who could do it, therefore the world must defer to his views on all matters. Such a view of the artist as solitary genius, exempt from ordinary social constraints, was also a product of the romantic era. Byron and Beethoven were prototypes, but no one carried it to Wagner's extremes. *Tristan and Isolde* is the ultimate romantic opera not just in its treatment of romantic love but in its embodiment of so many of the characteristics of the romantic era: its focus on inwardness, its outdoor settings, its rejection of traditional dramatic and musical forms, its medieval story, and its depiction of the hero as above social constraints.

Like act 1, act 2 begins and ends with the world of reality. It opens with Brangene warning Isolde that a tryst with Tristan would prove disastrous; it ends with the confrontation between Tristan and Marke and Melot. In between is the longest duet in

opera, more than forty minutes, with no action during the entire time. The duet, the centerpiece of the opera, is a paean to love and the night, a repudiation of the world's activities and daylight. These themes are explored in great detail and in many variations. All the basic ideas are contained in one twenty-seven-word passage: "Thus we died, undivided, one for ever, without end, never waking, never fearing, embraced namelessly, in love, given entirely to each other, living only in our love!"

For Wagner, love and death were inextricably linked. He wrote to his friend Rockel, "We must learn to die, and to die in the most absolute sense of the word; the fear of death is the source of all lack of love, and it is generated only when love itself has begun to fade." Love can only be sustained in death, in the night. In the real world, in daylight, lovers are doomed to the "mutual horror of lovelessness" because of love's "inevitable mistake of perpetuating itself beyond the inescapable laws of change, of prolonging mutual dependence—this resistance to the inevitable renewal and change of the objective world." Only in the subjective world, the unchanging world of the night, of the will, of death, can love last. The objective world is, in Tristan's words, filled with "the lies of daylight, honor and fame, power and profit." Hence "only one yearning remains, for holy night, where from the beginning love's wonder, alone true, laughs out."

Wagner's rejection of society as consisting of the lies of honor, fame, power, and profit reflect the influence of his anarchist friend Bakunin and of the writings of radical socialists such as Fourier, Saint-Simon, and Proudhon. His philosophical view—the objective world of action is ultimately meaningless, only the subjective world of the will is important—reflects the views of Schopenhauer. But for Schopenhauer the ultimate goal, achieving the night, calls for a resigned becalming of the soul. For Wagner it means achieving eternal love. Wagner's psychological perspective—true love is timeless, the negation of death—reflects a view derived from his own personal experience. Nighttime is the world of dreams and of the unconscious; in the unconscious there is no sense of time or death. Wagner's concept of love as eternal fusion

with the lover is probably an accurate reflection of his own capacity for loving. In *Tristan's* libretto there is no mention of sexuality. To the contrary, Tristan speaks of the "chaste night." In Wagner's libretto, love remains predominantly pregenital.

At the same time sexuality pervades the love duet; it is embedded in the music. This split reflects Wagner's own erotic life. He was sexually very active, often promiscuous. But his sexuality served the primarily pregenital aims of the love duet: timeless fusion, symbiosis, omnipotence. The split also reflects the difference between the actuality of his relationship with Mathilde Wesendonk and his intensely erotic feelings toward her.

The intensely sensual music makes *Tristan* the most romantic of all operas. In the romantic era music was the dominant artistic medium in Germany (in contrast, for instance, to England, where literature dominated). In the view of E. T. A. Hoffmann, a leading German romantic poet and novelist, "Music is the most romantic of all arts—in fact, it might almost be said to be the sole purely romantic one." Wagner understood that the real power of his opera lay in the music, not in the drama. Once, at a performance, he recommended to a friend, "Don't look so much. Listen more."

About an orchestral concert of his music he wrote, ". . . The effect was terrible . . . that is, the women gradually lost their heads. Emotion ran so high that sobbing and crying had to come to their aid." In order to evoke such emotionality in the audience, the composer must experience it first. His work "must necessarily call forth in the inspired musician a state of ecstasy wherewith no other can compare." Both composer and audience must "have fallen into a state of hypnotic clairvoyance. And in truth it is in this state alone that we immediately belong to the musician's world. From out that world, which nothing else can picture, the musician casts the meshwork of his tones to net us, so to speak; or, with his wonder-drops of sound he dews our brain as if by magic, and robs it of the power of seeing aught save our inner world."

Music plays a more dominant role in *Tristan and Isolde* than in any other of Wagner's operas. He wrote it while heavily under the influence of Schopenhauer, who viewed music as expressing "the innermost basis of the world, the essence behind appearance." The world of appearance is the world of the day, of action and of cause and effect. The world of essence is the world of the night, of passion and of limitlessness. Wagner used melodic, harmonic, and metrical devices to express this world of essences. His term for his melodic devices was "infinite melody," by which he meant two things: melody should be continuous, uninterrupted, and always musically meaningful, never just decorative or formulaic. Hence his long, discursive melodies which flow freely from voice to orchestra and back again.

Wagner's harmonic structure was also to be continuously flowing, without a formula. Chords are resolved in an infinite variety of ways, each resolution leading to another unresolved chord, with the traditional dominant-tonic resolution postponed repeatedly (in the minds of many, postponed interminably). The opening chord of the opera (the so-called Tristan chord) is F, B, D-sharp, G-sharp. A minor fifth, followed by a major third and then another major fourth, establishes no clear tonality and is highly ambiguous with regard to potential resolution. Both Bach and Mozart had used this chord, but in their usage tonality is clearly established and the direction of resolution comes quickly. Wagner resolves the chord stepwise, chromatically. First he raises the G-sharp to an A, then to an A-sharp, and then to a B. Meanwhile the D-sharp moves down a half-step to a D, and the F a half-step to an E. The final chord of the sequence is a diminished seventh chord, unstable by itself. It is the dominant to the key of A but is not resolved that way. This kind of floating, harmonic, semiresolution characterizes the entire opera. True cadences usually come only at specific nodal points in the dramatic action.

Wagner's metric patterns are equally fluid. He changes them so frequently that no clear meter is established in the listener's mind. Wagner clearly shared Coleridge's view that the origins of meter consist in an effort "to hold in check the workings of passion."

Through his avoidance of established meter, Wagner furthered his intent to communicate unchecked passion.

All these devices are part of what Wagner meant when he said, "The art of composition is the art of transition." These devices also lend to Wagner's music many of the aspects of unconscious thought. Such thought is characterized by condensation (combining multiple diverse elements), displacement (shifting onto something else), the equivalence of opposites (and others), and no clear sense of time. With his preference of night over day, of emotion over reason, Wagner strongly orients himself to unconscious thought processes. Wagner's music expresses exactly what he wanted it to. Whether one loves it or hates it depends on how one feels about what he has to say. That he succeeds brilliantly in expressing it musically cannot be denied.

Wagner carefully attuned words and music to each other. With regard to *Tristan and Isolde* he wrote (to Liszt) that he had drafted the music in his head before starting on the words. We know that for the *Ring* he wrote the words first, before writing the music. In the final products the music shaped the words and was in turn shaped by them. Wagner illustrated how he shaped music to words: he described how if the words are "love gives delight to living," the two ideas (love and delight) are closely related and accordingly no change of key is indicated. But if the words are "love brings delight and sorrow," since these are opposites the music must modulate between them. The key of the word "love" should continue through the word "delight" and then change with the word "sorrow." The change in key must, however, show the relationship between delight and sorrow as well as the difference between them. If the next line of the poem is "but even love's pain brings us joy," the key from the word "sorrow" should continue through the word "pain" (since the mood remains the same). But starting with the word "gives" it should begin shifting back to the original key of the word "love," arriving there with the word "joy."

The romantic aspects of *Tristan and Isolde* also involve the acting, the orchestration, the voices, and the scenery. Traditionally

the acting in *Tristan* has been such that the less said of it the better. The great Wagnerian voices have not been great actors. Fortunately there is so little action in the opera that the quality of the acting is the least important part of the performance. The orchestra is the central force in the opera. Nietzsche saw it as assuming the functions of the Greek chorus, as the commentator on the action. Thomas Mann saw Wagner's orchestra as "the kingdom of subliminal knowledge, unknown to the world Up There."

Wagner would have approved of both comments. His use of the orchestra was unique and influenced all subsequent musical or-chestration. He placed the orchestra out of sight of the audience so that it would not visually distract and so that its "voice" would blend completely with those of the singers. He used a large and extremely varied orchestra with the instruments combined in infinitely varied ways. Although his orchestrations were probably the most influential of any in the century, they also reflected the great interest in orchestration in the romantic era. Before the nineteenth century there were no texts on orchestration. The romantic interest in sound qua sound remains a focus of much musical thinking to this day.

Both Tristan and Isolde must have heavy, powerful voices. Although the dramatic soprano had been a staple of opera for some time, before Verdi and Wagner all tenor roles had been lyrical. That lyric quality was too unreal, too "pretty," and too conventional for many of the romantics. Beethoven, as is so often the case, set the precedent with Florestan. But only in Verdi and Wagner do we come upon the full-blown dramatic tenor, and Tristan is perhaps the outstanding role for this kind of voice. It has been called a Heldentenor, a heroic tenor voice. And singing the part of Tristan is a heroic undertaking: it is a rare tenor who can do justice to the demands of the part. To achieve the necessary dramatic quality, it requires a basically baritone voice that has been pushed up into the tenor range. Many great Wagnerian tenors started out as baritones; so did Caruso. A tenor can easily ruin his voice undertaking Tristan without the requisite physical

Tristan and Isolde: Oblivious to the world, Tristan and Isolde are totally absorbed in each other.

equipment and preparation. Listening to almost four hours of an inadequate Tristan can be an act of heroism on the part of the audience as well.

The scenery of the opera is entirely in the romantic outdoors. Act 1 is on a ship, act 2 in a garden, act 3 on a craggy coastline. The producer is also given full scope for lighting effects. Act 1 is set in the afternoon ocean sun, act 2 moves from twilight to night, act 3 is in flickering, morning sunlight. In the harsh glare of that sunlight we find a very different Tristan—mortally wounded, half delirious, and separated from Isolde. His view of the world is quite different from the ecstatic rapture of act 2. Before he had cursed the daylight; now only daylight can bring the ship with Isolde to him. He says, "Oh this sun, ah this day; ah, most sunny day of this delight!"

Isolde's wonderful potion has now become "the terrible draught which brought this anguish on me I, I myself, did brew." Where the expectation had been "eternal bliss" it is now "eternal torment." Tristan's only hope is that Isolde will come and cure him. He vacillates between conviction that, like his parents, he is doomed to die young, and the anticipation that Isolde will arrive in time to save him. He both yearns for Isolde and curses her. She should have let him die and saved him from "this terrible torment." Because of her, "I had to betray my noble lord."

The words that Wagner gives Tristan are extremely ambiguous, often self-contradictory. They reflect his delirious state. They also reflect Wagner's acknowledgment of reality—inevitably it will intrude on the romantic fantasy. In this almost hour-long monologue, Tristan reviews his entire life. It is a dying man's honest self-appraisal; his strengths and his weaknesses, his deepest conflicts and his highest aspirations are all examined. Wagner uses Tristan's "delirium" to allow him conscious access to his deepest unconscious. It is a profound, and profoundly sad, assessment. And therein, for Wagner, lies the true tragedy. The tragedy is even greater because, in a better world, it could have been avoided. The ship that brings Isolde also brings Marke, who has forgiven Tristan and is prepared to unite the lovers. But it is too late. Kurnewal, Tristan's ever-devoted friend, does not know that Marke comes in peace, and he dies attacking Melot.

In each act the conflict between love and duty is resolved by a different transforming event. In act 1 the transforming event—the potion—changes Tristan from devotion to duty to devotion to love. In act 2 the unexpected arrival of Marke and Melot turns Tristan from love back to duty. In act 3 Tristan vacillates between the two. The transforming event—Isolde's arrival and Marke's forgiveness—comes at the very last moment. By the time Isolde reaches Tristan he is almost dead, her name on his lips. He dies having achieved both duty and love, and neither. She cannot accept being without him, and the opera ends with an exquisite paean to eternal love as she sinks onto his body. They are reunited

in death. This magnificent aria has been called the Liebestod, the love-death. It was not Wagner's term. He called it the Verklärung, the transfiguration, the final transforming event. It is, as he intended, the ultimate romantic ending.

7

Verdi's Aida

FATHERS AND DAUGHTERS

AIDA is perhaps the grandest of grand opera. It has huge spectacles, ballets, exotic settings and costumes, large choruses and glorious music. Verdi wrote it when he was fifty-eight, famous and wealthy. It could easily have been his final masterpiece, and he may well have thought of it that way.

But *Aida* is much more than spectacular grand opera. It is also a profound study of two women in conflict between their love for a man and their devotion to their fathers. The opera has four major characters: a hero, the Egyptian soldier Radames; a heroine, the Ethiopian slave Aida; an antihero, the Ethiopian king Amonasro, Aida's father; and an antiheroine, the Egyptian princess Amneris. There are no villains because Amonasro and Amneris are doomed victims of fate rather than innately evil.

For almost all the opera the romantic hero Radames is an essentially one-dimensional figure. An idealist, he is swayed by both the attractions of a warrior's glory and the allure of Aida, the noble slave. Only at the end of the opera, when he refuses both to renounce Aida and to defend himself, does he show real strength of character. Like so many of Verdi's heroes, Radames concludes that ultimately nothing matters except his sense of integrity.

Aida: Invoking the threat of her mother's curse, Amonasro induces Aida to betray Radames.

Rejecting Amneris's pleas that he defend himself, he explains, "I have no fear of mortal wrath. Your pity is the only thing I fear." Verdi's profound sense that only one's personal integrity, one's honor, mattered in the long run had roots deep in his own personality.

By contrast, the antihero Amonasro is a man completely impervious to the blandishments of love or glory. He is single-minded, forceful, and ruthless in pursuit of his goals. Yet he is not a caricature; he can be compassionate and understanding. When, at the end of act 3, Radames decries himself as a traitor, Amonasro says, "No, you are not guilty. It was the will of fate."

The opera is in four acts. In act 1 the stage is set. All the action

takes place in acts 2 and 3. In act 4 there is also no action; it is devoted to a description of the consequences of the action in acts 2 and 3. Because Amonasro is the quintessential man of action, never troubled by internal conflicts, he has no place in acts 1 and 4. He appears only in acts 2 and 3, but his actions result in the tragic outcome. The turning point is his duet with Aida in act 3, where he succeeds in getting her to agree to induce Radames to betray the location of the Egyptian army.

The antiheroine Amneris is the most complex figure in the opera. Like Amonasro, she is a ruthless pragmatist. But she is also, like her rival Aida, very much in love with Radames. And, also like Aida, she is devoted to her father, the Egyptian god-king; out of loyalty to him she dooms her beloved. Too late, she desperately tries to save him. Hers is the most cruel fate, for while the lovers die honorably, she is left to live with her pain.

Aida is the central figure and a typical nineteenth-century operatic heroine. She is noble, proud, passionate, long-suffering, and dies for her man. Her choosing to die with him is both a reflection of her love for him and an atonement for having betrayed him. Only one person, her father, could have led her to betray this man whom she loved so deeply.

In her great aria at the end of the first scene of the opera, Aida foresees that the conflict between her loyalty to her father and her love for Radames will bring her to disaster. The duet between father and daughter in act 3 is one of passionate intensity. Her bond to him is too strong; she cannot resist him. She knows he is manipulating her, that he is using loving memories, loyalty, fear—anything he can think of to bend her to his will. When he invokes the threat of her mother's curse it is the final straw, and she gives in. The die is cast, the tragedy has become inevitable.

Such a tragic end for the heroine is typical of nineteenth-century opera. But the cause of the tragedy lying in a father-daughter relationship is unusual, except in Verdi's work.

Verdi wrote twenty-six operas. In almost half of them the father-daughter theme appears as a key dramatic element. It is to be found in three of Verdi's first four operas, disappears for five

years, then reappears in seven of the next eleven. Almost always the relationship has disastrous consequences.

In five operas the father (or father figure) causes the death of the daughter: *Nabucco, Louisa Miller, Rigoletto, La Traviata,* and *Aida*; in three the daughter is the agent of the father's death: *Oberto, I Vespri Siciliani,* and *Simon Boccanegra*; in one, *La Forza del Destino,* each is involved in the death of the other, and in one, *I Lombardi,* the father fails in his attempt to kill the daughter. *Aida* is the last and the greatest of Verdi's operas in which this relationship is important. Its role in Verdi's operas is unique in romantic opera. A study of Giuseppe Verdi's life indicates that the frequency of this theme is no coincidence.

Verdi was born October 10, 1813, in a rural hamlet in the principality of Parma in northern Italy. Severe poverty was the lot of the family, but his parents, despite being illiterate, did operate a tavern and general food store on the dirt-floored first level of their two-story house. They were somewhat better off than most of the townsfolk.

Verdi adamantly refused to discuss his childhood, save to say, "It was very hard." Although a great many of his letters are extant (he used copies of them to keep records of his business affairs), they shed no direct light on his early years. When he was two and a half, his only sibling, his sister Giuseppa, was born. She was mentally retarded at birth and lived only to age seventeen. We know nothing more about her.

In contrast to most towering musical geniuses, Verdi was not a child prodigy; he published no music until age twenty-five. He was, however, obviously a talented child, and at age seven his father bought him a small, secondhand, somewhat battered spinet. This was a major investment for a man of Carlo Verdi's means. Verdi also took organ lessons and three years later became the organist in the village church, a position he held for nine years.

When Verdi became church organist he moved to Busseto, a

town of two thousand, some three miles from his village. He lived with a cobbler and paid half his room and board from his salary. His father paid the other half. The move was arranged by his father to allow Verdi to proceed with his education, both general and musical. A good deal of music was available in Busseto, particularly in the home of Barezzi, the leading local merchant, who agreed to watch over this displaced ten-year-old and who later became not only Verdi's father-in-law but also his lifelong patron, friend, and supporter. Although Verdi's father obviously was concerned with his son's welfare and did far more for the boy than could have been expected (given Carlo's illiteracy and limited income), from this time on Barezzi became the valued father figure in Verdi's life. Meanwhile, his relationship with his own father became a mixture of duty and resentment.

At age twelve Verdi first became the focus of a conflict in Busseto, the kind of situation that recurred repeatedly throughout his life. This first time it paired the priest and the music teacher: the former wanted Verdi to concentrate on academic studies, the latter on music. Eventually the music teacher prevailed, but the argument sowed the seeds of Verdi's lifelong anticlericalism.

At fifteen he composed his first pieces but refused to allow them to be published, a practice he followed with everything he wrote before he was twenty-five. At sixteen he read the first Italian national novel, Manzoni's *I Promessi Sposi*. This book mobilized the Risorgimento, the movement for a unified Italian nation, and made an indelible impression on Verdi. For the rest of his life he was not only an ardent patriot but an active participant in the turbulent political struggles that characterized the forma-tion of Italy as a country. Manzoni also became his only living hero.

At age eighteen Verdi moved into Barezzi's house. A year later he moved again, this time to Milan where, with financial help from Barezzi, he continued his musical studies. But he was not considered sufficiently talented to be admitted to the conservatory there. When he was twenty his sister Giuseppa died. For the next three years he was a center of controversy in Busseto as the church

opposed his appointment by the town government as town music master, in those days a position of great importance to an Italian town. Verdi had to return to Busseto frequently from Milan in order to sustain his local support. Ultimately he won, but the church never allowed him to serve as organist and choirmaster. His anticlericalism was fueled again.

When he was named music master, Verdi moved back to Busseto from Milan and married Barezzi's daughter Margherita. Verdi's mother was "sick" that day and did not attend the wedding. As the newly married couple settled in, Verdi continued to work on his first opera, *Oberto*. Eleven months later Margherita gave birth to a daughter, Virginia. Before the year was out Margherita was again pregnant and Verdi had published his first music, a set of songs. In July 1838 a son, Icilio, was born. One month later little Virginia died suddenly at eighteen months. A year later Icilio also died suddenly. Verdi continued working on *Oberto* which was produced in November 1839. He was twenty-six years old.

The opera was a modest success, but it proved to be only a lull in the storm of disasters that was descending on Verdi. Seven months later, after a two-week illness, Margherita died of encephalitis. Despite his grief Verdi continued to work on his second opera, a comedy, which was produced just three months after Margherita's death. The opera was a fiasco. It had only one performance, though history has judged it less harshly.

Verdi now sank into intense mourning. He withdrew from all musical activity and social contact, stayed in a rented room, and generally dined out alone. After six months his friend Merelli cajoled him into reading a new libretto. It interested Verdi and, gradually emerging from his withdrawal, he began work on his third opera, *Nabucco*.

The fatal consequence of father-daughter relationships already appears in Verdi's first opera, *Oberto*. The heroine's father is killed by her lover, and at the final curtain she is alone, grieving and desolate. Verdi had started work on *Oberto* in 1835, before he was married. The seeds of the importance to him of the father-

daughter relationship therefore precede his tragic family events. An indication that his sister was a critical figure for him is found in the first names of Verdi's family. He was named Giuseppe, Joseph. His sister was named Giuseppa, Josepha. Verdi's parents clearly intended their son and daughter to feel close to each other. For his own daughter Verdi chose the name Virginia. He took the name from a Roman story about a girl who prefers death at her father's hand to being dishonored. For his son he chose the unusual name Icilio. In the Roman legend Icilio's fiancée is named Virginia, and after Icilio's death Virginia and Icilio's father together become political reformers. Both Verdi's parents' choice of names for their son and daughter and Verdi's own choice for his children implied a close relationship between brother and sister. One more unusual "coincidence": shortly after Margherita's death Verdi met Strepponi, a leading diva of the day. Seven years later she became his mistress and eventually—twenty years later—he married her. Her name was Giuseppina, little Josepha, and she was two years his junior, as his sister had been.

Years later, recalling the loss of his family, Verdi told an interviewer:

> But then my misfortunes began: my boy fell sick at the beginning of April. The doctors could not diagnose his trouble, and the poor little fellow slowly wasted away in the arms of his frenzied mother. But that was not enough. After a few days my little girl fell ill in her turn! . . . and the sickness ended in death! . . . Still even that was not enough. In the first days of June my young wife was seized with acute encephalitis, and on 19 June 1840 a third coffin went out of my house!
>
> I was alone! . . . alone! . . . In the short space of two months three persons dear to me had gone, forever: my family was destroyed! . . . In the midst of this terrible anguish, to keep my bond, I had to write and finish a comic opera!! . . .
>
> Un Giorno di Regno did not please. Certainly some of the fault was the music; part, too, in its execution. With a mind tortured by my domestic disaster, embittered by the failure of my work, I

persuaded myself that I had nothing more to find in music and I decided never to compose again.

Of greatest interest are the distortions of memory in this account. Not only is the sequence reversed (his daughter in fact died first) but the deaths occurred over a period of three years, not two months. That a memory deficit was involved here is most unlikely, not only from what we know of Verdi at age sixty-seven, but also because the date of his wife's death is precisely accurate. I suspect that the reversal of the death order reflected Verdi's confusing his childhood family with that of his early adulthood. In his original family he was the older, his sister the younger. In his adult family the girl was born first. Verdi's memory changed the sequence of his adult family to that of his childhood family. Similarly, the telescoping of time probably reflected the single unconscious meaning that the deaths held for Verdi. He had Alvaro express it for him in the last act of *La Forza del Destino*. As Don Carlo and Leonora (brother and sister) lie dying, Alvaro says, "I am the one who has sinned and I am condemned to live." This kind of guilt about being the one who has survived while loved ones have died is a common phenomenon. It has been observed most frequently in concentration camp survivors who lost their families and in soldiers whose companions died in battle. It clearly played a decisive role in Verdi's life, both in his behavior and in his operas. Not until he was in his seventies, when he had recreated the constellation of both his original and his second family—parents, son, and daughter—was he able to free himself from its grip.

One other aspect of Verdi's family relationships is relevant here. In contrast to his father, Verdi's mother remains a shadowy figure. We know practically nothing about her. Similarly, mother figures are rarely important in his operas. Yet besides being a genius Verdi was a man with considerable strength of character. One would suspect that his early relationship with his mother was a good one. It seems probable that the disappearance of mother figures in his work reflects a total repression—a "forgetting"—of his happy early

childhood memories. When painful memories are associated with guilt, the pain in the memory helps allay some guilt—we too suffered. When pleasurable memories are associated with guilt the opposite often occurs—the pleasure easily leads to the suspicion that perhaps we wished for the events to happen, and the guilt is aggravated.

Further evidence of the danger to Verdi of forgotten, happy childhood memories can be found in his operas. Two well-known examples are Germont's "Di Provenza" aria in *Traviata* and Amonasro's third-act aria in *Aida*. In both the father, by calling forth memories of happy childhood times, induces the child to take action that turns out to be disastrous. The origins of the "inexorable fate theme" which pervades Verdi's works is, I believe, to be found in the ever-threatening return of these forgotten memories, forgotten because they are associated with so much guilt, both in relation to his sister Giuseppa and to his wife and children.

The libretto that induced Verdi to return to work after the family tragedies and the *Giorno di Regno* fiasco was *Nabucco*. The plot centers on the relationship between the father and his evil illegitimate and noble legitimate daughters. The father becomes temporarily insane but recovers in time to foil the designs of the illegitimate daughter, who then commits suicide. The opera is most remembered for the chorus "Va Pensiero." Its line "Oh mia patria si bella e perduta" ("Oh my country so beautiful and lost") struck such a responsive chord in the ears of a people yearning for a unified Italy that the chorus became almost the equivalent of a revolutionary national anthem throughout the Risorgimento. Verdi became a revolutionary hero. Later, when the revolutionary forces decided to coalesce behind King Victor Emmanuel, Verdi's role was reinforced by the accident of his name. The acronym for Victor Emmanuel Rex D'Italia (Victor Emmanuel, King of Italy) turned out to be VERDI. Verdi's name appeared as graffiti all over Italy. From a psychological perspective, "Oh my country so beautiful and lost" is also a statement about the lost bliss of childhood.

This meaning of "country" was made explicit in the "Di Provenza" aria in *Traviata*, in which Germont reminds his son Alfredo of the happiness of his childhood in the provinces.

After *Nabucco* Verdi wrote *I Lombardi*, in which the father-daughter relationship is less central to the plot. The theme has begun to disappear from Verdi's work of this period and does not occur again in his next nine operas. With the exception of *Ernani*, none of these operas has survived in the standard repertoire. (I include *Macbeth* among these nonsurvivors because it is not the original 1847 version that is now heard but the much revised 1865 version.) The underlying theme of most of these operas from the period 1844–1849 is the struggle against oppressors, and indeed this was a period of revolutionary turmoil, culminating in the failed revolutions of 1848. In these operas the locus of tragic fate is predominantly in the outside world.

Luisa Miller, first produced in 1849, marks a turning point for Verdi in three ways. The father-daughter theme appears again— Luisa's attempts to save her father lead to her death; second, *Luisa Miller* is the beginning of the series of operas that established Verdi's true stature and that have remained staples of the repertoire—*Rigoletto*, *Il Trovatore*, and *La Traviata* appeared within the next four years; and third, the locus of fate shifts from the outside world to inside the individual. With that remarkable capacity for personal growth that characterized his whole life, Verdi was able to let go of the need to blame the outside world. And with that growth his creative powers increased dramatically.

Rigoletto was originally entitled *La Maledizione*, The Curse. The "fate theme" is still powerful, but the locus of that force is now fully internal. The curse is fulfilled because of unintended consequences of Rigoletto's actions. Verdi based the opera on Victor Hugo's *The King Amuses Himself*. The play is revolutionary in its depiction of corrupt nobility versus the honorable common people. While the play now seems terribly dated, Verdi's opera remains vital because in it the forces of love and hate are inside Rigoletto. He is both a loving father and a hate-filled man, and his failure to reconcile these two sides of himself leads to tragedy.

Verdi's shift of focus may have been a consequence of his own aging and maturation, the failed revolution of 1848, and his increasing closeness to Strepponi.

Rigoletto appeared in 1851; Verdi was thirty-eight years old. He had begun openly living with Giuseppina Strepponi in Paris in 1848. In 1849 they moved to Busseto, the small, conservative, rural, Catholic town where Verdi had lived as a child. He was the town's most illustrious citizen. Strepponi was a fallen woman—she had a number of illegitimate children. In the eyes of both Verdi's parents and the townsfolk, for him to live in their midst with her as his mistress was outrageous and unforgivable. Strepponi was ostracized, and she and Verdi were almost totally isolated socially.

Verdi's feelings about his father could no longer be contained. First there was a public letter stating, "I intend to be separate from my father both in my domestic and business affairs. . . . As regards the world, Carlo Verdi must be one thing and Giuseppe Verdi another." This was followed by a formal legal document entitled "Minutes of the Compromise Between Giuseppe and Carlo Verdi." In this "compromise" were spelled out the terms of Verdi's support for his parents, in a place three miles away from St. Agata, the residence Verdi was building for himself and Strepponi just outside Busseto. Verdi's loving feelings toward the father who had extended himself on behalf of his son were "forgotten"; they were repressed. Only bitterness remained in consciousness. The total, public separation from his father was an attempt at freeing himself from his conflict.

The following year his mother died. Verdi's next opera was *Il Trovatore*, his only opera in which a mother, Azucena, is a significant figure. Although it is filled with glorious music and remains an audience favorite, it lacks dramatic coherence. The theme was not close to Verdi's heart. When he started work on the opera Azucena was intended to be the central character, but in the course of the writing her role was reduced to secondary importance.

1853 also brought the first productions of *Traviata*, Verdi's only openly autobiographical opera. It is set in Paris, where Verdi and

Strepponi had lived together. Although it is eighteenth-century Paris, except for the ever-present threat of the censors it could easily have been set in the nineteenth century. The second-act country home where Alfredo has installed Violetta is clearly identifiable with St. Agata. Like Violetta, Strepponi was often sick. And Germont, whose duets with his son Alfredo and with Violetta are among the most intense and moving in all of Verdi's operas, could easily have been Barezzi, who, like Germont, at first succumbed to social pressure and ostracized Strepponi. Unlike Germont, Barezzi realized his mistake in time. He can stand as the model for what a patron of the arts should be. Reproached by Verdi for his behavior, he accepted Strepponi, and over the years they became close friends.

The bone of contention was, of course, that Verdi and Strepponi were not married. That was not to occur until ten years after they moved to Busseto. No one knows why the delay. It may have been Verdi's unresolved mourning over Margherita and the children. It may have been Strepponi's feelings about Verdi's anticlericalism. He considered religious people "all mad" but regularly dropped her off at church though he would not go in. In Verdi's mind the town's hostility and religion were connected. In his letter reproaching Barezzi, Verdi reminded him of the town church's refusal to make him organist thirty years earlier.

Verdi was now forty years old. He had written fifteen operas in the preceding decade; the next two decades would see only six operas. In four of these the father-daughter theme appears: *I Vespri Siciliani* (1855), *Simon Boccanegra* (1857), *La Forza del Destino* (1862), and *Aida* (1871). The two that do not contain the relationship are *Un Ballo in Maschera* (1859) and *Don Carlo* (1867). They are of interest here in that both contain elements of comic relief, which Verdi had eschewed since the *Giorno di Regno* disaster twenty years earlier.

Of these six operas only *I Vespri Siciliani* was a failure. *Simon Boccanegra* required major revision, but the revised version has survived. *Aida*, however, remains the greatest masterpiece of the group and one of the most popular of all operas.

As already noted, the dramatic turning point in *Aida* comes when Amonasro convinces Aida to betray her lover, Radames. This scene, with its range of emotions, its drive, its intensity, is the apogee of Verdi's many father-daughter duets. Amonasro is relentless and ruthless. Like Nabucco who was psychically impaired (he was insane), like Rigoletto who was physically impaired (a hunchback), like Germont who was socially impaired (a bigot), Amonasro is morally impaired. All are flawed fathers who cause their daughters' deaths. The importance to Verdi of this image of the loving but fatally flawed father was clearly expressed in a letter he wrote when the censors were trying to force him to change the character of Rigoletto: "I find this the most wonderful part: to portray this extremely deformed and ridiculous creature who yet is inwardly passionate and full of love. I chose the subject just for this reason, for all these original qualities and traits, and if they are cut out I shall not be able to compose the music." Twenty years passed between *Rigoletto* and *Aida*. They produced most of Verdi's great operas, and the father-daughter theme remained a driving force throughout. Those twenty years also contained important events in Verdi's personal life. At forty-six he married Strepponi; two years later he was elected to the newly formed Italian parliament; when he was fifty-three his father died, and he adopted his seven-year-old distant cousin Maria-Filomena; the following year Barezzi died.

Verdi was now fifty-eight years old and had been writing operas for twenty-five years. And now he stopped. For sixteen years he did not write a new opera. He revised previous works, oversaw productions, and supervised his estate and farm at St. Agata. In all his activities no detail was too small to receive his attention. Every word of the libretti, every note of the music, every stage gesture was carefully planned. He calculated to the second how long arias should take. He was a compulsive worker. As he said in later years: "Every man has his destiny: one to be a donkey all his life, another to be a cuckold, one to be rich and another poor. As for myself, with my tongue in my mouth like a mad dog, I'm fated to work to the last gasp!"

His compulsive work habits and his meticulous attention to detail paid off: his operas are superbly crafted. But combining creative freedom with compulsive rigidity came at a price. All his life Verdi was plagued with psychosomatic symptoms when he was writing operas. He had headaches and stomachaches; sometimes he would grow faint and have to lie down; often he would develop severe sore throats. In operatic literature the throat symptoms are attributed to Verdi's singing to himself. I suspect that when Verdi composed, it was accompanied by a suppressed cry for reconciliation and suppressed tears of atonement for his guilt. Verdi recognized the connection in himself between composing and dealing with grief, as we have seen from his vow, after his family's death, never to compose again.

In his hiatus of sixteen years Verdi did produce one masterpiece, his *Requiem*. The occasion was the death of Manzoni, the man whose book had so stirred Verdi at age sixteen. Manzoni had remained Verdi's hero. He met the man only briefly yet he revered him as "saintly." Many years later Verdi described his lifelong inability to grieve openly: "Great grief does not demand great expression; it asks for silence, isolation, I would even say the torture of reflection. There is something superficial about all exteriorization; it is a profanation."

It is difficult to grieve openly for someone we have hated as well as loved; we cannot easily free ourselves from the suspicion that some part of us wanted the person dead. But Manzoni was an idealized figure—here there was none of the ambivalence that Verdi had experienced toward his father, and so he was able to give full expression to his grief. And with it he gave up some of his lifelong hostility to the church. The convinced atheist, the passionate anticleric, wrote one of the world's greatest pieces of religious music. The church, however, was less flexible than Verdi: because the *Requiem* did not conform to the prescribed Mass, it was not allowed in church services.

Five years later, in 1879, Strepponi and a friend finagled Verdi into a meeting with Arrigo Boito. Sixteen years earlier Boito, then a brilliantly gifted twenty-one-year-old musician, writer, and

artistic gadfly, had, in the throes of a fit of Wagnerism, called Verdi "an idiotic old man who urinated on the alter of Art." Verdi was deeply offended and had thereafter refused to see him, though Boito had in the interim become a great admirer of Verdi. Forgiveness still came hard to Verdi. But the reconciliation was effected, and when Boito suggested collaboration on an opera, Verdi agreed. With the *Requiem* Verdi had finally been able to grieve. With the reconciliation with Boito he recreated the lost original and second family constellation. In Maria-Filomena and Arrigo Boito, he and Strepponi had a loving daughter and a loving son. Verdi was free to write again, freer than he had ever been.

And what an opera he wrote! *Otello* is considered by many to be the greatest romantic opera. At age seventy-four Verdi's work was far more subtle and complex than it had been when he completed *Aida* at age fifty-eight. Although *Aida* was his most sensual work to that time, sexuality is openly expressed for the first time in *Otello*. In all of Verdi's earlier operas love was purely romantic— the passion was that of idealization, there were no bedroom scenes. And this was clearly not a matter of fear of the censor— Bizet, Offenbach, and Saint-Saens had been staged for years. In his seventies Verdi made another maturational leap and found new creative powers.

In *Otello*, as in all of Verdi's work, there is a passionate will to life and an equally passionate will to death. His characters are always active; even in relation to death they are never passive. But because death is ever present, imminent, and inevitable, man's commitments—to love, to country—are worthless. The only worthwhile commitment is to one's own integrity. Honor matters, everything else leads to nothing. Verdi would have endorsed Scott Fitzgerald's aphorism, "Show me a hero and I will write you a tragedy."

But the reconstituted family, the reconciliation between father and son, Verdi and Boito, was to produce yet one more master-piece, *Falstaff*. Although now almost eighty years old, Verdi made one final maturational leap. Sixty years after the fiasco of *Un*

Giorno di Regno, Verdi was again free to write a comedy. The words of *Falstaff's* final chorus are: "All the world's a joke. Man was born laughing, swung this way and that by his heart and his head. All men are ridiculous; each laughs at the other, but he laughs best who laughs the last." The chorus is led by Falstaff. The flawed father figure persists to the end, but now he is held in amused affection. The hatred is gone.

In his remaining eight years Verdi wrote a few pieces but no more operas. Nonetheless we have one more opera to consider, and that is the one Verdi never wrote, *King Lear*. The tale of the man who caused the death of his three daughters first occupied Verdi's thoughts in 1843, and he actively worked on the opera for fifteen years, including many sketches and scene drafts. We do not know how actively Verdi considered the project after 1858, but given that in his later years he chose only libretti based on Shakespeare, it is unlikely it disappeared from his thoughts. He turned down several libretti for *Lear*, including one by Boito. He had "good" reasons for not pursuing *Lear*, he said, so many as to suggest that there was an underlying "real" reason. Likely the tale of a father who kills his daughters was too close to home. It remained the opera Verdi could not write.

He died January 27, 1901. At his funeral in Milan, 200,000 people, almost the entire population, lined the streets. He was the last of the great Italian artists of the mid-nineteenth century and the last great figure of the Risorgimento. We cannot imagine such a turnout for a classical musician nowadays, only for a popular musician. But in his day Verdi's operas were popular music. Our twentieth-century equivalent would have to be jazz. And the same passion for life, the same preoccupation with sadness and loss, and the same context of suffering at the hands of oppression character-izes jazz as it does Verdi's works. No jazz figure of a stature comparable to Verdi's has yet emerged. But it took three hundred years of opera to produce a Verdi.

❧ 8 ❧

Moussorgsky's Boris Godounov

THE CORRUPTING INFLUENCE OF POWER

MODEST PETROVICH MOUSSORGSKY began writing *Boris Godounov*, based primarily on Pushkin, in 1868, when he was twenty-nine years old. He completed his final version in 1872. Nine years later, one week after his forty-first birthday, he died, probably from malnutrition and alcoholism. The son of well-to-do landowners, he had shown some musical talent as a child but had little formal musical training until he resigned his army commission at nineteen. His musical training was, however, to be short-lived because of conflict with his teachers and because his family became impoverished. He was able to obtain an ill-paid government post, but for the rest of his life he lived on the edge of poverty.

From the time of Peter the Great, Russian high culture had been dominated by Western European influences. In the mid-nineteenth century a movement grew to develop indigenously Russian music. Perhaps in part because of his lack of formal musical training, Moussorgsky became one of its greatest protagonists. When he undertook *Boris Godounov* he intended to write a totally Russian opera: Russian story, setting, and characters; Russian music; and Russian issues. Although he (as well as later arrangers and directors) modified his original intent, *Boris Godounov* re-

mains an unmistakably Russian opera. Today it is the most performed Russian opera, both in and outside of Russia, and with *Eugene Onegin* is the only nineteenth-century Russian opera that is part of the standard repertory. This was not always so. After Moussorgsky's death the opera disappeared from sight until 1908 when Rimsky-Korsakov's revised version was produced. It is this "Westernized" version that continues to be generally performed. In addition to Moussorgsky's two versions and two of Rimsky-Korsakov, there are versions by Shostakovich and by Gutman and Rathaus. Each has its partisans.

Boris Godounov is a profound study of two issues: the corrupting influence of power, and the relationship between the ruler and the ruled. The corruption of power is a long-standing concern of opera and theatre and has fascinated the greatest writers for centuries, from the Greeks to Shakespeare. The focus in *Boris Godounov* on the relationship between the ruler and the ruled is unusual in opera, which generally concerns itself only with the rulers. Because this relationship is so important, choruses assume an unusually large role in *Boris*. Moussorgsky felt it was his special mission to depict the peasants operatically. In 1872 he wrote to his friend Stassov, "Man is a social being and cannot be otherwise; masses, like individuals, invariably possess elusive traits that no one has seen, that slip through one's fingers—to note them, study them, read, observe, conjecture, to dedicate one's entire being to their study, to offer the result to humanity as a wholesome dish which it has never before tasted, that is the task—the joy of joys!"

The Russian peasant is not only central to the opera but very carefully drawn. No other nineteenth-century opera devotes such attention to the poor. Giving the peasants so central a role was for Moussorgsky a way of distancing himself from Western European opera. The Russian serf had been freed from slavery at roughly the same time as his black American counterpart, in 1861, only seven years before Moussorgsky began work on the opera. In an attempt to save the family estate, Moussorgsky worked alongside the serfs, much to the dismay of his family. Although the family fortune was lost, the experience paid off. The

peasants are not stereotyped caricatures, as is so often the case in opera; they are real and human figures.

The relationship between the tsar Boris and the peasants is a highly personal one. The opera opens and closes with explorations of that relationship, using both soloists and chorus. In music only opera and oratorio offer such an opportunity, and because opera has the additional dimensions of acting and stagecraft, it is the ideal medium for the task. Boris and the peasants love each other and hate each other; they need each other and fear each other. In Moussorgsky's view it had always been this way in Russia and always would be. He emphasizes this sense of historical continuity and inevitability by devoting acts 1 and 3 to a study of the rise to power of Boris's antagonist and successor, Grigory-Dmitri. Boris does not appear in these two acts. While the prologue deals with Boris's rise to power, acts 2 and 4 concern his fall from power and his death.

The relationship between the hopelessly poor peasants and their all-powerful, frequently savage, and yet perennially vulnerable tsars is a dominant theme in Russian history. With the prescience of genius, Moussorgsky chose a subject that continued to domi-nate Russia in the century after the opera was written: a nation so fearful of its foes that it found security in a dictatorial ruler; a governmental process characterized by endless struggles for acces-sion to power and by government savagery in the name of law and order.

The events of the prologue take place five years before the rest of the opera. Moussorgsky introduces us to Boris as he ascends to power. The complicated relationship between Boris and the peas-ants is the subject of the two scenes of the prologue. In the first scene the police must push the peasants to demonstrate in favor of Boris, for he has publicly refused to become tsar. The policemen admonish the peasants: "Now then, have you turned to idols? Quickly, on your knees. What a lot of churls you are."

Privately Boris has arranged for the demonstration to assure that he has solid support for taking the throne. This picture of Boris, as the astute politician in control of events, stands in stark contrast

to the dying Boris at the end of the opera. Scene 1 ends with a group of pilgrims crying that only God and the church can induce Boris to accept the throne and save Russia from chaos: "Woe unto Russia. Our land groans for want of a ruler."

In the second scene of the prologue the crowd is already joyous in anticipation of Boris's coronation. But Boris begins his reign filled with sinister forebodings about the future, for he cannot forget that he would not be tsar had he not murdered Dmitri, the rightful heir. "My soul is sad. Strange dark forebodings and evil presentiments oppress my spirit."

Throughout the opera there are repeated references to the people's fear of the tsar, his cruelty and ruthlessness. Yet Moussorgsky makes it quite clear that, much as they fear a strong tsar, the people fear being without a strong tsar even more. Historically the fear was well founded, for whenever Muscovite Russia had been without a strong ruler she had been sacked repeatedly by Mongols, Poles, Tartars, and Cossacks, and her citizens slaughtered or sold into slavery. Only a powerful and ruthless tsar had proven capable of containing the nobility and its internecine warfare that left the nation weak and in chaos.

From the point of view of history, the real Boris, rather than being too ruthless, was too forgiving to be a good tsar. When he caught his courtiers plotting against him, he banished them to Siberia rather than ordering their execution. They later returned to plot against him once more. Similarly, he did not move decisively to crush the false Dmitri movement. The last few years of Boris's reign and the decade following became known as "the time of trouble," a disastrous period for Muscovite Russia. Famines, invasions, and internal disorder characterized the period, and the absence of a strong and ruthless tsar led to great suffering.

In addition to these peculiarly Russian reasons for wanting a strong tsar, the wish for an all-powerful ruler has a psychological root. It is in the nature of men to search for an omnipotent father who will both protect us from external danger and help us to control ourselves. This wish stands in opposition to the oedipal wish to destroy the father and have the mother to oneself. It is

precisely because both wishes are so powerful that the oedipal constellation poses such a source of conflict.

The idea of wishing for a powerful father figure to help us control ourselves may seem strange to Americans because our culture is one that emphasizes self-control. In early childhood we stress cleanliness and toilet training. This contrasts to many other cultures that set much less store by cleanliness and consider toilet training something that will take care of itself in due time. In their adolescence we expect our boys and girls to control their sexual impulses while other cultures consider such self-control unnatural and therefore never allow their adolescents to be alone with the opposite sex without a chaperon.

Yet underneath our vaunted Western European self-discipline, yearnings remain for freedom from self-control and for uninhibited gratification of our impulses. As long as those yearnings remain, though they may be deeply buried, a fear of them will also remain. And so we too, if we look inside ourselves, will find a wish for an all-powerful, loving father who will protect us from ourselves and from a world that would react unkindly to our unfettered demands.

In trying to understand Boris Godounov it is worth remembering that at the time of the founding of the American nation, the separate states, fearful of internal struggles for power, prevailed upon a reluctant George Washington to accept the presidency. They saw him as the only person who could hold the country together. He, in turn, foresaw that if he did accept, he would be accused of being power-hungry and of wishing to establish a dynasty. Indeed, he was accused of these and many other things. George Washington would have had no difficulty in empathizing with Boris's ambivalence about becoming tsar.

An all-powerful father will inevitably be the object of our fear, envy, and hatred as well as our love, as it was with the peasants and Boris. His foreboding in scene 2 of the prologue makes clear that, though he had gratified his wish to be tsar, he also recognized it would destroy him. In act 2 he says: "I have attained supreme power and this is the sixth year of peaceful rule. Yet there is no

happiness in my tortured soul. The judgment of the Lord lies heavily upon me. Terrible is the sentence of a guilty soul." The two sides of Boris's feeling about possessing the crown are also contained in his dying words in the last act: "Ya Tsar yeschyo... prostitye"—I am still the Tsar...forgive me." The process of Boris's destruction is the plot of the opera. It takes two forms: how Boris is destroyed by his enemies, and how Boris destroys himself.

Moussorgsky used Boris's vision of the blood-stained child, Dmitri, to describe Boris's self-destruction. From a psychological perspective the vision of Dmitri can be understood as a visual hallucination. It stems from Boris's desperate attempt to deal with his overwhelming guilt by having the avenging power appear outside of himself, rather than acknowledge it as being his own conscience. By experiencing the avenging power as outside himself—by projecting it on external forces—Boris protects himself from guilt, but at a high price. For now he feels powerless to control these external avenging forces.

From a cultural perspective, visual images with magical powers were an accepted part of sixteenth-century Russia. The worship of icons was a prominent aspect of the Russian Orthodox church and that church, as repeatedly emphasized in the opera, had a pervasive influence throughout the society. It was Boris Godounov who established a separate patriarchate in Moscow, inviting the Patriarch of Constantinople for a visit and then holding him prisoner until he agreed to the establishment of the Moscow patriarchate. This secular power over the church in Russia was counterbalanced by the prominent role of religion in peoples' lives. It was an intensely emotional religiosity; icons were omnipresent with mystical talismanic powers. Indeed, in the sixth century A.D. the Eastern Orthodox church banned the use of icons as idolatrous. But icons were too important to the people and have continued to play a prominent role to the present day. The worshiping of graphic images of saints formed fertile soil for Boris's fearsome visions of the saintly, dead Dmitri.

In another era, in another place, Boris's disintegration would undoubtedly have taken another form. Shakespeare's Lady Macbeth tried to wash the phantom blood from her hands. She had developed what we call a compulsive delusion. In our time, when powerful figures have disintegrated they have often come to interpret everything that happens as a conspiracy against them. The underlying personality disintegration is not essentially different from Boris's though its visible form is different. The underlying (unconscious) conflicts of human beings are universal; the visible form of expression of these conflicts (symptoms) depends not only on the individual but also on the social and cultural context.

What remains constant is the frequent occurrence of personality disintegration in people who are in positions of power. History is replete with them, from Caligula to Hitler. Power is dangerous; one acquires it at great peril. As Lord Acton said, "Power corrupts and absolute power corrupts absolutely. Great men are almost always bad men." *Boris Godounov* treats two aspects of the theme: Boris, who is destroyed by the experience of power, and Grigory-Dmitri, who is corrupted by the wish for power. The Boris of the prologue is a strong, realistic, wise figure—wise enough to recognize the danger to himself of accepting power. The Boris of acts 2 and 4 is a man in the process of being torn apart by the exercise of power, and who is ultimately destroyed by it. The Grigory of scene 1, act 1, is a rather ordinary monk. The Dmitri of the end of act 3 is a man who has abandoned his identity, his profession, and his religion—all sacrificed on the altar of his wish for power.

Moussorgsky introduces Grigory to us in act 1 by having him tell of a dream. Grigory has awakened, frightened, and asks his fellow monk Pimen to bless him. As Pimen does so, other monks sing Jesus' dying words, "My God, my God, why hast thou forsaken me?" Grigory has dreamed that he climbed a high tower in Moscow. All the people below looked like seething ants who were mocking him. He became frightened and ashamed and fell off the tower.

Dreams have meanings on two levels: the immediate (manifest content) and the timeless (latent content). The manifest content

Boris Godounov: Riddled with guilt over having murdered the child Dmitri, Boris is tormented by visions of him.

is made up of a combination of elements from daily events, issues, and personality elements that the dreamer is conscious of, if only dimly. The latent content is made of elements of which the dreamer is not conscious, aspects of his personality that lie deeply buried and generally have been with him since his childhood. On the immediate level Grigory's dream is about his aspirations to become tsar by assuming the identity of Dmitri. He is an ambitious man: in the dream he "towers over Moscow" and all the people are ants. But he is not the real Dmitri, so there is a danger he will be exposed, humiliated, and brought down. Moussorgsky also indicates a second, more hidden meaning to the immediate dream content. Offstage, monks are singing Jesus' words when he was high on the cross, looking down at people who mocked him. Grigory's decision to become a monk had a meaning he was not aware of: an identification with Christ, the son of the Almighty.

On an unconscious level Grigory's shift, from being a monk to being a contender for the throne, was not a real change at all. It was a substitution of one image of himself as all-powerful for another.

On the timeless level of the dream's meaning, the on-high, powerful, admired image and the fallen, helpless, humiliated image are merged. They both suggest a wish to return to infancy. The infant is both totally helpless, in that he is unable to do anything for himself, and immensely powerful, for his every wish is almost instantly gratified. There is also a sexual dimension to the timeless content: the wish to be seen as sexually powerful and its counterpart, the fear of being exposed and humiliated. This sexual aspect does not play a prominent role in *Boris Godounov*, but it does in most other operatic studies of the corrupting force of power, such as *Faust*, *Otello*, and *Tosca*. The centrality of oedipal issues is thus much greater in these other studies of power. Because the sexual element receives little attention in *Boris Godounov*, the oedipal dimension hardly appears. In *Boris* we are dealing with much earlier, pre-oedipal issues about power.

These residual childhood wishes for omnipotence, for instant gratification of all desires, for freedom from the external constraints of reality and from the internal constraints of conscience are at the root of the corrupting influence of power. In Grigory they were powerful enough to lead him to abandon his identity (by becoming Dmitri), his religion (by converting to Roman Catholicism), his vocation (as a monk), and his conscience (by trying to convince the soldiers they are looking for Varlaam and not him). In Boris the wish for power led him to murder the real Dmitri. But Boris is a far more complex and interesting figure than Grigory. Boris did not abandon his identity as a just and benign person, and for the most part he behaved as such when tsar. Nor did he abandon his conscience; rather, his conscience led to his undoing. By contrasting the transparency of Grigory to the complexity of Boris, Moussorgsky highlights the tragic impact of Boris's story. Grigory's story—that of a weak man corrupted by power—is the stuff of fairy tales in which the good are rewarded and the bad are

punished. (Grigory's punishment is not in the opera, but every Russian knows he was murdered soon after becoming tsar.) Boris's story is of a real, flesh-and-blood man—a mixture of good and bad. Corrupted by power, the bad in Boris destroys the good in him. This is the stuff of tragedy.

Because childhood wishes for omnipotence remain a part of every adult, no one is invulnerable to the corrupting influence of power. Because few people achieve power without having a strong desire for it, powerful people are likely to be especially vulnerable to corruption. They are unable to resist childhood wishes and all too often end up abusing their power to such an extent that society will no longer tolerate them. Not so with Boris. While he did not abuse his power, he could never free himself from his wish to do so, nor from his memory of what that wish had once led him to do. So he was destroyed by the conflict between his wish for power and his guilt over that wish. Grigory's story does not stir us; he is simply a weak man who is corrupted. Boris's story stirs us deeply: his is the tragedy of the flawed hero that has moved audiences since the time of the Greeks.

Because it deals with the universal theme of the consequences of power, the appeal of Boris's story is universal. The exquisitely detailed setting, however, is totally Russian. As performed nowadays, particularly with the many changes added by Rimsky-Korsakov, the opera is a mixture of two styles: traditional nineteenth-century grand opera and native Russian elements. Although Moussorgsky's intent to write a purely Russian opera has been modified, the opera is nonetheless Russian throughout. The only exception is act 3, set in Poland, which contains the only traditional operatic role for a woman and the only traditional arias.

Act 3 also features the only totally unsympathetic characters in the opera. Marian and Rangoni are scheming, unscrupulous, unpleasant figures. In the original version act 3 did not exist. Moussorgsky was forced to add it by the producers who felt the opera would fail without a female lead and a love interest, since operatic audiences in Russia at that time were so accustomed to traditional Western European operatic style. But Moussorgsky

made it quite clear that he had no sympathy with anything that was not Russian. To express this he chose two ancient enemies of Russia—Poland and the Roman Catholic church—as his non-Russian symbols. By focusing the only part of the opera written in traditional Western style on enemies of Russia, he actually strengthened the nationalistic impact of the rest of the opera.

Moussorgsky made the opera Russian through the use of a number of devices. The central character, as well as three other important figures, are basses, a voice much more favored in Russia than in Western Europe. Much of the music uses a modal rather than the traditional diatonic scale. Many of the tunes in the opera are Russian folk-style tunes, and there are several entertainment songs, mixing nonsense, homilies, and social commentary, which were quite popular in Russia. The harmonization and orchestration are open and jarring, even though greatly Westernized by Rimsky-Korsakov.

Boris's children are also very real figures. Children as real people are almost nonexistent in opera. When they do appear they are usually walk-ons or members of a children's chorus. The absence of children from opera is so striking that it cannot be attributed solely to the mechanical difficulties of finding children who can learn the parts or who have sufficiently strong voices. It also stems from the single-mindedness of many creative geniuses. Creative power, like political power, can corrupt. There is a grandiose aspect to the conviction that one has something to say that will be of importance to many thousands of people. The investment of enormous amounts of time and effort into one's own thoughts, ideas, and creations has a highly selfish aspect. Among operatic composers Wagner is best known for his egotism, self-centeredness, and total disregard for the rights of others, but it is the rare creative genius who does not have this side to a degree. The lack of investment in children is thus not surprising. Whereas most people fulfill their wishes for immortality through their children, the artist does it through his works. They are, in many ways, his children. In Russia children are of great importance, and the delineation of Boris's children, Feodor and Xenia, as well as

their relationship with Boris, is carefully drawn. By making the children real people and by depicting their importance to Boris, Moussorgsky emphasizes Boris's loving side and enhances the tragedy of his self-destruction.

One other important childlike figure in the opera is the Fool. In act 4 Boris comes upon the Fool in tears and asks if he can help. The Fool replies, "Order them killed, the way you killed Dmitri." Boris, to the astonishment of the crowd, does not reprimand the Fool. Instead he says to him, "Pray for me, blessed one." This theme—that the Fool is immune from punishment for speaking the truth—is a universal one. The best-known example in Russian literature is Dostoevsky's *The Idiot*, which also contains the element of the fool as saintly. In English folklore the best-known example is the court jester. In Moussorgsky's opera the Fool has a special significance because of the importance to Moussorgsky of the fate of the helpless and the innocent. No greater contrast could exist than that between the all-powerful Boris and the utterly helpless Fool. Yet it is the Fool who delivers the ultimately wise assessment of Russia's situation when he prophesies that Russia will soon see bitter tears, darkness, and starvation. At the end of the next scene, when all have left with the false Dmitri to overthrow Boris, the Fool is alone on stage. He repeats his earlier refrain, bemoaning the fate of Russia, weeping for her hungry people. The musical theme is repeated in the orchestra as the scene ends—but just as the history of Russia's suffering masses never really ends, neither does the scene end. The melodic line simply stops, one note short of the tonic. By not returning to the tonic, Moussorgsky conveys a poignant sense of pathos. With the true touch of the master, the most moving of messages is conveyed by the omission of one small note.

The importance of children is emphasized again in the closing moment of the opera. When Pimen tells Boris that Dmitri can perform miracle cures, Boris, convinced that the real Dmitri has risen from the dead, is overcome with guilt and fear. Gasping for breath and knowing he is dying, he calls for Feodor, so that he may give him advice on how to be a good tsar: Trust not the

Lithuanians, be stern but just, punish traitors mercilessly, guard the faith, and watch over your sister. To the end Boris remains the tragically flawed hero. Destroyed by guilt over what he has done to gratify his lust for power, his love for his children and his country remains unshaken.

It is more than a hundred years since Moussorgsky wrote *Boris Godounov*, yet he would find contemporary Russia remarkably similar to the sixteenth-century setting of his opera. Art changes, masterpieces remain timeless.

9

Johann Strauss's Die Fledermaus

WALTZING THROUGH THE
COMEDY OF LIFE

E, E-SHARP, F-SHARP. The overture to *Die Fledermaus* begins with three bouncy half-tone steps upward. We know we are in for a merry romp. The ringing tones are played forte, allegro vivace, by the violin and the woodwinds, an octave above the staff. The high jinks have begun, and everything is to be allowed except boredom. After just twelve measures of noisy whirling motion, the allegro vivace changes to an allegretto, and the E, E-sharp, F-sharp motif reappears as part of a sentimental little melody played softly by the oboe. Twenty measures later we are back to the opening theme, but only for eight measures. Then come six measures of slow, sonorous, bell-like tones, and for another sixty-five measures we are back to a sprightly allegretto containing two new themes. Only then do we finally arrive at what everyone has been waiting for, a waltz. Johann Strauss, Jr., was world famous as the "waltz king" and achieved his fame and fortune by playing dance music; but he was a superb master musician: composer, performer, and conductor.

At Strauss's funeral Edouard Hanslick, the nineteenth century's most famous music critic, lamented, "Vienna has lost its most original musical talent." Wagner once called him "the most

musical head I have ever come across" and said of his work, "In respect of charm, fineness, and true musical content one single Strauss waltz towers above most of the foreign factory products often so laboriously imported, as the Stefansturm towers over the kiosks of Parisian boulevards." Wagner's reference to Vienna's Stefansturm reflects his German resentment of the enormous popularity of Offenbach's French operettas. (Ironically, Offenbach was German-born.)

The wish to provide a German-language alternative to Offenbach was a significant factor in Strauss's writing of operettas. He was forty-four years old before he wrote his first one, having been a composer for twenty-five years. *Die Fledermaus* came five years later. The plot is based on a play by Meilhac and Halevy, who were the librettists for many of Offenbach's operettas as well as for Bizet's *Carmen*. In turn they had based their version on an earlier German play, *The Prison* by Benedix. Strauss makes the connection with Offenbach explicit by referring to a statue of him in the libretto. That it took Strauss so long to write anything but dance music was due to the peculiar commitment to that genre by the Strauss family, a commitment made up of a mixture of family tradition, the rewards of fame and fortune, and intense rivalry among the Strauss men.

The dynasty began with Johann Strauss, Sr., born in Vienna in 1804, the son of lower-middle-class tavern and dance-hall operators. The family was of Jewish origin, a fact the Nazis many years later tried to suppress. Johann Sr. became the acknowledged waltz king of Europe. His eldest son, Johann Jr., born in 1825, inherited his father's mantle and clearly surpassed him. A second son, Joseph, born in 1827, also went into the business as did Eduard, born in 1835. Eduard's son, Johann Strauss III (1866–1939), continued the dynasty. It finally came to an end with the death in 1969 of Johann III's nephew, Eduard Strauss.

Johann Sr. had no intention of starting such a dynasty. Quite to the contrary, he forbad his sons' studying music. Johann Jr. became a bank clerk, Joseph an architect. It was the boys' mother who secretly, against her husband's wishes, arranged for them to

Die Fledermaus: Count Orlofsky welcomes his guests and warns them to enjoy themselves—or else.

have music lessons. When the father discovered that Johann Jr. had a violin, he smashed it; mother provided her son with a replacement. It was not the only source of conflict in the marriage: Johann Sr. also had a mistress. When Johann Jr. was fifteen his father left his wife and their six children and moved in with his mistress, by whom he proceeded to have four more children. Four years later, when the divorce became final, Johann Jr., age nineteen, set up an orchestra that competed with his father's. Five years later, when his father died, Johann combined the two orchestras into one.

Brother Joseph, in turn, began conducting the orchestra eight years later. Brother Edouard's story was slightly different. In 1859, after fifteen years in the business, Johann had become so successful that he could not manage it all by himself. He was committed to summer concerts at the court in St. Petersburg; he was trying to compose, conduct, play the violin, and manage the touring orchestra. He called on Edouard for help. By 1862 Edouard had taken over the summer concerts, and soon he took over the court balls as well. He finally disbanded the orchestra in New York in 1902. Although he wrote hundreds of compositions himself, he must have recognized that he had neither his older brother's nor his father's talent. After Johann's death in 1899, Edouard became the violent champion of the family's honor, writing excoriating letters to the press whenever a negative item about the Strausses appeared. In 1907 Edouard's ambivalence exploded in full force. He took all of the two Johanns' unpublished manuscripts and sketches, packed them into boxes, and burned the entire lot.

Johann himself had always been a somewhat anxious man. Venturing outside the family domain of dance music made him apprehensive, and he was reluctant to tackle *Die Fledermaus*. But once having decided to do it, he closeted himself for six weeks and completed the score. The German-language libretto was prepared by Haffner and Genée, and the setting was moved to a suburb of Vienna. The first performance came on Easter Sunday, 1874. Although it has since become an international favorite, the opera was at first not a great success.

The financial recession may have kept Viennese theatregoers at home. But perhaps even the jaded Viennese were too stuffy for such a collection of duplicitous characters in a contemporaneous setting. In this opera an honest man or woman is nowhere in sight. It opens with Alfred attempting to seduce Rosalinde, his former mistress, now married to Eisenstein. Eisenstein had earlier humiliated his friend Falke by draping his drunken form on a statue (of Offenbach) in a public park. Falke, planning his revenge, induces Eisenstein to go to a party with the promise of available pretty women. Adele, Rosalinde's maid, lies to her mistress so she can go to the party disguised as a lady. Rosalinde is not really unhappy about Alfred's advances. The lawyer Blind is a corrupt fool, and the jailer Frank, the last character to appear in act 1, secured his appointment through political corruption and is only too happy to try to deceive and seduce Adele. In act 2 we also meet Count Orlofsky, the epitome of degenerate cynicism, and in act 3 Frosch, a drunkard.

Although the contemporaneous setting was unusual for musical comedy at the time, the irreverent tone was not. Appropriate subjects for irreverent treatment have varied widely, depending on what the censors have tolerated. Vienna in the 1870s obviously tolerated considerable mocking of royalty, at least of Russian royalty. The party at Count Orlofsky's in act 2 has been planned for maximal self-indulgence. Guests are not simply encouraged to drink, eat, gamble, and make love, they are required to do so or face their host's displeasure. Should anyone be bored, he will promptly be ejected from the party. The peremptory tone to his aria, "Chacun a son gout"—"Each to his own taste"—has a bitter edge to it. It is the only place in the opera where farce turns to satire.

Making Orlofsky's part a trouser role adds to the feeling of degeneracy by implying a bisexual element. Most comic opera trouser roles were reserved for adolescents, such as Cherubino in *The Marriage of Figaro* and Octavian in *Der Rosenkavalier*. The not yet fully formed sexual identity of adolescence makes a whiff of bisexuality in these parts feel quite comfortable. But Orlofsky is a

fully adult male, so the bisexual implication adds a perverse, slightly sinister feel.

Because of its penchant for irreverence, comic opera has had a very different history from serious opera. The latter has almost always enjoyed royal sponsorship while the former has had to rely on audience support. For the most part that audience was from the general population rather than from the elite who supported serious opera. The pattern continues today. Grand opera receives government and foundation support while musical theatre must rely on ticket sales.

Because comic opera had some of its roots in popular rather than elite entertainment, different locales produced different versions of the same opera. From the Middle Ages strolling minstrels had provided comic musical entertainments. In Italy these developed into more elaborate productions called *commedia del arte*. At the same time serious opera productions had become so long and heavy that interludes were introduced between the acts to provide comic relief. These *intermezzi* adopted many of the stock characters of *commedia del arte*, and out of this mixture Italian *opera buffa* came into being.

In France the rigid centralized bureaucracy allowed no music in the theatre and no spoken words or unaccompanied recitative in the opera house. Comic opera thus had to develop on its own. Although strongly influenced by *opera buffa* in the early nineteenth century, French comic opera continued to develop its own unique characteristics, and in the works of Offenbach it gave the world some of its finest comic operas. In England, which lacked the continental tradition of grand opera, comic opera developed fully out of folk music. *The Beggar's Opera*, the first and for a long time the best English comic opera, was constructed from a collection of such ballads. It and its successors proved so popular that Handel, then the leading opera composer in London, almost totally abandoned the genre in favor of oratorios. But England did not make its unique contribution to comic opera until 150 years

later when Gilbert and Sullivan combined the ballad opera and the British music-hall tradition into their comic opera masterpieces.

A similar pattern occurred in Germany. The *Singspiel*, a musical comedy, evolved out of comic folk music, finding its ultimate operatic expression in *The Magic Flute*. But the half-century after Mozart produced no significant school of German comic opera until the success of Strauss's *Die Fledermaus* spawned a whole tradition of light opera. Lehar and Friml continue to be performed. And, via Kurt Weill, the school influenced the development of twentieth-century American musical theatre. Of all these works, *Die Fledermaus* is the only one still regularly heard in the great opera houses.

Certainly Strauss is the greatest composer of this group. But *Die Fledermaus* is also the most "operatic" of all these works. Strauss was primarily an orchestral composer. In contrast to most comic opera, where the words and melodies are what really matter, Strauss's orchestra always retains a prominent role. At times the comic almost slides over into the serious as in Orlofsky's cynicism and Rosenstein's outburst against Rosalinde in act 3. Also, the vocal writing demands powerful, trained voices. Only a full operatic voice can do justice to Rosalinde's Czardas aria in act 2.

Aside from that great aria, act 2 is pure frivolity. Between choruses attesting to the joys of partying, most of the fun consists of a series of interactions between the main characters in which all pretend to be something other than what they are. The act ends with Falke's plot for revenge going according to plan, as Rosalinde (disguised as the Hungarian countess) makes off with the watch that her husband, Eisenstein (pretending to be a marquis), has been using to attempt to seduce her.

Act 3 begins with two comic interludes about drunkenness. The first is a monologue without music by the jail attendant Frosch, the second a pantomime with music by the jailer Frank. The comic situations in act 2 involve two people deceiving each other; the comic interludes that open act 3 involve only one person deceiving himself. The number of people involved recalls Freud's

attempts to classify the comic. A joke involves three people: the teller, the listener, and the subject of the joke; the comic involves two people: one who perceives what is funny and the one in whom it is perceived; while humor involves only one person who notices his own paradoxical situation.

This was not a very successful classification, but Freud was in good company. Trying to describe "the comic" has bedeviled some of the world's wisest thinkers. Henri Bergson tried (not too successfully) to elucidate the issue despite his awareness that "The greatest thinkers, from Aristotle downwards, have tackled this little problem which has a knack of baffling every effort, of slipping away and escaping only to bob up again, a pert challenge flung at philosophic speculation." The difficulty may begin with the tendency to contrast the comic to the tragic. Aristotle may not have started it, but his views have been highly influential. He saw tragedy as dealing with a "higher" and comedy with a "lower" way of life. Nietzsche eventually came to the opposite conclusion.

Among many other attempts to contrast the tragic and the comic, most center on man's efforts to exercise the freedom of his will, to master the world, and to act virtuously. In tragedy man ultimately fails, with disastrous consequences. In comedy either he ultimately triumphs or at least the consequences are trivial. For Kierkegaard "the tragic is suffering contradiction; the comic, painless contradiction." But Kierkegaard recognized that the comic was a broader category than the tragic: "Wherever there is life there is contradiction, and wherever there is contradiction the comical is present."

Comedy is the larger category because it can occur almost instantaneously, as in a pun, or can take place over a long period of time, as in comic plays and novels. It may also be sad, as in Chaplin's pantomimes, or serious, as in Swift's satires. But tragedy is never funny. Tragedy always requires an extended time period. It is the outcome of a process, an organic development leading to a foregone, inevitable conclusion. It always takes place in a larger

narrative context, as in plays, novels, or operas. Comedy is episodic—lost balances are restored, new futures implied, nothing is inevitable. Many stand-up comedians thrive on one-liners; there are no similar stand-up tragedians.

The truly comical makes us smile or laugh. But it is not at all easy to tell exactly what makes it funny. Among those who have addressed this question are Cicero, Hegel, Kierkegaard, and Freud. All saw the occurrence of something contrary to expectation as an essential element of the comic. I find most satisfactory Arthur Koestler's formulation: the formal structure of the comic is the simultaneous presence of two self-consistent but mutually incompatible frames of reference, or associative contexts, leading to an abrupt transfer from one to the other. I can think of nothing comic that does not have such a structure. The comic process is the way in which the incompatibilities are resolved, without impairing the autonomy and integrity of the person(s) involved. These are always threatened by the incompatibilities but always preserved in the process of resolution. It is a self-governing process, inherent in the comic structure, not determined by factors external to it. Coincidence is involved, rather than inexorable fate. It leads to laughter at absurdity, not to raging at the world. Things may be very threatening, contradictory, or confusing at the beginning of the process, but at the end they are always benign, rational, and clear.

Kant considered the comic an aspect of the sublime, which he defined as the disparity between form and content. He contrasted the sublime to the beautiful, which he defined as the harmony between form and content. Kant thus not only describes why music cannot be comic but also why beauty is such an essential element in music. His discussion also sheds light on another distinction between the comic and music. In the comic the comedian speaks to us, even if sometimes it is all internal, as when we are amused at ourselves. In music the composer/performer speaks for us. He makes it possible for us to experience within ourselves, to comprehend what we could not give expres-

sion to because it is not verbal, conceptual, or pictorial. Music helps us to discover ourselves.

The inability of pure music to be comic can also be understood from a psychological perspective. There can be no contradictions unless there is a logical thought process to be contradicted. But music does not communicate with us through our conscious, logical thought processes. It reaches us on a much more direct, emotional level. The directness and intensity of its emotional impact is because of its capacity for reaching us on an unconscious level of thought, and the language of the unconscious is not logical. It does not recognize the existence of contradictions. Such a language structure cannot encompass comic thinking, for the comic requires precisely such contradictions. Since dreams are a mixture of unconscious and conscious thinking, the comic can appear in them. Because the capacity for logical thinking develops only gradually throughout childhood, music can tap into some of our earliest feelings and concepts, things that remain with us, in the unconscious, throughout our lifetimes.

That *Die Fledermaus* is a comic opera is evident from our reaction as soon as the curtain rises. We find ourselves smiling and chortling throughout acts 1 and 2. But it is not until act 3 that the opera elicits real belly laughs. The jailer Frank's pantomime is very funny and is immediately followed by the equally drunken Frosch's hilarious monologue. In neither of these two passages is there a moment of that staple of opera, accompanied singing. Yet they are the most comic moments in the opera. The comic element resides in the verbal and the visual. Music, purely as music, is never comic. The only circumstance that might be considered an exception is when the music parodies itself. But the very fact that parody is involved means that there is an external referent, and so it is no longer pure music.

Frank's pantomime is visual comedy, as are cartoons and slap-stick. Frosch's monologue is verbal comedy, as are puns, jokes, and funny stories. These all conform to Arthur Koestler's requirement

that the comic structure simultaneously contain two mutually inconsistent frames of reference. But a musical structure that simultaneously contains mutually inconsistent frames of reference is not comic music, it is *unmusical* music. There are many different varieties of musical structures, but each requires consistency within the structure of its musical language. Without such a consistent structure, one that is understood by the listener, music loses its power to communicate.

The relative importance of music and words in opera has been much disputed. Given that we can enjoy listening to a recording of an opera without understanding any of the words, while no one would even consider watching an opera on TV, even in one's native language, without the music, the primacy of the music seems indisputable. Comic opera thus has a built-in paradox: for it to be comic the words must have primacy, for it to be an opera the music must predominate. Can we have it both ways? Rarely, I think. Comic operas represent a small part of the standard repertory. If the opera is in a foreign language the problem is almost insurmountable. But in our large modern opera houses, with their large orchestras, even if the opera is in our native language we usually understand only a small proportion of the words.

Comic libretti pose terrible problems for the translator. Not only are puns and jokes often completely untranslatable, but the words must conform to the music in placement of vowels and consonants, in placement of accents, in rhythm, and in length of phrase. Not surprisingly, essential elements of the comic libretto are inevitably lost. To cite just one example from *Die Fledermaus*: In the finale to act 1 is a famous line, "Glücklich ist wer vergist, was doch nicht zu ändern ist." The literal translation is, "Happy is he who can forget about what just can't be changed." In two respected libretti, one published by the Metropolitan Opera and the other by Schirmer, the line is different. One reads, "You alone, you alone, here we are we two alone." The other reads, "Night and day, light and gay, let us sing our cares away." Both obviously sacrificed meaning in order to preserve meter, phrasing, and rhyme.

I tried my hand at creating better versions. "Happy he, who can be, free of useless memory" preserved more of the sense of the German but still had two problems. The "ist" sound that closes out the little upward three-note phrase ends with a hard consonant. This gives a sharp ending that my "he" and "be" does not and thereby reduces the bouncy quality of the original. The second problem is that my language "free of useless memory" has a pompous, uncolloquial quality, inappropriate to the opera. My second attempt was "Once the milk, has been spilt, what's the point of useless guilt." This was much more colloquial and preserved the hard consonant, but the rhyme was no longer perfect. My third attempt was "You were kissed, but not missed, just another on his list." It has the colloquial quality, the rhyme is perfect, and it preserves the original sound, but some of the closeness to the original meaning has been sacrificed. Although I am sure others can do better than I have, the point is that a truly satisfactory translation of a comic libretto is probably impossible.

Yet for all the problems they pose, comedies set to music continue to have great appeal. For although pure music cannot be intrinsically comic, music can be an integral component of the comic in a variety of ways. It can acquire a comic dimension by association with a comic narrative, as in Richard Strauss's *Till Eulenspiegel*; by association with comic sounds or images, as in Saint-Saens's *Carnival of Animals*; or by association with comic pantomime, as in Tchaikovsky's Nutcracker Suite. It can parody itself. Sullivan was the master at parody of opera. Mabel's song, "Poor wand'ring one," in *The Pirates of Penzance*, is a wonderful parody of French sentimental opera. The finale to act 1 of the *Mikado* would have had Verdi splitting his sides. Even Handel could not have helped being amused at "All Hail Great Judge" in *The Trial by Jury*.

Richard Strauss, though he wrote *Der Rosenkavalier*, one of the finest comic operas, had his doubts if there was such a thing as "true comic opera." In a letter to Hoffmannsthal he wrote, "When have people been made to laugh by music in the theatre? At two or three places in the whole opera repertory; otherwise only at the

extemporizing of the actors or at spoken dialogue." It is much easier to produce great musical comedies and comic operettas than it is to produce great comic opera. The halls and the orchestras are almost always smaller, so the words can be easily understood. The role of the orchestra is almost always confined to supporting the singers. The work is specifically written for audiences that can understand the words. It is hard to imagine a Gilbert and Sullivan patter song in translation.

Finally, music is superb at expressing the ebullient, the joyous, the Dionysian dimension of the comic. Since the origin of comedy in primitive harvest/fertility ceremonies, dance has been an integral part of celebrations. Indeed, those celebratory dances may have been mankind's first art form, and with them his first attempts at music. All of these ways in which music can be a component of the comic can be found in *Die Fledermaus*. The music of the Champagne song is a bubbly enhancement of the effervescent elixir. Eisenstein's attempts to present himself as the virtuous, wronged husband in act 3 are straight out of Italian opera. And most important of all, of course, are all those wonderful, joyous waltzes. Ultimately they are what make the opera a masterpiece. The Viennese waltz is the last musical form to come out of Europe that has achieved popularity throughout the Western world. Johann Strauss is the acknowledged master of that form, and *Die Fledermaus* is his finest achievement.

❧ 10 ❧

Bizet's Carmen

ART AND ENTERTAINMENT:
CREATIVITY AND PLAY

CARMEN is not only one of the world's greatest operas but probably the most popular. At the Metropolitan Opera in New York it received 521 performances between 1883 and 1979; only *Aida* and *La Boheme* had more. *Carmen* is universally popular and the best-known work outside the world of opera. It has been transformed into ballets, musicals, and movies. To achieve both greatness and popularity an opera must offer both art and entertainment; it must have the open-mindedness of creativity and the boundaries of play; it must be both profound and simple; it must both enhance insight and reinforce prejudices.

A good start for an appreciation of how *Carmen* does this is the following quotation from Nietzsche:

> Yesterday I heard—would you believe it—Bizet's masterpiece for the twentieth time. Again I stayed there with tender devotion; again I did not run away. The triumph over my impatience surprises me. How such a work makes one perfect! One becomes a "masterpiece" oneself.
>
> Really, every time I heard *Carmen* I seemed to myself more of a philosopher, a better philosopher, than I generally consider myself:

154

so patient do I become, so happy, so Indian, so settled— To sit all five hours: the first stage of holiness! . . .

This music seems perfect to me. It approaches lightly, supplely, politely. It is pleasant, it does not sweat. "What is good is light; whatever is divine moves on tender feet": first principle of my aesthetics. The music is evil, subtly fatalistic: at the same time it remains popular—its subtlety belongs to a race, not to an individual. It is rich. It is precise. It builds, organizes, finishes: thus it constitutes the opposite of the polyp in music, the "infinite melody." Have more painful tragic accents ever been heard on stage? How are they achieved? Without grimaces. Without counterfeit. Without the lie of the great style

The work, too, redeems; Wagner is not the only "redeemer." With this work one takes leave of the damp north, of all the steam of the Wagnerian ideal. Even the plot spells redemption from that. From Merimee it still has the logic in passion, the shortest line, the harsh necessity; above all, it has what goes with the torrid zone: the dryness of the air, the *limpidezza* in the air. In every respect the climate is changed. Another sensuality, another sensibility speaks here, another cheerfulness. This music is cheerful, but not in a French or German way. Its cheerfulness is African; fate hangs over it; its happiness is brief, sudden, without pardon. I envy Bizet for having had the courage for this sensibility which hitherto had no language in the cultivated music of Europe—for this most southern, brown, burnt sensibility—How the yellow afternoon of its happiness does us good! We look into the distance as we listen; did we ever find the sea smoother? —And how soothingly the Moorish dance speaks to us? How even our insatiability for once gets to know satiety in this lascivious melancholy!

Finally, love—love translated back into nature. Not the love of a "higher virgin"! . . . But love as *fatum*, as fatality, cynical, innocent, cruel—and precisely in this a piece of nature. That love which is war in its means, and at bottom the deadly hatred of the sexes!—I know no case where the tragic joke that constitutes the essence of love is expressed so strictly, translated with equal terror

into a formula, as in Don José's last cry, which concludes the work: "Yes. I have killed her, I—my adored Carmen!"

Such a conception of love (the only one worthy of a philoso-pher) is rare: it raises a work of art above thousands. For, on the average, artists do what all the world does, even worse—they misunderstand love. . . . They believe one becomes selfless in love because one desires the advantage of another human being, often against one's own advantage. But in return for that they want to possess the other person. Even God does not constitute an excep-tion in this matter.

When their only child was born, on October 25, 1838, his parents named him Alexandre César Léopold Bizet. That they had high expectations for him was clear from the beginning. A wise godfather promptly began calling him Georges. But his father's conviction that he was destined to become a great composer became part of his self-expectation, and in a short life filled with far more rejection than recognition, he was plagued by self-doubt and sensitivity to criticism. His father, a singing teacher, recog-nized that the boy had great musical talent when he was very young. He was given some of the best instructors of the time and at age nineteen won the Prix de Rome, as had his favorite teacher, Gounod. But when that five-year stipend ran out Bizet found himself a penniless musician in Paris. He supported himself mostly by hack work, such as transcriptions. Although a number of his operas were performed, none was really a success. His gifts contin-ued to be recognized by fellow musicians, but he never achieved much public acclaim, although he did receive the Legion of Honor shortly before he died. He was sensitive to these disappointments: "I am often conscious of being the victim of persecution which probably exists only in my own mind. It really is a sickness, and I can only ask those who love me not to expose a very painful nerve which some trifling thing too easily sets in vibrations."

Nor was Bizet's personal life more satisfying. He was addicted to prostitutes, had numerous affairs, fathered an illegitimate child by

his mother's maid, and had an unhappy marriage to an emotionally disturbed woman. All his life he suffered from what was called "quinsy," repeated throat abscesses. Most likely they were streptococcal infections which also affected his heart. He could not climb five flights of stairs. The illness led to his death at age thirty-six, three months after *Carmen* was first produced.

Bizet started on thirty operatic projects we know of. Many were never finished. Only a few were produced in his lifetime, and none brought acclaim. *The Fair Maid of Perth* and *The Pearl Fishers* are occasionally produced today, though neither is included in Simon's *100 Great Operas*. A suite (Arlesienne) drawn from music he composed for a stage work and his Symphony in C are the only other of his works heard with any frequency. The latter, written when he was seventeen, was not discovered until this century. It is a testament to his gifts; many consider it the most mature work ever written by a seventeen-year-old, surpassing the creations of Mendelssohn and Mozart at that age. Yet were it not for *Carmen* Bizet would be considered a minor composer at best. *Carmen* is not only great and popular, it is also innovative, as Nietzsche observed. It is the first *verismo* opera, opera that looks at life as real and unpredictable and at people as complex mixtures of contradictory emotions. Bizet died as he was just beginning to hit his artistic stride.

He began work on *Carmen* in 1873, put it aside, and then fully composed it in 1874, completing the twelve hundred pages of manuscript that fall. The librettists, Meilhac and Halevy, were skilled and experienced. They took the novel by Prosper Merimee and crafted it into an excellent libretto. They were, however, famous and in the business for the money. With four other operas in production that year, they knew that *Carmen* was likely to be controversial and that the theatre in which it was to be produced, the Opera-Comique, was on the edge of bankruptcy. So they were of little help to Bizet in his struggle to have the opera produced as he had written it.

Parisian musical theatres at the time were governed by very strict rules, some by custom, some by official decree. At the main Opera House dialogue was not allowed; dialogue was in the form

of accompanied recitative. At the Opera-Comique dialogue was spoken. Notwithstanding its name, the Opera-Comique did not confine itself to comedies. But by 1874 the theatre had fallen on hard times; its offerings had become stereotyped. Of all its productions between 1830 and 1875, only one, Thomas's *Mignon*, survives. Paris itself had not yet recovered from France's defeat by Germany in the war of 1870 and the ensuing chaos. Rehearsals for *Carmen* were filled with conflict as the librettists repeatedly sought to tone down its sex and violence. That Carmen should be both heroine and villain was unprecedented. The women's chorus threatened to strike because they were asked to act and sing at the same time. The original director resigned because Bizet refused to write a happy ending.

Bizet resisted all attempts at changes and, by opening night, March 3, 1875, the company had become enthusiastic about the production. But the director was afraid to invite influential public figures for fear the opera would offend. Although it ran for more than forty performances, it was never a success, playing mostly to half-empty houses. Bizet died on June 1, thinking of himself as a failure. Not everyone shared his view. Tchaikovsky saw the original production of *Carmen* and predicted that within ten years it would be the most popular opera in the world. Paris, however, would not mount another production until 1883.

The day before he died, Bizet had signed a contract to stage *Carmen* in Vienna. This production premiered on October 23, 1875, and was a great success. Brahms, Offenbach, and Wagner all praised it highly. By 1878 the opera had triumphed in St. Petersburg, London, Dublin, and New York. The Vienna version contained recitatives, written by Guiraud, replacing all the original dialogue. This continues to be the most popular version. It must have been the version Nietzsche saw, for the recitatives greatly lengthen the opera. Bizet's tauter original version has recently come back into favor.

The overture is short and sprightly, except for a brief section of Carmen's fate theme at the end. The same casual, sprightly tone characterizes the first half-hour of the opera. It opens with the

Carmen: The women who work in the cigarette factory take a break.

humorous observations by the soldiers of the passing parade, continues with banter between them and Micaela, who has come looking for Don José. This is followed by one of the only examples in grand opera of children at play, as a chorus of urchins imitates the soldiers. Then comes a women's chorus extolling the pleasures of smoking. Bizet, urging a friend to attend a performance, wrote, "Well, this time I have written a work that is all clarity and vivacity, full of color and melody. It will be amusing. Come along; I think you will like it." The opera's opening scenes clearly meet Nietzsche's first principle of aesthetics: "What is good is light; whatever is divine moves on tender feet." It is all playful entertainment.

What distinguishes art from entertainment? Despite large areas of overlap, there are clear differences. No one would call Picasso's *Guernica* entertainment, as no one would consider a TV situation comedy to be art. Nor is the distinction simply between the comic and the tragic. Shakespeare's comedies are great art; some of Norman Rockwell's paintings are of sad situations, but they are more entertainment than art.

Entertainment tends to have narrow boundaries, its concepts tend to be simple, and it tends to reinforce prejudices. The narrow boundaries of entertainment reflect its close affinity to play, a form of action that is pleasurable, freely chosen, intrinsically complete, and noninstrumental. The children's chorus in act 1 of *Carmen* is a good example. The activity is clearly pleasurable—the children are having a great time. It is freely chosen—no one is making them do it. It is intrinsically complete—not only is nothing else needed for the activity, but it also has clear boundaries. The rules of the game are clear, even though they may be implicit rather than explicit. The boundaries are so important because it is essential that play be noninstrumental—that is, it can have no consequences outside its boundaries. Playing at soldiering cannot lead to actual fighting. As soon as there is injury or bloodshed, it ceases to be play. In competitive play, once the game is over winner and loser are again of equal status, or the game is no longer true play.

Entertainment's concepts tend to be simple; with too much complexity, entertainment loses its essential quality of being enjoyable. Since Bizet wanted his opera to be entertainment as well as art, he created the simple character of Micaela (who does not exist in the novel) to counterbalance the complexity of Carmen's character. The novel's Escamillo served perfectly as a simple counterbalance to the complexity of Don José. The music Bizet wrote for Micaela reflects her one-dimensional nature, as in her duet with Don José in act 1. The same is true of her big aria in act 3: it skirts the edge of sentimentality. Similarly, Escamillo's Toreador song comes close to being banal. They are also the two most popular arias in the opera, and many an Escamillo and Micaela have stolen the limelight from Don Josés and Carmens with their renditions.

Entertainment tends to reinforce prejudices. If we did not need our prejudices to remain at ease with ourselves, they would not persist with such power, despite their irrationality. When they are reinforced it makes us comfortable. Nietzsche was surely not aware that by associating Carmen's "lasciviousness" with a "southern, brown, burnt sensibility" he was reflecting a widespread Western prejudice that dark-skinned people are more sexual. Bizet, however, knew exactly what he was doing by locating his opera of sex and violence in Seville, a city that lies beyond the Pyrenees, that barrier that cuts Spain off from the rest of Europe. Attributing the forbidden impulses to "others" allows us comfortably to retain our own prejudices. For some reason Seville served this function for many operatic composers besides Bizet. Mozart, Beethoven, Rossini, and Verdi all set operas there. Nietzsche's comment may also have contained another prejudice, that nineteenth-century operatic favorite, misogyny. He delivered himself of a slew of misogynistic comments, modifying this prejudice only through his misanthropy, "Woman was God's second mistake."

After the cigarette-factory girls' chorus, Carmen makes her first appearance and sings the Habanera, her aria about the capriciousness and dangers of love. Bizet took the melody from a popular Spanish folk song, originally a rather orgiastic Cuban dance. Bizet

retained the modal quality, the rhythmic patterns, and the orgiastic quality of the original, improving the melodic line and adding sophisticated orchestration. Folk music tends to be very tied to time and place; art music aims at greater abstraction, greater timelessness. Bizet had a special talent for merging the two, for combining art and entertainment.

The distinction between folk music and art music, which has been so marked in the twentieth century, was often ignored in Bizet's time. The rapid expansion of the middle class in the first half of the nineteenth century brought pianos into many homes, and piano transcriptions of all kinds became the common format for most people's exposure to music. Bizet was often forced to eke out a living writing such transcriptions. Folk and art music were played and sung interchangeably.

When Carmen and the other cigarette-factory women return to work, Don José and Micaela sing a sentimental duet about the love between him and his mother. Suddenly the women pour out of the factory in an uproar. Carmen has stabbed one of her coworkers. She insolently refuses to answer the officer's questions and then entices Don José to let her escape. Her aria is a *seguidilla*, a Spanish folk-dance in rapid ⅜ time. But now, unlike in the playful Habanera, her seduction of Don José is serious business. In the Habanera her "If I love you, beware" was a humorous taunt. Now it leads to Don José going to jail for her. The pure entertainment is over. The drama has begun.

At the heart of the drama is Don José. From the beginning to the end Micaela is a simple, virtuous peasant girl. Escamillo is the same self-important, macho folk-hero throughout. Carmen too remains unchanged: she is a fascinating mixture of openness and deceit, amorality and idealism, fickleness and loyalty. But she is the same Carmen at the end that she was at the beginning. The drama is in the transformation of Don José from the simple, decent soldier, to the murderous, love-crazed outcast. The transition is subtle and gradual. In act 1 he is almost purely the hometown boy; only his vulnerability to Carmen's seductiveness indicates the other side of his character. In act 2 the two sides of

his character are in even balance: he is torn between staying with Carmen and returning to his regiment. In act 3 the uncontrolled outlaw has become dominant, and only the news that his mother is dying can call forth what is left of the good soldier. In act 4 his transformation is complete.

While reinforcing our prejudices is a hallmark of entertainment, offering us new insights is a hallmark of art. Indeed, Oscar Wilde considered it the defining hallmark of art, "Art, even art of fullest scope and widest vision, can never really show us the external world. All that it shows is our own soul, the one world of which we have any real cognizance. . . . It is Art, and Art only, that reveals us to ourselves." Art provides insight. Great art provides profound insight. In Nietzsche's words, "Really, every time I heard Carmen I seemed to myself more of a philosopher, a better philosopher than I generally consider myself. . . . Has it been noticed that music liberates the spirit? gives wings to thought? . . . Bizet makes me fertile." We know what distinguishes good music from bad music, but the difference between good music and great music remains elusive. Perhaps there are dimensions to music that can never be described in words. Certainly great music speaks to us on nonverbal levels. Sometimes we become so absorbed in this that we lose our verbal bearings. As Nietzsche put it, "Where am I?"

Each of the four acts begins with light entertainment. In act 2 it is more than twenty minutes before we reach a serious dramatic moment. The act opens with a short introduction, most of it for just solo bassoon and clarinet. It provides a strong contrast to the exuberant Gypsy Dance and Song that follow. The Gypsy Dance illustrates Bizet's great ingenuity and technical skills. Throughout its forty-six measures the bass is a steady, stepwise progression downward from an E to the E an octave below. Because Bizet has the harmony follow the bass line, a series of parallel fifths ensues,

imparting a Moorish folk-tune quality to the piece. It is all original Bizet, superbly crafted and orchestrated, yet retains its Spanish folk-music quality. Soon Escamillo enters with a crowd of hangers-on and sings his Toreador Song. The song is deliberately an unsubtle crowd-pleaser, because that is Escamillo's character. There follows a sprightly, intricate quintet about how useful women's wiles are in the smuggling business.

Don José now appears, having been released from jail. Carmen welcomes him by performing a castanet dance for him alone. Imperceptibly, and at first very faintly, the accompaniment to her dance turns into the military retreat call. As he, and we, finally become aware of it, he tells her he must return to the barracks. The combination of her castanet dance theme with the bugle recall theme is an excellent example of how Bizet uses the music to further the dramatic action. Carmen, having refused to go with her friends in order to be with Don José, is enraged that he proposes to leave her alone, and the dramatic action of act 2 begins.

Don José tries to reassure her of his love in his Flower Song. But this is no love song full of long, tender, flowing melodies. The melodic line is jagged, full of short phrases, chromatic progressions, sudden changes in dynamics and tempo. It is a song of passionate love but with an underlying, frantic quality. Carmen is unrelenting: if he loved her he would desert the army and join her. His conscience will not let him do that. But just as he is about to leave, his superior officer, Zuniga, enters to proposition Carmen. Don José draws a sword on him and is thus forced to go with Carmen. Their relationship is clearly foredoomed.

Because studying the creative process requires studying the inner workings of the mind, it has received the most attention from psychologists and psychoanalysts. Freud repeatedly stated that psychoanalysis had nothing to contribute to the understanding of creativity, and then proceeded to contradict himself by extensively studying creative works, processes, and people. He was

right that psychoanalysis could make only a modest contribution to an understanding of the creative product. But it can make a substantial contribution to an understanding of the creative person and the creative process.

Psychoanalytic studies of creativity have tended to approach the issue from either the perspective of the conscious (ego) processes involved or of the unconscious (id) processes. This fits well with traditional approaches to creativity, which emphasize the duality of rational and nonrational, inspirational elements. Nietzsche was aware of the importance of both dimensions: on the one hand he is "delighted by strokes of good fortune of which Bizet is innocent" and, on the other, "It is precise. It builds, organizes, finishes." Freud's discussion of the unconscious in the creative process centered on the role of fantasy and on how the creative process fostered the saving of psychic energy by allowing the expression of wishes that otherwise needed to be defended against. Freud's identification of unconscious fantasy as the source for much of the thematic material in creativity has influenced all subsequent studies of the subject.

Consciously or not, the artist has in mind that his creative efforts will be appreciated. By identifying with the appreciative audience not only is the artist less alone but his fantasies are no longer so dangerous, since they are now shared by many people. The identification works the other way, too. The audience is vicariously gratifying its own fantasies by identifying with the artist's ability to express them. The greatest aesthetic experience will involve a second identification, with the artist's creative process. This is what Nietzsche had in mind when he said, "It seems to me I experience its genesis." This can occur only through profound attention to a profound piece of music. Nietzsche felt Bizet's music made him a "better listener."

In the creative process the ego's function is to enable self-expression in the face of conflict. Two hundred years ago Schiller described creativity as requiring the ability to sustain two contradictory ideas in consciousness simultaneously long enough to allow a new solution to the conflict to evolve, a view recently elabo-

rated by Rothenberg. But creativity never just happens. Not only must the artist be dedicated to his work, he must also be willing to put in the tremendous effort involved. In Edison's well-known words, "Genius is 1 percent inspiration and 99 percent perspiration." The perspiration is required not only in the artistic activity itself but also in all the effort required to master and develop facility in the technical aspects of the artist's medium. Yet while technical mastery and facility are necessary, they are not sufficient conditions for artistic creativity. Bizet's comment on the subject was, "I mistrust my facility: I have around me ten intelligent fellows who will never be more than mediocre artists, and all because of the fatal confidence with which they abandon themselves to their great cleverness. Cleverness in art is almost indispensable, but it only ceases to be dangerous the moment the man and the artist find themselves."

One reflection of Bizet's great compositional skills was his ability to combine into a coherent whole an unusual variety of devices. He painted with an exceptionally large number of musical colors on his palette. Act 3 is replete with them. The entr'acte is built around a flute melody that lasts ten measures and covers two octaves. The recapitulation is with a very similar second melody starting a half-measure later, almost like a round. It starts out double piano, builds only to a single forte, and then tapers off to a triple piano. Its peacefulness is a strong contrast to the turbulence of the act to follow, but the pianissimo ending blends into the hushed opening of the act as the smugglers steal their way through a mountain pass. Their movements are accompanied by a melody consisting of a repeated short, jerky motif followed by a rapidly ascending and descending phrase, as they take a few stealthy steps and then pause before moving forward again, to assure they are not caught.

There follows an ensemble with chorus about the rewards and dangers of smuggling. All this sets the scene for a confrontation between Carmen and Don José, in which she tells him he is not

suited for gypsy life and should go home to his mother—and then recognizes he will kill her rather than be separated. In the fortune-telling card trio that follows, the music simultaneously describes the prophesy of doom for Carmen and of happiness for her two friends. Nevertheless, Carmen joins in the rousing ensemble chorus about how men are so weak that gypsy girls can always distract them—a comic statement about the power of female sexuality. Carmen's sexuality leading to her and Don José's death is a tragic statement on the same topic. Fear of woman's sexuality pervades nineteenth-century opera.

Micaela now appears, terrified by the surroundings but the same simple, virtuous, courageous girl we saw in act 1. She has come to fetch Don José, whose mother is dying. The smooth, soaring melody of Micaela's prayer floats over a wavelike accompaniment. Now Escamillo enters. He and Don José fight over Carmen, who stops Don José from killing his rival. Escamillo leaves first, inviting all to his next bullfight in Seville. As the act ends, Don José, warning Carmen that she has not seen the last of him, leaves with Micaela.

The short introduction to the last act of *Carmen* is another of Bizet's borrowed Spanish folk tunes. It was written by Manuel Garcia, father of three of the century's greatest singers, Maria Malibran, Pauline Viardot, and Manuel Jr. The act, like the other three, is divided into an opening section of light entertainment and a closing section of intense drama. Only now the contrast is at its most intense. The opening is a carnival scene anticipating the beginning of the bullfight, including children, hawkers, and a parade which ends with the appearance of Carmen on the arm of Escamillo. As the crowd enters the amphitheatre Carmen is warned that Don José is nearby.

But Carmen is true to her nature: she will run away from nothing. Even though she knows the risk involved, she will face whatever life has to offer. It would not be difficult to find in Carmen reflections of Bizet's unconscious views of women, but a model for her is much closer at hand. Bizet had a long-standing (probably intimate) relationship with a woman named Celeste

Chabrillon. They met when he was twenty-seven and she was forty-one. He often composed for hours on end in a room she had set aside for him in her apartment. She was the only woman invited to his musical soirees. She led a remarkable life: prostitute, circus rider, actress, demimondaine, mistress of famous men, and novelist. She wrote of herself,

> Moderation is no part of my nature. Joy, sorrow, affection, resentment, laziness, work—I have overdone them all. My life has been one long excess. . . . When I want something, I am willing to gamble ten or twenty years of my life to get it as quickly as possible. . . . Two defects in my character have protected me. I have always been capricious and proud. No one, among women whose tendency is to say yes, derives more pleasure than I do from saying no. So the men to whom I have given the most are those who asked least of me.

In the final dramatic confrontation between Don José and Carmen, although each knows what the outcome will be, neither can avert the disaster. He begs her to save herself by coming with him, as he cannot live without her. She cannot do that, it would mean living without freedom. Nietzsche saw Carmen's love for Don José as what he considered true love—"cynical, innocent, cruel—and in this precisely a piece of nature." He saw Don José's love for Carmen as exposing the falsity of the usual view of love which masquerades as unselfish but really wants "to possess the other person." He knew of "no case where the tragic joke that constitutes the essence of love is expressed so strictly, translated with equal terror into a formula, as in Don José's last cry, which concludes the work: "Yes, I have killed her, I—my adored Carmen."

Nietzsche correctly perceived in Bizet a soulmate. They both had a terror of loving another human being. They both, through their genius, had a "love affair with the world." They both saw the function of art describing the world as it is, without moral judgment. They both believed that art involved a fusion of the

Apollonian and the Dionysian. Nietzsche was right in his estimation of *Carmen*. It is the greatest operatic fusion of art and entertainment since *Don Giovanni*. It has not been equaled since.

❧ 11 ❧

Wagner's Ring

THE HEROIC SPIRIT
AND THE DEFECTIVE FLESH

RICHARD WAGNER possessed an abundance of both the best and the most bestial of human attributes. A transcendent musical genius and a profound and original thinker about opera, he was also a mediocre poet and an appallingly bad philosopher. This immensely committed and hardworking composer of operas was a conscienceless exploiter of friends, lovers, and patrons. These contradictions are reflected in Wagner's operas, particularly in his masterpiece, *The Ring of the Nibelung*. They also appear in his having the most passionate devotees and the most passionate detractors. Some, like Thomas Mann, were both simultaneously. Some, like Nietzsche, started out as devotees and ended up as detractors. Certainly more has been written about Wagner than about any other artist.

The *Ring* is the largest single artistic creation by an individual artist. Its four operas total some fifteen hours of playing time. Wagner began work on the libretto in 1848; he finished the composition twenty-six years later. He wrote the libretto in reverse sequence: *Götterdämmerung* first, then *Siegfried*, then *Walküre*, and last *Rheingold*. He then composed in the order of performance. He wrote the libretto for *Götterdämmerung* first because his origi-

nal plan had been a work about the heroic figure of Siegfried. But as he added opera after opera to make the succeeding one more comprehensible, the final work turned out to be as much about Wotan as about Siegfried, who does not appear at all in the first two operas, while Wotan disappears after the third opera. Wagner was explicit about his intent for his two central figures: Wotan was the defective man of the present, Siegfried the heroic man of the future.

The complete plot of the four operas can be found in any standard operatic collection. Briefly, it is the story of how Alberich, by forswearing love, steals the gold from the Rhinemaidens. A ring fashioned from the gold carries a curse; Wotan, unable to resist the appeal of power, seeks to acquire the ring, thereby abandoning his moral authority and sealing the doom of the gods. Siegfried, the hero of the future, gives the ring to Brunhilde, the embodiment of love that conquers all. Hagen, Alberich's son, in attempting to regain the ring, murders Siegfried, and as Brunhilde immolates herself on Siegfried's funeral pyre, the gods' home, Valhalla, goes up in flames. All perish and the ring is returned to the waters of the Rhine.

There are probably as many versions of what all this "means" as there are commentators. Thomas Mann, as well as numerous Freudian analysts, thought it an oedipal tale. (Wagner had written, "We need only to faithfully expound the myth of Oedipus according to its inmost essence, and we in it win an intelligible picture of the whole history of mankind.") Shaw thought it a Marxist tale. (Wagner wrote that he found "the root of all the misery in our present social state... in menial bondage to the stubbornest, the most lifeless product in all Nature, to sallow Metal.") Donnington viewed it as a Jungian tale of universal symbols. (Wagner had said that myth "is true for all time...is inexhaustible throughout the ages.") Self-psychologists see it as a depiction of narcissistic, world-destruction fantasies. (Wagner had written of the "downfall of mankind in history.")

Each commentator finds evidence for his view in the Ring itself as well as in Wagner's personal life history; each view has its

merits and its limitations. The *Ring* is so huge and so ambiguous, Wagner was so complex and contradictory a person, that no single perspective can be comprehensive. My focus is on the dual views of man in the *Ring*—on the one hand the almost invulnerable, utterly fearless hero for whom all things are possible; on the other hand the hopelessly defective yet profoundly wise god for whom doom is inevitable. These two images pervade the *Ring*. They are also two images that pervaded Wagner's picture of himself. It is no accident that the *Ring* is a mixture of the two. The myth of Siegfried and the myth of the downfall of the gods have totally separate origins; Wagner spent a third of his life combining them. It did not resolve his personal dilemma, but it did result in an incomparable masterpiece.

No one has ever accused Wagner of humility. No artist has ever had such expectations of his work: it would unify Germany, change the world, save mankind. Ordinary opera could not accomplish such goals because it was too entertainment oriented, too full of artificial devices and rituals. Wagner called his works music-dramas, unified blends of poetry, drama, and music. They were to be *Gesamtkunstwerke*—total works of art. Only through such a unified creation could his goals be accomplished, and such a unity could be achieved only by having the entire production handled by one man. And so he set out to do it all: to write the libretto, compose the music, write the stage directions, act as producer, design the theatre. And he *succeeded* in doing it all. The first performance of *The Ring of the Nibelung*, in a theatre of Wagner's design at Bayreuth, in 1876, converted what had seemed a grandiose fantasy into reality.

It was a heroic undertaking and a successful one. In understanding Wagner's life and his work, one cannot underestimate the importance of his ability to convert a grandiose fantasy into a reality. For the heroic is the intended subject of the *Ring*. In Wagner's mythology there are six echelons of beings. In ascending order of merit they are: the dwarfs, the giants, the humans, the spirits, the gods, and the heroes. The heroes are higher forms of being than the gods. The sense of God as a perfect being is a

central aspect of our monotheistic Judeo-Christian tradition. In many polytheistic traditions, such as the Greek, gods are larger than life, but like men they are flawed. Wagner's gods are in this tradition. What is unique about the mythology in the *Ring* is the status of the hero, who stands above the gods. At the same time he is, despite his exalted position, in many ways like a human. This concept of the extraordinary man, the superman, is as integral to Wagner's work as it was to his self-image.

Throughout history the heroic has retained its appeal. Heroes in every nation, every culture serve important developmental, psychological, social, and religious functions. We use them as models, as teaching devices for the transmission of cultural values, as rallying points. Their birth dates become our festivals of celebration and their death dates our days of atonement. Through identification with a hero, we expand our sense of identity; but this kind of expansion comes at the price of a sacrifice in autonomy. We acknowledge this problem when we suspect unalloyed hero worship in an adult. For although hero worship is a part of normal development, if it persists into adulthood as a dominant part of a personality it becomes abnormal. The hero whom Wagner worshiped, and expected everyone else to worship as well, was himself.

Wagner not only documented this self-image in his writings, he also demonstrated it in his human relations. Friends, lovers, relatives, colleagues, and benefactors existed only to serve his wishes. His behavior was unconscionable; it ranged from amoral to illegal. Yet he was such a charismatic person that both Wesendonck and von Bulow, whose wives he seduced, remained loyal to him, as did Liszt, Cosima von Bulow's father. So did poor, mad King Ludwig of Bavaria. The king built a castle dedicated to Wagner and idolized the composer until the day he drowned, probably a suicide. The idea that the hero is not subject to the rules of civilized behavior is important throughout the *Ring*. Siegfried is the son of Siegmund and Sieglinde, a match that combined incest and adultery. Siegfried slays his adoptive father Mime and then beds his aunt, Brunhilde. That all the lesser

beings are greedy, power-mad, and unscrupulous is not surprising. They—the gods included—are after all lesser beings. That the hero is above ordinary human constraints reflects Wagner's view of himself.

In the hands of a genius like Wagner, such freedom from the constraints of convention can result in great creative innovation. And Wagner forever changed the world of music. His use of motifs, chromatic harmonizations, and irregular phrases; his dense orchestration; his abandonment of traditional solos and ensembles, regular meters, and a fixed tonic; even his placement of the orchestra in a pit, are all very much part of music today.

In his determination to free himself from the bonds of traditional opera, Wagner rejected the concept of the melodic line carried by the voice and accompanied by the orchestra. Not only does he rarely use melody in the traditional sense, frequently the main theme is in the orchestra rather than in the vocal parts. Indeed, in his search for unity of execution, the voice for Wagner often becomes one of the many instruments of the orchestra. He replaced traditional melody with motifs. A motif may be no more than a few notes or it may be many measures in length, each referring to a specific person, idea, feeling, or event. Depending on how one counts them, one can catalog more than a hundred different motifs in the *Ring*. Wagner once wrote with great pride that in *Rheingold* practically every measure consists of variations on previously stated motifs. Although many of the motifs are intended as self-explanatory program music, many are recognizable only by being identified in context. The motif is designed to serve as a clue to the composer's intent. Through their repetition in context, Wagner familiarizes us with them even as he subtly varies them to indicate that the situation resembles, but is not identical to, a previous one. He also combines and recombines motifs in a great variety of ingenious ways. The entire *Ring* cycle is a tremendously intricate series of subtly varied motifs, a remarkable tour de force. Nothing comparable to it has ever been written.

Another striking aspect of the music of the *Ring* is the relative absence of phrases or stanzas. Wagner omits these deliberately. It

is part of his rejection of what he considered obsolete, traditional opera. In replacing the periodicity of phrases with the building up of motif upon motif, of incomplete climax upon incomplete climax, in a continuous flow, Wagner furthers his focus on the heroic, the eternal, the timeless, the superhuman. Ordinary human lives are governed by the inexorable passage of time. By not dividing his music into rhythmic segments, Wagner removes us from our usual world. That the audience should be oblivious to time was also clear from how *Rheingold* was to be performed—two and a half hours of uninterrupted music.

The emphasis on the heroic and the superhuman has another side: it is dehumanizing. The messages of the motifs are symbolic, and Wagner did indeed think of his characters as symbols, not as people. The most human instrument of all, the human voice, literally and figuratively plays second fiddle. There are very few ensembles; the interactions between people have little significance for Wagner. A curious result of this is that despite Wagner's intention that his work be a unification of poetry, drama, and music—and not, as he thought most opera was, an overemphasis on music at the cost of other aspects—more than any other operatic composer, Wagner's music is universally enjoyed without staging and often without voices. Psychologists would call this the return of the repressed, namely, that the unconscious intent, the opposite of the conscious intent, turns out to be the actual result.

Wagner crafted his tale of Siegfried primarily from Icelandic and German sources whose earliest forms date back to the fifth century A.D. He intended it to have universal appeal, and it does. Siegfried is the child of royalty. His parents are related by family, and the circumstances of his conception are unusual. At birth he is spirited away and reared by foster parents. Nothing is known about his childhood. On reaching manhood he returns, achieves an important victory over a powerful opponent, and is betrothed to a princess. He meets with a strange death.

That the appeal of this tale is universal is demonstrated by how many hero myths contain these same eight elements: royal lineage, related parents, unusual birth, rearing by a foster parent, an

unknown childhood, the return and triumph over a powerful opponent, betrothal to a princess, and a strange manner of death. This sequence occurs in the tales of Arthur, Asclepias, Heracles, Jason, Moses, Nyikang, Oedipus, Romulus, Theseus, Watu Gunung, and others. Students of mythology differ on how to understand these striking similarities. Some favor the idea of diffusion, spread from one culture to another; others favor the idea of universal symbols, inherent to *Homo sapiens*; still others favor the idea that mastering the developmental tasks and mysteries of life present similar challenges for all cultures.

In understanding the role of the heroic in the *Ring* we must consider not only the universal appeal of hero myths and their special meaning for Wagner, but also the view of the hero in the mid-nineteenth century. Thomas Carlyle, in his book *Heroes and Hero-Worship*, took a utilitarian view: "Universal History, the history of what man has accomplished in this world, is at bottom the History of the Great Men who have worked here." The American James Russell Lowell took a moral view: "The idol is the measure of the worshiper." In the romantic era, when these views were prevalent, Wagner's fascination with the heroic was not out of place. He would surely have fully concurred with Emerson's view that, for the creative individual, "nothing is at last sacred but the integrity of your own mind."

As it is with most conscious self-images, however, the self-image of heroic splendor contains the seeds of its opposite, the self-image as deformed and defective. In Wagner's life the conscious manifestation of this was his lifelong preoccupation with his body. Freud once remarked, "The self is first and foremost a bodily self." By "first" he meant that the infant's earliest developments of a sense of self come from bodily sensations and movements. By "foremost" he meant that, if only on the unconscious level, the critical importance of bodily dimensions to the sense of self remains throughout life. In normal development, with increasing maturity, bodily dimensions play a decreasing role in the construct of the conscious self. In Wagner, whose self-image contained such powerful remnants of infantile grandiosity, the inevitable accompanying

elements of infantile helplessness took the conscious form of bodily preoccupations. The facts of his life had much to do with this particular choice of overt symptoms and their reflections in his operas.

Distortions of the human body abound in Richard Wagner's work—animal shapes, odd sizes, wounds, as well as displacements in time and space. That Wagner's own bodily concerns importantly influenced this aspect of his work can be inferred both from his life's story and from the fact that the distorted bodily images are almost always male (Ada, in *Die Feen*, and Kundry, in *Parsifal*, are the only significant exceptions). Four major themes from Wagner's life are reflected in these distortions: his own health problems, particularly his erysipelas (a severe, recurrent skin infection); his love of animals, vegetarianism, and fervent opposition to vivisection; his concerns about his paternity; and his personal wanderings. These four themes appear repeatedly in all of Wagner's mature operatic tragedies, especially the *Ring*.

Mid-nineteenth-century operatic audiences were not accustomed to grotesques on stage (Rigoletto was a rare exception), but they were familiar with them elsewhere. Not only was this the era of "freak" shows, but the deformed figured prominently in the works of writers such as Poe, Hugo, Twain, and Dickens. Such distortions are commonly found in dreams. Influenced by Nietzsche and Schopenhauer, Wagner saw primitive forces and their manifestation in dreams as the road to enlightenment and truth. He had a remarkable capacity for transforming his primitive character structure and fantasies into reality. In his artistic expressions, through his creative genius, this resulted in unique masterpieces. In his personal life it led to much chaos, not to mention amoral, antisocial, and illegal behavior.

In his infancy Wagner was surrounded by violence and illness. Prussia and Austria were fighting Napoleon at the time, and at Leipzig, his birthplace, Napoleon lost a major battle. The outbreak of typhus following that battle, when Richard was only six months old, killed his father. Even before then, at two months, he had been taken by his mother on a dangerous hundred-

mile journey through enemy-held territory to visit Ludwig Geyer (whom his mother married shortly after the death of Wagner's father).

He was a sickly child. The first attacks of erysipelas came before he was ten years old, and the infection was to plague him throughout his life. We can, of course, only speculate how these early exposures to violence, sickness, and death affected him. Bodily preoccupations, however, played a prominent role all his life. At various times he had severe complaints of bladder troubles, constipation, stomachaches, and insomnia. How much of this was physical and how much psychosomatic is unclear. We do know that he had megacolon, a greatly expanded lower intestine.

Most debilitating of all was the erysipelas. Nineteenth-century physicians had a remarkably thorough and accurate understanding of the symptoms, course, and contagiousness of the infection. Unfortunately their treatments were extremely primitive. In the first half of the nineteenth century erysipelas was frequently treated with incisions and bloodletting. Most likely Wagner was subjected to such treatments as a child. Later he went to spas for rigorous treatment via diet and baths, which he described as "water torture." When an attack involved his face he would sometimes not go out for long periods of time until the infection had passed. When his bride-to-be, Minna, kissed him on the lips during an attack of facial erysipelas, it was, for Richard, then age twenty-one, a token of the specialness of her love for him.

The deformed body is almost ever-present throughout the *Ring*. The opening scene of *Rheingold* consists of interaction between the Rhinemaidens—mermaids—and the dwarf Alberich. They call him "a scaly, spotted lecher of small stature." In the next scene we are introduced to the one-eyed Wotan and the giants Fafner and Fasolt. Indeed, no humans at all appear in *Rheingold*; the rest of the characters are all gods and goddesses. We must wait until *Walküre* for ordinary humans.

Wagner's erysipelas was a wound that would not heal. Although that theme appears only indirectly in the *Ring* (the World Ash Tree never recovers from Wotan's removal of one of its branches),

it is an important theme in both *Tristan and Isolde* and in *Parsifal.* It requires Isolde's magical powers to heal Tristan's wound before the opening of the opera, and she arrives too late to heal him again at the end. Amfortas, too, has a wound that will not heal until Parsifal brings his magical power to bear on it. Besides his many bodily complaints, Wagner also suffered repeated bouts of depression, at times with suicidal thoughts. The wound that would not heal was psychical as well as physical.

Animals are important throughout the *Ring.* In *Rheingold* there is a snake and a toad. In *Walküre* we have the warrior-ladies' mounts, including Brunhilde's special horse Grane. In *Siegfried* a dragon, a bear, and a bird all play significant parts. Birds appear again in *Götterdämmerung.* From a very early age Wagner had shown a great love for animals, often bringing home the stray or wounded. As a small child he had reacted violently to seeing a butcher slaughter an ox. He kept a variety of pets, but dogs were his constant companions. He was once bitten on the hand by a bulldog and was unable to compose for some time, but he continued to cherish the animal. When his ex-wife Minna died, he did not attend the funeral. A few days later, however, on learning that his dog Pohl had died, he had the dog disinterred and held a solemn service for it.

Closely connected to this love of animals was Wagner's vegetarianism and stand against vivisection. Late in life he adopted a more Christian identity. He viewed the symbolic offering of flesh and blood, in Communion, as Christ's exhortation that his followers be vegetarians. He considered a return to natural food the only hope for the salvation of mankind. Similarly, his lifelong anti-vivisectionism also acquired a moral and religious dimension in his later years. Vivisection was now wrong because it led to the use of animals to try to find a cure for syphilis, and syphilis was punishment for sexual transgressions.

This strain of puritanism was the opposite side of Wagner's adulterous promiscuity and the endorsement of incest that runs throughout the *Ring.* The puritanical strain was already evident in *Tannhäuser* and reached its height in *Parsifal.* Wagner never re-

solved this conflict in himself. The heart attack that killed him at age seventy was probably precipitated by a violent argument with his wife Cosima over his interest in a young girl. It seems that in some great musicians who have succeeded in making their gran-diosity a reality, the grandiosity helps to preserve their life and potency. It can wreak havoc with the lives of those around them, but it spares them from internal conflict. A number of great conductors, Toscanini, for example, apparently remained sexually active into their eighties. Verdi and Richard Strauss were still actively composing at that age.

Anthropomorphism and transformation into animals are also features of the *Ring*. Alberich is transformed first into a snake, then into a toad. Fafner appears first as a giant, then as a dragon. Such human-animal transformations were, until the Judeo-Chris-tian tradition, part of most religions—Indian, Egyptian, Greek, central African, American Indian, and Nordic. Wagner first used the concept in his first completed opera *Die Feen*. In it Ada has been transformed into a doe. He used it again in *Lohengrin*, where Godfrey has been transformed into a swan. Fafner and Siegfried can converse because Fafner is a transformed giant, but it is only when he has tasted Fafner's blood that Siegfried can converse with the birds.

The birds speak the real truth to him, including prophecy of his future. Having partaken of Fafner's blood, Siegfried can now also hear the truth as men speak; he hears what Mime means, not what Mime says. From the cultural perspective Wagner here reflects the romantic era ideal of man living in perfect harmony with nature. From the psychoanalytic perspective, human com-munication with animals reflects preverbal, pre-oedipal communi-cation. Just as the *Ring* contains many elements of pre-oedipal world destruction fantasies (as in the final denouement), it also has many elements of pre-oedipal symbiotic unity and bliss (as in the merger of Siegmund and Sieglinde, of Siegfried and Brunhilde, and in Siegfried's relation to nature). Birds appear again in *Götterdämmerung*. But whereas the wood bird in *Siegfried* is a symbol of life and love, the birds that carry Wotan the message of

Siegfried's death are ravens, symbols of scavenging and death. Their names are Thought and Memory. Thus they are tokens of the verbal, of the oedipal, and, for Wagner, of doom.

The other important animal in the *Ring* is the wild bear whom Siegfried, in his first appearance, drags along to frighten Mime. Siegfried is totally open about his contempt for Mime: "When I watch you standing, shuffling and shambling, servilely stooping, squinting and blinking, I long to seize you by your nodding neck and make an end of your obscene blinking!" The words are unmistakably similar to those Wagner used to describe Jews in his many anti-Semitic statements.

It was no coincidence that Wagner chose a bear to threaten Mime, the Jew. When Wagner devised a family crest for himself it consisted of a vulture carrying a shield with the constellation of the Great Bear upon it. In German the word *Geier* (pronounced like Geyer) means vulture or hawk. The constellation Great Bear has another name, the Wagon. The wagon driver is the *wagener*. Wagner Sr. had died when Richard was six months old; Ludwig Geyer was the only father he knew. Although Geyer died when Wagner was only eight, Richard continued to use the name Richard Geyer until he was fourteen. Whether Geyer or Wagner Sr. was actually Richard's father remains unclear. What matters is not that we don't know, but that Wagner didn't know. And though we now know that Geyer had no Jewish blood, Wagner all his life thought that he might have. The connection between the bear and Wagner's feeling about his lost father was already clear at age twenty-four when he started work on a libretto entitled "The Happy Bear Family, or Woman's Wiles Outsmarted." Despite rejecting Geyer's name and his supposed Jewishness, Wagner clearly also identified with Geyer, a friend of Wagner Sr. Repeatedly—one might say compulsively—Wagner seduced his friends' wives—as he must have supposed Geyer had seduced his mother. And despite his virulent anti-Semitism, he maintained close personal and professional relationships with many Jews.

The importance to Wagner of his unclear paternity shows up repeatedly in his work in an emphasis on names and paternity.

The theme appears first in *Die Feen*, again in *Lohengrin*, and once more in his last opera, *Parsifal*. The question "Bear or vulture?", "Wagner or Geyer?", maintained its significance throughout Wagner's life.

The next character to appear on stage after Siegfried and the bear is Wotan. Only now, in his final appearance in the *Ring*, he is a wanderer. This theme, the body dislocated in space, also recurs in six of Wagner's thirteen operas. In *Die Feen* Arindal lives in both the real world and in fairyland. The Dutchman of *The Flying Dutchman* is doomed to roam the seas. Tannhäuser lives both in Venusberg and on earth. Lohengrin must remain away from Montsalvat or lose his holy power. Wotan wanders the world, searching for a solution to his dilemma. Parsifal has traveled restlessly, not knowing where he is from.

The pervasiveness of this theme parallels the facts of Wagner's life. In infancy and childhood, due to the war and his mother's relationship with Geyer, he experienced a number of moves between Leipzig and Dresden. As an adult he was constantly traveling, conducting and overseeing operatic productions. Repeatedly he was forced to move by hotly pursuing creditors. From ages thirty-six to forty-eight he was in exile because of his political activities. From ages fifty-two to fifty-seven he was again exiled from Bavaria because of his illicit relationship with Cosima Liszt von Bulow. At various times he maintained his primary residence in Germany, Austria, France, Latvia, Switzerland, and Italy.

Richard Wagner's endless wandering was paralleled by his endless womanizing. Compulsive promiscuity is not an uncommon phenomenon, but Wagner's penchant for the wives of close friends is unusual. Together with the endorsement of incest that pervades the *Ring*, it strongly suggests a massive need to deny oedipal castration anxiety. That ultimate fear of bodily damage appears only in *Parsifal*, in the figure of Klingsor, who has castrated himself.

Although some of the themes in *Parsifal* have antecedents in *Tannhäuser* and *Lohengrin*, Wagner's final opera is in most ways a radical departure from his other operas. No longer does the man seek salvation through the unqualified love of a woman. Here,

Ring: The one-eyed Wotan, having forfeited his right to rule because of his greed, will soon find his staff no match for Siegfried's sword.

quite to the contrary, it is only by rejecting the woman that the man finds salvation. The woman is no longer constant and loving: Kundry is erratic and deceitful in her behavior, but she is truthful in her words. What had been a split image in *Tannhäuser* (the bodily Venus and the spiritual Elisabeth) is now fused into the single figure of Kundry.

In the *Ring* Alberich was able to steal the ring by renouncing love. In *Parsifal* Klingsor, the embodiment of evil, similarly derives his power from having renounced sexual love. By resisting Kundry's wiles, Parsifal not only achieves his own salvation but heals Amfortas's wound and saves the Company of the Holy Grail. In the end Kundry dies, and the men find salvation in their bond to one another and their Christian faith. Only in this last opera did Wagner attempt to deal with his deepest con-

flict—his inability to identify with a father figure and to reconcile with him.

A vast amount of information about Wagner suggests that he suffered from a narcissistic personality disorder. The dictionary definition of this type of character structure could have been written with Wagner in mind: "Grandiose sense of self-importance or uniqueness; preoccupation with fantasies of limitless success; need for constant attention and admiration; and disturbances in interpersonal relationships such as lack of empathy, exploitativeness, and relationships that vacillate between the extremes of overidealization and devaluation."

Trying to understand this kind of personality structure, the question arises to what extent the primitive, infantile elements reflect developmental failure (that is, failure to achieve normal developmental milestones) and to what extent they reflect regressive phenomena (that is, a return to earlier forms of defenses, interests, ways of adapting) resulting from an inability to come to grips with later developmental tasks, particularly oedipal issues and castration anxiety. Inevitably both will be involved, but the ratio is important. Three pieces of evidence suggest that regressive elements were central to Wagner's character structure.

The first is the way the sequence of themes unfolds in his operas. In the earlier works, *The Flying Dutchman, Tannhäuser,* and *Lohengrin,* the man can only be saved through the totally unquestioning love of an earth-mother figure. In the *Ring* the incestuous oedipal triumph is the attempted solution, but it fails. In *Parsifal,* his last work, Wagner finally addresses his core conflict, his inability to identify with a father figure. The earlier fantasies are of an omnipotent, all-giving mother. Next come the fantasies of oedipal triumph and the recognition of the failure of that solution. Finally the mother is renounced and reconciliation with the father is achieved. The sequence suggests emotional growth over the course of his lifetime, much more likely to occur if the original

difficulties involved regression than if they were primarily the result of developmental failure.

The second piece of evidence, related to the first, is that for the last twenty years of his life Wagner was able to sustain a relationship, albeit with some difficulty, with one woman.

The third piece of evidence is Wagner's remarkable capacity for concentrated work and continued investment in a task over long periods of time. The *Ring* was a twenty-year project. The kind of ego strength required for such an accomplishment is unlikely in a character structure burdened with major developmental failures. Wagner had areas of great ego strength, even though their maintenance required unremitting admiration, attention, support, and sexual gratification. Such areas of ego strength in a character structure with many primitive features most likely reflect considerable successful maturation, marred by severe regression.

The heroic self and the defective self are both almost omnipresent in the libretto of the *Ring*. Sometimes they exist simultaneously, sometimes alternatively; sometimes one is transformed into the other. The music parallels the libretto. Some elements of the music convey the heroic; slightly altered, in a slightly different context, the same musical elements convey the defective, insecure body image. Just as animals are transformed into people and vice versa, so the motifs are constantly undergoing transformations, mergers with other motifs, inversions, relocations. Just as the characters are unreliably located in time and space, so the meters are constantly changing, the phrases are of unpredictable length. The unique character of individual instruments is obscured by having them play in unison. The sense of lack of bodily integrity, of a defective self, is thus in the music as well as in the libretti.

But the stuff of life is not made up of partial self-images such as heroic or defective. It is made up of human relationships, relationships between unique individuals. Wagner's characters are not unique individuals, they are symbols. Each "represents" something; each motif also "stands for" something. Words and music are both about symbols, not about people. And so, though Wagner may touch us deeply, it is essentially a solitary experience. We are

turned inward toward ourselves, not outward toward other people. Ultimately there is something dehumanizing about it. Through his genius Wagner succeeded in converting his grandiose, narcissistic fantasies into operatic realities. Through his creations we partici-pate in his triumph. But for us, as it was for him, it remains a self-centered experience.

This grandiose, narcissistic, dehumanizing aspect of Wagner's work was what made it so available to the Nazis. Much has been made of Wagner's anti-Semitism, his German chauvinism, and other aspects of his life and literary productions that found reflections in Nazism. But Wagner was influential only because of his great operas, and they contain relatively little of German chauvinism or anti-Semitism. What the *Ring* does contain is the same celebration of a heroic ideal that characterized the rise of Nazism and the same celebration of destructive conflagration that characterized its fall.

There are, of course, tempting analogies between the *Ring* and Nazism, such as between the enslaved Nibelungen who are worked to death in *Rheingold*, and the concentration camps. Or between Wotan, who has barricaded himself in Valhalla, awaiting the end, and Hitler doing the same thing in his bunker. Such analogies are intriguing; they are also treacherous. One can never know whe-ther there is a causative connection or whether they both sprang from the same social, cultural, and political soil, and in similar personalities. Regardless of one's view of this issue, there certainly was something prophetic in Nietzsche's words a half-century be-fore Nazism:

> Wagner's stage requires one thing only—Teutons!—Definition of the Teuton: obedience and long legs. It is of profound significance that the arrival of Wagner coincides in time with the arrival of the "Reich": both events prove the very same thing: obedience and long legs. Never has obedience been better, never has command-ing. Wagnerian conductors are particularly worthy of an age that posterity will call one day, with awed respect, the classical age of war.

Wagner will continue to be an ever-fascinating subject. Few who are interested in opera would disagree with Thomas Mann when, four years before his death, he wrote, "How many professions and confessions I have already made on the subject of Wagner, for Wagner and against Wagner—it seems as if it will never end."

❧ 12 ❧

Saint-Saens's Samson and Delilah

THREE THOUSAND YEARS
OF BLINDING GUILT

CAMILLE SAINT-SAENS'S *Samson and Delilah* was first produced in Weimar, Germany, in 1877, through the efforts of Franz Liszt. It was not until 1890 that Paris saw it, which is odd since it is typical French grand opera, a mixture of musical styles—classical, romantic, Middle Eastern, sacred, and so on. It has all the ingredients of nineteenth-century French grand opera—sex, violence, choruses, duets, solos, dancing, exotic settings, and dramatic staging. Yet it is a coherent, powerful work of art, and what holds it together is not only Saint-Saens's great music and the close atunement of text to musical meaning, but also the continuing significance for us of the biblical tale.

Starting early in the nineteenth century, Paris became the leading center of grand opera for composers of all nations. Rossini, Donizetti, Bellini, Berlioz, Wagner, and Verdi wrote operas for production there. But it was the librettist Eugene Scribe and the composer Giacomo Meyerbeer (born Jakob Liebmann in Berlin, 1791), who, beginning in the 1830s, established the full-blown Paris grand opera: five acts of highly melodramatic plots and music, ballets, spectacular stage effects, and florid singing. Most of Meyerbeer's operas have too much of everything for our tastes

today, but for a while they were the rage of Paris. This dismayed and enraged Wagner and was an important source of his anti-Semitism. Although *Samson and Delilah* is a toned-down version of that art form, and although Saint-Saens is a better composer than Meyerbeer, the opera is in that tradition—the last great opera, in fact, in that style.

Saint-Saens was born in Paris in 1835. Like Mozart he was a true musical prodigy. He played the piano at three, composed at five, read orchestral scores for pleasure at six, and gave his first concert as a pianist at ten. At age twenty-five he amazed Wagner by playing the entire piano transcription of *Tristan and Isolde* from memory. He could do the same with all thirty-two of Beethoven's piano sonatas. His astounding facility did not always stand him in good stead: many of his several hundred compositions are superficial, routine, and bland, albeit always skillful. Still performed frequently today are only his three symphonies, five piano concerti, the Carnival of Animals, and the Introduction and Rondo Capriccio. Of his twelve operas, only *Samson and Delilah* is in the repertory. It was his first; he spent seven years on it.

All his life Saint-Saens suffered from mood swings. The depressions were sometimes fairly severe. Most of the time he was in a highly energized state, interested in everything, not just all kinds of music. He wrote ten books, including one on philosophy and one on ancient Roman theatres. He composed, conducted, and performed on both piano and organ. He was an inveterate traveler. Besides bouncing around Europe, he twice visited the United States, made repeated trips to North Africa, and journeyed to South America and Indochina. He was a music critic, active in many organizations, received numerous honors, and, most unusual for a musician, saw a statue of himself erected in his lifetime.

From 1851 to 1876 Saint-Saens served as a church organist and so was quite familiar with the Old Testament tale of Samson and Delilah. The historical figure Samson lived around 1150 B.C.E., when the Hebrews were a loose collection of rather primitive

seminomadic tribes. (The word "Hebrew" is derived from the an-
cient word for "dusty," referring to their donkey caravans.) The
Philistines were a more advanced civilization and dominated the
fertile Eastern Mediterranean coastal plain. The two cultures lived
in uneasy relationship—they traded, intermarried, and fought.
The original Samson was a Hebrew military hero. Tales of his
prowess were handed down by oral tradition and over the centuries
were greatly embellished into the legendary form we know. In-
deed, before the biblical compilation of the present version around
600 B.C.E., the entire Delilah episode was not part of the tale.

The story begins at a time when God is punishing the Israelites
for their sins by subjugating them to the Philistines. An angel of
God appears to a man named Manoah and his barren wife and
informs them that she is already pregnant with a boy who would
be "God's Nazarite from the womb. And he shall begin to
liberate Israel from Philistine power" (Judges 13:5).

The story then jumps to Samson as a young man. He has
married a Philistine woman who, by crying and nagging, persuades
him to reveal to her the secret of a riddle to which her friends
want the answer. Samson accuses these friends of having "plowed
with my heifer" and slays thirty Philistines. Samson goes home to
his father and later returns to Philistine territory to reclaim his
bride. When informed that she has married his best man, he burns
their fields. They in turn burn his bride and her house. He in turn
slaughters many of them and then retreats to a cave. The Philis-
tines put together an army to attack Samson, but the Jews deliver
him to them. Samson breaks his bonds and, with a jawbone, slays
a thousand Philistines. He is parched from his labors in the sun,
but God provides him with spring water. Thereafter Samson
spends the next twenty years as a judge—the leader—of the
Israelites. The remainder of the tale concerns Samson's visit to a
Philistine prostitute, the Delilah episode, and the story of his
regained strength and the destruction of the Philistine temple.

In early versions Samson was thus a most areligious figure—a
brutal, vengeful, whoring loner, the original Rambo. At the time
of the first Old Testament compilation he was given a miraculous

birth. In the second, his story was converted to that of the hero who is tempted by a woman, falls, and then is redeemed. That story had its prototype in Adam in the Judeo-Christian tradition and in Hercules in the Greco-Roman tradition.

The addition of being blinded for sexual transgression inevitably suggests connections with the tale of Oedipus. Because Homer's version of Oedipus dates to well before 800 B.C.E., it is not inconceivable that the Philistines brought the concept with them from Crete. The ancient Israelite culture was, however, far less sophisticated than the Greek. While the Greek version focuses on profound issues of human conflict, Samson has no such problems. His defenses are built around identification with the aggressor (I am not going to be the victim, I am going to be the aggressor), reaction formation (I am not passive, I am active), and counter-phobia (I am not afraid of doing it, I love doing it). His choice of woman is anti-oedipal: she is alien, forbidden, and promiscuous.

With the onset of the Christian Era, perceptions of Samson began to change. Paul, in the Epistle to the Hebrews (11:30), includes him among the heroes and prophets who conquered through faith. Augustine ranks Samson as a holy figure along with Moses and Daniel. By 700 A.D. the Alexandrian school of exegesis was writing of Samson as a Christ-like figure. Almost every line of Samson was analogized to Jesus; most often mentioned were the birth to a barren woman after a visit by an angel; the consecrated son destined to liberate his people; Delilah and Judas both offered money to betray Samson and Jesus, and both repent their betrayal; both Samson and Jesus triumph alone, without help; both are delivered to the heathen by the Jews; at the end Samson is between pillars, Jesus between two thieves; and both sacrifice themselves to save the Jews.

The Samson story appeared often in medieval literature (as in Chaucer and Boccaccio) and in Renaissance literature (as in Burton, Spencer, and Shakespeare). As the image of Samson became more Christ-like, the Rambo-like hero receded. Samson became an Aristotelian tragic figure whose punishment was worse than his sin. The counterphobically masculine Samson, who

denied his feminine side and was promiscuously heterosexual, was not compatible with the bisexual figure of Jesus, who eschewed any overt sexual expression. Thus the greatest Christian literary treatment of the story, Milton's "Samson Agonistes," deals only with the very last part of the story—the blinded Samson— omitting all the episodes about his earlier violent and sexual behavior. Indeed, the tragic view of Samson had become so common by the 1600s that the verb to "sampsown" came into usage, meaning "to cast down in dejection and anguished thought."

Milton's "Samson Agonistes" came out of the Christian tradition but also contained Milton's insight into the duality of the Samson figure as reflected in the choice of title. "Agonistes" refers both to the active, sadistic side of Samson—the agonist—and to the passive masochistic side—his agony. Milton's Samson is a guilt-ridden man trying to regain God's favor. Despite his vitriol against Delilah, he ultimately blames only himself. His punishment is deserved, but for all his tragic suffering he draws on his sadistic side to achieve his forgiveness from God—just as in the biblical version, when he pulled down the temple pillars. Although Delilah's sadism in her betrayal of Samson was not to be forgiven on grounds of patriotism or religion, Samson's sadism in killing thousands brought him forgiveness from his God.

Handel took Milton's poem and converted it into an oratorio faithful to Milton's vision. Although it is occasionally performed as an opera, it remains essentially an oratorio in that it deals almost exclusively with ideas and only very minimally with action. At least ten other operatic versions of Samson exist. Only Saint-Saens's version is regularly performed. Its plot encompasses the entire Delilah story (acts 1 and 2) and Samson's blindness and death (act 3). It is thus primarily a story of love and sex and only secondarily a tale of sin, guilt, and redemption. But because it starts with an oratoriolike religious beginning and only later progresses to more typical operatic scenes, it was once described as "starting as oratorio, ending as opera; starting as Bach, ending as Offenbach." Indeed, Saint-Saens originally planned to write it as an oratorio. It was the librettist Lemaire who suggested

an opera instead, thus establishing that writer's only claim to fame.

The introduction to the opera is unusual. After just a few chords we hear a chorus of Jews lamenting their enslaved state. When the curtain rises we find them in a square in front of a temple to the Philistine god Dagon. Samson tries to convince them to rebel against their oppressors. Drawn by the commotion, the Philistine official Abimelech enters and taunts them. Samson challenges him, seizes his sword, and slays him, thereby initiating the rebellion. A high priest of Dagon is unable to mobilize the Philistines, now frightened of Samson. Only in this opening scene is there anything of the original, biblical Rambo. Now Delilah comes out of the temple with her attendants. Despite being warned, Samson cannot resist the seductive appeal of the Philistine priestess.

Act 2 is set in Delilah's luxurious home. She has already failed three times to elicit from Samson the source of his power, but she promises the high priest of Dagon that she will succeed. The rest of the act consists alternately of exchanges between them of love and of conflict over his refusal to reveal his secret. Delilah uses all her wiles and when she eventually succeeds, soldiers rush in and cut off Samson's hair.

Saint-Saens's Delilah is a far more complex person than Milton's. Yes, she is a treacherous seductress, evidenced by her appearance and actions. But through her words and music she is also Samson's passionate lover. Nowhere is that clearer than in the love duet in act 2. Listened to with closed eyes, it has the impact of a great duet of lovers. Looked at in the context of the drama, Delilah reveals the other side of herself, the treacherous temptress. To Saint-Saens she is both. He brilliantly exploits the tendency of human beings to perceive sexuality visually (as in clothes and in pornography) and to perceive love auditorally (as in love songs and love poems). This difference may be partly culturally determined, but it also has developmental origins. Mature love requires complex ego functions, functions whose development comes later in childhood and depends heavily on the capacity for symbolization,

linguistic and otherwise. Such symbolic-linguistic development is primarily auditory. Delilah's loving sexuality is expressed in words and in the music, but her visually expressed sexuality, her appearance and actions, is hostile in intent. It is sexuality without love.

The same connection between primitive sexuality and the visual is found in dreams. Herein lies another reason why Handel's Samson, which contains so little dramatic action and is so focused on abstract, spiritual love, is a better oratorio than an opera. Saint-Saens's version is full of action and conflict. It is about both spiritual and flesh-and-blood love. Opera's capacity to reach us simultaneously through the eye and the ear makes it the ideal medium, in Saint-Saens's skilled hands, for delineating a three-dimensional Delilah. Although the plot and action depict her as a villainess, the power of the music is so great that she becomes a complex, interesting person.

Samson is very much the male counterpart to Delilah. His sexuality is as self-centered and manipulative as is hers. We know from his story that throughout his life he was fascinated by the forbidden woman. As his wife and his whores he chose women from the Philistines, his enemies. His attraction to the anti-oedipal woman is his lifelong Achilles heel. It reveals his fragile potency, for he depends on the seductiveness of the woman. She, as seductress, is the sexual initiator; he is the responder. His sexuality reveals the vulnerability of his counterphobic and reaction-formation defenses. But Samson has a preconscious awareness of the regressive nature of his sexuality, and Delilah understands and exploits his guilt. As she says, "I have prepared my weapons, he will not be able to resist my tears." Samson is, for his part, quite conscious that his attraction to Delilah reflects his vulnerability. As he says, "I curse my love, but I still love." Indeed, because of this awareness he leaves her after their first night together, and in the opera her rage over this rejection is an essential part of her decision to betray him.

Samson's fragile power is reemphasized by locating its source in his hair. The connection between hair and power exists in many mythologies; the origin of the crown may well have been to

Samson and Delilah: The blinded, enslaved Samson is forced to turn a millstone as Delilah taunts him.

protect the ruler's source of power, his hair. In the Samson story, hair has another significance. The angel had told Samson's mother that he would be a Nazarite, one who dedicated himself to God. One of the requirements for being a Nazarite was never to cut one's hair. Other requirements included drinking nothing alcoholic and never touching a dead body. But Samson had never abided by these rules. A man could give up his status as a Nazarite and return to ordinary secular life by completing a complicated set of rituals, including cutting his hair. Thus while Delilah's intent was to deprive Samson of his strength, she also completed a required ritual that Samson had neglected to perform, since he clearly had not dedicated himself to God.

The rules for being a Nazarite were action-oriented. Action can be seen and therefore can cause the development of shame and

can bring on retribution. Shame and fear appear very early in human development, much earlier than guilt. Similarly, shame appears earlier than guilt in the Judeo-Christian tradition. Adam's reaction to eating the forbidden fruit was not guilt but shame about his nakedness. The biblical Samson expresses no sense of guilt; he asks only for strength to avenge himself and to die with his enemies. By the time of Milton his guilt is the central issue. Along the same lines, suicide, the ultimate expression of unbearable guilt, does not exist in the Old Testament. The only three Old Testament figures who die deliberately are Samson, Saul, and Ahitophel. All three die as a way of either defeating an enemy or avoiding defeat. Judas is the first biblical figure to commit suicide out of guilt.

The beginning of the shift from shame to guilt comes with Moses. The Ten Commandments contain the first injunction against the purely internal, i.e., thou shalt not *covet* they neighbor's wife. It is the last of the Ten Commandments. Now the wish itself became sinful; it did not require the act. Moses was pre-prophetic. From the time of the prophets on, guilt gradually became more important as the signal of the taboo, and with Christianity it became the central issue. Samson was to liberate the Jews from the shame of their enslavement while Jesus was to save them from the guilt of their sins.

Act 3 finds Samson imprisoned, "eyeless in Gaza," turning a millstone. He calls upon Jehovah to take his life so he can atone for the misery he has brought upon his people, now again enslaved. But in an offstage chorus the Jews are unrelenting in their condemnation of Samson. The final scene of the opera takes place inside Dagon's temple where the Philistines are enjoying a bacchanalian celebration, complete with the requisite ballet. Samson is led in by a little boy and mocked by Delilah and the high priest. A sacrificial ceremony is begun. Samson is made to kneel, chained between two pillars. He sends the little boy out of the temple and then, his strength returned, tears down the pillars, crushing all inside the temple to death. It is unclear whether the return of his

strength was through God's miraculous intervention or if the Philistines had carelessly let his hair grow back.

In contrast to Samson's blindness in act 2 is the immensely colorful display of the Philistine bacchanalian celebration. Throughout the act there are numerous references to eyes, glances, and faces. Yet Samson's blindness is ever-present and overriding. The audience is both the spectator enjoying the bacchanalia and, through identification with the dancers, a participant in it. Both voyeuristic and exhibitionistic impulses are stimulated. At the same time, via identification with the blinded Samson, shame and guilt over these impulses are aroused. Fortunately we know that, unlike Samson, our transgressions are in fantasy only, and so the heightened tension serves not to make us anxious but to increase the dramatic impact of the opera.

Just as being a member of the audience has an inherent voyeuristic dimension, so being a performer has an inherent exhibitionistic one. In most ways the audience is passive while the performer is active; but the audience is doing the active looking while the performer is being looked at. Here again, via identification, each participates in the other's activity. These forces are a central component of the bond between audience and performer. That bond is one aspect of what makes a live performance more electric than a canned version.

The centrality of voyeurism-exhibitionism in the Judeo-Christian concept of sin is illustrated by Adam and Eve's first reaction to eating the forbidden fruit—they become aware of their nakedness and cover their genitals. The theme occurs again six chapters later when Ham is punished for looking at his father's genitals. To this day, in some Orthodox Jewish traditions, a son may not see his father's genitals.

Sexual exhibitionism-voyeurism is the focus of these earliest biblical examples, as it is of Freud's original study of the subject, in his "Three Essays on Sexuality." Nowadays, with a greater focus on earlier developmental phases and a recognition of the importance of shame in them, we view exhibitionism-voyeurism from a broader developmental perspective. From the earliest infantile

grandiosity there is a demand to be looked at admiringly. Every mother is familiar with the endless "Mommy look at me" of the toddler. And there is much exhibiting of physical prowess and attractiveness before sexuality becomes the central issue.

The biblical tale of Samson, and Saint-Saens's version of it, encompasses all of these: from his specialness in the eyes of God at his birth, to the flaunting of his independence and his destructiveness, to the outpouring of the singers' voices and the polymorphous-perverse bacchanalia, to the conflation of sex and power in Samson's relationship to Delilah. Similarly, blindness as punishment already exists in Genesis, when the men of Sodom are smitten with blindness. The Old Testament taboo on looking is an important component of the Jewish proscription on iconography. It stands in marked contrast to the New Testament promise, in Revelations, that the virtuous shall with their own eyes see God. Visual imagery has been a central aspect of Christian devotion, particularly in Catholic and Orthodox churches.

Because they lend themselves to intensely dramatic treatment, religious subjects and figures are quite common in opera. Prominent examples are Mozart's *Magic Flute*; Bellini's *Norma* and *I Puritani*; Meyerbeer's *Les Huguenots*; Gounod's *Faust*; Wagner's *Tannhäuser, Ring,* and *Parsifal*; Delibes's *Lakme*; Massenet's *Thais*; and Puccini's *Tosca*. Even that confirmed atheist, Verdi, put them into *I Vespri Siciliani, Nabucco,* and *Don Carlos.* Saint-Saens was thoroughly imbued with the Christian tradition, but unlike Milton he retained the earthy, flesh-and-blood, Old Testament Samson. His opera contains elements of the whole sweep of the Samson story. More than a hundred years since *Samson and Delilah* was first performed, this tale of bloodshed and revenge between Jews and Palestinians in Gaza remains popular and sadly timely.

13

Offenbach's The Tales of Hoffmann

THE IMPOVERISHED GERMAN JEW
AND THE CELEBRATED FRENCH CATHOLIC

JACQUES OFFENBACH's only grand opera was first performed in Paris's Opera-Comique theatre on February 10, 1881, four months after his death. Knowing how ill he was, he was determined to finish it, for he was perpetually haunted by the fear that the name he had made for himself through his operettas would perish utterly. But he did not live to complete it, nor are there notes to indicate clearly what he had intended in many places (most of his notes were destroyed in a fire). Thus a variety of different versions have been compiled, modified, and sometimes mauled. None can claim to be the "true" opera. It is as though fate had made Offenbach's opera as elusive as true love was to his hero, Hoffmann.

The libretto is based on a group of stories written by E. T. A. Hoffmann (1776–1822). They were converted into a play by Barbier and Carre in 1851, for which Offenbach conducted incidental music. Twenty-five years later Barbier converted the play into the libretto for Offenbach's opera.

The prologue is set in a tavern in Heidelberg, Germany. The villainous Councilor Lindorf is scheming to entice the opera

singer Stella away from her lover, the poet Hoffmann. As was customary at the time, the villain is a bass, the heroine a soprano, the hero a tenor. In each of the three acts (the three tales) the villain is played by a bass and the heroine by a soprano. The opera is most effective if one singer does all the roles, but the demands on the voice are so great that few singers can do the entire opera well, and so the parts are often split. A group of students enters, soon followed by Hoffmann who sings a song about a strange character named Kleinzach. Klein means small in German; Zach probably is an abbreviation for Zachariah, the biblical figure (from the Hebrew *zakar'Yah*, renowned God). The character is taken from E. T. A. Hoffmann's story "Klein Zaches Named Cinnabar," first published in 1819. Cinnabar is a compound of mercury, that most changeable of metals. Kleinzach (repeatedly rhymed in the song with Tric-Trac, a dice game) is described as a "deformed little creature; a hunchback with a lump for a stomach, splay feet, and a black nose." In the story he temporarily acquires magical powers, and one of his triumphs is as a violinist.

This strangely talented, mercurial, risk-taking, odd-looking, violin-playing little creature with the Jewish name cannot help but have touched a responsive chord in Offenbach. He was born Jakob Offenbach in Cologne, Germany, on June 21, 1819. Jakob grew up in an environment pervaded by the long-standing European tradition of virulent anti-Semitism. Although Constantine had granted the Jews of Cologne the right to hold office in the fourth century, with the coming of the Crusades in the eleventh century they suffered considerable persecution. When the Jews were expelled from Cologne in 1424, a number of them moved just outside the city limits to Deutz, which became a prominent Jewish settlement. Offenbach's grandfather, Juda Eberst, had lived in Offenbach-on-Main, a suburb of Frankfurt, where he had been a music teacher (his pupils included the Rothschild children). His son Isaac left home at age nineteen to become an itinerant violinist and cantor. In 1802 he arrived in Deutz, a community ideally suited for him since it was no longer just a Jewish settlement but also had become a home for much of

Cologne's entertainment industry. Censorship in the major European cities often led to the location of theatres on the outskirts, as was the case with Shakespeare's Globe Theatre, situated in the red-light district. Isaac was so often called "the Offenbacher," after his town of origin, that he dropped Eberst and took Offenbach as his last name, a not uncommon custom at the time. It was also a better stage name.

An economic slump in 1816 closed much of Deutz's entertainment industry. To feed his growing brood, Isaac had to return to his original trade of bookbinding, an occupation he detested. He decided to move the family to Cologne where he could again earn a living through music and where, three years later, Jakob was born. Isaac was a man of formidable accomplishments. Besides violin he taught flute, guitar, and singing; he was a composer who had two of his Singspiels produced; he also published a translation of the Hagaddah. Still, it could not have been an easy decision for him to leave the Jewish settlement in Deutz. Jews had only been allowed back in Cologne since 1798. Jewishness now no longer pervaded life outside the home, as it had in Deutz. He did serve again as a cantor from 1824 to 1828, but mostly he gave music lessons and played violin in taverns. Life inside the home was clearly demarcated from life outside, a split Jacques recreated in his adult life.

Little Jakob showed musical ability at a very early age and was taught the violin by his father until he was eight years old, at which time he shifted to the cello. The family was poor. The parents and their ten children (Jakob was number seven) lived in a narrow apartment facing onto a noisy alley in an area of secondhand dealers. There are numerous versions (all probably apocryphal) of how young Jakob shifted to the cello; likely he initiated it himself, for his father did not teach cello, and sending the son out for lessons cost money. At the same time, it also contained the potential for earning money, and not long after, Jakob, his sister, and older brother were performing as a trio in various bistros.

By the time he was eleven his father was passing him off as two years younger in order to market him as even more of a

prodigy. At age fourteen there was no longer anyone in Cologne who could teach him cello. His father packed up Jakob and his eighteen-year-old brother and took them to Paris. Possibly by plan, possibly because he could not find adequate employment in Paris, after three months the father returned to Cologne, leaving the two boys to fend for themselves. Although technically not eligible, he was so clearly gifted that Jakob was admitted to the Paris Conservatory of Music. His father had also obtained a job for him singing in a synagogue.

He lasted only a year at both places. The conservatory was too rigid and constricting, and he found himself a better job playing in the orchestra of the Opera-Comique. Here he was not only surrounded by more experienced musicians, he was also exposed to music not available to him in Cologne. For the two decades before his birth that Catholic German city had been governed by the French and, after their departure, by the Prussians. The cultural life of the city was at low ebb. The music young Jakob had heard outside his home was a potpourri of popular, folk, and faintly classical. As so often happens in occupied lands, satire and parody were popular, in songs as well as in street theatres and carnivals. Humor became an integral part of Jakob's way of life, and he was often fined for high jinks while playing cello at the Opera-Comique.

Through contacts in the orchestra he was invited to play in the salons of wealthy people and became popular as a cellist. He was not only a talented musician but a gifted entertainer. He imitated animal sounds and made all kinds of strange noises with his instrument. Critics likened him to Liszt and Paganini, both of whom had been supreme masters of their instruments as well as flamboyant entertainers. Besides being a humorist himself, Offenbach was also the butt of much humor. Of medium height, he had a large head, a gaunt body, a beaked nose, long, unruly hair, and a thick German Jewish accent. When he became famous, cartoonists had a field day with him.

Getting himself established in Paris was a difficult struggle. In later years he wrote about the loneliness of those times, still an

adolescent on his own in a foreign country. He would often solace himself with an eight-bar melody which had been sung to him by his mother when he was a young child. He could remember no more of it but would sing the fragment to himself over and over again. Yet he made no attempt to return to his family. It was six years before he visited Cologne again. Money surely was not the only reason he stayed away from home for so long. He was already determined to transform himself from poor, little, German Jewish Jakob Offenbach to Jacques Offenbach, quintessential Catholic and Parisian boulevardier.

In the midst of his song about Kleinzach, Hoffmann slips into a reverie about his beloved Stella. The astonished students soon bring him back to his song. After some sarcastic exchanges with Lindorf, Hoffmann agrees to tell tales of his three loves. He has already identified Stella as a combination of all three—artist, courtesan, and young girl. The prologue ends with Hoffmann announcing the name of the first of his loves, Olympia.

The Kleinzach song is the only real aria in the prologue. It is also the only moment of satire and parody in the opera. Yet until the *Tales of Hoffmann* it was as a writer of satirical operatic parodies that Offenbach achieved his fame. It had never been his ambition to make a career of being a cellist; he had always wanted to be a composer and had published his first work at age fourteen. He was to become the most famous and most successful composer of operettas the world has ever known, writing some one hundred works in that genre. But arriving there was a long, hard journey. The Parisian world of operetta was a closed society, and for years Offenbach could not get his works produced. He earned his living as a cellist, doing transcriptions and other odd jobs. At age twenty-five he fell in love with an eighteen-year-old girl of Spanish extraction. Her parents would consent to their marrying under two conditions. First, he had to prove he could support her; a successful concert tour to England as a cellist met that requirement. Second, he had to convert to Catholicism; he did and they were married. The German Jewish boy had become the French Catholic man, so much so that one French biographer wrote of

him, "It is hard to conceive of the fact that Jacques Offenbach was born in Cologne."

The first decade of Jacques's adult married life was not easy. From 1844 to 1848 the couple lived in Paris, and Jacques earned his living playing in salons and occasional concerts. His reputation as a composer was limited to his songs and some chamber music. Try as he would, he could not persuade anyone, particularly not the Opera-Comique, to mount his operettas. He even paid out of his own pocket to have one produced at a small theatre; it was a failure. Finally, in 1847, a friend produced one of his operettas, *The Alcove*. It might have been the beginning of a career, but the revolution of 1848 intervened. It was a disaster for him; he had been connected to nobility through his salon performances and had to leave Paris. The family fled to Cologne, but revolution came to Cologne too. Finding himself once more in poverty (and being a man much more given to political expediency than to convictions), Offenbach wrote revolutionary songs and changed his name back to Jakob.

Within a year, however, the revolution had failed in Cologne. Louis Napoleon had become president of France, and Offenbach was able to return to Paris and resume his former life. In 1850 his father died; that same year he became music director of a Parisian theatre. It provided him a steady income but did not lead to production of his work. In 1851 Louis Napoleon proclaimed himself emperor and the Second Empire began. Although it would ultimately prove to be the perfect atmosphere for Offenbach, for the next four years he continued to struggle. He had one brief success in 1853, but the following year he wrote to his favorite sister, Netta, "The golden future of which I dreamed is no closer. Every day hope dwindles bit by bit. I am planning to move to America." Two of his sisters had already moved there, and it was only at the last minute, after making all the necessary arrangements, that he changed his mind and stayed in Paris.

In 1855, when he opened his own theatre, his career took off. The theatre had only fifty seats, but it was quite large enough for musical comedy. That year Offenbach produced ten of his works

there. His melodic and rhythmic gifts were ideally suited to the saucy, satirical, outrageous plots he chose and perfectly fit the mood of the times. He became the emperor's favorite composer, the toast of Paris, and remained so for the next fifteen years. Most operettas are so bound to their time and locale that they do not survive for long. A number of Offenbach's continue to be played regularly. Recently a production of his *Bluebeard* closed in Berlin after twenty-nine consecutive years on stage.

He was a celebrity, welcomed everywhere, yet he remained attached to his wife and his children. His home was his castle and his sanctuary; his family was to have nothing to do with the world of his work. His four daughters were not allowed to attend performances at his theatre until after they were married. His faithful wife was not to know about his many mistresses. He went to great lengths to keep her in ignorance. Once, while traveling with his longtime mistress, the singer Zulma Buffar, he had a friend insert an announcement of an appearance by Zulma in the newspaper of a distant town, which he knew his wife would read. The connection between his work and his mistresses was not just part of his life in the real world, it was also part of his inner life. He once wrote, "Love is like the opera. One gets bored but one always returns."

Olympia, Hoffmann's love in act 1, is a mechanical doll created by the villainous Dr. Spalanzani with the assistance of the equally corrupt lens-maker Coppelius. Coppelius sells Hoffmann a set of magical spectacles that make Olympia appear alive to him. As in a dream, the fantastic now seems real to him. This idea of the fantastic as real was a central characteristic of German romanticism; it pervaded German opera, as in Weber and Wagner. E. T. A. Hoffmann was one of the founders of the German romantic movement, and his work was widely influential. Surprisingly, the fantastic, dreamlike elements of the *Tales* are far more prominent in the original stories than they are in the opera—it is rare to find an opera plot that is more realistic than what the

libretto is based upon. In drawing on four of Hoffmann's stories Offenbach was returning to the Germany of his youth, as he was in writing a serious opera, in contrast to the flippant French operettas that had made him famous.

The action of act 1 centers on the efforts of Spalanzi and Coppelius to cheat each other out of the potential spoils from the creation of Olympia. Spalanzi offers to buy Coppelius out by signing over to him a note from the moneylender Elias, whom Spalanzi knows has gone bankrupt. (Elias, the Jewish moneylender, is a traditional, stereotypical literary figure. He was also a figure from Offenbach's childhood: his maternal grandfather was a moneychanger.) Olympia spins out of the ballroom after a wild dance with Hoffmann. The act ends as Coppelius returns and in a rage of revenge for having been cheated, smashes her to pieces. Hoffmann, his magical glasses broken, realizes that his love was only an illusion, a mechanical doll.

The setting for act 2 is the world of illicit sexuality that Offenbach knew well. The act opens (and closes) with the undulating, sensuous melody of the Barcarole. The location is the luxurious Venetian home of the courtesan Giulietta, who becomes the second of Hoffmann's loves, notwithstanding his protestations that he could never fall for such a woman. She is bribed to seduce Hoffmann by the evil Dapertutto (the devil in disguise) through his offer of a magnificent diamond. Her task is to acquire Hoffmann's reflection (his soul) for Dapertutto, as she had already acquired for him the reflection of her current lover, Schlemiel.

The origins of the figure of the "schlemiel" are lost in Jewish antiquity. It may go back as far as one Shelumiel, mentioned in the Book of Numbers. Over the centuries he became a stock figure in Jewish, and particularly in Yiddish, folklore, always handling situations in the worst way possible and dogged by bad luck. He is one of the staples of self-deprecating Jewish humor. Offenbach was certainly familiar with the figure from his childhood. E. T. A. Hoffmann, however, borrowed his Schlemiel from an 1813 German novel by the French refugee Chamisso. Not Jewish himself, Chamisso, drawing on his experience as an expatriate and world

traveler, wrote a romantic tale combining elements of the Faust legend and the story of the Wandering Jew. It was Chamisso's Faust-Jew who lost his soul-shadow. In the opera the single figure is split into the Christian Hoffmann and the Jewish Schlemiel.

Once Giulietta has seduced Hoffmann and he has given up his shadow for her, Schlemiel and Hoffmann fight a duel over her. Schlemiel is killed. Both the Christian Hoffmann and the Jew Schlemiel have sold their soul to the devil for the love of a courtesan. One cannot help but wonder what it meant to Offenbach that, at the end, the Christian Hoffmann is saved while the Jew Schlemiel is doomed. Perhaps he had Giulietta say it for him: "What fools these men of genius are." The act ends with Giulietta accidentally drinking poison intended for Hoffmann's companion Nicklausse, who drags Hoffmann away to forestall his being apprehended for the murder of Schlemiel. In another, less satisfactory version of this act Giulietta sails off in a gondola with her new lover, the dwarf Pitichinaccio.

Pitichinaccio, like Kleinzach, is physically deformed. Although of average height, Offenbach was not just thin, he was emaciated, never weighing more than ninety pounds. Modern psychiatry, with its regrettable tendency to diagnose by clusters of symptoms, would undoubtedly say he suffered from anorexia nervosa. That illness rarely affects men, appearing predominantly in adolescent girls; it is characterized by a persistent aversion to putting on weight. Offenbach was notorious for only picking at his food. After just a few mouthfuls he would push it away and light another cigar. Cigars, besides being available in every room in his house for the use of guests, also filled a fifteen-drawer cabinet reserved for his use only. He once said of himself, "I have three passions: cigars, women, and gambling."

Anorexia is also characterized by a compulsion to ceaseless activity, usually in the form of exercise. In Offenbach it took the form of ceaseless work: he composed everywhere—at home, in bistros, while riding in his carriage. He could not work when music was being played, otherwise nothing distracted him. Indeed, he preferred working with lots of activity around him. He could

not tolerate being alone. He was also a perfectionist. His manuscripts are remarkably neat and clean; he never went out without being impeccably and fashionably dressed; he was fanatical about punctuality, constantly taking out his watch to check the time. Everything about his productions had to be perfect. When the covering of a seat in his theatre was torn, he had the entire theatre redone in expensive velvet. Cost was no object in either his business or personal life; he was a terrible money manager. Fortunately his wife was extremely frugal and was often—but not always—able to stave off financial disaster.

The financial misfortunes were recurrent. When Offenbach's operettas were successful he made a great deal of money, but he would squander it on extravagances and gambling. A failure would then plunge him into bankruptcy. There were times when he had to stay out of Paris lest creditors seize him.

In his thirties Offenbach began to suffer from increasingly troublesome arthritis. Outbreaks of severe joint pain plagued him for the rest of his life. Sometimes, unable to walk, he would be carried around in a chair. Sometimes he could hardly hold a pen. Emaciated as he was, he was extremely sensitive to cold and, particularly in his later years, would sit swathed in blankets, even in warm weather.

His roller-coaster life continued until 1870 when disaster struck again. France and Germany went to war, and once again (like the operatic Hoffmann at end of act 2 and like the real E. T. A. Hoffmann) Offenbach was forced to flee. His wife took the children to her native Spain. He traveled from Austria to Switzerland to Italy. He was German by birth, was famous, and had enemies. He was accused of being "a Prussian at heart" and of having contributed to France's defeat by undermining French discipline through his frivolous music which had "opened for Bismarck the way to Paris." Only this time he neither could nor wished to go to Germany, where he was publicly attacked for supporting France.

Despite his exile, Offenbach remained a staunch French patriot: "Ah! what horrible people these Prussians are and what a grief for me to think that I was born on the banks of the Rhine and am

linked in any way with those horrible savages! Ah! my poor France, how I thank her for having adopted me among her children." Being German had been a "grief" to him for a long time. Starting in the 1850s he had become increasingly anti-German, especially anti-Cologne, even trying to prevent the production of his operettas in his native city.

Much as he liked to think the French had adopted him, at best they were foster parents. He could never be truly a part of the family. As soon as family problems arose he was excluded—and the French family was having troubles. As seemed to be their wont, whenever their monarch was deposed they squabbled among themselves. After the 1870 defeat by Germany, another commune was set up in Paris. Chaos ensued and within a period of weeks 25,000 Frenchmen fell at the hands of their compatriots.

1870 was the only year in his career as an operetta composer that Offenbach did not write a single operetta. Nor were things much better when he returned to Paris in 1871. He was no longer the king of operetta, having been replaced by Lecocq and Strauss. He enjoyed occasional successes with new works and revivals, but he was as extravagant as ever and by 1875 was again bankrupt. Only a lucrative trip to America in 1876 restored his finances. Thereafter he wrote only one more really successful operetta, in 1879, the year before his death. Much of the time in these last years he was ill and in great pain.

The sickness and untimely death of the artist is the subject of act 3 of the *Tales*. There are four main characters in the act: the young singer Antonia, her loving father Crespel, the evil Dr. Miracle, and Hoffmann. Crespel is afraid that if Antonia continues singing she will die, as her mother had, and that if her lover Hoffmann returns that is exactly what will happen. The slightly deaf, incompetent servant Frantz, however, lets Hoffmann into the house. Hoffmann and Antonia sing a love duet and then, rather than leave, Hoffmann hides behind a curtain while Antonia retires to her chamber. When the evil Dr. Miracle, under whose "care" Antonia's mother had died, appears, Hoffmann understands the situation. Dr. Miracle diagnoses the absent An-

tonia to Crespel's rage. Crespel finally succeeds in getting Dr. Miracle out of the house. Hoffmann persuades Antonia to promise not to sing again. But Dr. Miracle magically reappears through a wall and, seizing Crespel's violin and conjuring up the voice of Antonia's mother, gets her to sing until she drops dead.

The greatest dramatic intensity in the opera is to be found in act 3. All four characters represent powerful aspects of Offenbach's inner life. Antonia and Hoffmann reflect two of his self-images. The setting is Munich, Antonia is German. A serious musician, she is sickly, feminine, weak, and tied to her long-dead mother. She reflects Offenbach as a little boy. E. T. A. Hoffmann, the worldly writer of fantastic tales with thinly veiled, biting social commentary, reflects the adult Offenbach, the celebrated composer of operatic satires. The operatic Hoffmann has been out of the country for a long time. In the aria that opens the act, Antonia sings of the turtle dove who has flown far away but who knows that he still loves her. Antonia and Hoffmann are the child and the adult reunited at long last, but too late.

Crespel and Dr. Miracle are two father figures, the one loving, the other murderous. They reflect two images Offenbach had of his father, images he never was able to integrate. In E. T. A. Hoffmann's original story the two images were combined in the figure of Crespel while the doctor played an insignificant role. Offenbach wrote them as two very separate figures. He could not integrate them but identified with both. Inside his home he was the devoted, loving husband and father who let only his wife see how anxious and depressed he often felt. Outside he was the promiscuous, gambling, irascible celebrity. Most likely his antipathy toward Cologne, his reluctance to having his operettas performed there, which became so marked after his father's death, was the consequence of this unresolved conflict. Only toward the end of his life did he begin returning to Cologne voluntarily. At the same time Dr. Miracle is also the one urging Antonia to sing like her mother, "the greatest singer in Germany." He is the force in Offenbach that keeps him working on his opera until it kills him. He is the father that abandoned him in Paris at age fourteen.

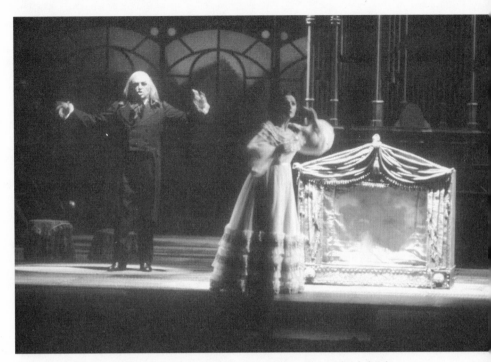

The Tales of Hoffmann: Dr. Miracle induces Antonia to sing, which both know will lead to her death.

That Dr. Miracle harms his patients is not surprising. Even at the end of the nineteenth century, medicine had little real treatment to offer those to whom it ministered. It probably harmed as often as it helped. Not until the mid-twentieth century, with the advent of antibiotics and a sophisticated understanding of biochemistry, could physicians claim an ability to treat many diseases successfully. Opera is full of physicians, ranging from Mozart's and Rossini's Dr. Bartolo, who is merely a foolish incompetent, to Donizetti's Dr. Dulcamara, who is a quack, to Berg's and Offenbach's doctors, who are evil personified. A benign, competent physician is not to be found among them.

Dr. Miracle reflects both the fantastic and the scientific. In the romantic era art and science were not regarded as two separate spheres, as they have been for most of the twentieth century.

Knowledge of one was seen as enhancing knowledge of the other. Erasmus Darwin expounded his scientific theories in verse; Words-worth, Coleridge, and Shelley all owned microscopes. Nowadays only the sciences of mathematics and physics seem to retain the connection, as in their use of "beauty" as one criterion of the validity of a theory. Serious modern music and art have, to a large extent, moved so far away from the world as we apprehend it that they are incomprehensible to most people. Something important has been lost in the process.

At the end of act 3 of *Tales* Antonia is dead, as was Olympia in act 1 and Giulietta in act 2. In fantasies, as in dreams, loss of love is equivalent to death; this being nineteenth-century opera, it is the woman who dies. In real life, loss of love is merely loss of love. And so it is in the epilogue, when Hoffmann is back in the tavern with everyone in exactly the same place they had been when the curtain fell on the prologue. His tales over, Hoffmann and the students decide to return to the more rewarding enterprise of getting drunk. Lindorf goes off to claim Stella. Hoffmann, left alone, renounces his love for Stella as his Muse appears to him. She offers a higher form of love. As the opera ends, Lindorf and Stella leave Hoffmann who has fallen into a drunken sleep.

Offenbach knew he was dying when he wrote his only opera. Returning from a last visit to Cologne he pleaded with the director of the Opera-Comique to hurry with the production: "I have only the one wish, to see the premiere." After three decades of writing satirical French operettas he had turned to the German romantic E. T. A. Hoffmann for his one serious opera. But just as Offenbach had at last managed to give up his persona as the French satirist to write a serious German opera, so Hoffmann had given up his wish for the flighty Stella and returned to his original love, his Muse. In renouncing Stella for the Muse, Hoffmann was helped by two people, Nicklausse and Lindorf.

Throughout the opera Nicklausse is Hoffmann's faithful com-panion and his voice of reason. He unfailingly tells Hoffmann that the women he chooses will lead him not to blissful, passionate, requited love but to hopelessness and self-destruction. Nicklausse

is a trouser role; he is both man and woman, without his own sexual interests. In him Offenbach saw himself as a happy preadolescent, loved and valued by his family. Nicklausse may also have contained elements of Offenbach's young son, whom he adored and who had the same special place in his father's heart as Offenbach had at the same age.

In the epilogue Lindorf takes Stella away from Hoffmann, just as Spalanzi, Dapertutto, and Dr. Miracle had taken his three loves from him. He passionately desires them, but to possess them would have destroyed him. That these hateful father figures save Hoffmann from himself is not as paradoxical as it seems. The fourteen-year-old Offenbach must have had mixed feelings about the father who on the one hand lovingly brought him to Paris, recognizing his son's great gifts, but on the other left him, just barely an adolescent, to fend for himself in an alien world. Children tend to explain the world in terms of themselves. When deserted by a parent they "understand" it to mean that they have been bad and that the parent hates them for it. Offenbach spent forty-five years "showing" his father he didn't care. He wrote frivolous comedies instead of graduating from the conservatory and becoming the classical musician he was expected to become. He renounced his German identity for a French one and his Jewish identity for a Christian one.

It was the exceptional Jew who was accepted into nineteenth-century European society, and that acceptance was always tenuous. Because academic careers were generally foreclosed to them, fields where success could be achieved purely through individual effort, such as music, were likely areas for Jews. Meyerbeer and Mendelssohn were also Jewish, but they both came from wealthy Berlin families and had grown up in an assimilated atmosphere. (Mendelssohn's family had converted to Christianity.) Offenbach traveled a much longer road, from an almost ghettolike background to hobnobbing with royalty. Although he strove mightily to be accepted, and was in many ways very successful at it, his

dimension as an outsider remained integral to his success. All his operettas were satirical; they parodied the mores and structures of society.

The Christian faith that Offenbach adopted was the bedrock upon which the edifice of Western art and Western science were erected. The Christian deity who says "trust in me," who says "the truth shall set you free," was essential to the confidence that the world was accessible to rational analysis which made scientific inquiry a worthwhile undertaking. It took a thousand years, from Augustine to Copernicus, for that confidence in a rational deity to become sufficiently imbued in the Western mind as to produce the explosion of scientific progress that came with the Enlightenment. The logical, rational world created by the Christian deity could be studied because the world was predictable, and predictability was the basic paradigm of Western science until the mid-nineteenth century.

By contrast, the Jewish deity, the God of Job, fostered a very different kind of thinking. God says to Job, "Can you find out the purpose of the Almighty?" and "Where were you when I laid the foundations of the earth? Tell me if you have understanding?" Such a worldview precludes a science that postulates a predictable world, and Jews made few significant contributions to Western science before the nineteenth century. Similarly the Jewish taboo on iconography resulted in no great Jewish painters until the end of the nineteenth century. Indeed, until very recently every one of the Jews who made a significant contribution to the Western world had abandoned formal Judaism. Spinoza, Heine, Mendelssohn, Marx, Disraeli, Freud, Mahler, Einstein, Trotsky, Kafka, Wittgenstein, Schoenberg—not one of them remained religious. What they all brought to their work was a profound understanding of the Christian world in which they lived while they retained the deep skepticism of their Jewish heritage.

This very Jewish acceptance of unpredictability, combined with the Christian-based scientific method, was precisely what was needed for scientific progress beginning in the mid-nineteenth century. It seems an unlikely coincidence that of the four most

influential minds of the century, Darwin, Marx, Freud, and Einstein, only Darwin was not an assimilated Jew. Certainly their partial outsider status was a factor. Recently assimilated groups often strive harder for achievement, and their status allows them to take a different perspective. As outsiders often do, all three also worked alone—Marx in the library of the British Museum, Freud in his office, unable to get an academic position, and Einstein while earning his living in a patent office.

But I believe there was another, deeper reason for their unique achievements: they were not just assimilated outsiders, they were all specifically Christianized Jews. Marx had converted at age six, Freud had been raised in his earliest years by a deeply religious Catholic wet nurse, and Einstein had gone to Catholic schools throughout his early education. All three were geniuses who shared a common background, one containing both Christian and Jewish worldviews. At the particular time in history when they lived, that combination played a significant role in their capacity to make such extraordinary contributions. It seems unlikely that the Jewish contribution to the Western world will ever again reach the peak it did in the century between 1850 and 1950.

In music, Mahler and Schoenberg are examples of creative geniuses who embodied the same mixture of Christian and Jewish traditions. Offenbach never reached that level of creativity in his operettas. He could only humorously parody the world in which he had chosen to live. He was an innovator, but one would hardly rank him among the greatest composers. Not that he did not have the ability. Nietzsche said of him, "He could have been a Mozart." But, unlike Marx, Freud, Einstein, Mahler, and Schoenberg, Offenbach's primary motivation was to be accepted in the Christian world. He wrote his operettas for audience approval more than out of artistic conviction. And he got what he wanted. Unfortunately, in Oscar Wilde's apt phraseology, there is only one thing worse than not getting what one wants, and that is getting it. Offenbach sacrificed his creative potential to his wish for acceptance. Only at the very end, in the *Tales of Hoffmann*, with

its return to the symphonic musical style of his native Germany and its many allusions to Jewish figures, did he allow himself to reach deep inside, include all of himself, and create a great work of art.

14

Verdi's Otello

LOVE AND HATE, WORDS AND MUSIC

THE OPERA does not start, it explodes upon us with a screaming, dissonant chord. Otello's ship is trying to enter the harbor of Cyprus in a wild storm. The chorus wavers between lamentations that he will crash upon the rocks and prayers that he will make it home. Only Iago mutters that he hopes Otello drowns. At last the ship makes safe harbor and Otello makes the grandest entrance in all of opera. Standing high on the ramparts he sings, "Rejoice! The Muslim's pride is buried in the sea." The crowd hails their hero and gloats over the slaughter of their enemy. Otello is master of all that lies before him, of men and of nature. The world obeys his will.

W. H. Auden, following Schopenhauer and Nietzsche, defined opera as "an imitation of human willfulness." Shakespeare's play, as well as Verdi's opera, is a study of how Otello's spontaneous, emotional willfulness is converted from mastery to self-destruction by Iago's controlled, scheming willfulness.

In romantic opera the willfulness of man and nature complement each other. Storm scenes were used in many operas—Rossini used them in *The Barber of Seville*, *La Cenerentola*, and *William Tell*, and Verdi had already used one in *Rigoletto*. In *Otello*

there immediately follows a chorus about another of nature's violent forces, fire. Now Iago enlists Roderigo in his scheme to bring down Cassio, whom Otello has just appointed as his captain, a position Iago expected. Goading Cassio to consume more and more wine, Iago and Roderigo provoke him into a quarrel. Now a human violent force, drunkenness, leads to a wild melee in which Cassio wounds Montano. The noise arouses Otello from his bed; incensed with Cassio for his behavior, Otello demotes him and tells Iago to restore order. All this takes place in less than twenty-five minutes.

The speed of the opera's opening contrasts sharply to the slowness of its gestation. Its premiere took place on February 5, 1887, at La Scala in Milan. Verdi was seventy-three years old; it was the first performance of a new opera by him since *Aida* in 1871. Although he had written the Requiem and revised both *Don Carlos* and *Simon Boccanegra* in the intervening years, many thought he would never write another opera. When his friend, the Countess Maffei, suggested he had a duty to write more, he replied, "Are you serious about my moral obligation to compose? No, no, for you know as well as I that the account is settled." Four other people also thought differently: his wife, Giuseppina Strepponi; his publisher, Ricordi; the composer-conductor Faccio; and the composer-librettist Boito. The first three of these conspired to bring Verdi together with Boito after seventeen years' estrangement. Boito was undoubtedly in on the plot, for within three days of the meeting, which took place in July 1879, he presented Verdi with an outline of a proposed *Otello*. Verdi had been a proud, touchy, and stubborn man all his life. He was now almost sixty-six years old, and age had not yet mellowed him. He liked the scenario for the opera that Boito showed him, but he would not commit himself to writing the music and refused to meet further with Boito to discuss it. Instead he suggested that Boito complete the libretto and mail it to him for his consideration. This was done in November, but Verdi did nothing with it for eight months, and when he began work on it the next year, the collaboration did not go smoothly. Ricordi wisely suggested an

indirect approach: Boito should first revise the libretto for Verdi's failed opera *Simon Boccanegra*. That collaboration worked well, and when the revised version was performed in March 1881 it was a great success.

But Verdi was still not ready to commit himself to *Otello*. Instead he worked on a revision of *Don Carlos*. Not until 1884 did he seriously turn to writing *Otello*. Now, except for one eight-month interruption during which Verdi again would not speak to Boito, the collaboration went smoothly. He took great pains with the opera. In order to memorize the whole libretto, he wrote it out by hand several times. The music was written so that it would fit with the sound and rhythm of every word, of every phrase. The stage directions were worked out in great detail and were later published separately by Ricordi. When the opera was finally finished in 1886, Verdi was pleased with the result. Still, he remained anxious. Less than two months before the premiere he wrote to Ricordi regarding his choice of the singer for the part of Iago, "My meeting with Maurel has convinced me (although he will do it well) that nobody will ever perform and sing Iago as it should be done.... And I deeply regret having written that part! And also...the opera!!" He insisted on full control over everything, including the right to cancel the first performance if he was not satisfied with the dress rehearsals. But the rehearsals went well, Verdi participating with the vigor, energy, and enthusiasm of his younger years. The premiere, with Faccio conducting, was a triumph. The second cello part was played by a young Italian musician named Arturo Toscanini. It had taken more than seven years, but the result was the greatest Italian operatic tragedy ever written.

Why did it take Verdi so long? Why had he not written an opera for sixteen years? He had always had a depressive side to his personality; certainly it was more prominent in these years, as is clear from the gloomy tone of much of his correspondence. But he remained active throughout this time, albeit mostly in managing his estate and trying to ensure that productions of his operas were of high quality. There is no evidence of the lassitude, the loss of

energy that characterizes a real depression. Nor is there any evidence of depressive feelings of self-devaluation and guilt. This period in Verdi's life is best described not as one of depression but as one of great sadness.

He had many reasons to be sad. He was losing much of what had mattered most to him in his life. Old friends were dying off. The industrial revolution that had swept northern Europe had left agricultural Italy behind. Her economy was in bad shape and the political situation was no better. In even worse shape was the one thing that mattered most to Verdi, Italian opera. While French and German opera were flourishing, Italian opera languished. With the exception of Verdi, it had in fact been languishing for a long time. Were it not for Verdi's works, Boito's *Mefistofele* and Giordano's *La Gioconda* (with a libretto by Boito) would be the only Italian operas written between 1843 and 1890 that are still in the current repertory. And neither of these is of the quality of any of more than a dozen Verdi operas.

Thus for decades Verdi felt very much alone. And when *Otello* was finished the old sadness returned: "Since *Otello* now belongs to the public, it has ceased to be mine, it has become totally detached from me; and the place that it occupied within me was so great that I feel an enormous void, which I think I shall never be able to fill." Were it not for Boito, who ranks as one of the greatest librettists, Verdi would probably never have written another opera. Verdi had not counted on Boito's persistence. One last time, by getting him to write *Falstaff*, Boito helped Verdi fill his sense of emptiness.

Shakespeare, Boito, and Verdi built into the figure of Otello the potential for the kind of emptiness and vulnerability that Verdi himself was feeling. Nonexistent in the beginning, its visibility increases as the plot develops. It is first made explicit in the great duet between Otello and Desdemona that closes act 1. They speak of how she loved him "for the dangers I had passed, and I loved her that she did pity them" (Boito took the words verbatim from Shakespeare). Desdemona's sympathy for him made her more lovely and relieved his "darkness" with "glory, paradise, and

the blessings of the stars." In the course of the opera, as he becomes more doubtful of her love, that "darkness" descends over him.

As a basis for love, Desdemona's admiration for the danger Otello has passed, and his need for her pity, form a shaky foundation for a marriage. Furthermore, she is white while he is black. Although his blackness is emphasized more in the play than in the opera, continental audiences did not need to be reminded of the dangers implicit in his being a Moor. The real threat of an invasion by the Ottoman Empire remained. That they had once reached the outskirts of Vienna had not been forgotten, and until 1878 they continued officially to rule the Balkan states. The Muslim presence there continues to be a source of fear and conflict to this day.

In the play Desdemona has secretly married Otello, against her father's wishes. Iago points out to Otello that as she had deceived her father, she could well deceive her husband. He is much older than she; he is an uneducated warrior, lacking in social graces. She is the daughter of a Venetian senator, he rose from slavery. She is a gentle, sheltered girl, he is a rough warrior, accustomed to the company of violent men. Otello becomes concerned about these issues: "Maybe she is lost because I do not lay the subtle snares of love, maybe because I decline into the vale of years, maybe because I have on my face this dusky hue." The marriage is vulnerable from the start. That, paradoxically, she is the stronger of the two is revealed in their act 1 duet when, overcome by his feelings, Otello falls to the ground. Bending over him, she helps him up. The curtain falls on the act as dawn rises and the still blissful couple returns to bed.

Act 2 is built around three sets of conversations, with a set piece at the end of each. The first conversation is between Iago and Cassio. Iago, pretending to be Cassio's friend, convinces him that the way to get back into Otello's good graces is to have Desdemona plead his case with Otello. Iago, not altogether incorrectly, describes her as "our commander's commander." Iago then sings his aria "Credo," in which he describes his total

nihilism, his view of himself as the embodiment of the evil that is man's true nature. The second conversation is between Iago and Otello. He brings Otello to observe the meeting between Cassio and Desdemona that he has set up and, while pretending to be Otello's friend, plants the seed of suspicion that Cassio and Desdemona are lovers. When Desdemona enters she immediately asks Otello to forgive Cassio, feeding the flame of his already smoldering jealousy. There ensues a quartet of the three principals and Emilia, Iago's wife.

In an interlude amidst this second part of the act, a chorus sings Desdemona's praises. It is the most static moment in the opera, but, as is clear from Ricordi's production book, the action is to be maintained by pantomime movements by Iago and Otello. The third conversation is again between Otello and Iago. Pretending to soothe Otello, Iago suggests that he has seen Desdemona's handkerchief in Cassio's possession and that Otello could test her fidelity by asking her for the handkerchief—which Iago already has in his possession. The act ends in an intense duet between Iago and Otello in which they swear fealty to each other in a vow of vengeance.

The plot of act 2 follows very closely Shakespeare's act 3. By omitting act 1 of the play Boito accomplished two purposes: he shortened the libretto, which could not possibly encompass all the words of the play, and he made each act follow almost immediately upon the previous one. The entire action thus takes place on one day, which contributes to the dramatic continuity and intensity of the opera. Such plot alterations are, of course, common when a story is used in a different artistic form. Shakespeare did the same thing when he drew the plot for his 1604 play from a story, "The Moor of Venice," written in 1565 by Cinzio Giraldi.

One of Shakespeare's most important changes was to alter Giraldi's source of Iago's rage at Otello. In Giraldi's story Iago is in love with Desdemona. In Shakespeare's version Iago is concerned only with men. He has nothing but disdain for women; he even kills Emilia at the end. The change allowed Shakespeare to con-

vert what had been a rather stereotypical love story into a complex psychological study of jealousy, suspiciousness, and paranoia. But these three feelings do not spring only from issues of hetero-sexuality. They also involve powerful elements of unconscious homosexuality. The opera is more about the love/hate relationship between Otello and Iago than it is about the love/hate relation-ship between Otello and Desdemona.

Nowhere in opera is homosexuality dealt with openly. In one sense this is not surprising inasmuch as the social, moral, and legal strictures against it were so pervasive in nineteenth-century West-ern society that composers would have had a hard time finding something already written on which to base their libretti. On the other hand opera had always been the medium par excellence for dealing with taboos. Murder, torture, and rape pervade opera. Most of the *castrati*, who dominated the operatic stage for so long, were homosexuals, so the world of opera was well acquainted with the reality of homosexuality. Indeed, the connection between music and homosexuality has ancient roots. The Chinese Emperor Shin (2255 B.C.E.) is quoted as having said, "Let the music follow the sense of the words; keep it simple and ingenuous. Vain, empty, and effeminate music is to be condemned." And in the Greek myth of Orpheus, when he is slain, his head and his lyre float to the isle of Lesbos.

Although moral strictures against homosexuality have been more stringent in the Judeo-Christian tradition than in some others, the vast majority of societies have had such a taboo in one form or another. To be this pervasive, a taboo must either serve an important social function or have deep roots in human nature. Since homosexuality differs from murder, torture, and rape (in that it does not involve a powerful person abusing a weaker one, as these other pervasive taboos do), its taboo does not have the same social function. Its origins are, instead, deep-rooted in human nature. For *Homo sapiens* is a bisexual species, both physiolog-ically and psychologically. And because sexual identity is a critical

dimension of most people's sense of identity, a threat to that sense of themselves is powerfully feared.

Why most people have a clear heterosexual identity while a few are bisexual and some are homosexual remains a subject of dispute. Almost all observers, including Freud, agree that a genetic-biological component is involved, though Freud emphasized psychological/developmental aspects more than most investigators. Regardless of how its source is understood, there is general agreement that all people, even those most clearly heterosexual in their interests, have a contrasexual element in their unconscious makeup. In most people that element is sufficiently integrated and defended that it poses no threat under normal circumstances. But the need to keep it out of conscious awareness persists, hence the taboo.

Because most studies of homosexuality have, at least until very recently, been written by men, the relationship between jealousy, paranoia, and unconscious homosexuality has mostly been dis-cussed in relation to men. But both Freud's first case discussion of the issue, as well as Fourier's (published a century before Freud's), involved women. It is the misfortune of paranoiacs that their defenses against the breaking-through into consciousness of their unconscious contrasexual impulses are fragile. In this sense the paranoiac is right: there *is* something out to get him. Only that something is not in the outside world but is his own unconscious homosexual wish that threatens to overwhelm his conscious sense of sexual identity.

When Iago says to Otello, "Beware, my lord, of jealousy," he knows exactly what he is doing. He knows that Otello needs the image of Desdemona as loving only him to maintain his sense of masculinity. In Shakespeare's words, by making Otello jealous, Iago intends to drive him "even to madness," as he makes the "Moor thank me, love me, and reward me." On the conscious level Iago is manipulating Otello for revenge; on the unconscious level he truly wants Otello to love him. For, all his protestations to the contrary, Iago, like all other human beings, wants to be loved, particularly by the person in the world whom he most

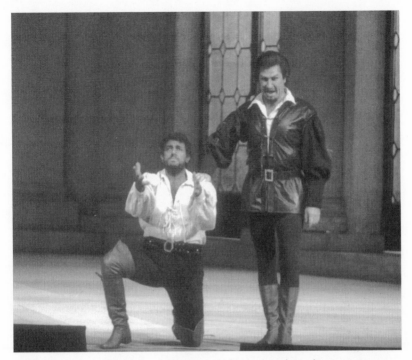

Otello: Iago's evil scheming has succeeded in giving him dominance over
Otello.

admires. Otello is Iago's ideal. Iago is explicit about why he is so
enraged at being passed over for Cassio. He considers Cassio to be
a "foppish captain." Cassio is an educated man while Iago, like
Otello, has come up through the ranks in "a hundred well-fought
battles." On some level Iago understands that the reason he is
only an ensign, while Otello is the general, is that Otello has the
wisdom to pick Cassio as his captain, something Iago would never
have done. He both loves and hates Otello. He is the torturer who
both loves and hates his victim. At the beginning of the long
dialogue between the two of them that ends act 2, Otello still
wavers between faith in Desdemona and faith in Iago. By the end
of their conversation Iago has succeeded in inducing a state of
paranoid jealousy in Otello.

Iago is the mirror-image of the paranoiac. Instead of the

persecuting force being experienced as outside himself, he has identified with it: he is the persecuting force. In their closing duet Otello and Iago jointly swear revenge. Now Otello is no longer the passive victim but becomes the active avenger. He has become like Iago, and Verdi underscores this by giving them identical lines. The words of their oath are, "I swear by the marble heavens, by the forked lightning, by death and the destructive sea." Verdi is reminding us that, right from the beginning of the opera, the external storms were allegorical for the internal storm of jealousy.

Verdi revered Shakespeare, whose plays and many of whose sonnets are pervaded by the theme of jealousy. The theme also hangs over Verdi's operas, particularly after 1848. Of the fifteen operas he wrote after that date, in only one, *I Vespri Siciliani*, is it not a central issue. Some have speculated that this reflects his relationship with Giuseppina Strepponi. He was such a private man that we do not know if he was jealous of her rather notorious life before he met her. We do know that she was jealous of him. Whether or not she had reason for her jealousy also remains unclear. Over and above Shakespeare's and Verdi's personal predilections toward jealousy, it was a common theme in all nineteenth-century Italian opera. Romance is the framework, but most of the substance of the operas is often devoted more to jealousy and its consequences than to romance. *Otello* is in good company.

In act 3 Iago completes his destruction of Otello's integrity. No longer troubled only by doubts, Otello cannot control himself. What had been an internal struggle is brought into the open for all to see. The act opens with a brief orchestral introduction which starts softly, gradually rises to a crescendo around variations on the theme that had accompanied the introduction of the jealousy issue in act 2, and then falls again to a pianissimo as the curtain rises on Iago setting up Otello to eavesdrop on Cassio. Desdemona enters, and despite her protestations of innocence Otello cannot contain his rage. When he has chased her out Otello next eavesdrops on a conversation between Iago and

Cassio. Able to hear only half of what is said, and primed by Iago to interpret everything as Iago wishes him to, Otello becomes fully convinced of Desdemona's infidelity.

The ambassador from Venice now arrives with his entourage. As Otello publicly rages at Desdemona, all are shocked at the change in him, yet they still view him as the heroic leader he had been. In a fury he sends them all away and, overcome by his emotions, falls to the floor in a convulsion. As the offstage chorus once more hails him as the Lion of St. Mark, Iago leans over the prostrate figure and gloats, "Behold the Lion." Toward the end of act 1 Desdemona is bending over a prostrate Otello, overcome by his love for her. At the end of act 3 it is Iago who is standing over the same prostrate Otello, now overcome by his rage at her and, on the unconscious level, his love for the man now standing over him.

With the greater staging flexibility offered by the medium of film, Zefferelli, in his version of the opera, places the chorus, singing of the heroic Otello, high on the ramparts. Iago, singing of the collapsed Otello, is in the lower regions of the castle. Similarly, Verdi has the tenor voices of the chorus ranging up to a G an octave above middle C, while Iago goes all the way from an E-flat above middle C down to a B, an octave below middle C. The chorus sings the pure interval of tonic and fifth while Iago sings a complicated chromatic line of indeterminate tonality. Visually, vocally, and musically, we are simultaneously located in the stormiest depths of Otello's unconscious and in the uppermost levels of his conscious mind. Iago speaks for the self-obsessed, abnormal, fragmenting Otello, the chorus for the realistic, healthy, heroic man.

One of Freud's brilliant insights was to realize that the concept of "normal" was an abstraction, or, to borrow the terminology of the sociologist Max Weber, an "ideal type." That is, it exists only as a concept, never in reality. In Freud's language the highest level of personal integration and social adaptation a person can attain is

"normal-neurotic." In the complicated process of growing up, everyone develops unresolved conflicts, utilizes inadequate defense mechanisms, and retains unrealistic fantasies. Childhood wishes for omnipotence, for total dependence and total autonomy, for instant gratification and the like are never completely abandoned. The extent to which they interfere with ordinary living varies greatly, from the normal-neurotic to the psychotic. Their omnipresence is the origin of the universal fear of one's own unconscious; the potential for their overwhelming us is always there. Otello had achieved a high level of personal and social integration. But the foundation upon which it was built was fragile, and under the impact of Iago he became overwhelmed by his unconscious conflicts.

One of Freud's greatest errors was to see psychoanalysis as a value-free enterprise. The idea that science involves the value-free observation of facts, though now largely abandoned (by philosophers of science, if not all scientists themselves), was still the prevailing view in Freud's time, as it had been since the seventeenth century. A popular misconception is that Freud believed in "sexual freedom." In fact he opposed existing hypocrisy about sex, but by no means was he an advocate of sexual license. The value system that runs through his work is one based on the quality of human relationships. Although he never spelled it out, a person's capacity for relationships can be assessed along four dimensions: the capacity to sustain a relationship over a long period of time without ambivalence; the capacity to see other persons as individuals in their own right, without the need to manipulate them; the capacity for empathy; and the capacity for intimacy.

As with the concept "normal," these four capacities are ideal types. The best, most enduring marriage is never without ambivalence. The most respectful relationship will contain manipulative elements. At times of stress, empathy is never at its greatest. And there is no such thing as unqualified intimacy. Nevertheless, the degree to which a person possesses these capacities will determine the quality of his or her relationships. While derived from Freudian psychoanalytic psychology, these four capacities turn out to be

applicable to any of the other major psychoanalytic psychologies, Jungian, Adlerian, Kleinian, Rogerian, or Kohutian, though each will have a slightly different emphasis.

More than most of the others, the Freudian view emphasizes the importance of sexuality in intimacy. Since at least some homosexual relationships meet the four criteria, the status of homosexuality has remained a subject of dispute. An objective dis-cussion of the issue continues to be clouded by religious and political questions of intense controversy. Where homosexuality fits on a spectrum from "most normal" to "most psychopathological" will probably remain an unsettled issue for a long time to come. Since overt homosexuality exists in a significant proportion of the population (estimates range from 2 to 10 percent), it is a matter of no small importance.

Verdi, more than any other operatic composer except Mozart, was primarily interested in the complexities of human relation-ships. It was why he was so devoted to Shakespeare, who had the same focus. But Shakespeare assured that his *Othello* should also be understood in religious terms: the word "devil" (or variants thereof) occurs twenty-seven times and the word "heaven" forty-nine times, both more often than in any other of his plays. Desdemona is the embodiment of good, Iago the embodiment of evil, and Otello is everyman, caught in between. Because in opera (particularly in tragic opera) everything is writ large, these quali-ties are more exaggerated in the opera than in the play. Verdi was explicit about wanting it this way: "Copying reality is a nice business, but it is photography, not painting."

Verdi distinguishes between his three main characters musically: Desdemona sings simple, flowing lines; her harmonies are almost never dissonant, her cadences are clear and predictable. By con-trast, Iago's lines are jagged, chromatic, irregular, his cadences sudden. At the same time Boito gives Desdemona rhymed phrases in regular meter. By contrast Iago's phrases are unrhymed and irregular, as for example in his "Credo." In explaining to Verdi his

intent in writing the words to the "Credo" in "broken meter and without symmetry," Boito stated that it would make it "wicked." Verdi's accompaniment is equally disjointed, with a mixture of densely packed chromatic sonorities and little turning figures. The "Credo" has no antecedent in Shakespeare. The violence of its words and music are Boito's and Verdi's distillation of Iago's evil nature, which Shakespeare had scattered through his play. Otello's words and music contain some elements characteristic of Desdemona's and some of Iago's. He is at his most lyrical, most rhythmical and sequential at the beginning of the opera, before he comes under Iago's sway. As he becomes more conflicted and disorganized, his music becomes less regular, more chromatic and dissonant.

The tragic mood of the opera's last act is set by a mournful melody, played first by the English horn, then by the flutes, in the short prelude before the curtain rises on Desdemona's bedroom. The setting is dark, claustrophobic. Verdi wrote, "My opera is a drama of passion, not a spectacle; it is almost an intimate drama. I even intend to reduce the size of the Scala [Milan] stage for the last act. I fear that the Opera stage will be too vast for *Otello*." The act is in two parts. The first involves Desdemona and Emilia, her maid. The second involves Otello and Desdemona. In her opening conversation with Emilia, Desdemona makes known her premonition of death. She sings two big arias, the first about a deserted maiden who cries, "He was born to his glory and I to love and to die." The words recall those of the love duet that closed the first act. The second aria is an Ave Maria. In between the two arias Desdemona quietly says goodbye to Emilia. But before Emilia can leave she says goodbye a second time, starting with a forte high A-sharp. It recalls and has the same dramatic impact as did Otello's entrance in act I.

The opera is full of reminiscences; Verdi uses them to tie the work together. They are akin to Wagner's motifs, but Verdi uses the device much more sparingly than Wagner. Also akin to Wagner, but different, is the way *Otello* is a continuous opera, with the orchestra providing the continuity. Desdemona's two arias

interrupt that continuity, as do a few other set pieces in the opera, such as Iago's "Credo." Such set pieces were the hallmark of opera before the mid-nineteenth century, including Verdi's earlier operas. Whereas Wagner broke completely with that tradition, Verdi remained committed to many of its principles, even though in *Otello* he broke free of many of its rigidities.

The set pieces were also quite appropriate for an operatic version of a Shakespearean play. Shakespeare's use of soliloquies is analogous to operatic set pieces. They are devices well suited for expressing the utmost limits of human experience. George Bernard Shaw said of his own work, "My plays bear very plain marks of my musical education. My deliberate rhetoric, and my reversion to the Shakespearean feature of long set solos for my characters, are pure Italian opera." But the soliloquies are carefully planned interruptions in the otherwise continuous dramatic flow of Shakespeare's plays. It took a Verdi successfully to combine continuity with such interruptions.

The nineteenth century saw an enormous increase in interest in Shakespeare in all the arts. Dozens of operas were based on his plays. Only a few survive at all today—Rossini's *Otello*, Bellini's *I Capuleti e i Montecchi*, Thomas's *Hamlet*, Gounod's *Romeo and Juliet*, Nicolai's *Merry Wives of Windsor*. None of these is top-quality opera. Only Verdi's *Macbeth*, *Otello*, and *Falstaff* are fully successful translations onto the operatic stage of Shakespeare's masterpieces. One reason why Verdi succeeded where others failed is that whereas grand theorists like Wagner and Sophocles are espousing philosophical ideas in their works, Verdi and Shakespeare are primarily interested in the human drama on a very individual level. Another reason is that, with the aid of Boito, Verdi achieved a successful balance between the roles of music and words. When the Florentine Camerata invented opera at the beginning of the seventeenth century, one of their purposes was to place emphasis primarily on words. Hence they devised the recitative, a single, declamatory vocal line to be freely sung to simple accompaniment. The music was never to interfere with the comprehension of the words, in contrast to the then predominant

polyphonic style in which the words were frequently lost. But as Italian *opera seria* developed in the seventeenth century, it became dominated by a rigid, florid musical style. The reforms instituted by Gluck in the eighteenth century led to a famous battle, fostered by the Parisian press, between the Italian emphasis on music and the French emphasis on words. It came to be called the Battle of the Buffons, after the 1752 production in Paris of Pergolesi's *opera buffa, La Serva Padrona.*

Throughout the history of opera this question of the relation-ship between words and music has continued to be a central concern. In the first half of the nineteenth century the emphasis was clearly on the music, influenced by Mozart who explicitly gave it priority. Wagner hoped to give words equal prominence, but he exaggerated his writing skills, and it is his music, not his libretti, that give him his stature in the world of opera. In his *Pelleas and Mellisande*, Debussy subordinated the vocal line to the words and the orchestra. It is thus an opera difficult to access for someone not fluent in French. Richard Strauss struggled with the issue all his life; his last opera, *Capriccio*, is all about it.

Ultimately in grand opera, music has the upper hand, at least from the audience's perspective. We go to the opera to hear Verdi's music sung and played, not to listen to Boito's words. Verdi understood well that the words were of greater importance for the singer than for the listener, even when he set Shake-speare. He wrote to the singer who was to premiere the role of Macbeth, "I will not cease to recommend that you study the dramatic situations and the words: the music will follow on its own."

But there was no way even as skilled a librettist as Boito could possibly transform all of Shakespeare's great poetry into a libretto. Shakespeare's play has something like twice as many words as does Boito's libretto, and the libretto is filled with repetitions. Purely narrative and descriptive language has relatively little emotional content; the emotional content of language is conveyed through the use of metaphor. Only a small percentage of Shakespeare's marvelous metaphors can be found in Boito's libretto, and much

of their content is inevitably lost to the listener. In opera the emotional content that metaphor brings to poetry is found in the music and in the interpretation of that music by the singer (and the conductor). As Verdi indicated, the libretto is of greatest importance to the singers, conductor, and stage director. To the audience it is secondary to the music.

Words and music have something in common. They are our two most powerful languages for emotional communication. The other arts have the capacity for emotional communication, but they are not really languages in that they do not have the organized structure, the syntax, of a language. Mathematics has the structure of language but lacks the capacity for emotional communication. Speech expresses a form of symbolic thinking; so do the visual arts, dreams, and music. But speech is unique in that it alone allows self-reflective thinking. Only through speech do we become able to think about thinking.

The capacity for self-reflective thinking comes, like most things in life, at some cost. Although it makes thought more precise and capable of generalization and abstraction, its development results in the loss of potential for other capacities. Lost with the development of speech is some of the all-embracing quality of emotional response. The infant does not separate emotion from perception or sensation. It reacts in a total way. With self-reflective speech, some of that quality is lost. Music speaks to us in a language that is not self-reflective. It retains more of the capacity for immediate, total emotional response that we lose with speech. Whereas speech had always been a communal activity, when it developed into written language it became a private one and hence lost even more of its emotional quality. Music is experienced as a communal activity. Even when listening to *Otello* alone, one has more of a sense of relationship to Verdi than one does to Shakespeare when reading his *Othello*.

Music never has the capacity for logical reasoning and problem-solving of self-reflective speech. Still, life does not proceed in a logical fashion, things don't happen in sentences, and so music can describe aspects of life that speech cannot. No one brought

up in the Western musical tradition can mistake the meaning of the notes that open the second half of act 4 of *Otello*— a sustained, double piano E natural, almost three octaves below middle C, played in unison by the double basses. First it rises upward in thirds, then it falls back, only to rise again in an expanded version. Almost every commentator on this passage uses the same word, "ominous." Otello is standing in the doorway of her bed chamber as Desdemona sleeps. Where Shakespeare has him already fully decided at this moment that he will kill Desdemona, Verdi has him still consciously undecided. In high operatic style he is torn between love and hate. But through the musical line Verdi also makes it clear that there is no question about the outcome.

The ominous theme is now picked up, an octave higher, by the celli, as Otello enters the room, lays down his sword, and blows out the candle. A twisting little theme of eighth notes now adds to the sense of impending doom. The twisting theme turns into a frightening line of rapidly rising staccato notes that go from a G just above the E that opened the scene to a G an octave above middle C. It feels as though Otello is about to kill her. But then he hesitates as the ominous theme returns, now modified to end each time in a sighing F natural, E natural. Then, instead of F natural, E natural, it turns into F-sharp, E natural, and suddenly we have the love theme from act 1. The musical reminiscence of their love heightens the terror of the duet that follows as Desdemona, denying unfaithfulness, pleads for her life. Although torn by his remembered love for her, Otello cannot control himself and smothers her with a pillow. Her last shriek of fear brings Emilia, soon followed by the other principals.

In rapid succession Emilia reveals the truth about the handkerchief, the exposed Iago flees, and Otello falls on Desdemona's body as he stabs himself. The turbulent music that accompanied Iago's exposure and flight is now replaced by the sighing theme of a few minutes before. As Otello is dying, the sighing theme again turns into the love theme. This time the reminiscence

is complete as Otello repeats the words from act 1, "a kiss, another kiss, and yet a kiss." What began in triumph and love, ends in love and death. The cycle of life, and the opera, is over.

🌿 15 🌿

Puccini's Tosca

SOUND AND FURY

THE OPERA opens with furious sound—three chords in quick succession: B-flat major and then A-flat major, both in middle-low register, followed by an E natural major chord running from two octaves below middle C to two octaves above. There is no melodic line; the three tones are part of the whole-tone, not the diatonic, scale. The three chords are harmonically unrelated. The interval between B flat and E natural, a diminished fifth, had, since the Middle Ages, been known as the "diabolus in musica," the devil in music, because of its capacity for grating on the ear. Abruptly, without an overture, the curtain opens onto the first scene, the inside of a church. In the first few seconds Puccini introduces us to the ironic worldview of *Tosca*—the devil is in the church—and to the opera's dominant character, Scarpia, whose motif (the three opening chords) persists, mostly unchanged, throughout the work.

Puccini was an ardent student of the products of his operatic predecessors and contemporaries. His style was uniquely his own, but he integrated into it gleanings from many other composers. His use of motifs is derived from Wagner, but different. Although there are more than fifty different motifs in *Tosca*, they are used

solely as musical indicators of the action. They provide structure for the listener. In contrast to Wagner, however, the motifs remain mostly the same throughout the opera. Puccini does not vary them and use them as the basis for his harmonies and melodies as did Wagner. When he does vary a motif it is only to indicate a new or different aspect of the character or theme of the motif. Despite Puccini's many more modern elements, his underlying approach remained in the tradition of Italian grand opera. He was the last composer in that great tradition.

The violent, dramatic quality of the opening chords is continued with the opening words of the opera. The revolutionary, Angelotti, having just escaped from Chief of Police Scarpia's prison and seeking a hiding place, rushes into the church crying, "At last." But now, having set the emotional tone for the whole opera, the Scarpia motif is temporarily set aside as Puccini abruptly shifts to totally contrasting moods—the comic with the sacristan, and the romantic with our hero, Cavaradossi, and our heroine, Tosca.

After Angelotti has hidden himself, Cavaradossi arrives to continue work on his painting. Tosca enters and is immediately jealous of the beautiful woman whose picture Cavaradossi is painting. Eventually he succeeds in reassuring her, and they agree to an assignation that evening. When she leaves, Angelotti reemerges. The Scarpia theme now returns as Angelotti describes Scarpia as a villainous monster and Cavaradossi calls him a "slimy hypocrite whose mask of piety and virtue covers every vice that man can think of." Whereas before the motif was triple forte, now it is piano, to assure that we hear Cavaradossi's every word. Angelotti now disappears from the opera. Since Sardou's play, upon which the opera is based, had twenty-three characters, many had to be eliminated. Reducing Angelotti to a minor character is necessary but unfortunate, for his story gave the play its realistic historical grounding. Angelotti is being pursued by Scarpia at the request of Lady Hamilton, Lord Nelson's beloved. At the time, 1800, she is the wife of the British ambassador to Rome. Angelotti is a supporter of Napole-

on's attempt to overthrow the oppressive regime in Rome. When Lady Hamilton publicly supports the regime, Angelotti reveals that he had known her many years earlier when she was a London prostitute. In revenge she asks Scarpia to pursue him.

When Scarpia now appears onstage the first two chords are just as they were originally, but this time the high E natural is preceded by a screeching chromatic, upward scale in the flutes and the violins. The sound is startling. Tosca, still suspicious of the woman in Cavaradossi's painting, returns, and Scarpia fans her jealousy in the hope of using her to locate Angelotti. A special Te Deum Mass is beginning in the cathedral to celebrate Napoleon's supposed defeat at the battle of Marengo. As the act ends Scarpia is simultaneously participating in the Mass and singing of his lust for Tosca.

Puccini, perhaps more than any other operatic composer, paid precise attention to how every note would sound to the listener. Because sound itself was so important to him he used an unusually large and varied orchestra. Tosca is scored for two piccolos, three flutes, two oboes, an English horn, two clarinets, a bass clarinet, two bassoons, two contrabassoons, four horns, three trumpets, three trombones, a bass trombone, timpani, a side drum, a triangle, a celeste, bells, a harp, a carillon, cymbals, a gong, and the usual five string sections—first violins, second violins, violas, cellos, and basses, not to mention gun and cannon shots. Puccini makes use of every tone color available in his huge palate of sound, from the top of the orchestral range, as when the piccolos screech their highest notes in accompaniment to Tosca's screams in act 2, to the lowest, as when the deep bells ominously and repeatedly ring at the end of act 1. In addition, Puccini's original score is splattered with dynamic and expressive markings, instructing the musicians exactly how the notes should be played.

Puccini's attention to the details of sound extended to their accuracy when they were borrowed from the real world. He traveled to Rome to sit on the ramparts of the Castel Sant'Angelo to make sure he had the sound of its and Saint Peter's bells

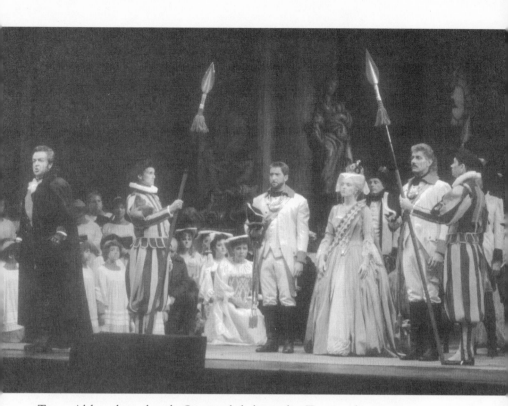

Tosca: Although in church, Scarpia, left, lusts after Tosca and revenge.

precisely right for act 3. When words were taken from the real world, their sound as well had to be exact. When the church was reluctant to give him precise language for the section preceding the Te Deum in act 1, he wheedled, cajoled, and threatened (including that ultimate threat, "I'll turn Protestant") until he got what he wanted. Similarly he went to great lengths to ensure that the words to the shepherd's song in act 3 were appropriate for the era and place. Puccini was not a *verismo* (realistic) composer in the same sense as his contemporaries Leoncavallo and Mascagni. But in his use of actual sounds he borrowed from them.

His debt to Verdi was lifelong. (It was upon hearing a performance of *Aida* that he determined on a career as an opera composer.) His use of the orchestra to establish atmosphere, his

intense chromaticism, and his use of the whole-tone scale contain echoes of Debussy, his abrupt tonal shifts and dissonant harmonies of Wagner. The Puccini sound is distinctly Puccini. But its eclectic origins are evident, and so his operas do not have quite the same sense of coherence that most great operas have.

How music actually sounds depends not only on how it is written and played but also on the setting in which it is performed. Puccini was especially conscious of this factor. Act 1 of *Tosca* takes place in a cathedral, and Puccini wanted the Te Deum at the end of the act to sound as it would in an actual cathedral. The old European cathedrals had reverberation times (the time between when you first hear a sound and when you can no longer hear the last echo) of between five and ten seconds. The average European opera house has a reverberation time of 1.5 seconds. In order to give the Te Deum as much as possible of the reverberant, echoing quality of a cathedral, Puccini used a variety of devices— the long-lasting deep bells, the sustained notes in the strings, the heavy use of resonant brass instruments. He succeeds admirably; the Te Deum sounds to us almost as if we were actually sitting in a cathedral.

Although many factors are involved in determining the acoustics of a hall, its reverberation time can have an especially important impact on how an opera sounds. Played identically in the Royal Opera House in London (reverberation time 1.1 seconds) and in the Teatro Colon in Buenos Aires (reverberation time 50 percent longer, 1.7 seconds), the opera will sound very different. Puccini knew that *Tosca* was well suited to a large, reverberant hall. He thought *Butterfly* better suited to a smaller hall and attributed its opening night failure partly to the size of the hall. Where one sits in a hall can also greatly affect an opera's sound. Mozart, having investigated, felt his *Magic Flute* sounded much better in the boxes than in the gallery.

Besides offering better sound, sitting in the boxes had other benefits. When the Florentine Camerata started opera they intended to model it on Greek theatrical production. But the Greek amphitheatre was quite large and open to the entire population.

In its early years opera was exclusively an activity of the nobility. By that time many aristocratic houses were built around great central halls, a design favored by Palladio, the sixteenth-century architectural genius. These halls, designed for ceremonial and theatrical events, could hold hundreds, sometimes even thousands. But entrance was reserved for the aristocratic classes, by invitation only. Gradually the halls came to be designed specifically for theatrical productions, including galleries. The theatre designed in 1637 by Bernini, for Cardinal Barberini, accommodated three thousand people. That same year the first theatre replacing the galleries with boxes was built in Venice. One's social status soon came to depend on the desirability of one's box. Despite the fact that theatres gradually moved away from purely aristocratic centers as they became commercial ventures, the status of boxes has continued to the present day.

In the mid-eighteenth century, opera houses began a new role as important public buildings. Frederick the Great of Prussia built the first one in Berlin in the 1740s. Soon they sprang up throughout the Western world, generally in monumental Greek style. In the nineteenth century they often replaced the building of cathedrals as the central icon of European culture.

The exigencies of financing opera, the most expensive of theatrical undertakings, gradually led to the reinstitution of galleries instead of boxes, since they could accommodate a larger audience. For the same reason opera houses continued to be built to accommodate as many people as possible. To hear Mozart's *Don Giovanni* performed in the large houses of New York, Chicago, and San Francisco is a much different experience from hearing it performed in the opera house in Prague, where it first appeared in 1787. That house is still in use and seats seven hundred people, almost all in the small orchestra or the rows of boxes in a vertical horseshoe.

Although *Tosca* was written for a large house, the Te Deum at the end of act 1 cannot be too loud and reverberant. One must also be able to hear Scarpia. Convinced that his fanning of Tosca's jealousy will lead him to Angelotti's hideout, he rejoices in

anticipation of both hanging Angelotti and forcing Tosca to submit to him. The act ends as it began, with the devil in the church. Scarpia's words are, "Tosca, you make me forget God." Its closing sounds are the same as those that opened the opera—Scarpia's sinister motif. Scarpia's powerful influence is never far from our awareness in act 1, but because of the comic sections involving the sacristan, romantic sections involving Cavaradossi and Tosca, and religious sections involving the choir, the act has a balance between elements of love and hate.

No such balance exists in act 2. With the sole exception of Tosca's aria, "Visi d'arte, visi d'amore" ("I have lived for art, I have lived for love"), the act is pure hate. (Puccini thought the aria interrupted the action and wanted to eliminate it, but it was so popular with audiences and sopranos that, despite his accurate assessment, he left it in.) The act is set in Scarpia's study; he is musing on the situation. When his henchmen inform him that they failed to find Angelotti at Cavaradossi's house, but did see Tosca there, he has Cavaradossi seized and brought to him. Tosca arrives, and as Cavaradossi is being tortured in the next room, Scarpia tries to learn from her Angelotti's hiding place. Unable to bear Cavaradossi's screams any longer, she tells him. A messenger arrives with the news that the earlier report had been incorrect—Napoleon has won the battle at Marengo. Cavaradossi rejoices and Scarpia, enraged, orders him taken away for execution the next morning. Scarpia then offers Tosca freedom for Cavaradossi in exchange for her sexual favors. The execution will be mock, and he prepares papers allowing the two of them to leave Rome. As he approaches Tosca to claim his reward, she stabs him with a knife, lays candles around his body, and leaves quietly, taking the exit papers from his lifeless fingers.

Grand opera is full of nasty villains. But even in the company of such sadists as Mephistopheles and Iago, Scarpia is unique, for his sadism is overtly sexual. To make sure we are fully clear that Scarpia is a sexual sadist, Puccini has Scarpia say so three times: "A forcible conquest has a keener relish than a willing surrender";

"Your eyes which darted hatred at me made my desire all the fiercer"; "How you hate me; this is how I want you."

Although the word "sadism" is taken from the Marquis de Sade, who was a sexual sadist, it usually refers to taking pleasure in cruelty, without involving anything overtly sexual. An element of pleasure in cruelty exists in all of us. If it didn't, slapstick wouldn't have the universal appeal it does, nor would violent, blood-and-gore movies be so popular. In our culture the enjoyment of actual, rather than make-believe, cruelty is frowned upon. (In some cultures the spectacle of torturing a prisoner of war was a great public event.) We are, however, accustomed to seeing cruelty in young children and consider it part of parental responsibility to teach them to give up such pleasures. As is so often the case, when something that was a normal part of early childhood persists into adulthood, it is evidence of difficulties in the process of growing up.

The route from normal childhood cruelty to adult sadism is complex and tortuous. Sadism in an adult will have many other functions besides a continuation of childhood pleasure. It can, for example, serve to maintain a sense of identity, defend against feelings of helplessness or emptiness, or convert passivity into activity.

When the sadism is sexual we find it particularly unacceptable, for good reason. Not only do we consider that sexuality should be related to love rather than to hate, but we recognize intuitively that sexual sadism is likely to reflect a more serious personality disturbance than ordinary sadism. Similarly, since we are all human and will carry within us some remnant of sexual sadism, overt sexual sadism is more likely to make us uncomfortable with ourselves. Some people find overt depictions of sadism enjoyable— "I'm not doing it, he's doing it, and so I don't have to feel guilty." In Puccini's era stage examples of sexual sadism were very rare. His decision to depict Scarpia as he did could not have been accidental, for Scarpia is not just a villain. He is also the strongest male figure in the opera. Cavaradossi is pallid in comparison.

Scarpia is also a baritone, a voice Puccini rarely used. His lead males are usually slightly insipid tenors.

Some clues to the fascination Scarpia held for Puccini can be found in his letters. In them he describes himself as having a "Nero complex," as being a "passionate hunter of fowl, women and libretti," and his operatic characters as "my puppet execution-ers." Like Nero, Scarpia was a Roman executioner who, in the words Puccini gave him, says of his attitude toward women, "I have strong desires. I pursue what I desire, glut myself with it and discard it." Puccini created no other operatic character like Scar-pia, although Turandot has a strong sadistic side. He did, however, spend much time considering an opera—*The Woman and the Puppet*—in which the denouement is an openly sadomasochistic sexual union between the hero and the heroine. Puccini never wrote the opera, but the planning had gone so far that the author of the story threatened to sue Puccini for not writing it.

Act 2 opens with Scarpia again gleefully anticipating hanging both Angelotti and Cavaradossi and forcing Tosca to submit to him; it continues with the torturing of Cavaradossi; it ends with Tosca stabbing Scarpia to death. Turn-of-the-century audiences were not accustomed to such on-stage brutality, and some found it grossly offensive. Perhaps they could have accepted the sadism of a villain such as Scarpia, but it was too much to have the heroine Tosca stab Scarpia with a cry of "This is the kiss of Tosca" and then gloat over his prostrate form: "Are you choking in your blood? Die, you fiend, die! Die! Die!" As Scarpia lies dying, his motif reappears, but this time the last chord is in the minor key. This minor-key version of his motif is heard even after his death. Although he is gone, his villainy lingers on.

Puccini's ironic comments about his sadistic impulses undoubt-edly were insights into himself. But there is no evidence he was ever overtly sadistic. What made Scarpia and Tosca so attractive to him was not primarily their sadism but their freedom from guilt. Remorse was a feeling alien to both of them. Scarpia's lack of remorse is expected; Tosca's is a surprise. As she lays out the body and then leaves, she shows no emotion, and the music is subdued

and calm. Underneath Tosca's emotional surface is a will of iron. In contrast, remorse pervaded not only most of Puccini's operas (*Manon Lescaut, Boheme, Butterfly*) but also his life. From childhood on, transgression followed by remorse seemed to dominate his existence.

The origins of this pattern are obscure. Giacomo Puccini was the sixth of seven children, the first boy. His father was the fourth generation of church organists in their town. We can only speculate about the impact of the birth of his brother Michele, three months after his father's death, when Giacomo was six. He always felt guilty about the contrast between his own success and his brother's sad life and untimely death in the Amazonian jungle. His mother was determined that he follow in the family tradition and become the local church organist. At first Giacomo resisted musical training. Instead he was a mischievous truant, frequently in trouble with the local authorities. His first music teacher gave up on him, finding him without talent. Despite his uncooperative behavior, his mother sent him to a second teacher who took a paternal interest in him, and he became an apt student.

With increasing maturity he developed the capacity for sustained, hard work, but he never freed himself from his need to get into trouble. As a "passionate hunter of fowl" he was repeatedly in trouble with the law for hunting illegally. Once he was almost shot as a poacher; once he was arrested for photographing a secret military installation. In his search for libretti he could be very devious. His machinations to get the rights to *Tosca* away from Franchetti were totally unscrupulous. He had behaved equally badly toward Leoncavallo about *Boheme*. He collected fast cars and boats and recklessly was involved in dangerous accidents with both. He loved practical jokes and obscene language. He was a prodigious womanizer, which ultimately led to real tragedy.

But Puccini was also a man of conscience, so his compulsive misbehavior left him in a constant state of remorse and self-doubt. He was hypersensitive with regard to any slight and had frequent bouts of depression. He said of himself, "I have always carried with me a large bundle of melancholy. I have no reason for it, but so I

am made." He confided his innermost thoughts to his longtime friend (and onetime mistress) Sonia Seligman. In 1908 he wrote of having "often lovingly fingered my revolver," in 1911 of being "in despair," in 1921 of being "eternally discontented."

Nowhere was Puccini's pattern of misbehavior and remorse more evident than in his relationship with women. When Puccini was twenty-six his mother died. She had been a powerful woman against whom he had rebelled since childhood; at the same time he was intensely attached to her. At the time of her death he prophesied accurately, "Whatever triumph art may bring me, I shall never be very happy without my darling mother." His ambivalent relationship with her was clearly transferred to Elvira Bonturi-Gemignani, whom he had known before her marriage to a friend of his. Shortly after his mother's death, she moved in with him, together with her daughter. Two years later their only son, Tonio, was born.

For Puccini, as for many men, an illicit sexual relationship protected him against guilt over incestuous wishes. His affair with Elvira was undoubtedly passionate, but when she and the two children became his "family" the protection against his unconscious guilt was gone. He embarked on an unending series of affairs. Not surprisingly, the women were almost always beneath him socially and intellectually. An exception was Sonia Seligman. Their affair was short-lived, but they remained lifelong friends. Puccini's need for transgression and remorse did not allow him to keep the affairs secret from Elvira. Somehow he always arranged for her to find out about them. For example, he would write about them to his "friend" Pagni, who promptly sold the letters to the highest bidder.

Over the years the relationship between Puccini and Elvira became a series of bitter recriminations followed by attempts at reconciliation. They could neither live together amicably nor could they separate. When Puccini was forty-six Elvira's husband died, so at last they could marry. If anything this seemed to aggravate the situation. Four years later, in 1908, Elvira's jealousy became psychotic: she accused a young maid in the household of

having an affair with her husband. Nothing could dissuade her from her pathological jealousy of the girl. She hounded her remorselessly, and the girl ultimately committed suicide. When autopsy revealed she was a virgin, her family sued. Eventually they accepted a large monetary settlement and Elvira did not go to jail. Puccini separated from Elvira, but he stood by her throughout the ordeal. Afterward they reconciled and remained together for the remaining fifteen years of his life.

Puccini chose women of inferior status as objects of sexual desire in most of his operas as well as in his life. Manon, Mimi, Musetta, and Butterfly—all are tainted. To varying degrees they are passive victims of a fate that is both unjust in its cruelty and just in its punishment of illicit sexuality. In some ways Tosca is like them. Both as an artist and as Cavaradossi's mistress she is outside conventional moral standards. In other ways Tosca is different, more like Elvira. She is an independent woman of strength, and her unreasonable jealousy seals her doom. Puccini built into this, his most powerfully dramatic opera, his two images of femininity: his mistresses and Elvira, fused in the figure of Tosca. He also built in his two images of his own masculinity: Scarpia, the transgressing sexual seducer, and Cavaradossi, the loving, remorseful artist. Puccini's conscience did not allow him to escape guilt-free in his relationships with either Elvira or his mistresses. Although Tosca was the most complete woman he ever depicted, her sexuality was too assertive for him. He came to call her his "Roman whore" from his "opera vile."

Although to modern audiences there is nothing vile about the opera, act 2, with its on-stage attempted rape, torture, and murder, is unusually violent. The culmination of the violent action is Tosca's murder of Scarpia. But just as he ended act 1 with a mixture of the sinful and sacred, so Puccini ends act 2 by having Tosca lay out Scarpia's body with candles and a cross. Puccini built his opera on the traditional pattern of theatrical production: act 1 sets the scene for conflict, act 2 contains the dramatic action, act 3 presents the resolution. The dramatic quality of the plot, the visual impact of the action were the first things Puccini looked for

when he considered writing an opera. He chose a number of his operas (including *Tosca*) after seeing a play produced in a language he could not understand. After seeing an English-language performance of Belasco's play *Madame Butterfly*, Puccini went backstage to seek permission to convert the play into an opera. Belasco is said to have described the scene that followed: "I agreed at once and told him he could do anything he liked with the play and make any sort of contract, because it is not possible to discuss business arrangements with an impulsive Italian who has tears in his eyes and both arms around your neck."

Puccini was explicit about his feelings: "I have the great weakness of being able to compose only when my puppet executioners move on the stage"; "And Almighty God touched me with His little finger and said: 'Write for the theatre—mind well, only for the theatre!' And I have obeyed the supreme command." Although he took infinite care with his libretti and often drove his librettists to distraction, he still wrote to them, "Be sparing of words and try to make the incidents clear and brilliant to the eye rather than to the ear." His stage directions were extensive and highly detailed. He was obsessed with the importance of the precise timing of the raising and lowering of the curtain: "A curtain dropped too soon or too late often means the failure of an opera."

After a short unison horn passage, the curtain rises on act 3, on an empty scene, the ramparts of the Castel Sant'Angelo. There follows a long passage of shepherd's bells, fading away into a song by a shepherd boy. Everything is slow-paced; the contrast with the uninterrupted action of act 2 could not be greater. Indeed, there is really no action at all in act 3 until the final three minutes of the opera. Bucolic as this opening scene is, Puccini does not let us forget this is a tragedy. The shepherd's bells passage is all in parallel fourths, a harmonically unstable sequence. Far underneath the high-pitched bells we can just hear the deep-pitched drums repeating the Scarpia motif.

Most of act 3 is devoted to the love between Tosca and Cavaradossi. Its centerpiece is Cavaradossi's great aria "E Lucevan

le Stelle," ("By the Light of the Stars"). Remembering his love for Tosca, he sings of never having loved life as much as now that he is about to die in despair. The aria does not interrupt the slow pace as did Tosca's aria in act 2, but rather provides a focus to the act. It is followed by a long duet between the lovers. Tosca explains that it will be a mock execution; he agrees to follow her instructions. But when he asks to hear her sweet voice just once again, Puccini makes it clear that Cavaradossi does not share Tosca's conviction that all will end well. And while Tosca is all exultation, Puccini's directions are for Cavaradossi to sing sadly. He is correct, for Scarpia, before he died, had secretly arranged for the execution to be real.

Although Cavaradossi is a noble and loving character, he has none of the force of Scarpia. Scarpia dominates to the end. As she leaps to her death to escape Scarpia's men, Tosca shouts, "Scarpia, we meet before God." The music is from Cavaradossi's aria. Some commentators have decried this, feeling the music should have been Scarpia's theme. But it seems to me that Puccini knew exactly what he was doing. Tosca's words are about Scarpia, but at the same time her feelings are equally about her love for Cavaradossi.

In contrast to Scarpia, Cavaradossi, facing death, is filled with remorse and self-doubt, as was Puccini all his life. The image of the loving man as fragile had a long history in the Puccini family. When he was just six he had lost his father, who, in turn, had lost his when he was three years old. Puccini did not think he was very intelligent, describing himself as "more heart than mind." His self-doubt led him never to be fully satisfied with his operas. He would constantly revise them. All except *Tosca*. Except for a few minor changes after the first performance, it remained just as he had written it, without modification. *Tosca*, once completed, was something he could not return to. There was too much of himself in it. To have changed anything would have been like trying to change his personality. It would have meant giving up his identity.

❧ 16 ❧

Puccini's Madame Butterfly

THE NOBLE, SUBORDINATE WOMAN
AND THE FLAWED, DOMINANT MAN

PUCCINI completed *Madame Butterfly* in 1904. The setting was contemporaneous, in keeping with the principles of *verismo*, or realistic, opera; the locale was Japan. Exotic, alien cultures were popular settings for nineteenth-century theatrical productions, for maritime empires were critical to the commerce of industrializing nations, and travel to distant lands was no longer inordinately hazardous. It was the era of Theodore Roosevelt, America's most imperialistic president. In Puccini's opera Pinkerton, the American lieutenant stationed in Japan, has a sense of American "manifest destiny" and American superiority that reflects contemporary thinking in the United States. American as well as European warships were cruising the Pacific, and Japanese ports were suitable for the kind of "rest and recreation" that Pinkerton sought. Great artists are of their time but also ahead of it: there is something almost eerily prophetic that this operatic study of the consequences of imperialism, racism, and sexism is set in the town of Nagasaki.

The libretto was derived from an actual incident. Tsuru Yamamura was a young Japanese girl who became pregnant by an Englishman and attempted suicide. Her son was raised in an

American missionary school in Japan. This episode was converted into a story by John Luther Long in 1898 and then into a play by David Belasco. Puccini saw the play in London in 1900 and obtained Belasco's permission to convert it into an opera. Interest in the story may well have been heightened by the current fascination with the "scandal" of an affair between a geisha and a prominent German military figure.

The clash between oriental and occidental cultures is a theme that pervades the opera. The tension is sustained by both Pinkerton's and Butterfly's denial of its implications. In the original version of the libretto Puccini had Butterfly say that she had first recoiled from the idea of marrying Pinkerton because he was "an American, a barbarian." Puccini wisely took this line out. To have Butterfly aware at the outset of the import of their cultural differences would have undermined the dramatic movement of the opera.

Puccini was fascinated by both America and the Orient. His *Girl from the Golden West* is set entirely in America, and *Manon Lescaut* ends there. *Butterfly* and *Turandot* are both set in the Orient. No other nineteenth-century composer had such an interest in the America of the time. The use of exotic settings such as the Orient was, by contrast, a common device. *Madame Butterfly* is unique in that the clash between two cultures is the integrating theme of the entire opera. The consequences of that clash are explored through their impact on the opera's central figure, Butterfly. But each of the lesser figures also serves to elucidate some aspect of the cultural conflict, and one of the great strengths of *Madame Butterfly* is the care which Puccini gives to the characterizations of all of them.

Pinkerton, though he dominates much of the first act, remains secondary to Butterfly. He represents one aspect of the American character: a somewhat stereotyped, simpleminded nationalism, a naive belief in his own superiority and invulnerability. His Japanese counterparts are Goro, the marriage broker, and the Bonze, Butterfly's uncle. Goro represents the compliant, submissive strain of Japanese culture, striving at all costs to avoid giving offense.

The Bonze represents the violent, authoritarian, family-and-tradition-oriented side of Japanese culture. Suzuki, Butterfly's maid, and Sharpless, the local American consul, also stand as cultural counterparts. Each represents a wise observer, sufficiently detached from the scene to see what is happening from the perspective of both cultures, but each unable to influence the course of events. Their function in the opera has its origins in the chorus of Greek drama—bystander and commentator, but not active participant.

The theme of incompatible cultures appears immediately in the first scene of the opera. Goro struggles unsuccessfully to avoid offending Pinkerton while the lieutenant is unaware of how rude he appears to Goro. Then, in a conversation with Sharpless, Pinkerton observes that in Japan both houses, with their movable partitions, and marriage agreements appear to be elastic. He is oblivious to the fact that the seemingly elastic Japanese house is really quite a stable structure, and that the marriage contract is in fact tightly binding. After suggesting American omnipotence— wherever ships sail Americans will be there, plucking and possessing the flowers of the region and never losing—Pinkerton toasts the day he will marry a real American wife.

From a psychological perspective, Pinkerton is childish and grandiose. He is blind to his own limitations as well as to external reality. From a sociological perspective, Pinkerton expresses a common turn-of-the-century image of Americans: racist, expansionist, superior, self-righteous. Musically Puccini makes Pinkerton representative of American nationalism by incorporating strains from *The Star-Spangled Banner*. But by using the National Anthem only in connection with Pinkerton and not with Sharpless (who understands that cultural difference is not cultural superiority), Puccini points out that the stereotyped view of Americans represented by Pinkerton does not describe all Americans. Pinkerton and Sharpless thus reflect Puccini's ambivalence about America: he was both fascinated and repelled by it. After a visit in 1907 he wrote to his friend Sybil Seligman, "I've had all I want of America."

In the same scene Sharpless tries repeatedly to warn Pinkerton

of the dangers of a marriage to Butterfly if he does not take it seriously. Sharpless understands that ultimately not only Butterfly but Pinkerton too will be hurt. When Pinkerton talks of his free and easy life with a girl in every port, Sharpless cautions, "Yes, your pleasures are legion, but what a sadness in your heart." As the wise observer, Sharpless sees the real implications of Pinkerton's statements. The lieutenant's inability to care about Butterfly as a person, his view of her as solely an object to give him pleasure, will ultimately bring him great pain.

The most explosive dramatization of the cultural conflict occurs in the middle of act 1 when the Bonze denounces Butterfly for betraying her people by surrendering her religion. His words are brutal: "Cio-Cio-San, Cio-Cio-San, abominazione" ("Butterfly, Butterfly, what an abomination"). The depth of the cultural misunderstanding is later illustrated in the marriage ceremony. Butterfly believes she is entering an "American" marriage, a permanent commitment. Pinkerton believes he is entering a "Japanese" marriage, an easily renounced arrangement. He enters the marriage "by his own wish and free will," and she "by the consent of all her kinsmen." His statement is both the truth (it is his choice) and a lie (he does not consider it a marriage). Her statement is totally untrue (her kinsmen are far from consenting). In the love duet between Butterfly and Pinkerton that closes act 1, the same theme appears most poignantly. While Pinkerton sings of his adoring passion, his bride sings of how in America they catch butterflies and pin them under glass. He reassures her that he has caught her only so that she cannot get away since he loves her so, and she accepts his version. Of course, her appraisal is far more accurate.

From the very opening of the opera Puccini continuously reemphasizes the conflict of cultures by using the pentatonic scale in the music set for the Japanese, but not for the American, characters. Although some of the pentatonic themes are Puccini's, some (seven have been identified) were taken from existing Japanese music. To our Western ears this lends an exotic quality to the opera. The pentatonic scale with its five tones (omitting the

fourth and seventh tones of our diatonic scale) sounds "oriental" to us.

But this scarcely means that Puccini wrote Japanese music. The language of music is extremely culture bound, far more so than that of the other arts. Westerners can appreciate the beauty of a Japanese painting, a Chinese vase, an Indian temple sculpture, or an African mask. But it is a rare Westerner who can understand and thereby appreciate the symbolic communication of Japanese, Chinese, Indian, or African music.

The symbolic language of music stands halfway between the language of speech and that of the visual arts. Speech reaches the narrowest audience, its boundaries having been established by the history of nations. The communication boundaries of music are those of cultural tradition. We can truly understand only the music, based on the tempered scale, that has developed throughout the Western Judeo-Christian world.

In addition to the pentatonic scale, Puccini uses a variety of other musical devices—rhythmic, harmonic, instrumental—to convey an oriental flavor. It is a reflection of his genius that he is able to do this within the framework of traditional nineteenth-century Italian operatic music. We do not experience an oriental quality grafted onto occidental music but rather an integrated whole. In lesser hands the effort would have turned into a disastrous pastiche. In Puccini's hands it became a masterpiece.

While Puccini always identifies Goro and Suzuki with oriental sounds and Pinkerton and Sharpless with occidental sounds, he uses both for Butterfly. For it is within her that the clash of cultures has its most profound impact. And in dealing with it she will be the stronger person. In the love duet that ends act 1 we have the first hint of this. Although only a girl of fifteen, consumed with romantic love, Butterfly has a dim sense of what the future holds. In the duet she says to Pinkerton, "I have come to the door of love where exists the happiness of those who love and those who die."

But for all his words of love in this great duet, it is not love that is on Pinkerton's mind, it is sex. That he should want Butterfly as

a sexual partner is not an accident: she is ideally suited to protect him from guilt about his sexuality. Such guilt has been connected with sexuality in the Western Judeo-Christian tradition since Adam and Eve. It received a major impetus through Paul and through Augustine, who postulated that original sin was passed from generation to generation via the male sperm. With the advent of Protestantism guilt became institutionalized and, though somewhat separated from its religious roots by the Enlightenment, reached new heights in the Victorian Era. For many nineteenth-century men sexuality was so connected with guilt that it had to be separated from love. The devalued woman, the woman not worthy of love, became the object of sexual desire. Many men who could afford them had mistresses.

Butterfly is perfectly suited for this role. She is still a child of fifteen years, not yet fully a woman. She is from an alien race, not suitable as a marital partner. She worked as a geisha and is therefore viewed as equivalent to a prostitute. This kind of figure—the devalued, often exotic, sexualized woman—was quite common in romantic opera. From this point of view, these operas are highly sexist.

The other side of the coin is that these women are also the heroines of their stories. They are noble, loving, long-suffering, and self-sacrificing. By contrast the men are thoughtless, uncaring, and self-centered. The men have worldly power, but because of their character flaws they are unable to choose their own destiny. The women are without worldly power, but their strength of character enables them to choose.

Their destiny is one of suffering and often death. The psychological term for choosing to suffer is masochism, which may be either sexual or moral. Sexual masochism—needing to suffer in order to be able to experience sexual gratification—is not depicted in nineteenth-century opera. Moral masochism—needing to experience oneself as the suffering victim—is characteristic of most nineteenth-century operatic heroines. Indeed, the male-dominated, highly sexist nineteenth-century world frequently imposed

considerable suffering on its women. Not surprisingly, masochism was considered an inherently feminine trait.

Its supposed biological basis was explained using arguments of social Darwinism. Man began as the hunter and turned his aggression outward in his work. Woman stayed at home to care for the family; she had to turn her aggression inward. Outwardly turned aggression is fertile soil for sadism, as inwardly turned is for masochism. So aggression and sadism were thought to have become staples of the male character while passivity and masochism infused the female. Although the argument about a sex-based predisposition to sadism and masochism continues to the present day, the predominant twentieth-century view is that constitutional factors are generally far less important than socio-cultural factors.

Butterfly could serve as the prototype for the late nineteenth-century view of womanhood. Although she is the victim of imperialism, racism, and sexism, she also helps to create her own situation. In many ways she plays directly into Pinkerton's needs: she welcomes his treating her as a child; she thinks of herself as a fallen woman because of her father's disgrace and because of her having been a geisha. In offering herself to Pinkerton totally, abandoning her religion and her family, she abandons her own identity. She participates in his need to deny that she is an independent human being, a woman whose existence is equally important as his. She plays into his need to treat her as an object and not as a person.

But if *Madame Butterfly* consisted only of stock characters representing concepts or ideas, it would not be a great work of art. For that an opera must have characters with whom we can identify. They must strike us as real people who are changed by events. The emotional impact of Puccini's opera lies in the development of Butterfly's character. In contrast to the other figures, who remain essentially the same throughout the opera, Butterfly changes. In the first act she is a naive, idealistic, giddy, petulant, romantic child. Only occasionally does she hint of other sides to herself—for example, her mention of death in the duet

with Pinkerton, and in the ominous chords as she describes her father's suicide.

In act 2 Butterfly is no longer a child but has become a woman. In her conversations with both Suzuki and Sharpless, she is no longer a passive reactor to events but often the initiator. She is mistress of the household and a gracious hostess. With her greater maturity comes a greater sense of reality—but she is not quite ready to face the full facts of her situation. She knows them but cannot acknowledge them. Deep inside herself she is aware that her relationship with Pinkerton is doomed. Consciously she clings to the notion that he will return to her, as in the aria "Un Bel Di"—"One Beautiful Day."

When Suzuki advises her to marry someone else because Pinkerton will not return to her, Butterfly strongly rejects the idea. When Sharpless tries to read Pinkerton's letter to her, she prevents him from doing so. When he too suggests that she remarry, she becomes angry, then triumphantly shows him Pinkerton's child. Butterfly is repeatedly intense and assertive in act 2. Not only does she often speak of death, but when she finds that Goro has been telling people that her son is illegitimate, she tries to kill him. The violence of her reaction to Goro's accusation reflects her inner awareness—though not yet conscious—that what he, Suzuki, and Sharpless are saying contains a grain of truth. Butterfly's capacity for great love, as in "Un Bel Di" and in her feeling for her son, and her capacity for strong anger, as in her reaction to Goro, are evident throughout the act. She is no longer the naive adolescent of act 1; she has become a mature woman with strong convictions.

Between acts 2 and 3 Puccini uses another musical device to illustrate the cultural difference: the long orchestral interlude with hummed, choral accompaniment that closes act 2. The action is over yet Butterfly remains on stage, immobile. She has undertaken a night-long vigil, awaiting Pinkerton's arrival the next morning. Western drama (plays as well as operas) use the device of acts to convey the passage of time and move the action along. The structure is well adapted to our occidental sense of time as linear

and unidirectional, and to our sense of change as purposive and progressive. For us time moves forward from one point to another at an unchanging pace. A moment gone can never return. We must act now.

The traditional oriental sense of time, by contrast, is circular rather than linear, and the oriental sense of change is that it is accidental and transient. An occidental artist is generally esteemed for his originality; the oriental artist is esteemed for his skill in maintaining tradition. For the oriental there is no need to seize the moment, to take action. The moment will return. For an occidental, waiting all night long would be a "waste of time"; for Butterfly, her vigil is a savoring of a long moment.

Similarly, on stage we expect action, not a set tableau as at the end of act 2. Western plays and operas are dramas (from the Greek word *dran*—to do or to act). Actionless scenes like this one are quite rare in romantic opera. The tableau quality of the scene is further enhanced by the libretto. Not only is there no stage movement, no physical action, there are also no words—no mental action. Butterfly is not actively thinking (which requires words), she is only feeling. Hence Puccini has the chorus hum. The total effect is almost mesmerizing; we too feel suspended in time.

In act 3 Butterfly emerges as a woman of great strength of character. Now it is she who dominates the situation. Neither Sharpless nor Suzuki can summon the courage to tell her that Pinkerton has arrived with his American wife, Kate, and wishes to take his son away. But as soon as Butterfly sees Kate, she understands and forgives her. The transition from Butterfly the child, who in act 1 petulantly ordered around her servant, Suzuki, to Butterfly the woman is now complete as she tells Suzuki, her valued companion, to leave her alone. Suzuki knows that Butterfly will commit suicide, but there is no arguing with Butterfly's words, ". . . Va, te lo comando"—"Go, I command you."

In act 1 Pinkerton was the commanding figure, now it is Butterfly. Puccini also describes Butterfly's emotional growth musi-

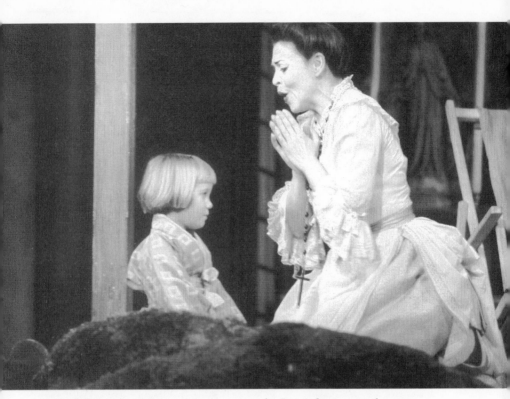

Madame Butterfly: Before committing suicide, Butterfly prepares her son for life in America.

cally. The flirtatious girl of act 1 has short, staccato phrases. The mature woman of act 3 has long, legato lines.

Only when confronted with Kate does Butterfly finally face the reality that Pinkerton has deserted her. In her view she is left with three choices—marry the oafish Yamadori, return to being a geisha, or commit suicide. Her choice is unhesitating.

Butterfly's preparations for her suicide are methodical and include an effort to prepare her son for his future in America. Her suicide is not an impulsive act. It needs to be understood from both a sociological and a psychological perspective, though from both views it is an attempt to solve what she perceives as an insoluble problem. Butterfly's suicide is, in her society, the honor-

able response to an unacceptable loss of face. It protects not only her but also her entire family against disgrace. Understood psychologically, Butterfly kills not just herself but also Pinkerton, the Pinkerton whom she had emotionally carried within herself for three years. Every suicide contains this aspect of murdering someone carried emotionally as part of oneself. Psychoanalysts call this a form of masochistic attack. Butterfly's suicide also expresses her tie to her father, who had committed suicide by order of the Mikado.

That the nineteenth century would see suicide as the woman's solution is not surprising: it is the ultimate expression of masochism. The nineteenth-century woman was dehumanized—in the upper classes by being simultaneously condescended to and placed on a pedestal, in the lower classes by being exploited in the sweatshops of the early industrial revolution. The long-suffering, noble woman who ends by committing suicide is so common in nineteenth-century opera as to almost define the genre. To include just a few from the standard repertory: Aida, Senta, Tosca, Leonora (*Il Trovatore*), Gilda, Juliet, Thais, Norma, Ophelia, Gioconda, and Brunhilde. Men die almost as frequently in nineteenth-century opera as do women, but rarely from suicide. In the operas analyzed in this book, the men are the only ones to die in just two: *Don Giovanni* and *Boris Godounov*. The women are the only ones to die in four: *Faust, Carmen, The Tales of Hoffmann,* and *Madame Butterfly*. In eight operas both die: *Lucia, Tristan, Aida, The Ring, Otello, Tosca, Salome,* and *Samson and Delilah*. But whereas half the women commit suicide, only two of the men do, in *Lucia* and *Otello*.

During the nineteenth century the cause of suicide was understood in widely different ways. At one extreme stood Marx, who saw the cause as purely external: suicide was caused by bad societal structures that impacted on the individual. At the other extreme was Freud, who saw the cause as purely internal, a response to psychological conflict. In between stood Emile Durkheim, Puccini's contemporary, who viewed suicide as an internal potential whose actualization depended on the structure of the society.

Durkheim studied the societal characteristics that led to different rates of suicide. Puccini's view is generally closest to Durkheim's. Butterfly is masochistic, but her society has both placed her in an untenable position and sanctioned suicide as a solution.

Butterfly, who started out as a naive, submissive child, has become a dominating woman who controls events. Pinkerton, who started out as the superior, aggressive master of all he surveys, has become a conscience-stricken coward. Unable to tolerate his remorse, he flees the scene.

Before stabbing herself Butterfly says farewell to her son. By telling him that he is descended from the "throne of high Paradise" she reminds him that he is Japanese, while by placing an American flag in his hand she tells him to become an American. The last words we hear are Pinkerton's plaintive, offstage cry, "Butterfly, Butterfly." He is overwhelmed with guilt. And he knows, albeit unconsciously, that in killing herself she is also, symbolically, killing him.

But the clash of cultures and the reversal of roles is not yet over. The music of Butterfly's death is a melody which, as it omits the sixth note of the scale, has a modal quality. It is played in unison by the entire orchestra. The last five notes are E, D, C-sharp, F-sharp, B. To our Western ears this sequence (4, 3, 2, 5, 1) is so strongly associated with a standard dominant-tonic ending in the key of B minor that, at the end of the phrase, although the orchestra is playing in unison, our ears supply the "missing" D and F-sharp of the B-minor triad. In one of the most startling endings in opera Puccini adds a G-major chord, triple forte. Because our ears are still "hearing" the F-sharp of the B-minor key, this crashing G-major chord sounds dissonant, though it is actually a pure G-major chord.

Through his music Puccini has each of us experience the clash of cultures within ourselves. Indeed, he has us create it in ourselves. It is an unstable state. Puccini describes that musically too: the chord does not rest on the tonic G but on the third—B. This is played by all the low-register instruments—cellos, double

bass, contrabass, trombone, timpani. The crashing G-major chord that closes the opera is thus highly unstable. In a stroke of genius Puccini musically recapitulates the theme of the entire opera in the last two measures.

17

Richard Strauss's Salome

PERSONAL AND SOCIAL DISINTEGRATION

RICHARD STRAUSS was already Germany's most celebrated composer in 1905 when Kaiser Wilhelm II observed, "I like that man Strauss, but his *Salome* will do him much damage." A century later our view is close to the reverse: he was not a very likable man, but his *Salome* is a splendid opera. It is based on an 1892 story by Oscar Wilde, that brilliant, witty, unfortunate man who once said, "Criticism is the only respectable form of autobiography." The many various critics who have studied this most controversial of operas have labeled it everything from profound to banal, from reactionary to revolutionary, from dangerously immoral to nothing but bourgeois moralism. Any commentator on the opera risks being hoist on Wilde's petard.

The biblical tale of Salome is a brief passage found in Matthew 14:6–11:

> But when Herod's birthday was kept, the daughter of Herodias danced before them, and pleased Herod.
>
> Whereupon he promised with an oath to give her whatsoever she would ask.
>
> And she, being instructed of her mother, said, "Give me here John the Baptist's head in a charger."

263

And the king was sorry; nevertheless for the oath's sake, and them which sat with him at meat, he commanded it be given to her.

And he sent, and beheaded John in prison.

And his head was brought in a charger, and given to the damsel: and she brought it to her mother.

Wilde drew upon a wide variety of versions of the biblical tale in writing his play—novels by Flaubert and Huysman, Massenet's opera, a poem by Heine, a play by Mallarmé, paintings by Leonardo, Dürer, Rubens, and Moreau. Although many of these versions contained embellishments on the original biblical tale, Wilde's version must be considered very much his own. Most striking is the erotic cast he gives to the entire tale—in Salome's relationship with John the Baptist, in Herod's incestuous interest in his stepdaughter/niece Salome (he married her mother after the murder of her father), and in having Salome kiss the lips of John's severed head which precipitates Herod's order to have her slain. In the biblical version, having John slain is Herodias's wish. In the play Salome explicitly states that it is her wish, further emphasizing the erotic element.

Wilde's hope was that he could get Sarah Bernhardt to do Salome's dance naked. But it was not just the dance he conceived as giving the play a musical dimension. The whole play was so conceived. He wrote that his *Salome* contains "refrains whose recurring motifs make it like a piece of music and bind it together as a ballad." He was speaking of the original version which he wrote in French. That language contains far fewer glottal stops (sounds like "k" which require shutting off the flow of air) than either English or German and is thus better suited for musical lines. The play was, however, soon translated into both German and English, both lacking much of the limpid, flowing, sensuous musical quality of the original. But it was still far too controversial to pass the English censors. Its first production was in Paris in 1896, by which time Wilde was in a British prison because of his overt homosexuality. Not until 1905 was it produced in England.

Nowadays, despite its representation of incest, perversion, and necrophilia, we do not consider Salome pornographic because its artistic merit clearly gives it redeeming social value. This concept did not exist in turn-of-the-century England. More than any other country it still feared that Calvin was right in his view that "the whole man is in himself nothing but concupiscence," and that censorship was therefore necessary to protect the public from itself. Wilde's Salome was the ultimate literary expression of what was called Decadent Art, a movement that had its origin in Poe. In France, Poe's work had influenced the development of Symbolism and, at the turn of the century, of Art Nouveau. At the same time in Germany the movement was called Jugendstil, while in England the period was called the "yellow nineties." It was characterized by an emphasis on the sensuous, the morbid, the decorative, the ambiguous.

For the opera Strauss used a German translation by Lachmann of Wilde's original French version. He had to cut the length almost in half for it to be suitable for a one-act opera. He did this by eliminating a number of minor characters and much dialogue. But the final libretto is made up almost exclusively of Lachmann's translation of Wilde's prose. Such verbatim conversion of a play into an opera libretto is rare. Of operas in the current standard repertory, only Debussy's Peleas and Melissande is similarly constructed. Through the music to which he set Wilde's play, Strauss moved his opera beyond the Decadent Art tradition which, for all its revolutionary content, retained traditional artistic structural concepts. In his Salome Strauss moved beyond those structures, which his earlier operas and tone poems had relied upon, toward the modern musical structures that were soon to be developed by Stravinsky and Schönberg. There is much chromaticism, dissonance, and atonality in the opera; but the chromaticism harkens back to Wagner, the dissonances are frequently alloyed with consonances, and the atonality eventually leads to traditional dominant-tonic resolutions. Strauss expressed his need to go beyond the "limits of tonality" whereas Schönberg saw a "necessity to abandon" it.

In the history of aesthetics Strauss's *Salome* is analogous to Picasso's contemporaneous (1907) *Demoiselles d'Avignon*, often considered the first modern painting. The figures are distorted but are still structurally intact, in contrast to Picasso's later cubist painting in which the structures have been taken apart. The term "deconstructionism" achieved prominence in the second half of the twentieth century based on the work of writers such as Derrida and Foucault. But the theory had its origins in Nietzsche and Heidegger, and the practice in the music of Strauss and Satie, the paintings of Picasso and Braque, and (somewhat later) the writings of Joyce and Eliot.

The history of Western art is replete with changes of style, from gothic to baroque to classical to romantic. None of these involved such an abrupt change, such extensive abandonment of long-standing artistic conventions, as did the advent of modernism in the years 1900 to 1925. In its mixture of decaying late romanticism and incipient modernism, *Salome* is a truly transitional work. To its turn-of-the-century audience it was shocking in both its words and its music.

The opera opens with three soft, short, orchestral measures, typical Straussian upward sweeping scales, in the key of C-sharp minor, a key that indicates Salome throughout the opera. The single setting of the one-act opera is the moonlit courtyard of the palace of King Herod Antipas. A cistern opens onto the courtyard. Onstage are the Syrian officer Narraboth, a page, and a few soldiers. Narraboth is gazing at the adjoining dining room where Herod and his family are entertaining guests. The page is gazing at the moon. Their opening dialogue introduces the opera's central theme—that the compulsive looking which characterizes sexual obsession will have dangerous consequences.

NARRABOTH: How beautiful is the Princess Salome tonight!

PAGE: Look at the moon, how strange the moon seems. She is like a woman rising from a tomb.

NARRABOTH: She has a strange look. She is like a little princess who has little white doves for feet. One might fancy she was dancing.

PAGE: She is like a woman who is dead. She moves very slowly.
NARRABOTH: How pale the Princess is! Never have I seen her so
pale. She is like the shadow of a white rose in a mirror of silver.
PAGE: You must not look at her. You look at her too much.
Something terrible may happen!

This opening passage also contains the mysterious moon which
reappears throughout the opera, as well as its identification with
death and with the dancing princess. Similarly the music prefig-
ures what is to happen. The opening key of C-sharp minor is used
for Salome throughout. Sometimes the key is changed, but the
C-sharp tone is retained as a signifier of Salome. D-flat minor
(enharmonic to C-sharp, that is, the same key on the piano but
having a different musical role) is the key of the moon, indicating
that it is closely related to Salome. The sweeping upward scale of
the opening measure reappears frequently when Salome is men-
tioned. The second time the page warns Narraboth not to look at
Salome we hear the threatening theme to which Salome will later
demand John the Baptist's head. The soldiers comment both
about the quarreling Jews (D minor) and that Herod (C major
and minor) is staring at Salome.

Soon we hear Jokanaan's (John's) voice booming out of the
cistern where Herod has imprisoned him, in a ringing diatonic C
major, sharply contrasting to the complicated chromaticism of all
that has gone before. Everyone else in the opera is full of complex,
twisted feelings. Jokanaan is utterly single-minded. He abhors
Herodias's incestuous relationship with Herod (brother of her
murdered former husband) and preaches that Jesus is the Messiah.
When Salome rushes into the courtyard, fleeing Herod's lecherous
glances, the stage has been set for the action to follow. Strauss has
also demonstrated how the opera will be constructed musically.
Instead of the traditional structure built around musical phrases
and harmonic resolutions, the structures providing cohesiveness
will be relatively invariant key signatures, motifs that are varied to
fit the situation but always remain recognizable, and florid tone
pictures painted by a huge orchestra. When Salome bursts onto

the stage we have barely had time to settle into our seats (less than five minutes have passed), but the opera is in full swing. It is a startling experience today. How it must have felt to audiences almost a century ago!

Hearing Jokanaan's voice, Salome bids Narraboth to have him brought out of the cistern, as we hear flickers of her dance music. Narraboth refuses, Herod having forbidden it. Knowing that Narraboth is enamored of her, Salome entices him to have the prophet brought up. She becomes fascinated with Jokanaan's body, alternately finding it repulsive and beautiful. When she finds it beautiful, consonances appear in the music; when she finds it repulsive the music remains dissonant. Jokanaan consistently curses her and rejects her advances. Now more and more obsessed with him, Salome insists she will kiss his mouth. Her obsession is more than Narraboth can stand and he commits suicide. As Jokanaan returns to his cistern the orchestra plays a theme that will later accompany her demand for his head.

The interaction between Jokanaan and Salome has been conceptualized as that between a vigorous new order and a decaying old one; between rigid moralistic masculinity and flexible, amoral femininity; between otherworldly asceticism and pervasive worldly sexuality. Most find Strauss's music for Jokanaan weak and banal. Some, particularly Marxist critics, view Jokanaan's total rejection of Salome as reflecting his lack of humanity, as when she asks, "Tell me what to do," and his only advice is, "Seek out the Son of Man." They thus consider the relatively empty music accurately reflective of Jokanaan as a hollow man.

Herod comes into the courtyard looking for Salome. His entrance is announced by disconnected, fragmented lines played by the deep brasses. He is the ruler, but he only seems deep and strong; in fact he is fragmented and weak. He is indifferent to Narraboth's suicide but thinks the moon looks like a madwoman and feels a cold wind. Herodias, the amoral cynic, says the moon is just the moon and that Herod is imagining the wind, as she berates him for continuing to look at Salome.

As Herod tries unsuccessfully to get Salome to pay attention to

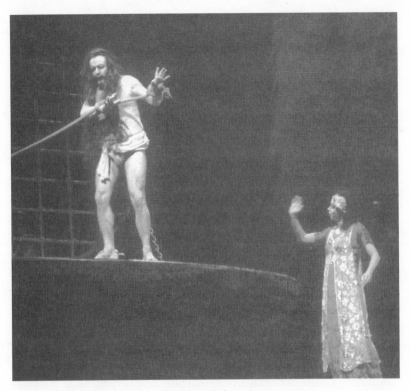

Salome: Jokanaan vehemently rejects Salome's propositions.

him, the voice of Jokanaan is heard. The Jews argue among themselves and try to get Herod to turn Jokanaan over to them; the Nazarenes pronounce him a prophet of the Messiah; Herodias wants Herod to have him silenced. Herod thinks Jokanaan may be a holy man. Despite his denials, Herod is afraid of Jokanaan, particularly when he hears that the Messiah can raise people from the dead. He disregards all the pleading regarding the prophet and asks Salome to dance for him. At first she refuses, but when he swears an oath that he will give her anything she wants she agrees.

Salome's dance begins ominously, with frequent changes of rhythm. After a while it settles down into an extended waltz which continues almost to the end, when the varying rhythms return. The music runs the gamut from diatonic lilting waltz to

ragged, disjointed, dissonant, chromatic passages. At the end Salome momentarily stands immobile, gazing at the cistern, before throwing herself at Herod's feet. Herod is delighted until she demands, as her reward, the head of Jokanaan on a platter. Herod offers her all kinds of treasures instead, but she holds him to his oath, and seven times she demands the head. Unable to budge her and having sworn an oath before guests, he orders the soldiers to carry out her wish as he repeats the words of the page at the beginning of the opera, "Something terrible is going to happen."

When the severed head is brought to her Salome sings a long love song to it. Both the words and the music are filled with reminiscences from throughout the opera. Ultimately Salome, saying that if only Jokanaan had looked at her he would have loved her, bemoans the fact that now her lust can never be sated. Herod, again repeating the page's words, starts to leave the courtyard. He turns to look back. A moonbeam has lighted up Salome who, to a triumphant tune from her dance, is ecstatically kissing Jokanaan's lips. It is too much for Herod. He orders the soldiers to crush her under their shields, as Jokanaan had prophesied would happen. From the moment Herod orders her killed to the fall of the curtain is just seven measures lasting twenty seconds. The opera ends as suddenly, but not as softly, as it began.

Salome is a textbook of psychopathology. Narraboth suffers from an atypical impulse-control disorder; Herod has phobias in addition to his voyeurism; Herodias is an antisocial personality; Salome starts out as a narcissistic personality, moves to a fetishistic obsession with Jokanaan's body, and ends up a psychotic necrophiliac. Everyone is suffused with perverse sexuality; even Jokanaan is obsessed with it. The subject fascinated the creative world at the turn of the century. Krafft-Ebing had published his *Psychopathia Sexualis* in 1886 and Freud and Breuer their *Studies on Hysteria* in 1893. The revolt against the nineteenth-century puritanical attitude toward sexuality was in full bloom.

Freud conceptualized neurosis and perversion as opposite sides of the same coin. In neurosis the unacceptable sexual impulses are repressed and result in the formation of symptoms, but the

defenses are adequate to preserve the primacy of normal sexual interests. In perversion the impulses break through to consciousness and replace normal sexual interests. The opera conveys the compulsive quality of the perverse impulses. When Salome says, "I wish to see him closer," and Narraboth tries to keep her from Jokanaan, her reaction is, "I must see him closer." She cannot tolerate having her impulse frustrated. Gratifying it is necessary if she is to retain her sense of herself. The threat of loss of sense of self as a coherent person, of the loss of one's identity, is the ultimate psychic abyss. Symbols for that abyss pervade the opera—in the cistern, in the moon in which everyone except Herodias sees his personal abyss, in Jokanaan's eyes, which seem to Salome "like the black caverns of Egypt where dragons make their lairs."

Salome's reaction to Jokanaan also accurately describes the ambivalence involved in the perverse impulse. She finds various parts of Jokanaan's body alternately attractive and repulsive. The perverse impulse reflects a need to retreat from normal, loving sexuality. The sexual interest is no longer in another person but only in a part of the person or some object. The retreat from loving the other person as a person inevitably carries guilt with it. When the attractive object is at the same time a repulsive object, it serves to alleviate some of the guilt.

Everyone has some remnants of childhood sexuality in themselves. In most people the special appeal of selected bodily features are of relatively little importance and do not interfere with normal sexuality. Common examples in current Western culture are the sexual significance of women's hair for men and of men's muscles for women. By focusing on compulsive looking, the opera draws the audience into participation in the impulses of the characters on stage. There is an element of voyeurism in watching any stage performance. Usually the audience is not conscious of this in themselves. But when Salome does her striptease with her dance of seven veils, only the most repressed in the audience will not become aware that they, like Herod, have voyeuristic impulses.

Salome is fifteen years old, barely out of puberty, a particularly
vulnerable age for girls. Freud's theories about psychosexual devel-
opment were so brilliant and insightful that many of his followers
have found it hard to accept that he could be very wrong on some
subjects. One of those was female psychosexual development. His
view that the castration anxiety that accompanies the male
Oedipus complex is central to the little boy's development has
stood the test of time. But Freud had a very orderly mind which
required that there be an analogous course in the little girl. Hence
penis envy became the equivalent force in his view of the little
girl's development.

Unfortunately he chose the wrong analogy. The reason that
castration anxiety has such an overwhelming impact on the boy is
that it is a threat to his bodily integrity, and to a child bodily
integrity is the core of his sense of self. Regardless of how
disturbing penis envy may be to a girl (and it can be an important
issue), it is not a threat to her bodily integrity. Only with puberty,
when her whole body changes shape, when she starts unprovoked
bleeding, does the girl experience a threat to her bodily sense of
self comparable to castration anxiety in the boy. Freud recognized
the inadequacy of his theory of female development. He acknowl-
edged his inability to answer the question he posed: "What do
women want?" It is also of interest that, in contrast to all his
other studies which emphasize the childhood origins of adult
psychosexual issues, in his one case study of female homosexuality
he considered the possibility that its primary etiology may have
been in puberty.

Freud was a revolutionary genius, but like all revolutionaries he
was also a man of his time. The sexual revolution, in which he
played such a significant role, was going on all about him, in the
sciences as well as in the humanities. The feminist revolution took
another fifty years to achieve a comparable status. It is not
surprising that his basic attitudes toward women reflected those of
his bourgeois, middle-class world. One of these was that women

lacked men's strength of moral conviction. Freud saw that the foundations of man's superego were laid down in the oedipal period, through the boy's identification with his father's prohibitions. He also saw that the process in women was different. It took place gradually over a longer period of time. He concluded that this resulted in a weaker superego in women.

Freud never reconciled this pejorative inference with his recognition that the early establishment of men's superego meant that it often contained primitive, destructive fantasies and that these later resulted in considerable neurotic conflict and, when their existence was externalized, in hostile, destructive behavior. The development of the female superego is different. Because it develops over a period of time, it is less likely to have so many primitive fantasies connected with it. Rather than being "weaker" it is often less rigid, less punitive, and more realistic than that of men.

Another subject on which Freud missed the mark was the role of familial childhood sexual abuse. In his earliest studies he considered it to be an issue in every case. When he realized that what he was hearing from his patients was often their childhood fantasies and not descriptions of actual events, he lost interest in the subject of childhood sexual abuse. His discovery of the role of childhood sexual fantasies was of critical importance. His subsequent neglect of the role of actual childhood sexual abuse was not rectified until the second half of the twentieth century. We now know not only that it is not uncommon but that Freud was right in his original observations—it seriously complicates normal development.

Salome is thus doubly vulnerable: she is barely out of puberty, and she is subjected to incestuous overtures from her stepfather. Right from the beginning we know how disturbing this is to her. Her first words are, "I will not stay. I cannot stay. Why, why does the Tetrarch watch me all the time with his mole's eyes from under his shaking eyelids? It is curious that the husband of my mother looks at me like that." That her perception was correct is confirmed when Herod and Herodias enter. His first words are, "Where is Salome? Where is the Princess? Why did she not return

to the banquet as I commanded her?" while Herodias's first words
are, "You must not look at her. You are always looking at her."

Salome is thus established as victim before she turns into
villain. Perhaps even more than Wilde's words, Strauss's music
elicits our sympathy for her. The music is so erratic—it moves so
quickly from fluttering sounds of vulnerability to fragmented,
violent outbursts. It moves from the depths to the heights and
back again, from sweet lyricism to frantic dissonance. Terrible
though Salome's actions are, Strauss makes us empathize with her,
makes us acknowledge that there is some of her in us. The opera is
about her, and no other character in it elicits our empathy. When
Herod orders her killed, we recognize that it was inevitable but
take no satisfaction in it. To the end we experience her as both
victim and villain, two sides of ourselves that we know all too well
but are often reluctant to acknowledge.

Salome was not just a shockingly different opera for the audi-
ence, it was so also for the performers. During the first rehearsal
all the soloists almost quit. Marie Wittich, the soprano who had
been chosen for the role of Salome, objected not only to the
technical difficulty of the part but also to having to sing over such
a large orchestra. Besides, she said, "I am a decent woman, I won't
do it." Eventually all objections were overcome, and the first perfor-
mance was a great success—there were thirty-eight curtain calls.
Within two years it had been produced in more than fifty cities.

The premiere took place in Dresden on December 9, 1905.
Gustav Mahler had wanted the premiere for Vienna, but despite
his great prestige as director of the Vienna Opera he was unable
to overcome the objections of that city's censors. Since the 1890s
Vienna had been governed by reactionary anti-Semites. Censor-
ship is always at its most intense when it is most futile. The city
was home to the paintings of Klimt, Schiele, and Kokoschka, the
writings of Hoffmannsthal and Schnitzler, and the theories of
Freud. All, like Wilde's play, undermined the existing social
conventions. Strauss's music undermined the comparable musical
conventions in the city that for a century had prided itself upon
being the center of great music.

The censors may not have read Plato, but they shared his view that "A change to a new type of music is something to beware of as a hazard of all our fortunes. For the modes of music are never disturbed without unsettling of the most fundamental political and social conventions." It was to be less than a decade before the collapse of the Austro-Hungarian Empire plunged the Western world into the two devastating wars that dominated the first half of the twentieth century. Salome was an opera of its time, the first great modern opera. Only the judgment of history will tell, but in my opinion it remains the greatest modern opera. Hugo von Hofmannsthal, who was to become Strauss's leading librettist, called it his "most beautiful and distinctive work." Strauss does not rank with the towering geniuses of music, with Bach, Mozart, Beethoven, Wagner, or Verdi. But he does rank high among all the rest. One cannot improve on his self-assessment as "a first-class, second-rate composer."

18

Richard Strauss's
Der Rosenkavalier

OLD WINE IN A NEW BOTTLE

HUGO VON HOFMANNSTHAL, the librettist for *Der Rosenkavalier*, felt
that "all developments move along a spiral curve." Accordingly he
had no hesitation in mixing a variety of eras in the opera. The
work is basically in seventeenth-century Italian *opera buffa* style.
Its sources are primarily from the French literature. Its setting is
eighteenth-century Vienna. Its music is built around the late
nineteenth-century Viennese waltz. And the stage setting for the
first act is an almost exact replica of Hogarth's 1745 drawing *The
Countess's Morning Levee*. As the curtain rises the Marschallin and
Octavian (a trouser role) are arising from her bed after a night of
lovemaking. The rapidly climactic upward and downward phrases
that open the short overture have been interpreted by various
musicologists as representing either mutual orgasm or Octavian's
premature ejaculation. The Marschallin is, after all, an experi-
enced married woman in her mid-thirties with a variety of previ-
ous lovers, while he is a callow adolescent, half her age, involved
in his first affair.

As the curtain rises the music has become soft and languorous.
Strauss indicated "sighing." In their long opening duet their
respective characters are established as he naively and impetuously

Der Rosenkavalier: The Marschallin, center, reluctantly receives a motley crew of petitioners.

pledges his undying love while she, somewhat sadly, a bit mater-
nally, but never unkindly, tells him he will soon leave her.
Hofmannsthal indicates the whole nature of their relationship in
the first lines of the opera:

> OCTAVIAN: The way you were! The way you are! That no one
> knows, no one would imagine!
> MARSCHALLIN: Are you complaining about that? Would you prefer
> that many know?
> OCTAVIAN: Angel! No! Happy am I that I'm the only one who
> knows what you are like.

Their conversation is interrupted by the arrival of her thirty-
seven-year-old cousin, Baron Ochs, who has come to town to
marry the fifteen-year-old Sophie and is asking the Marschallin to
arrange for the traditional presentation of a silver rose to the
bride-to-be. Octavian must hide in a closet from which he
emerges dressed as "the maid, Mariandel," whom Ochs promptly
tries to seduce. A whole host of characters now enters—a hair-
dresser, an attorney, a widow with brood, a singer, and so on.
Eventually the Marschallin chases them all out and sits alone
musing about growing old. Octavian briefly returns and they part
ambiguously, without kissing, as the act ends.

When *Der Rosenkavalier* was first produced in Dresden in 1911,
special trains were scheduled to accommodate all the dignitaries
who wished to attend. It was the last "grand" grand opera
premiere. The opera was a collaboration between Strauss, Ger-
many's leading conductor/composer, and Hofmannsthal, her lead-
ing poet/playwright. The two had first met in 1900 and had begun
working together in 1906. Their collaboration continued until
Hofmannsthal's death in 1929. Their first joint effort was the
opera *Elektra* (1909), based on Hofmannsthal's play. In it Strauss
took the modernity of *Salome* one step further, largely aban-
doning tonality and flowing vocal lines. The idea for a totally
different kind of opera, a comedy in *opera buffa* style, came from
Hofmannsthal.

He had been born in Vienna in 1874 and achieved fame as a

poet at an early age, later as a playwright. Brilliant and widely read, he was essentially a nineteenth-century romantic poet with great interest in symbolism and in the relationship between the comic and the tragic. For him, true love involved far more than sexuality; it included friendship, compassion, tenderness, and understanding. He was not comfortable with fin-de-siècle Vienna's cynicism and emphasis on sexuality for its own sake. He broke with his mentor, Schnitzler, over the latter's *The Road into the Open*. He considered Wagner's *Tristan and Isolde* love duets "intolerable erotic screamings."

Hofmannsthal drew on a wide variety of sources for the characters in *Der Rosenkavalier*, chiefly from French literature. The central figure, the Marschallin, Marie Therese, Princess Werdenberg, is primarily based on Beaumarchais's 1784 play, *Le Marriage de Figaro*. That tale was set in Spain whereas the opera is set in 1745 Vienna during the reign of Maria Theresia. In Beaumarchais's (and Mozart's) version there is no actual affair between the older woman and the young man. The Marschallin's young lover, Octavian (the Rosenkavalier of the title) is also based on Beaumarchais's Cherubino. But in that Octavian marries quickly he is like Octave in Molière's 1671 *Les Fourberies de Scapin*, and in his fantasies about sexual conquest like Couvray's 1781 figure, Faublas.

Baron Ochs of Lerchenau is drawn primarily from Molière's 1669 *Monsieur de Pourceaugnac*, secondarily from English figures such as Shakespeare's Falstaff and Sir Toby Belch, Sheridan's Bob Acres, and Goldsmith's Tony Lumpkin. All of these stem from the stock Commedia del Arte and Harlequinade figure of the foolish old lecher. Young Sophie's father, Faninal, is based on two figures from Molière, Geronte in *Scapin* and Monsieur Jourdain in his 1670 *Le Bourgeois Gentilhomme*. Nouveau riche fathers marrying their daughters to impoverished noblemen was not an uncommon event in the eighteenth century.

Hofmannsthal's use of language styles was as eclectic as his sources for characters—from the pompous, formal, chancery style of the Notary and of Octavian's presentation speech, to Ochs's vernacular, when he isn't trying to play "nobility"; from upper-

class Viennese to country speech; from eighteenth-century court language to nineteenth-century dialect. Hofmannsthal called it "costuming through speech." He published his libretto separately as a play and in that form all his subtle nuances of language add greatly to the richness of the production. In the opera, where many of the words are lost to even the most fluent German speakers, one cannot catch all the implications without knowing the libretto verbatim. It also makes translation into another language, often useful in comedy, an impossible task. Hofmannsthal was, of course, fully aware of all this and not concerned about it. He considered the emotional, connotative aspects of language to be the most important, and not just in librettos. Of Shakespeare's plays he said, "They are pure operas... the word is always expression, never information."

Although their relationship had its ups and downs, Strauss and Hofmannsthal formed a mutual admiration society. Shortly after they first met the poet wrote to the composer, "What I feel is more than mere belief in a possibility: I know we are destined to create together one, or several, truly beautiful and memorable works." At one point, not having heard from Strauss for some time, Hofmannsthal wrote, "What has become of you? I am quite alarmed, so long is it since I heard from my alter ego."

Many years after the event, Hofmannsthal described Strauss's reaction when he first showed the composer an outline for *Rosenkavalier*: "The effect of this tale on Strauss is as clear as though it happened yesterday. His attention was extraordinarily productive for I was feeling as though the unborn music was already being distributed by him over the scarcely formed shape of the story. 'We'll do it!' said Strauss. 'We'll put it on, and I know in my bones what they'll say about it. They'll say that their expectation has once again been shamefully misplaced; that this is definitely not the comic opera for which the German people have been waiting for decades. And with such a commentary is our opera bound to fail. All the same, let's keep a correspondence going while we are at work on it. Get you home at once and let me have Act I as soon as ever you can.'"

Strauss's alleged doubt about the future of the opera appears suspect. He clearly intended their correspondence about it to be available for posterity. And when he received Hofmannsthal's draft of the first act he wrote back, "The opening scene is delightful: it will set itself to music like oil and melted butter: I'm hatching it out already. You're da Ponte and Scribe rolled into one." Hofmannsthal promptly responded, "As our Elektra has slain her thousands, so our new venture will slay its ten thousands, like Saul and David in the Bible." He was right. The opera became their greatest success and has remained so.

Five years after it appeared Strauss wrote to his librettist, "I am ultimately the only composer who has humor and wit and a marked parodistic talent. Yes, I feel downright the calling to be the Offenbach of the twentieth century. . . . Starting with *Der Rosenkavalier* is our way: its success proves it, and it is also this genre (sentimentality and parody are the sensibilities to which my talent responds strongest and most fruitfully) that I happen to be keenest on." Interestingly, Hofmannsthal wrote back, "That other element which you also command, that mastery of the dark and savage side—which I intentionally refused to nourish—remains nonetheless one of your most valuable gifts."

Their relationship was mutually supportive but not totally equal. Hofmannsthal was an extremely touchy man, and Strauss often had to smooth ruffled feathers. And, what is most unusual in a relationship between a composer and a librettist, Hofmannsthal was clearly the leader. It was he who suggested the idea for the opera. It was he who persuaded Strauss to write an "old-fashioned Viennese waltz, sweet and yet saucy, which must pervade the whole of the last act," as well as a "Mozartian duet" for the finale. Furthermore, in contrast to most operatic libretti which are quite short and repetitive, Hofmannsthal's libretti are full-length plays. Instead of the libretto indicating a broad content area, with the composer having full freedom to indicate the subtleties musically, Strauss had to compose almost every measure for the singers precisely following Hofmannsthal's words.

Occasionally Strauss rebelled, as when he "accidentally" set

stage directions to music and then asked Hofmannsthal to rewrite the passage to go with the music he had written. When Strauss asked Hofmannsthal to make changes, the poet almost always graciously complied, without ever giving up overall control over the project. Strauss often had a better dramatic sense than Hofmannsthal, and his suggestions for improvements in the dramatic action were usually incorporated.

Strauss openly acknowledged the influence Hofmannsthal had over him. In 1916 he wrote, "Your impassioned protest against the Wagnerian way of music-making has sunk deep into my heart and opened a door on an entirely new landscape. . . . I now see my way clear before me, and I thank you for having opened my eyes. But now you must write me suitable librettos." Indeed, that influence continued even after the poet's death; in almost every Strauss opera after 1929, Hofmannsthal's touch can be seen.

Each of the three acts of *Der Rosenkavalier* has a mixture of romantic tenderness involving the Marschallin, Octavian, and Sophie, and buffoonery involving Ochs. Act 2 is set in the Faninal home. He and his maid Marianne are eagerly awaiting the arrival of Octavian and the silver rose, the first step toward marrying Sophie into nobility. Octavian arrives, and in the process of making the presentation he and Sophie fall in love. Strauss's music for their rapturous duet is among the most exquisite he ever wrote. When Ochs arrives, his coarse and obnoxious behavior toward Sophie is exceeded only by that of his retinue, who appear amid much hue and cry. Sophie and Octavian realize they are deeply in love and that she can never marry Ochs, which is enraging to her father and unbelievable to Ochs. Octavian draws a sword on Ochs, who sustains a minor flesh wound which he milks for all it is worth. Ochs is given a note from "Mariandel" agreeing to meet him that evening for an assignation, thus setting the stage for his subsequent humiliation in act 3. Delighted with the note, and somewhat tipsy, Ochs sings a long song of anticipation of the night to come while Faninal's maid fumes about his not giving her an adequate tip. Although there have been snatches of waltz throughout the first two acts, Ochs's monologue brings

the first full flowering of Strauss's magnificent, half-parodistic Viennese waltz melodies.

Strauss said of himself, "Work is a constant and never tiring source of enjoyment, to which I have completely dedicated myself." He was a meticulous worker; his writing table was always impeccably neat and organized. His operas were usually written in three phases. First drafts were penciled into well-worn notebooks which he always carried with him. Next came a piano score in ink. Finally there was the full orchestral score. This was so completely worked out in his mind that it contained few erasures or changes. Most composers develop their scores from the bottom up, since the full sound is often determined by the bass instruments. Strauss always worked from the top of the page down, starting with the piccolo, explaining that this way there was less danger of his sleeve smudging the ink. All his sketchbooks and preparatory notes were carefully indexed and filed. He often referred to them for, as he said, "I often write down a motif or melody, then put it away for a year. When I return to it I find that quite unconsciously something in me—the imagination—has been at work on it."

His schedule was as precisely organized as his papers. His wife laid it out for him and assured that he stuck to it. When she thought he had lingered over breakfast long enough, she would announce, "Richard, now go compose." While he was at work no interruptions were allowed. During the day he would work either in the garden or at his table. In the evening he would try out what he had written on the piano. He said of himself, "Two bars of a melody occur to me spontaneously, so I spin it out and write a few more bars, but soon I sense inadequacies, and I lay one foundation stone after another until at last I find the right version. That sometimes takes a long time, a very long time. A melody which seems to have been born in a moment is almost always the result of laborious work." When that laborious work took place at the piano, his wife was known to call from the next room, "Enough of that already. Move on, move on."

Long after the opera was finished, Hofmannsthal wrote to

Strauss, "In *Rosenkavalier* . . . the whole life of the thing is centered on the orchestra and the voice is only woven into it, emerging sometimes and submerged again, but is never—unless my impressions deceive me—wholly sovereign, never takes the lead." Among a number of reasons for this, foremost is the length and subtlety of the libretto. Strauss had little freedom to develop the vocal line if he was to follow the words, whereas he had much more flexibility with regard to the orchestral part. In order to accommodate the libretto Strauss invented a vocal style that was halfway between speaking and singing. Instead of long flowing vocal lines there are short phrases, as in a conversation. The tempo of natural speech is preserved.

This actually suited Strauss very well: "Only short themes occur to me, but I do understand how to use such a theme, to paraphrase it, and to draw out all it contains." It was primarily the orchestra that he used to draw out all the possibilities of his short themes. At least at this time in his life he liked a large orchestra— 114 pieces. And he wrote a great many notes for them, about three times as many as in Mozart's *Marriage of Figaro*. There are so many notes, they often go by so fast, that we do not hear them individually at all. We hear a wash of sound. The huge orchestra is used to provide a great variety of tone paintings. Strauss's operas have been called tone poems with words. In actual practice that is also how he wrote them. He would completely finish an act and send it off to the printer even before he had in hand the completed libretto for the next act. Although he paid careful attention to the dramatic flow of the entire opera, each act in itself was a complete piece of music.

Just as Hofmannsthal's literary sources were eclectic, so were Strauss's musical sources. It has been said that *Der Rosenkavalier* is one-third *Marriage of Figaro*, one-third *Meistersinger*, and one-third *Fledermaus*. Most explicitly Mozartian is the closing duet. The large orchestra and the subordination to it of the voices, the use of motifs, the chromaticism is Wagnerian. The centrality of the waltz, as well as the waltz style, is directly from Johann Strauss. Although he resided in Vienna for only relatively short periods,

Richard Strauss maintained a house there and often visited the city, knew it well, and must have felt comfortable setting the opera there.

But the Vienna Strauss was comfortable with the late-nineteenth-century Vienna of waltzes and sentimentality, not the early-twentieth-century Vienna of artistic and intellectual ferment, the world of Schönberg, Berg, Schnitzler, Freud, and Schiele. That was the world of *Salome* and *Elektra*. Starting with *Rosenkavalier*, Strauss turned to the past for his influences. Although he lived and composed for almost another forty years, he adopted none of the rapidly changing musical styles of the time— atonality, twelve-tonality, serialism, and so forth. In retrospect he said of his *Salome*, "One can consider it a unique experiment with particular material, but not one recommended for imitation." And thirty years after writing *Elektra* he is said to have expressed astonishment that he could have produced something so difficult.

Not that the many operas and orchestral and vocal pieces he wrote between the beginning of World War I and the end of World War II are simple. They are highly complex works, suffused with his superb command of his craft and his own particular, partly chromatic, partly traditional style. They remain in the repertory, receiving occasional performances. But none has found the widespread acceptance of his tone poems and of *Salome*, *Elektra*, and *Rosenkavalier*. For the most part the peculiar mixture of historical references and semimodern techniques of his other works have given them appeal to a limited audience. In his eighties he wrote a few pieces—for example the Metamorphosen, the Oboe Concerto, and the Four Last Songs—that are a distillation of his musical thinking, particularly the complex reworking of short phrases. Many critics consider them the best work of the second half of his life.

Strauss was clear that he wanted *Rosenkavalier* to be funny. He wrote to Hofmannsthal, "Don't forget that the audience should also laugh! Laugh, not just smile or grin! I still miss in our work a genuinely comic situation: everything is merely amusing, but not comic!" In the first half of act 3 they pulled out all the stops to

achieve that end. The setting is an inn to which Ochs has been lured on the pretext of an assignation with "Mariandel," but which is actually a setup to humiliate him. Among the preparations are trap doors, false windows at which strange heads will unexpectedly appear, and children hired to rush in and call him "Papa." The resultant melee leads to Ochs calling in the police. Faninal and Sophie enter and add to the general confusion. Peace is restored only by the arrival of the Marschallin.

Whereas the comic in acts 1 and 2 always contains elements of the affectionate and sentimental, this scene is pure farce. Every conceivable device from traditional eighteenth-century farce is utilized—the stage gimmickry, the greedy and concupiscent old lecher attempting to seduce a boy dressed as a girl, the servants helping the young lovers to foil the old man, utter chaos on stage. But it is not just Ochs who is "fooled" by the cross-dressing Mariandel. We too have been fooled since the very beginning of the opera. The highly heterosexually erotic opening scene, played by two women, has strong homoerotic overtones. The ambiguity does not make us anxious, rather we are amused. We know that Strauss and Hofmannsthal are fooling around with us. Such a trouser role can work in comic opera, as here and in *Fledermaus*, but not in nineteenth-century serious opera. It was rarely tried, and when it was, as in Verdi's *Masked Ball* and Gounod's *Faust*, the figures are somewhat humorous adolescents and minor parts.

In contrast to the farcical first half of act 3, the second half is all affection and sentimentality, including elements of real depth and pathos. Even Ochs, humiliated and defeated as he is, leaves with some dignity, realizing he can never reveal what he now knows, namely that Octavian and the Marschallin were lovers. Having chased everyone else out, the Marschallin is left alone with Octavian and Sophie. Strauss was concerned about the end of the opera. He wrote to Hofmannsthal, "The end must be very good, or it will be no good at all. It must be psychologically convincing and at the same time tender, the words must be charming and easy to sing, it must be properly split up into conversation and again into numbers, it must provide a happy

ending for the young people and yet not make one too uncomfort-
able about the Marschallin. In short, it must be done with zest
and joy."

He achieved his desired result admirably in the two closing
numbers. In a magnificent trio the Marschallin turns Octavian
over to Sophie. Sadly but graciously she gives him up to a girl
his own age, as she had known she would have to when they
arose from bed that morning. Hofmannsthal's words and Strauss's
music make this one of the most poignant moments in opera. At
first Octavian is torn between the two. Then, recognizing the
Marschallin's wisdom and generosity (and growing up a bit himself
in the process), he turns to Sophie as his bride-to-be. Their
closing love duet is the most traditional music in the opera. The
complexity of the real world has, for the moment, been replaced
by a fantasy of happily-ever-after. But only for a moment. When
the lovers have left the stage, a handkerchief that Sophie dropped
is left on the floor. It is the traditional symbol of an infidelity to
come. Before the curtain falls, a little servant boy comes in and
snatches up the handkerchief. The last scene had been too
serious; a closing comic touch was needed.

Strauss the composer remains controversial. Glenn Gould con-
sidered him "the greatest composer of our time." Ernest Bloch
referred to him as "the master of the superficial." Even more
controversial is Strauss the man. None of the numerous studies of
his life provides a coherent picture; he remains an enigma. He was
born in Munich on June 11, 1864. His only sibling, his sister
Johanna, was three years his junior. His mother was the daughter
of a well-to-do brewer, and his father was Germany's most accom-
plished French horn player as well as a dogmatic, idiosyncratic
man. He allowed no music by Wagner to be played in his very
musical household. Whenever possible, Franz Strauss did whatever
he could to irritate Wagner. When Wagner died the entire
Munich orchestra stood in a minute of silent tribute. Franz Strauss
remained seated.

Richard was clearly gifted as a child. He started piano lessons at four, wrote his first composition at seven, and had his first work published at seventeen. By age twenty he had written two symphonies in addition to numerous chamber works, piano pieces, and songs. These early works are highly classical in style. He was still very much under his father's influence and disliked Wagner. At age seventeen he had never heard any of the music of *Tristan and Isolde*. One day he brought the score home, played it on the piano, and withstood his father's violent protests. He became a worshipful devotee of Wagner and continued to be influenced by him for the rest of his life.

Strauss thought opera was dead as an art form because Wagner's work was an insurmountable summit. But then, in his characteristically impish style, he added, "But I have got out of the difficulty by making a detour around the foot of the mountain." On a different occasion he said, "With the B-major chord at the end of *Tristan*, romanticism is at an end for 200 years; we must see about starting somewhere else."

He found his detour to somewhere else in the modern idiom of *Salome* and *Elektra*. But then, starting with *Rosenkavalier*, he turned toward the past. His ten subsequent operas all draw on historical models cast in his own unique idiomatic style. In his last opera, *Capriccio* (1942), he quotes music by Couperin, Rameau, and Gluck. The opera is modeled on Mozart's *Der Schauspieldirektor*, as *Rosenkavalier* is on *The Marriage of Figaro* and *Die Frau ohne Schatten* on *The Magic Flute*. One of his last orchestral works, the 1945 Sonatina for 16 Wind Instruments, was dedicated "To the divine Mozart at the end of a life filled with gratitude." At age twenty-four he once declared himself to be a "Lisztian." It is as though, in order to get out from the shadow of Wagner, and having failed to find a new direction he was comfortable with, he spent the rest of his life drawing on the giants of the past.

Strauss made numerous comments about his own work. In 1919, with regard to the classical composers, he said, "If each of these great men has conquered a mountain nine thousand feet high among the principal works in the sphere in which he

excelled, while I have ascended one of only four thousand five hundred feet, I can be content, and may look back with satisfaction on my life's work." In 1923: "Formerly I was in the vanguard. Today I am almost in the rearguard." In 1935: "Without being immodest may I finally—naturally at a fitting distance—also mention my life's work, as possibly the last offshoot of the world theatre development in the realm of music." In 1942: "Many now consider *Elektra* the highspot of my work. Others vote for *Die Frau ohne Schatten!* The general public swears by *Rosenkavalier!* One must be content, as a German composer, to have got so far." And in 1945, age seventy-nine: "I know exactly the distance which separates my operas (in breadth of conception, primary melodic invention, cultural wisdom) from the immortal works of Richard Wagner."

Strauss is thought by some to be a writer of program music, intended to suggest a sequence of images or incidents. His tone poems have been extensively analyzed in terms of the direct tie between the music and the literary sources. Similarly the Symphonia Domestica and the opera *Intermezzo* are viewed as direct comments on his personal life. At the same time a piece like Metamorphosen could not possibly be construed as programmatic. Strauss did not help clarify this issue; his statements on the subject are very contradictory. "There is no such thing as abstract music; there is good music and bad music. If it is good, it means something; and then it is programme music." And: "To me the poetic programme is no more than the basis of form and the origin of the purely musical development of my feelings—not, as you believe, a musical description of certain events of life. That would be quite contrary to the spirit of music. Nevertheless, in order that music should not lose itself in pure willfulness and wallow out of its depth, it needs certain formal restrictions, and these are provided by the programme." And: "I am a musician first and last, for whom all 'programmes' are merely the stimulus to the creation of new forms, and nothing more."

Yet his tone poems are clearly programmatic, and to deny that something like *Intermezzo* is not programmatic (here in the sense

of explicitly autobiographical) is nonsense. At one performance, to Strauss's great delight, the performers wore masks of Strauss and his wife. The opera does not treat her kindly, and indeed she seems to have been a very difficult woman. The Hofmannsthals and the Mahlers could not tolerate her and did everything to avoid social contact. Alma Mahler quoted her as saying, "Oh men, keep them on a tight rein, that's the only way"—while making the motions of holding the reins with one hand and a whip in the other. On one occasion, suspecting that Strauss was having an affair, she stalked off to an attorney to file for divorce. Upon finding out that she had been completely mistaken, she reluctantly forgave her totally innocent husband. After the premiere of his early opera *Feuersnot* she stalked out, insisting that he walk three paces behind her, loudly proclaiming that he had stolen it all from another composer.

The singer Lotte Lehmann described Pauline Strauss as deriving "an almost perverse pleasure from proving to her husband that no amount of fame could alter her personal opinion of him as essentially nothing but a peasant, a country yokel . . . nor was his music, as she readily explained to all who would listen, anywhere near comparable to that of Massenet." After a performance of one of his operas, when he was being applauded, she proclaimed that the applause should be for her instead. Demanding, domineering, and demeaning as she was, Strauss remained devoted to her for the fifty-five years they were married.

One suspects she was envious of his success, having had only a modest career as a singer herself. Although Strauss was a homebody who disliked socializing, he was a prodigious worker who composed constantly. He also did an enormous amount of conducting, which first brought him fame. His last appearance as a conductor was at a radio concert, two months before his death at age eighty-five. Also keeping him away from her was the card game skat. Strauss was not just addicted to it, he was highly skilled at it. After every concert it was essential that three orchestra members be available for a game. At Bayreuth the festival management

made up the losses of those who had been required to play against him, since he almost always won.

Perhaps in no area is it more difficult to get a clear picture of Strauss than in his relation to the Nazis. On the one hand are the many ways in which he was an active participant in Nazism. He held formal positions with the regime, wrote music for official Nazi occasions, took Toscanini's place at Bayreuth when that dedicated antifascist refused to come because of his convictions, had a close personal relationship with Baldur von Schirach, the Gauleiter of Vienna (where Strauss had moved in 1941), and participated in the conversion of the 1941 Salzburg Festival into a Nazi celebration.

On the other hand was his insistence that the librettist Stefan Zweig's name remain on the announcements of their opera *Die Schweigsame Frau*, despite official objection, Zweig being Jewish. This action led to his being barred from conducting in Germany for a period of one year, though he was permitted to travel abroad to conduct. He had contempt for bureaucracy in general. When asked by the Nazis to fill out a form about his work, he answered a question requiring two references, "Mozart and Beethoven." Although world-famous when the Nazis came to power, he was already seventy years old and may have felt too old to emigrate. Furthermore, he had a partly Jewish daughter-in-law and grandson whom he successfully protected from the Nazis. As Germany's foremost composer and a wealthy man, he clearly was in a position to take a principled stand but lacked the courage to do so. Once he decided to stay, whether what started out as expediency ended up as active support is very hard to say.

One way of looking at why Strauss remains such an enigma is that he was a man who felt he had a great deal to hide. The blatantly autobiographical elements of some of his music, more obvious than in any other composer, suggest that they served more to mask than to reveal. Hofmannsthal, who worked so closely with him for more than twenty years, said, "My personal relations with Strauss, as always, casual but charming." Like Hofmannsthal, Zweig noted that underneath his polished, aloof, sardonic surface,

Strauss had a darker side: "One senses that something demoniacal lies concealed in this remarkable man, something which first makes one a trifle mistrustful when one sees the precision, the method, the solid craftsmanship, the apparent nervelessness of his way of working." Strauss once wrote to his friend Schuster, "Chevalley advises me against always composing myself. Do you know a composer who has ever composed anything but himself? Funny people, these aestheticians!" But he also wrote to Hofmannsthal that in dramas and novels the characterizations of artists, "particularly composers," stirred in him "an inborn antipathy."

His music contains one clue regarding what he may have felt he had to hide. His tone poems are all about men. They are also, in comparison with his operas, the weaker works. His operas are all about women, and the women in them are the stronger figures. Pieces such as Don Juan, Ein Heldenleben, and Thus Spake Zarathustra have a shallow, exaggeratedly heroic quality. Perhaps Strauss felt that underneath a somewhat shaky masculine identity, supported through reaction formations, there was a stronger feminine identity.

More likely Strauss seems such an enigma because he actually was an enigma. He lacked a strong sense of self, a coherent core. He said of himself, "I always write in too complex a way—it's because I have a complicated brain." His brain was so complicated because, lacking a coherent sense of self, he was constantly trying to locate himself through inputs from the outside world, as in his borrowings from the great composers of the past. Having a dominating, controlling wife was probably the only kind of intimate relationship he could sustain. Among the operas discussed in this book, Hofmannsthal is the only librettist who was the leader, with the composer the follower. Strauss needed words to write music. Whenever he was reading he sketched musical equivalents to the words. In addition to his librettists he set to music the words of at least seventy-four different authors.

About his songs he wrote, "Musical ideas have prepared themselves in me—God knows why—and when, as it were, the barrel

is full, a song appears in the twinkling of an eye as soon as I come across a poem more or less corresponding to the subject of the imaginary song while glancing through a book of poetry. If, however, the flint does not strike a spark at the decisive moment, if I find no poem corresponding to the subject which exists in my subconscious mind, then the creative urge has to be rechanneled to the setting of some other poem, which I think lends itself to music."

The greatest composers, no matter how stressed with internal conflicts they may have been, all had strong senses of commitment to relationships and to ideals. In order to stand somewhere you have to know who you are, to have a center to yourself. Intense commitment to relationships and to ideals is what grand opera is all about; it is what makes grand opera so powerfully appealing. Not having a coherent sense of self, Strauss lacked the capacity for intense commitment in his personal, professional, and political relationships. And because of that deficiency, despite his towering musical genius, one leaves a performance of even his greatest work, Der Rosenkavalier, feeling that somehow, somewhere, something was missing.

Afterword

ALTHOUGH OPERA has existed for almost four hundred years, the composers examined in this book all wrote between 1780 and 1910—less than a third of that time. The decision to discuss operas only from that period was not arbitrary; these are almost exclusively the operas people have been going to see. Between 1883 and 1979 there were 12,113 performances at the Metropolitan Opera in New York City. Of these, less than 1 percent were of operas from the period before 1780. At Chicago's Lyric Opera, between 1954 and 1980, 3 percent of the performances were from before and 10 percent from the period after the era covered in this book. Not surprisingly, the great opera houses of the world have often been described as period museums. The label is accurate, the pejorative connotation inappropriate. We need our museums; in them repose the best of our cultural heritage.

The overwhelming popularity of nineteenth-century opera inevitably raises the question of how to understand the relative lack of interest in operas of the seventeenth, eighteenth, and twentieth centuries. In the studies of the Metropolitan and Lyric Operas mentioned above, the only seventeenth-century composer included was Monteverdi. No Peri, Cavalli, Lully, or Purcell. And the eighteenth century is represented only by Gluck. No Handel, Haydn, Pergolesi, Rameau, Scarlatti, or Vivaldi. Yet they were the

giants of opera in their time, and we continue to recognize people like Handel, Haydn, Scarlatti, and Vivaldi as nonoperatic composers of the first rank.

I believe the lack of interest in these works stems from our expectation that when we go to the opera we shall see an unfolding drama, one that deals with the consequences of human complexity. But *opera seria*, the dominant form before the nineteenth century, was not designed to deal with such complexity. Descartes, the leading philosopher of the time, acknowledged the existence of six, and only six, human emotions: wonder, love, sadness, desire, joy, and hatred. *Opera seria* arias were almost always in A-B-A form. A theme, a contrasting theme, and then a recap of the original theme. Each of the two themes expressed a different emotion. Such a rigid, compartmentalized format does not lend itself to complex, dramatic development. The musical idiom of the time was similarly compartmentalized: music was either just slightly dramatic, or moderately so, or heavily dramatic. *Opera seria* was built of blocks with clear edges; they do not provide the kind of dramatic flow we have come to look for in opera.

Perhaps if we could hear baroque opera performed the way it was intended to be, we would find more in it. In all the arts the baroque style was intensely decorative. In opera it was the singer who supplied the decoration. What the composer wrote was only an outline for the singer who added ornamentation—often very elaborate—to the written line. A singer's skill in this regard was important. Nowadays it is rare for singers to be trained in or skilled at ornamentation, so we lack access to this rich, flexible aspect of baroque opera.

The small representation of twentieth-century opera in the standard repertory has been almost as striking as the few works from the seventeenth and eighteenth centuries. Of all the productions at the Chicago Lyric between 1954 and 1980, only two were by composers born in this century, Britten and Penderecki. Even as we approach the end of the century, Britten's works are the only

operas by a composer born in the twentieth century that are clearly established as part of the standard repertory.

The situation of twentieth-century opera is in some ways similar to that of other art forms. All twentieth-century art has reflected the consequences of the abandonment of the basic language used by the artist and understood by the public. Although many changes of style have occurred over the centuries, from baroque to classical to romantic to impressionist, the public has always been able to understand what the artist is saying, be it in painting, music, or poetry. New styles have frequently provoked strong negative reactions, but not from an inability to understand the artist's intent. Furthermore, style changes have come gradually— but in the twentieth century a new school of painting or composing seems to emerge into prominence almost every decade.

The situation of twentieth-century opera is different from other art forms in that because it demands an integration of music, drama, poetry, and staging, its coherent totality is damaged by the absence of an agreed-upon language in each of the art forms. Most orchestral concerts now include some modern music; exhibitions of modern painting draw large crowds; modern drama and poetry are widely accepted. Although the language of each art form is not easy to understand (reflecting how hard it is to understand this most turbulent century), each has found a way to reach its audience. But combining such difficult and changing artistic languages into the coherent whole that opera requires has so far proved elusive.

The problems of modern opera may also demonstrate that in opera, things are always writ large. It has been the medium par excellence for grand, heroic passions. But ours has been a century in which the grand, heroic passions of romantic love, religious fundamentalism, and nationalistic fervor have wreaked such devastation that, rather than admire them, we have come to mistrust them. The novels of Kafka, the poetry of Eliot, the plays of Beckett are not about heroes, they are about antiheroes. The issues that have occupied twentieth-century artists are the struggles for a sense of identity and for the small things that make life

worth living. They are fit subjects for a novel, a poem, or a play, where issues can be writ small. They are suitable for lieder. But the soaring voice, the glory of opera, so well suited to the expression of grand, heroic passions, is ill suited for the artistic treatment of the issues of the nonheroic.

Fortunately there continue to be composers willing to wrestle with the challenge of writing opera. New operas appear more frequently, and there is renewed interest in baroque opera. Productions by small as well as large opera companies are increasing. As an art form, opera is clearly alive and well. How much of twentieth-century opera will continue to be produced by the middle of the twenty-first century remains to be seen. Perhaps a Penderecki, a Glass, an Adams, a Davis, or one of dozens of other composers now living or yet to be born will find a permanent niche in the operatic repertory.

Perhaps none of them will. Art forms have their own life histories. The era of new opera may be over. The multimedia possibilities that only opera provided for three hundred and fifty years are now available through movies and electronic media. But the art of one age does not replace the art of the past. The masterpieces of grand opera will remain among the treasures of the Western cultural heritage.

A Note on Sources

THE LITERATURE on opera is enormous. My aim here is to comment briefly on some of the sources I have used, to assist the reader who may wish to pursue topics discussed in the book.

General

The *New Grove Dictionary of Opera* (New York, 1992) is a four-volume, 5,200-page compendium which covers almost every conceivable aspect of opera. It is a good place to begin looking up anything operatic.

Alfred Einstein's *Music in the Romantic Era* (New York, 1947) is a thorough, albeit somewhat pedantic, review of the musical world of the opera composers of the nineteenth century.

Joseph Kerman's *Opera as Drama* (republished, Berkeley, Calif., 1988) is probably the most influential opera book of the past half-century. Not easy reading, opinionated and polemical, it is filled with knowledge and insight.

Reinhard Pauly's *Music and the Theater* (Englewood Cliffs, N.J., 1970) surveys the world's great operas. Written for the relative novice, it pays more attention to staging than most other review books.

Patrick J. Smith's *The Tenth Muse* (New York, 1970) is an excellent survey for those interested in libretti and librettists.

Ulrich Weinstein's *The Essence of Opera* (New York, 1964) collects short writings about opera by some of the world's most astute observers. It is for leisurely sampling rather than reading through.

Three books use a format similar to mine but approach opera from different perspectives: Paul Robinson's *Opera and Ideas* (New York, 1985) is concerned chiefly with philosophy and ideology. Herbert Lindenberger's *Opera: The Extravagant Art* (Ithaca, N.Y., 1984) is a literary, aesthetic, and sociological study.

Robert Donington's *Opera and Its Symbols* (New Haven, 1990) uses the perspective of Jungian psychology.

Mozart

Depending on one's level of interest, three biographies of Mozart should be considered: Marcia Davenport's *Mozart* (republished, New York, 1979) is a popular, sentimental, "you were there" version. Richard Baker's *Mozart* (New York, 1982) is short but substantive. Wolfgang Hildesheimer's *Mozart* (New York, 1982) is a thorough, scholarly study.

H. C. Robbins Landon, *Mozart: The Golden Years, 1781–1791* (New York, 1989), an excellent study of the years in which Mozart wrote his great operas, is also a beautifully produced book.

Brigid Brophy's *Mozart the Dramatist* (republished, New York, 1988) is a sophisticated, thoughtful discussion of his five greatest operas.

Ivan Nagel's *Autonomy and Mercy* (Cambridge, Mass., 1991) looks at the cultural and philosophical assumptions underlying Mozart's dramaturgy.

Francis Carr's *Mozart and Constanze* (New York, 1985) explores their marriage.

Jonathan Miller's *Don Giovanni: Myths of Seduction and Betrayal* (New York, 1990) is a collection of splendid essays about the figure and the opera.

For direct quotations from Mozart, two versions available in English are Friederich Kerst's *Mozart: The Man and the Artist Revealed in His Own Words* (republished, New York, 1965), a short sampler; and Emily Andersen's *Letters of Mozart and His Family* (London, 1985), a three-volume compilation.

Beethoven

Maynard Solomon's *Beethoven* (New York, 1977) remains the most sophisticated biographical study, though the standard is the massive three-volume biography by Alexander Thayer, best approached in Elliot Forbes's one-volume abridgment, *Thayer's Life of Beethoven* (Princeton, N.J., 1967).

Denis Arnold and Nigel Fortune's *Beethoven Reader* (New York, 1971) is a fine collection of essays on Beethoven, including Winton Dean's excellent discussion of *Fidelio*.

Frida Knight's *Beethoven and the Age of Revolution* (New York, 1973) is an interesting, albeit biased, study of the political context of the era.

The workings of Beethoven's mind have been much examined from a variety of perspectives. Two studies from a religious viewpoint are J. W. N. Sullivan's *Beethoven: His Spiritual Development* (London, 1927), and Wilfrid Meller's *Beethoven and the Voice of God* (New York, 1983). Two studies from a social, philosophical viewpoint are: W. J. Turner's *Beethoven: The Search for Reality* (New York, 1927), and John Crabbe's *Beethoven's Empire of the Mind* (Newbury, England, 1982). Ernest Newman's *The Unconscious Beethoven* (New York, 1930) is a psychological study. Barry Cooper's *Beethoven and the Creative Process* (Oxford, England, 1990) is a scholarly musicological study.

Rossini

Three biographies of Rossini, depending on one's taste, are Francis Toye's *Rossini: A Study in Tragi-Comedy* (New York, 1934), a classic version written in a rather florid but quite enjoyable style; Richard Osborne's *Rossini* (London, 1986), a straightforward version; and Herbert Weinstock's *Rossini: A Biography* (New York, 1968), the most comprehensive version.

On the subject of creativity and mental illness, two books from very different perspectives should be read together: Kay R. Jamison's *Touched with Fire* (New York, 1992) approaches the issue from a biological standpoint; Albert Rothenberg's *Creativity and Madness* (Baltimore, 1990) uses a psychological perspective.

Donizetti

William Ashbrook's *Donizetti and his Operas* (Cambridge, England, 1982) combines biography with a discussion of Donizetti's work.

Ellen Bleiler's *Lucia di Lammermoor* (New York, 1972) focuses on the opera and its background.

The history of divas is well reviewed in two books: Rupert Christiansen's *Prima Donna* (New York, 1984), and Ethan Morden's *Demented* (New York, 1984).

Harold Schonberg's *The Glorious Ones* (New York, 1985) includes chapters on male singers and conductors as well as divas.

The literature on performance anxiety is unimpressive. Two books that discuss the issue are James Ching's *Performer and Audience* (Oxford, England, 1947), and S. Aaron's *Stage Fright* (Chicago, 1986).

Gounod

James Harding's *Gounod* (New York, 1973) is not a very satisfactory biography, but it is the best I could find in English.

Charles Gounod's *Memoirs of an Artist: An Autobiography* (Chicago, 1895) is fascinating, as much for what it doesn't say as for what it does.

J. W. Smeed's *Faust in Literature* (London, 1975) is an excellent survey, though there is no substitute for returning to Marlowe's, Goethe's, and Mann's original treatments of the subject.

Wagner

Bryan Magee's *Aspects of Wagner* (Oxford, England, 1988), a short volume of essays, contains more wisdom about Wagner than many of the hundreds of lengthy studies of him, besides being beautifully written. If you wish to begin exploring Wagner or plan to read only one book about him, read Magee.

J. Deathbridge and C. Dahlhaus's *The New Grove Wagner* (New York, 1984) offers a brief overview of his life, writings, and operas.

Curt von Westernhagen's *Wagner* (New York, 1981) is the best biography. Some of the most brilliant minds of the past century and a half have discussed Wagner, and their views continue to be of interest. The four most worth reading are Friedrich Nietzsche's *The Case of Richard Wagner* (New York, 1967); George Bernard Shaw's *The Perfect Wagnerite* (London, 1972); Thomas Mann's *Pro and Contra Wagner* (London, 1988); and Theodor Adorno's *In Search of Wagner* (London, 1981).

Robert Donington's *Wagner's "Ring" and Its Symbols* (London, 1974) discusses the operas' symbolism from a Jungian perspective.

Edward Dent's *The Rise of Romantic Opera* (Cambridge, England, 1976) is a solid historical discussion.

Two worthwhile books on heroism are Lord Raglan's *The Hero: A Study in Tradition, Myth and Drama* (New York, 1956), and Joseph Campbell's *The Hero with a Thousand Faces* (Princeton, N.J., 1949).

Maurice Keen's *Chivalry* (New Haven, Conn., 1984) investigates the origins of the concept.

Verdi

George Martin's *Verdi: His Music, Life and Times* (New York, 1983) is the best biography of Verdi.

James Hepokoski's *Giuseppe Verdi: Otello* (Cambridge, England, 1987) discusses all aspects of the opera.

Hans Busch's *Verdi's Otello and Simon Boccanegra* (Oxford, England, 1988) collects letters and other original source documents about the writing and production of the opera.

Gary Schmidgall's *Shakespeare and Opera* (New York, 1990) surveys the subject.

Sandra Corse's *Opera and the Uses of Language* (Cranberry, N.J., 1987) is an excellent study of how different composers relate music to words, and includes a chapter on *Otello*.

L. E. Boose and B. S. Flowers's *Daughters and Fathers* (Baltimore, 1989) contains essays on the subject drawn from a variety of perspectives.

Wayne Koestenbaum's *The Queen's Throat* (New York, 1993) is a provocative, idiosyncratic study of a neglected topic, homosexuals and opera.

Moussorgsky

M. D. Calvocoressi's *Modest Mussorgsky: His Life and Works* (London, 1967) is the standard English-language biography.

J. Leyda and S. Bertensson's *The Mussorgsky Reader* (New York, 1970) includes letters and commentaries by his contemporaries.

R. Taruskin's *Mussorgsky: Eight Essays and an Epilogue* (Princeton, N.J., 1993) is an excellent collection of recent scholarship.

The literature on the psychological hazards of political power is sparse. Relevant are Theodor Adorno's *The Authoritarian Personality* (New York, 1950);

Harold Lasswell's *Psychopathology and Politics* (New York, 1960); Ronald Sampson's *The Psychology of Power* (New York, 1966); and Abraham Zaleznik's *Human Dilemmas of Leadership* (New York, 1966).

Johann Strauss

H. E. Jacob's *Johann Strauss: Father and Son* (London, 1940) is a useful biography of the major figures in the Strauss dynasty.

Richard Traubner's *Operetta: A Theatrical History* (New York, 1983) surveys that closely related field.

Three books attempt to survey the broad field of comedy: Morton Gurewitch's *Comedy: The Irrational Vision* (Ithaca, N.Y., 1975); George McFadden's *Discovering the Comic* (Princeton, N.J., 1982); and Richard K. Simon's *The Labyrinth of the Comic* (Tallahassee, Fla., 1985).

Bizet

Two satisfactory biographies of Bizet are Winton Dean's *Georges Bizet: His Life and Work* (London, 1965), and Mina Curtiss's *Bizet and His World* (New York, 1958).

Susan McClary's *Carmen* (London, 1992) explores the opera.

Silvano Arieti's *Creativity: The Magic Synthesis* (New York, 1976) offers a comprehensive review of a contentious subject.

A. Rothenberg and C. Hausman's *The Creativity Question* (Durham, N.C., 1976) compiles some of the best writings on the topic.

Saint-Saens

James Harding's *Saint-Saens and His Circle* (London, 1965) is a somewhat superficial biography.

C. Saint-Saens's *Outspoken Essays in Music* (New York, 1922) is an interesting collection of his writings.

B. Mazar's *Old Testament History of Contemporary Events* (New York, 1964) contains an excellent discussion of the origins and development of the original Samson tale. F. H. Krouse's *Milton's Samson and the Christian Tradition* (Princeton, N.J., 1949) picks up where Mazar leaves off.

David Allen's *The Fear of Looking* (Charlottesville, Va., 1974) is a psychoanalytic discussion of looking and being looked at.

Bram Dijkstra's *Idols of Perversity* (Oxford, England, 1986) places Saint-Saens's figure of Delilah in historical context.

Offenbach

Peter Gammond's *Offenbach: His Life and Times* (Kent, England, 1980) is a worthwhile biography.

H. W. Hewitt-Taylor's Hoffmann: Author of the Tales (Princeton, N.J., 1948) investigates the fascinating figure of E. T. A. Hoffmann.

Sanford Pinsker's The Schlemiel as Metaphor (Carbondale, Ill., 1971) offers a contemporary view of the historical figure.

Ruth Gay's The Jews of Germany (New Haven, Conn., 1992) provides an excellent historical survey from the time of Christ to Hitler.

Puccini

Mosco Carner's Puccini: A Critical Biography (New York, 1959) is the standard in the field.

J. L. DiGaetani's Puccini the Thinker (Bern, Switzerland, 1987) lends support to the composer's stature despite his dismissal by many critics.

Mosco Carner's Madam Butterfly (London, 1979) and his Tosca (Cambridge, England, 1985) are excellent studies of the operas.

Marvin Carlsen's Places of Performance (Ithaca, N.Y., 1989) provides a fine study of theatres, including opera houses.

Leo Beranek's Music, Acoustics and Architecture (New York, 1962) covers the subject well.

Catherine Clement's Opera, or the Undoing of Women (Minneapolis, 1989) takes a feminist view of the operatic depiction of women.

Richard Strauss

Alan Jefferson's Richard Strauss (London, 1975) is a short, balanced biography.

Bryam Gilliam's Richard Strauss and His World (Princeton, N.J., 1992) offers an excellent collection of sophisticated essays about Strauss as a composer, dramatist, and person.

Rudolf Hartmann's Richard Strauss: The Staging of His Operas and Ballets (Oxford, England, 1980) covers the staging of all his operas, a topic often neglected in the operatic literature.

H. Hammelman and E. Oser's A Working Friendship: The Correspondence Between Richard Strauss and Hugo von Hoffmannsthal (New York, 1970) supplies an excellent translation of the correspondence on which the remarkable collaboration of the two was based.

Alan Jefferson's Rosenkavalier (London, 1986) is a thorough study of the opera. Derrick Puffett's Richard Strauss: Salome (Cambridge, England, 1989) is also worthwhile.

Sigmund Freud's Three Essays on Sexuality (London, 1953), though dating from 1905, remains the most thorough discussion of his views on childhood sexuality and its relation to neurosis and perversion.

Index

A NOTE ON THE AUTHOR

Eric A. Plaut was born in New York City and completed his undergraduate and medical studies at Columbia University. In addition to many years in private practice, he has taught psychiatry at the University of California at San Francisco, Indiana University, Yale University, the University of Connecticut, and Northwestern University, where he has been professor of clinical psychiatry and behavioral sciences since 1981. Before coming to Northwestern he served as commissioner of the Connecticut Department of Mental Health. He has published widely in the fields of psychiatry and psychoanalysis. He lives in Evanston, Illinois, with his wife Eloine and their son Ethan.

Names of singers in the productions pictured in the book:

Don Giovanni: Samuel Ramey as Don Giovanni
The Barber of Seville: Frank Lopardo as Count Almaviva
Lucia di Lammermoor: June Anderson as Lucia
Faust: Mirella Freni as Marguerite, Nicolai Ghiaurov as Mephistopheles
Tristan and Isolde: Janis Martin as Isolde, Jon Vicker as Tristan
Aida: Siegmund Nimsgern as Amonasro, Susan Dunn as Aida
Boris Godounov: Nicolai Ghiaurov as Boris Godounov
Die Fledermaus: Anne Howells as Count Orlofsky
Das Rheingold: James Morris as Wotan
Samson and Delilah: Agnes Baltsa as Delilah, Placido Domingo as Samson
The Tales of Hoffmann: Normann Mittelmann as Dr. Miracle,
Valerie Masterson as Antonia
Otello: Placido Domingo as Otello, Sherrill Milnes as Iago
Tosca: Siegmund Nimsgern as Scarpia
Madame Butterfly: Catherine Malfitano as Butterfly
Salome: Siegmund Nimsgern as Jokanaan, Maria Ewing as Salome
Der Rosenkavalier: Anna Tomowa-Sintow as the Marschallin